The First Artists

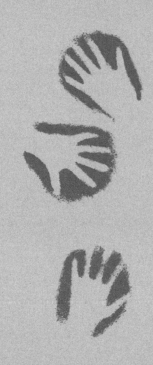

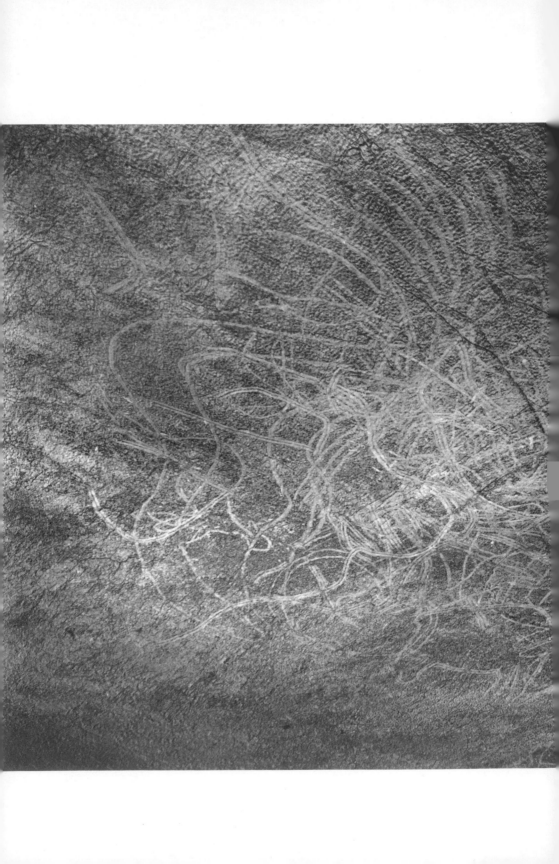

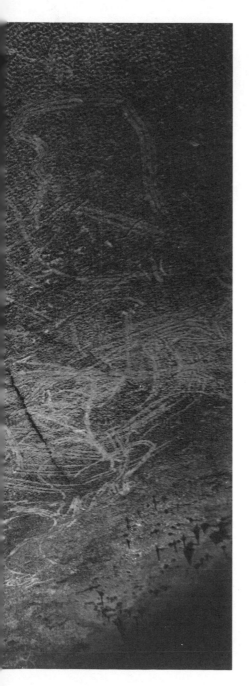

The First Artists

IN SEARCH OF THE WORLD'S OLDEST ART

MICHEL LORBLANCHET
AND **PAUL BAHN**

FOREWORD BY PIERRE SOULAGES

Thames & Hudson

For Jean-Marie and Hélène Le Tensorer,
and for Colin and Jane Renfrew

Frontispiece:
1. Finger-flutings in the soft rock surface at Pech-Merle (Lot).

First published in the United Kingdom in 2017 by Thames & Hudson Ltd,
181A High Holborn, London WC1V 7QX

The First Artists: In Search of the World's Oldest Art
© 2017 Thames & Hudson Ltd, London

British Library Cataloguing-in-Publication Data
A catalogue record for this book is available from the British Library

ISBN 978-0-500-05187-0

Printed and bound in India by Replika Press Pvt. Ltd.

Contents

Foreword

When you go to the Louvre, you see five centuries of paintings, but even if you saw ten, what are ten centuries when compared to three hundred? Because you are seeing at least two or three hundred centuries in the prehistoric painted caves, including the ones discovered recently, like Cosquer or Chauvet.

So should we look for meanings? One is perfectly entitled to do so, and we may even find them one day – but we'll never be able to verify them! On the other hand, where the ancient artists' techniques are concerned, if you put forward a hypothesis, you can verify it. This is what Michel Lorblanchet does, and that's why I was immediately interested in his work.

When I enter a painted cave, like everyone, I am overwhelmed; one is entering a belly, the belly of the earth! And when, in a moment of intense emotion, I discover the products of people from hundreds of centuries ago, I am more profoundly moved than when I go to the Louvre. There are certainly things in the Louvre that overwhelm me, but they are far more recent – they are only a few centuries old! I feel much closer to the lions of Chauvet than to the *Mona Lisa*. When I see their works, I consider the prehistoric artists to be my brothers.

What interests me about these ancient paintings is what happened
with the people who made them, in terms of materials – that is the best
way to approach these things, far better than trying to figure out their
meaning... because it's well known that when you talk of meaning, you're
only talking about yourself. We don't have the same myths, or the same
society, as the authors of the prehistoric paintings. Our view of them
is personal. So what is a 'work of art'? What interests me are not the
reasons why the paintings were made, but the practices of the painters.
What causes me to wonder and perplexes me is the way they painted.

Painting began with black... Black is an original material! Painting
began with black, red, earth – and in the shadows, in the darkest places,
beneath the earth, where one can imagine that people could have sought
different colours... perhaps they already knew that black is the colour that
includes all colours – it is the colour of light! The word 'presence' is the
key word for everything that is artistic: a work is eternally 'present'.

Pierre Soulages

Introduction: what is 'art'?

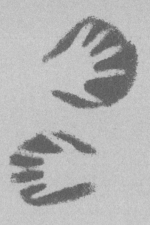

In this book, we shall strive to avoid imposing any personal point of view onto the products of prehistoric societies, or promoting any kind of theory about art: in any case, what is 'art'? In the words of Ernst Gombrich (1950: 4), 'There really is no such thing as art: there are only artists!'

Definitions of the word 'art' generally incorporate notions of 'beauty' and 'pleasure', but such notions tend to trouble archaeologists, who reject the term 'prehistoric art' because 'art', as we might propose to define it today (an accomplishment of human skill, the aim of which is the satisfaction of an aesthetic pleasure, not the meeting of any utilitarian need), was supposedly unknown to early human populations. This problem has sparked an international debate attempting to replace the term 'rock art' with something more accurate and suitable (although nobody has succeeded so far!). Many scholars are concerned that the term 'art' has led to monolithic, all-encompassing theories of artistic behaviour, squeezing 40 millennia of hugely varied image-creation into a single category. And what we today call 'contemporary art', with its notions of the 'death of art' or 'end of art', can shed little light on the world of prehistoric creations. One certainly needs to be wary of modern

aesthetic discourse, to see in figures on rocks and cave walls something more than their simple beauty and their formal qualities. The study of early art must strive to recreate how the people of the past perceived and used the images.

Some specialists have eluded the 'rock art' problem by avoiding such a dangerous label and adopting alternatives such as, for example, 'images of the Ice Age' (Bahn & Vertut 1988; Bahn 2016). However, although one should use the word 'art' prudently where ancient periods are concerned, the debate about the term is largely redundant. The notion of art certainly has a very long history, and its definition has often varied and has evolved through time, with a gradual loss of its sacred and religious character since the Renaissance. As H. Belting (1989: 10) put it: 'From the Renaissance onwards there emerged the concept of "art", and the "era of the image" ended.'

Though it is true that for a long time art had a primarily utilitarian function – most often religious – at the same time it has always had aesthetic content. It would be simplistic and utterly wrong to deprive early people of aesthetic feeling. It is even probable that art arose from the pleasure of the perception of shapes and colours, and that for hundreds of millennia it was essentially an aesthetic game, before becoming a religious activity for a few dozen millennia, only returning to its roots in recent times.

There has never been the slightest opposition – indeed, on the contrary, there has always been a close association – between aesthetic functions and utilitarian, religious or magical functions. Through its visual impact, religious art aims to impress believers and facilitate their communication with the divine. In traditional art, beauty also ensures the effectiveness of the magic of particular objects. Striking colours and shapes are an expression of the respect due to the forces that rule the world, and of the effort to please them. Since at least the early Upper Palaeolithic, beauty – figurative or simply ornamental – has above all been functional.

This book aims to analyse the earliest human creative behaviour and identify the first artistic expressions, trying to distinguish apparently non-utilitarian products that were detached from the immediate needs of survival. Artworks are defined here as 'marks of the mind on nature that express a concern with aesthetics, theoretically linked to symbolic or playful behaviour, even though one cannot always differentiate or demonstrate these aspects'. We shall seek out all the manifestations of art at its very start, from human appropriation of nature's curiosities to

artificial creations that, whatever their purpose and content (of which we are totally ignorant), involve an interplay of materials, colours and shapes (which we can observe). Their production implies a transformation of material, a preconception of the object to be obtained through that transformation, and an elevation of the mind – that is, a form of spirituality involving a personal fulfilment and accomplishment.

Our analysis will take the form of an enquiry, an investigation, with the (we hope) objective viewpoint of the archaeologist, yet always acknowledging all the risks and uncertainties of scientific research.

Chapter 1

Theories, chimps and children: early attempts to tackle the problem

A wide variety of theories have been put forward successively in an attempt to explain the emergence of figurative and parietal (i.e. wall) art during the Upper Palaeolithic in certain parts of the world, and during the Holocene in others. There have been two principal kinds: *biological theories*, which put the emphasis on humans themselves – their primate instincts, the functioning of their nervous system and their psychological characteristics – and on the arrival of a new human type, *Homo sapiens sapiens*; and *socio-economic theories*, which put the emphasis on specific social and economic contexts and progress in this domain, in order to explain the emergence of figurative art.

Among the authors who made a major contribution to research on prehistoric art during the first three quarters of the twentieth century, three French specialists stand out for their particularly pertinent opinions, which are still contributing to research today: the psychologist Georges-Henri Luquet, and the prehistorians Henri Breuil and André Leroi-Gourhan.

After a discussion of these first important theories, we will present a brief outline of the main current opinions about the biological and socio-economic mechanisms that directed the emergence of art.

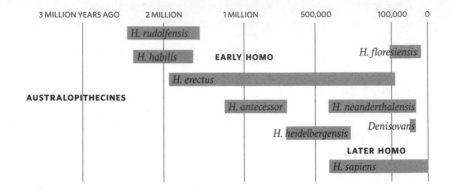

3 MILLION YEARS AGO	2 MILLION	1 MILLION	500,000	100,000	0

H. rudolfensis

H. habilis EARLY HOMO *H. floresiensis*

H. erectus

AUSTRALOPITHECINES

H. antecessor *H. neanderthalensis*

H. heidelbergensis Denisovans

LATER HOMO

H. sapiens

Period	Date
Lower Palaeolithic (Oldowan, *Homo habilis*; Acheulian, *Homo erectus*)	*c.* 2.7 million–*c.* 200,000 BP
Middle Palaeolithic (Mousterian, Neanderthals)	*c.* 200,000–30,000 BP
Châtelperronian (final Mousterian)	starts > 41,000 BP
Aurignacian (start of Upper Palaeolithic; anatomically modern humans)	*c.* 35,000 BP (earlier in some areas)
Gravettian	*c.* 30,000 BP
Solutrean	*c.* 21,000 BP
Magdalenian	*c.* 17,000–11,000 BP

2. Timelines showing the main human species and archaeological periods mentioned in this book.

First Theories

Luquet

In 1926, Georges-Henri Luquet, whose excellent writings about Palaeolithic art are still of great value, addressed the problem of the origin of figurative art. He was one of the first to put forward the hypothesis that it was born of a progressive awareness of the figurative capacities of marks on bone or stone which for a long time were accidental or at least unintentional. It was the chance production of images that led to an awareness not only of the resemblance of unintentional marks to some element of the real world, but also of the figurative power of the graphic act itself – that is, of the possibility of intentionally producing images resembling things. This idea, which was also more or less that of Breuil since the beginning of the century, would subsequently be adopted

by numerous prehistorians of the time and, more recently, by other researchers such as the psychologist William Noble and archaeologist Iain Davidson.

The intentional production of a figurative work presupposes two conditions: the wish to make it, and the ability to do so – in other words, both the desire and the technical capability to create such an artwork. The technical capability certainly existed by the start of the Upper Palaeolithic – humans had long been able to modify pre-existing material, as shown by their fabrication of tools and the first jewelry.

Regarding the rise of an awareness of a capacity for creating images that look like things, and of a desire for making them, Luquet found a model in children's drawings (see also pp. 30–1): 'Just as the child finds in the lines it has drawn with no figurative intent a resemblance to real objects, so the first Aurignacians could have seen similarities in lines they had drawn, or more generally in shapes they had created with no figurative intent; and since the idea of prey was usually present in the minds or at least the subconscious of these hunters, their interpretative imagination was naturally inclined to recognize animals in these chance images.' The often geometric decoration of portable art (especially weapons and tools) cannot really provide evidence of accidental figurative images giving rise to a process of purposeful representation. On the other hand, in the disorganized finger-tracings in the caves of Hornos de la Peña, Altamira, Gargas and La Croze à Gontran, for example, which Breuil called 'macaronis' and which he assigned to the earliest periods, Luquet saw a great reservoir of accidental shapes offered to the imagination of the Aurignacians. The digital intertwinings were already 'lines purposefully placed on a support', and some of them suggest parts of animals, muzzles, dorsal lines, legs, and so on. It is the imitation of some of these accidentally figurative lines that led the Aurignacians to make some on purpose, either with their fingers or, later, through engraving or finger-painting; this latter technique is perfectly represented in the Spanish cave of La Pileta. Different moments in the development of figurative art can also be seen in the cave of La Croze à Gontran (Dordogne), where bands of multiple finger-meanders seem to have given rise to parallel incisions, made with flint, that imitate them, and then to linear engravings of animal profiles.

Luquet then asked himself the question: how did prehistoric people come to make finger-drawings on cave walls? His answer was not without humour. He imagined that Aurignacian children, at a loose end like all children whose parents are busy with engrossing occupations,

Theories, chimps and children

as hunting and gathering must have been in that period, were inclined to imitate the adults who they saw decorating portable objects. They thus transposed the graphic act from the portable to a parietal support by clumsily drawing tangles of lines on clay in caves. Fortunately Luquet qualified his hypothesis: all the macaronis are not the work of children, many of them having been made by adults.

He also sought the origin of purposeful fingermarkings on clay in the familiarity that the Palaeolithic hunters had with the tracks left by their prey; each animal produced different prints, which the hunters were perfectly able to read and decipher. So the imitation of prints, especially

I don't believe it!
How we came to terms with the existence of ancient art

Until the mid-nineteenth century, there was no real conception of prehistory or of how old prehistoric art might be – in Europe it was simply seen as 'pre-Roman'. The first pieces of Palaeolithic portable art known to have been discovered were found in about 1833 in the cave of Veyrier (Haute Savoie), near France's border with Switzerland: an engraved antler pseudo-harpoon and a perforated antler baton decorated with an engraving. A horse head, engraved on a reindeer antler, was found in 1842 at Neschers (Puy-de-Dôme), and a reindeer foot-bone bearing a fine engraving of two hinds was discovered in the French cave of Chaffaud (Vienne) in 1852. This latter piece was believed to be Celtic in date, since there was as yet no concept of an Old Stone Age, and was only properly identified some years later through comparison with examples excavated from Palaeolithic occupation layers (Bahn 2016).

It was not until the 1860s, after decades of sporadic and misunderstood finds, that the existence of Palaeolithic art was established and accepted through the discovery of engraved and carved bones and stones in a number of caves and rockshelters in southwest France, particularly by the French palaeontologist Édouard Lartet and his English associate, the businessman and ethnologist Henry Christy. These objects came as a great surprise: their quality was astounding, since it had been assumed that prehistoric people were primitive savages with no leisure time and no aesthetic sense. Yet there could be no doubt that the objects were authentically ancient: they were all associated with Palaeolithic stone and bone tools and the bones of Ice Age animals. A piece of mammoth tusk

from La Madeleine, for example, has a depiction of a mammoth engraved on it (Bahn 2016). There followed a kind of 'gold rush', with people plundering likely sites for ancient art treasures.

The phenomenon was so new and unexpected that museums took time to make up their minds about it; but by 1867, Palaeolithic art objects were sufficiently well established for fifty-one pieces to be included in the 'History of Work' section of the Universal Exhibition in Paris. The identification of Palaeolithic portable art did not, however, lead immediately to an awareness of the existence of cave art. Some excavators and visitors had seen art on cave walls, but they assumed it could not be ancient – it was inconceivable that it might have survived so long.

The pioneer who made the crucial mental leap was a Spanish landowner, Don Marcelino Sanz de Sautuola, who noticed in 1879 that the bison figures painted on the ceiling of the cave of Altamira, near the Cantabrian coast of northern Spain, were very similar in style to the images in Palaeolithic portable art. Unfortunately, most of the archaeological establishment refused to take his published views seriously, dismissing him as naive or a fraud. One of the many reasons why Altamira remained unaccepted by most scholars for twenty years was that its bichrome paintings were simply too sophisticated and beautiful. These were very different from the figures scratched on bone. In a letter to Émile Cartailhac dated 19 May 1881, Gabriel de Mortillet claimed that 'Simply by looking at the drawings you sent me in your letters, I can see that it is a farce, nothing more than a hoax. They have been done and shown to the whole world so that everyone can have a laugh at the expense of palaeontologists and prehistorians who would believe anything' (Bahn 2016).

Altamira was found far too soon – it is still one of the best two or three decorated caves ever discovered, and claims one of the very few decorated ceilings. If it had contained more modest and simple outline animals, the idea of Palaeolithic cave art might have been accepted more readily and rapidly. It was in southwest France, once again, that the final breakthrough occurred, when in 1895 engravings were found in a gallery of the cave of La Mouthe (Dordogne). Since the gallery was blocked by Palaeolithic deposits, it was obvious that the engravings must be of the same age. Further discoveries soon followed in other caves in southern France, culminating in those at Les Combarelles and Font-de-Gaume in 1901, which at last established the authenticity of Palaeolithic cave art (Bahn 2016).

Theories, chimps and children

the prints and clawmarks of cave bears, may have played an important role in the birth of intentional lines capable of depicting a specific subject.

Finally, Luquet attributed an essential function in this domain to the natural shapes of walls, which suggest silhouettes that can be completed with drawing; he was opposed to a 'premeditated use' of natural shapes, but he accepted – as one of the sources of figurative art – the purposeful accentuation of a resemblance seen in natural shapes, and he commented on numerous examples.

Many aspects of Luquet's views can be upheld: the general mechanism of plastic creation starting from an awareness of an accidental graphic capacity is widely accepted today, as is the role in the genesis of art of fingermarkings, animal tracks and prints, and the natural shapes of cave walls. The opinions of many present-day researchers are similar to those of this precursor, sometimes without their realizing it. Ernst Gombrich (1969) reminded us that, already 500 years ago, Alberti saw the first roots of art in this 'role of projection'. He himself stressed the part that must have been played by 'strange rock formations and cracks and veins in the walls of caves. Could it not be that bulls and horses were first "discovered" by man in these mysterious haunts before they were fixed and made visible to others by means of coloured earth?'

In reality, the creative function of natural rock shapes is not limited to cave art. Mythologies and cosmogonies give meaning and language to every element of the landscape. For Australian Aborigines, the surface of the Earth is a map of the 'Dreamtime': the rocks, the valleys and the mountains are petrified spirits or the traces of their exploits, and it is this eternally living mineral universe that beckons the rock-engravings and paintings.

In some European caves, a veritable overlapping of clawmarks (PL. XXI), finger-flutings (FIGS 1, 3, 84) and engravings has been recorded, and there are clear relationships between these different traces: in the cave of Aldène (Hérault) an engraved circular sign has been suggested, and its execution guided, by a bear clawmark integrated into the drawing. In this same cave there seems to be a constant rapport between the animal engravings and the bear clawmarks that cover and fill the graphic space (Vialou 1979). In the Combel gallery of the cave of Pech-Merle (Lot), one of us (ML) has recorded four rubbed handprints of red ochre, placed exactly below four cave bear clawmarks. This intentional positioning indicates that the clawmarks must have provoked the human markings. The chronological relations between clawmarks and painting were also highlighted by Breuil on the walls of El Castillo (Spain), where clawmarks

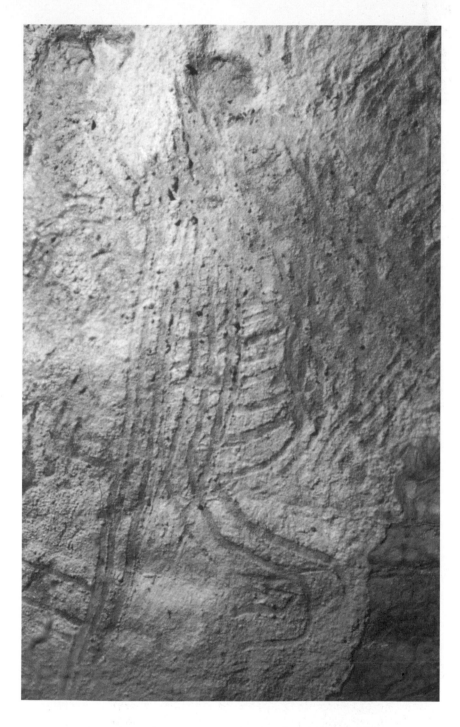

3. Finger-flutings on a cave ceiling at Pech-Merle (Lot).
The surface of the rock is covered in a soft layer known as
mondmilch ('moonmilk'), which can easily be marked with fingers.

Theories, chimps and children

are located between two superimposed layers of painting. In addition, Breuil emphasized the importance of animal and human prints, as will be seen below, and the abundance of engravings of prints in Australian Panaramitee art, as well as their sporadic presence in early phases of European art (Delluc & Delluc 1985), also support Luquet's hypothesis.

The idea of a contribution by children to the process of the emergence of intentional forms is interesting, but it gives rise to some reservations, because it is clear that many fingermarkings are the work of adult hands and digits. However, the contribution of children is evident, not only on the ground (footprints) but also on the cave walls. A multidisciplinary research programme is needed to study all the Pleistocene mechanical images obtained by the direct imprint of parts of the body, such as fingermarkings, negative or positive hands, and finger-dots, in order to try to determine the number, sex and age of the authors, and thus contribute to our knowledge of the ways in which underground sanctuaries were frequented.

However interesting the comparison of prehistoric drawings with children's drawings may be, one should also be cautious. The child's perception of an image in a tangle of lines may offer us an interpretative model for the origin of art, but we should not forget that the child, as it becomes aware of its capacity for figuration, does not draw any old motif, and that there are obligatory stages in the development of its graphics – especially the first stage, which comprises human depiction, a self-representation in the form of a stick figure with no body. So the awareness of resemblance and the capacity for creation are not the only factors influencing the origin of representation. Some internal data linked to the child's mental structure and its development must be involved.

It is astonishing that, in the mechanisms he studied, Luquet only envisaged the creation of *figurative* images, primarily through an awareness of resemblance, as was also proposed later by Davis (1986) or Davidson and Noble (1989). We think that – as envisaged by Davidson and Noble – similar mechanisms could be invoked to explain the appearance of the geometric signs that are regularly drawn beside the figurative art, from the start of the Upper Palaeolithic. For a long time the makers of tools, especially the creators of handaxes or bolas, had been capable of producing geometric shapes. A few rare incisions in the form of zigzags or regular grids, for example, show that the perception of an accidental geometric organization was possible as the Upper Palaeolithic began, although these are all isolated pieces (see Chapter 4). The development of jewelry, decorated objects and of portable art

as a whole, together with the recognition of fortuitous accidents of resemblance, combined to produce an awareness of the general iconicity of marks, at the same time leading to the geometric signs and human and animal figures that together characterize the emergence of the great Pleistocene art.

Breuil

Abbé Henri Breuil's extensive experience of cave art and portable art led him at an early stage to an interpretation that was similar to that of Luquet in some respects. Although he was an archaeologist, not a psychologist, he too was spontaneously attracted by children's drawings. In 1906, in an attempt to understand the origin of art, of which he was studying 'the remotest of all its incarnations, works by troglodytes, reindeer and mammoth hunters', he strove to 'grasp the first hint of figurative depictions in an emerging intelligence'. In the stages of development of children's graphics that he observed, he hoped to discern an interpretative model of the first creative mechanisms of the 'childhood of humanity'. He thus analysed the instinctive processes of a child's reading of surrounding images, of imitation, of 'dramatic mime' consisting of 'treating objects as people', and of production of drawings or models in accordance with a progression from simple to complex – from summary graphic assemblages to the details that are added to them. He noted that automatic prints and shadows projected onto a wall may have played an important role in inciting this process.

Breuil was the first to emphasize the importance of fingermarkings: 'It seems that it was by using fingers to take the clay that covered the walls or ceilings of caves that the idea arose of drawing images there. The mechanical action had unintentionally left imprints there. Once they had been noticed, people tried to make them pleasing to the eye and curious to look at.... In various caves these decorations changed into images of animals, likewise made with fingers.' He explained this appearance as follows: 'The series of lines, accidental at first, and then controlled, produced two-dimensional outlines that were at first recognized afterwards, and then repeated in a desire to make an image that looked like something, either by using a natural pre-existing rock-shape, or fully created' (Alcalde del Río et al. 1912; Breuil 1952).

Breuil later detected three possible points of departure for Upper Palaeolithic figurative art: mimicry based on the notion of physical resemblance; animal and human prints; and 'pierres-figures' or natural rock forms. To this he added the hypothesis of magic, introduced

Theories, chimps and children

into Palaeolithic art research in 1903 by S. Reinach: a drawing or sculpture conferred power over the creature depicted, constituting a taking possession of the subject. So magic itself implies a need for naturalistic depiction.

Hence Breuil saw the source of art in 'the notion of physical resemblance, first between two beings, and through mimicry and play, which one could call dramatic art'; mimicry gives one a hold over the imitated animal. Ethnographic parallels show that a mask or a graphic depiction of the subject gives the owners or the authors of the image a magical power that may favour the hunt or ensure the multiplication of the prey. The tracks that lead to the animal, making it possible to approach and capture it, will be reproduced with the same desire of taking possession. From the depiction of prints is derived the representation of the complete animal, in a dorsal projection or absolute profile. Similarly, the resemblance between a natural form and a real being can lead to plastic creation. 'The art of the pierre-figure, generally unverifiable in the old Palaeolithic when it may perfectly well have existed, was preserved accidentally in all human milieus, but it only led to three-dimensional figures, in statuary, just as disguises quickly led to dolls.'

Along with worked flints, in the first half of the nineteenth century French archaeologist Jacques Boucher de Perthes had collected a great number of curious stones that he had interpreted as the symbols of the first men, testifying to an 'innate need of religion'. The theory of the pierres-figures, considered too subjective, was widely debated at the start of the twentieth century (as we shall see in Chapter 5). Although the study of parietal art revealed the frequent utilization of natural shapes in the wall, in contrast the isolated pierres-figures display no sign of human work, and were rejected by most prehistorians. Breuil, like Luquet, used them prudently and pertinently.

Breuil distinguished the origins of parietal art from that of portable art. According to him, 'human statuary derives from fur dolls'. As for the often geometric decoration of objects, this has its origin in butchery marks on bones. It is true that a certain number of Aurignacian bone baguettes bear more or less regular transverse striations which evoke butchering marks (Chollot-Varagnac 1980). The unintentional striations on the first shaped bone tools were also interpreted by Breuil as accidental decoration, which was then reproduced intentionally. In that case the decoration would be 'an ornamental transposition of elements of technical origin'. These technical elements that became decoration would include, for example, the traces left in the material by the manufacture of bone

or reindeer-antler tools, or the rhythmically distributed striations that facilitated the adherence of a point to the shaft of a spear.

So, thanks to his almost unequalled experience of Palaeolithic art, Breuil succeeded in producing a synthesis of the psychological and magical theories of his time. His magical interpretation was so strongly criticized by the next generations of prehistorians (Raphaël, Laming-Emperaire and Leroi-Gourhan) that it has practically been abandoned today (Lorblanchet 1995). Yet one of his most pertinent remarks (1926) is worth remembering: 'If art for art's sake had not arisen, magical or religious art would never have existed. If magical or religious ideas had not made it possible to insert art... into the serious preoccupations of real life, then art – too weakly grafted onto the essential occupations of daily life – would have risked remaining at an embryonic stage.' This major idea, hardly surprising from a priest like Breuil, is still causing interesting debates. Art, at first free, was then invested with an external function. Born 'accidentally', through play and pleasure, it attained its importance and its seriousness by making use of beliefs; the message it carried became its strength. By losing its religious content, modern art thus seems to be returning to its origins (at the risk, according to certain art historians, of losing its vitality!).

Two principal aspects of Breuil's position raise some reservations. First, although he envisaged a sporadic origin of the decoration of objects in butchering marks, he interpreted the whole of Palaeolithic art from the angle of realism – probably because of the magical power of realism – including not only the animal and human depictions but also the parietal signs that accompany them, in which he primarily saw schematic depictions of objects; the tectiforms were 'houses of the spirits', the claviforms were 'clubs', etc. For Breuil, Palaeolithic art was essentially realistic, which, in contrast to Leroi-Gourhan, led him into error, since he minimized the general importance of signs, and considered the beginnings of art through a univocal and homogeneous model.

Secondly, Breuil had an evolutionist concept of Palaeolithic art, seeing it develop from simple to complex forms: the macaroni rapidly led to realistic shapes, handprints and stencils, while bare linear drawings led to more detailed naturalism and, finally, to polychrome figures; schematization was a late degeneration of naturalism. The only difference with Leroi-Gourhan's chrono-stylistic system, based on the same principle of continuous 'progress', is that, according to Breuil, the evolutionist scheme was repeated in two successive cycles during the Upper Palaeolithic.

The comparison made by Breuil between children's drawings and prehistoric drawings is no more convincing than that attempted by Luquet, since modern children are strongly influenced by their education and their social milieu, characterized by multi-millennial traditions, whereas the prehistorian has to strive to understand how art was born in a world where it did not yet exist. Another troubling point, which neither of these specialists mentioned, is that the drawings of modern children regularly start with a global self-portrait, by rudimentary human designs, whereas prehistoric art begins with animal figures or signs as well as body parts. These beginnings are not identical.

Leroi-Gourhan

André Leroi-Gourhan considered that art arose in the Upper Palaeolithic, with the Neanderthals and their predecessors being only modest forerunners. Before the appearance of modern man, 'there was a full range of what could be called pre-artistic manifestations: ochre, cupules, natural shapes, create a narrow halo around the flat skull of Neanderthal Man' (1965). So the 'halo' is 'narrow'... and this 'flat skull' is not yet that of an artist; it has the capability of producing art, but 'with no comparison' to what developed next.

In his brilliant little book *Les Religions de la Préhistoire* (1964), Leroi-Gourhan based his investigation in the religious sphere and, in drawing up the inventory of evidence for early behaviour that was 'symbolic', 'magical' or 'religious' (notions that are difficult to distinguish when one goes back in time), he prudently declared: 'Among all this ambiguous evidence, few indisputable facts survive, and they are very late.' The treatment of the dead, a bit of ochre, a few fossils, piles of spheroids, a few cupules or incisions on bones all seem to him 'highly insufficient for producing even a sketch of religious behaviour'. This scepticism, based on the limited nature and small amount of data, can still be found in the literature today, which is returning to some very old positions.

In *Le Geste et la Parole* (1964–65), Leroi-Gourhan distinguished a 'prefigurative period' between about 50,000 and 30,000 years ago, characterized by the collection of natural curiosities (stones, fossils, minerals), the presence of parallel engraved lines, lines of cupules, and the use of pigments with no figurative evidence. This period finally crosses the Châtelperronian and continues into the Aurignacian, when the first figures appear. Dating between 30,000 and 23,000 years ago, these constitute what he called 'Style I or primitive period'. In the execution of these first works, primarily comprising the engraved blocks of the Vézère valley,

he saw everything 'that one could expect from a debut'. He also stressed their 'abstract' nature, giving the word a somewhat particular meaning, that of an art which 'isolates', which attaches itself to a part by separating it from the whole, which 'selects expressive points – phallus, vulva, bison or horse head – and assembles them into symbols, into a mythological whole to constitute a mythogram'. And hence, 'art began with the abstract and even the prefigurative' and 'not in the naïve depiction of the real'.

Leroi-Gourhan repeatedly associated the emergence of art and language in a theory that is still gaining ground, although its source is often forgotten: 'At its start, figurative art was directly linked to language, and much closer to writing in the broadest sense than to a work of art; it is a symbolic transposition and not a copy of reality. The oldest figures known do not depict hunts.... These are graphic pegs with no descriptive binder, supports of an irremediably lost oral context.... Language and figuration come from the same capacity for extracting from reality the elements that reproduce a symbolic image of this reality.'

It is also interesting to note that Leroi-Gourhan saw the hundreds of millennia before the appearance of figurative art as the era of rhythms – the sound rhythms of toolmakers striking stone, and the rhythmic marks on bones and stones that are all 'technical rhythms', not yet 'figurative rhythms'. The 'figurative rhythms', in the form of regular marks, in a sort of accountancy, only appear at the end of the Mousterian – whatever the meaning of the series of lines, they constitute the first evidence of true figuration, about 35,000 years ago.

In Leroi-Gourhan's point of view one finds the contrast and sometimes the contradiction – which are inevitable and still present in today's theories – between the explosion of art at the start of the Upper Palaeolithic, which may appear 'sudden', and the slow advance that announces it and makes it possible. Even though he saw a remote link between aesthetic expression – in the form of rhythms – and toolmaking, it is especially at the end of the Mousterian that he perceived the true beginnings of art.

However, despite the relatively abrupt appearance of the first Aurignacian figures, Leroi-Gourhan tried to set up what he called a 'progressive trajectory, the longest known in the arts, from 30,000 to 8000 years ago' (1964). This notion of a 'trajectory' of art that 'matures' gradually, of a 'slow rise of realism' in the course of the Upper Palaeolithic, led him to envisage a beginning in formless lines, to integrate 'rhythmic marks' in the start of art, and also to see Aurignacian images as an 'abstract art'. This is doubtless why he gave the term 'abstract' the unusual definition of an art

which isolates a part of a whole, emphasizing the often fragmentary nature of the first figures in the Périgord. However, this definition would be better suited to the fundamental process of synecdoche (a graphic shortcut where the part represents the whole), which has been common, from the start, in the arts of the whole world. On the other hand, if one considers 'abstract' to mean graphics that make no reference to the real world, and if one thinks that abstract art is not figurative, then the Périgord's first animal and human evocations, sometimes produced by synecdoche, can simply be called 'schematic', but strictly speaking they constitute a 'figurative' art like, for example, the Panaramitee style in Australia (FIG. 97). The few, highly theoretical debates that have been provoked by the ambiguity and incomplete nature of some images should not conceal the fact that most of them can be identified immediately (or at least one knows which animal or human segment is involved). Moreover, these figurative images are accompanied by truly abstract motifs – cupules – and hence we find, right from the start, as we shall see below, a very close association of figurative and abstract that characterizes the whole artistic phenomenon.

The concept of a progression also perhaps led Leroi-Gourhan to exaggeratedly minimize the Aurignacian portable art of the Swabian Jura (Germany), which is fully figurative, although also stylized, and already apparently 'evolved', to use the vocabulary of evolutionary theory. This art too is associated with cupules and various totally abstract marks on bones. The debate continues, but today it has entered a new phase thanks to the claims about the antiquity of Chauvet cave's art (see Chapter 8), and to the accumulation in the past few decades of some very ancient pieces of evidence for aesthetic behaviour.

It is clear that Leroi-Gourhan's work poses the big questions: it is the source – more or less conscious and more or less clearly expressed by some prehistorians – of current thought on the origin and evolution of prehistoric art.

Current interpretations:
the biological foundations of Pleistocene art

The biological foundations of Pleistocene art can be seen at different levels. Some researchers have wondered if art, at its beginning, was a 'primate art', with Palaeolithic people sharing some of their deep aesthetic impulses with anthropoid apes; others have tried to establish the origins of art in the functioning of the mammalian nervous system and in the

images it produces; and others still, more numerous, believe that the emergence of figurative art during the Pleistocene is closely linked to that of language and to that of a new human type, *Homo sapiens sapiens*.

Primate art

Humans and the anthropoid apes (chimpanzees, gorillas, orang-utans and gibbons) belong to the order of primates. The cognitive and behavioural differences they display are, according to primatologist Robert Yerkes, more often quantitative than qualitative, a question of more or less rather than presence or absence. According to modern biology, humans and chimpanzees are very close, since they share 99 per cent of their genetic material. This proximity explains why the behaviour of the great apes, prehistoric people and modern children has often been compared.

At the beginning of the twentieth century, the psychological development of young chimpanzees and of children was compared; then, after the Second World War, researchers took an interest in the psychology of visual perception among chimpanzees, gorillas and gibbons, and then in their graphic expressions (Schiller 1951). Starting in the 1950s, in the USA and some European countries, and at the instigation of ethologist and artist Desmond Morris, research took place into ape drawings and paintings from a totally new perspective (Morris 1962, 2013; Rensch 1984; Lenain 1997) – that of defining the animal origin of the aesthetic sense, at an extremely primitive stage, before culture itself (PL. I). Through experimentation and comparison, it was thus important to determine the animal basis of the human creative impulse.

This perspective also concerns the archaeology of art: the prehistorian justifiably wonders how the 'art' of primates can shed light on the first graphic stutterings of prehistoric people – how it resembles or differs from them. Making animals in captivity draw and paint, giving them all the necessary material, has been strongly criticized, especially as, in nature, none of their spontaneous activities is comparable to this. However, experimenters consider that the apes respond to the human request in their own way, so their response is significant.

One important remark must be made immediately. The superficial resemblance of ape art to abstract art should not deceive us; apes have no global consciousness of their creation, like painters can have of their work. They paint through immediate and instinctive reaction to an external stimulus, and when their capacity for concentration is exhausted they abruptly lose interest in what they are doing. What they produce can be compared to a 'gestural painting', but it is a painting of the moment,

Theories, chimps and children

bereft of any intention to communicate. Contrary to the work of Jackson Pollock or Georges Mathieu, for example, it does not aim to construct an image, so it does not continue beyond the instant of its creation to become a true, durable 'work of art'.

The paintings and drawings of the great apes firstly reveal the decisive importance of the graphic field constituted by the rectangular sheet of paper offered by the experimenter. They react to the invitation of the rectangle by choosing to paint in the centre of the sheet first, then in the corners, organizing their marks in accordance with the horizontal or vertical guiding lines of this field. Another remarkable feature in their graphics is the appearance of recurrent structures 'resulting to a large extent from the movement patterns that characterize the drawing gestures, such as the coming and going of the wrist and forearm' (Lenain 1997). Clusters of curves thus appear due to the repeated movement of the forearm, sometimes resulting in ellipses, the hand being brought back to its starting point, and fan-shapes made up of convergent strokes spread over the whole surface of the sheet. There are also parallel lines, aggregates of straight and curved lines, as well as simpler forms such as dots, arcs and even sometimes circles.

In rare cases, a certain consciousness of motif appears to manifest itself, with spontaneous fan-shapes of lines, by constant repetition, being perceived and reproduced intentionally in accordance with a technique implying a prior mental representation of the motif. Lenain (ibid.) recalls that a female chimpanzee apparently drew a 'bird' and another time a 'cherry', but this was an utterly exceptional event, not really demonstrated, and which may have occurred under human influence. Apes' graphics are generally abstract, shapeless and not geometric. Even though a few motifs do recur, graphic symbolization is exceptional.

The anthropoids paint and draw as play, but they follow precise rules that express a sense of order, rhythm and symmetry. They display a marked taste for the effects of symmetry by, for example, balancing an off-centre drawing on the sheet, or by producing 'mirror' structures which respond to each other. According to Lenain (ibid.), the apes' pictorial play is based above all on the need to 'mark, disturb the established visual order'; the function of the first brush- or pencil-stroke is already to attack the field, to unsettle it by making a line on it. So the sense of order is accompanied by a pronounced taste for its opposite, disorder. Apes are irremediably trapped by the pleasure of this 'disturbing-mark game', whereas children, although more clumsy when they start, are not such victims of the mechanism, and they rapidly escape

it to attain symbolization and representation. It is only much later that they sometimes rediscover the fascination of the pure mark, of abstract art – light years away from ape art.

Another instructive observation of ape behaviour, made even before Morris's research, was reported by the zoologist Julian Huxley (1942): Meng, a young gorilla, several times followed with his index finger the outline of his shadow projected onto his cage's white wall, as if he wanted to draw his silhouette. According to Huxley, this gesture could shed light on the origin of human art – its first linear markings were perhaps guided by the shadow of objects projected onto the cave wall. This strange scene takes one back to Pliny the Elder (*Natural History*, book XXXV) who wrote that 'the principle of painting consisted of tracing, thanks to lines, the contour of a human shadow'. Pliny developed the idea in the myth of the potter's daughter of Sicyon, whose lover was to go travelling, and who kept a clay portrait of him modelled from the shadow of his face projected onto the wall.

More recently G. C. Westergaard and S. J. Suomi (1997) have reported new experiments with capuchin monkeys (*Cebus apella*), which have a propensity for creating and using tools. When presented with balls of clay associated with leaves, stones and paint, the monkeys began to mould, strike and roll the balls to give them a new shape, and to paint them with their fingers or with leaves soaked in paint. When plaques of clay were presented to them, they engraved them with a stick, a stone or fingers, producing more or less parallel but disorganized marks that resembled the fingermarkings in Palaeolithic decorated caves. According to the authors, *Homo habilis*, like the capuchins, was capable of producing non-figurative marks that could serve as a basis for the development of the figurative expression which, in the human lineage, followed the emergence of abstract thought.

Experiments that show the aesthetic capacities of great apes can certainly shed interesting light on the first artistic manifestations of humans. But it is, of course, difficult to compare the behaviour and productions of apes and monkeys with those of prehistoric people. The conditions are extremely different. The precise influence of the experimenter on the behaviour of the laboratory apes is hard to evaluate, and Pleistocene hominins had nobody to provide them with paper and colours, and nobody to imitate.

The marks produced for hundreds of millennia on bones or stones by different kinds of humans were doubtless accidental for the most part. When they were deliberate, they were responding to the 'disturbing-mark

game' displayed by apes. But in that case, the supports of the prehistoric marks that have survived did not permit the extensive gestures that can be seen in the drawings by apes on big flat surfaces whose very regularity stirs the hand's movement. The constraining outline of a bone, for example, scarcely permitted vast sweeping curves. Palaeolithic marks on bones are almost always organized transversally to the diaphysis or the piece's largest dimension, and are secondarily orientated longitudinally.

So there is a troubling resemblance between the experimental lines of the great apes and most early hominins. Two kinds of simian graphics seem particularly close to prehistoric human productions: symmetrical layouts, and what can be called 'emergent figuration'. The mirror symmetry used by apes is inherent in the nature of primates, but the symmetrical layout of ape graphics is merely an immediate *response* to the solicitation of a previous drawing, whereas the manufacture of a handaxe by *Homo erectus* is an authentic *creation* in which the object's symmetrical structure is entirely preconceived. In short, apes and humans use the same impulsive basis, but humans play with it, whereas the ape is its prisoner.

'Emergent figuration' is also a response: a few rare apes who have been taught a form of human language make a figurative reading of their works when answering the experimenter's question about the content of their drawings, just like young children discern – *after the event* – many things in their inextricable scribblings. This late reading may explain the origin of the motifs, and it is doubtless also the origin of figuration. Hence, it is the instinctive gestures, the recurrent structures and intuitive sensitivity to potential that are shared by the great apes and the hominins that define the biological base of art. It was these graphics, repeated through the millennia of the Lower and Middle Palaeolithic, that made possible the gradual awareness of graphic art and the birth of symbolic forms.

Art only appears with consciousness, when perceived forms are preconceived and regularly reproduced, and when the consciousness of the creative capacity opens up limitless scope for developing forms. In a way, it does not really matter if the countless elementary Palaeolithic marks are intentional or not: the limit between intention and impulse is vague, inconspicuous and diachronic. All the marks – purposeful or not – that prehistorians study are the roots of art, they are potential art. Other conditions are required for it to spring up. Like the emergence of articulated language, the emergence of art demands not only the necessary biological capacity but also a *collective* need in relation to the group's imagination: to identify, reproduce forms and offer a reading of them, or in other words to give them a meaning that can be shared. In its

full meaning of a production of forms intended to be seen, plastic art is a language, a means of communication; it has a biological foundation, but it is above all social, cultural and symbolic.

Comparison of ape drawings with the first human markings leads to another observation. In its original diversity, prehistoric art displays a particular assemblage of marks that appears in an early period and that is especially close to simian graphic impulses. Alongside the statuettes or animal prints and signs, there is a different assemblage of 'automatic' images that exclude any effort at depicting the external world. These are marks produced by the direct projection of the artist's anatomy: finger-flutings, -marks and -dots, and, secondarily, positive and negative hands and 'rubbed hands' – that is, the whole area of art made up of prints of the human body.

There is no difference between the disorganized finger-flutings of the European and Australian decorated caves and the experimental scribbles and daubings of gorillas and chimpanzees with their hands coated with earth or colour, or the finger-drawings of capuchins on clay plaques. One can also see little difference between the finger-dots of hominins and apes. Meng the gorilla's gesture in tracing the outline of his shadow also evokes the production of negative and positive human hands on cave walls, because, in both cases, there seems to be a pleasure in defining and fixing an image of oneself, of depicting oneself.

Jewelry, which is probably (along with body-painting) the oldest art form, is also a way to re-present oneself, that is, to present oneself to others, by projecting a chosen image of oneself. However, it is probable that this metamorphosis of humans decorating themselves is far more than simple personal gratification within the group; there was doubtless already a demand for freedom, a revolt against the physical appearance imposed by nature, a first victory over the forces that threaten individuals, condition and dominate them. A metaphysical function seems to accompany the social function of jewelry.

The essential difference, though, between the automatic art of the first humans and certain markings by apes that look similar to them is the human taste for images and motifs, which is not unknown among other primates, but is particularly strong among humans. The automatic art is already symbolic. The hand represents a social person, and dots are organized into signs. While some finger-flutings are clearly figurative, it has been shown (Lorblanchet 1989) that in most of the European panels of disorganized fingermarkings, dubbed 'macaronis' by Breuil, one can discern the start of figurative motifs. The figurative components extricate

Theories, chimps and children

themselves from a formless "magma", from such a web of lines is born
a hoof, such curving lines give birth to a nameless muzzle, a wavering
line of a backbone, an eye conceals itself, and the space is vibrant with
awakening life' (ibid.: 114). Contrary to the opinion of Breuil (1952)
or Luquet (1926), this birth of shapes out of the shapeless may have a
symbolic function, but it has no chronological value. Finger-flutings are
known not only in the early phases of art, but also in other periods and
from numerous parts of the world. The birth of shapes is a repetitive
phenomenon, or in other words not historical.

The art of children
An interest in children's drawings, and their stages of development, only
began in the late nineteenth century and, as we saw above, it was Luquet
(1927) who was a pioneer in this field. He saw the imagery as passing
through a succession of four stages, after a period of simple scribbling:
in *fortuitous realism*, the child notices a similarity between its scribbles
and something in the world, such as a bird, and this eventually leads the
child to intend the representation of something; when this approach
is consistently used, it leads to *failed realism*, in which adults can begin
to recognize what the child is depicting, even though many 'mistakes',
omissions and distortions are being made, such as limbs emerging from
the head. This gradually leads to *intellectual realism* (at about 5–7 years)
in which improvements are being made to characteristic shapes and
features, and finally to *visual realism*. Luquet saw no abrupt changes
between the stages, but rather a gradual transition. One drawback to
his approach was that he firmly believed that children intended their
drawings to be naturalistic, when in fact they may also be trying to
express moods and ideas.

Subsequent researchers have likewise seen a progression of different
stages. While the drawing of a circular shape with a few marks inside
it constitutes the apex of ape art, this is the first step in child art (Morris
2013: 50; Machón 2013; Cox 1992; Thomas & Silk 1990). From this stage
there is a rapid development to the circle becoming a head, and then,
by the age of about four, a body with limbs emerging from it – the so-
called 'cephalopod stage' (PL. II, FIG. 4). Then the limbs move down from
the head and are attached to a torso. Children subsequently advance to
scenes, to more accurate bodily proportions and to anatomical details,
with pictures becoming more personal and individual as external factors
have an increasing influence on style and content. In the 1950s, Kellogg
(1955, 1967, 1969) studied more than a million drawings by young children

4. In this recent drawing by a three-year-old child, the realization of body image is evident. The 'cephalopod' or 'tadpole-man' self-portrait is among the first figurative motifs drawn by children.

from thirty countries, and found an amazing degree of similarity between them, with the same images constantly recurring, such as people, houses, boats, flowers and suns. She perceived a succession of five stages – scribbles, diagrams, combines, aggregates and pictorials.

Child art can therefore be seen as 'an unfolding visual language' (Morris 2013: 56) in which, once an advance has been made (such as adding a torso to the head), there is no reversion to the previous stage. Nevertheless, despite the universal similarities, it is obvious that there is great variation in ability, ranging from slow-starters to prodigies.

Art and hallucination

According to David Lewis-Williams and Thomas Dowson (1988) the mammalian nervous system constitutes a 'neurological bridge' that leads directly to the psychological behaviour of our *Homo sapiens sapiens* ancestors, which was identical to our own, and this enables us to understand the manufacture and origin of images. In the view of these authors, many parietal figures depict the visions seen in an altered state of consciousness in the course of a 'shamanic trance'. They distinguished six categories of 'entoptic motifs', mental geometric shapes

Theories, chimps and children

that are imposed on the mind during hallucination, and three stages in the production of mental images. This theory aroused a worldwide debate. Applied in particular to Palaeolithic art, it gave rise to two books (Clottes & Lewis-Williams 1996; Lewis-Williams 2002). However, many ethnologists and prehistorians (e.g. Hamayon 1995, 1997; Bahn 1997, 2010; Francfort & Hamayon 2001; Helvenston & Bahn 2005; Lorblanchet et al. 2006) expressed numerous reservations and criticisms, especially as the objective archaeological demonstration of a form of shamanism is virtually impossible. Leroi-Gourhan (1964), wondering about the existence of Palaeolithic shamanism, had no idea what kind of evidence could even begin to prove it.

Among the many criticisms put forward, we should point out that the so-called 'entoptic motifs' actually correspond to basic geometric forms that have existed in the human mind quite naturally since the manufacture of the first flint shapes by *Homo erectus*, the maker of handaxes. They are also among the graphic impulses of the great apes, who display no apparent sign of trance. These elementary geometric shapes are produced by the mental structure of primates in its most normal and sound state, outside of any intervention by shamanism.

Art and language
Like Leroi-Gourhan before them (though they do not cite him), Davidson and Noble (1989) closely linked the birth of images and that of language, and their theory led to a widespread debate. The two authors, an archaeologist and a psychologist respectively, supported the idea of a late emergence of developed language. They criticized all interpretations of archaeological data that aimed to highlight the symbolic behaviour of the hominins of the Lower and Middle Palaeolithic, and considered that symbolism appeared with art and language at the start of the Upper Palaeolithic, or in any case with the arrival of modern humans.

Like Chase and Dibble (1987), and in contrast to many researchers, they rejected the idea of any symbolic behaviour in the production of marks, the manufacture of tools, the collection of curiosities, the treatment of the dead or the use of pigments before the Upper Palaeolithic. In order for these acts and this material evidence to be symbolic, they must have a meaning which can be understood by others: 'for meaning in symbols to be shared they need to be repeatedly and widely used' (Davidson & Noble 1987: 128). They stressed the rarity of the early evidence – its frequent uniqueness does not support the idea of shared meaning – and its immense dispersal through the hundreds

of millennia of the Lower and Middle Palaeolithic. They asked how a unique object can have meaning, using as an example the ivory blade from Tata, Hungary, that some researchers have compared to sacred Australian objects known as *churingas*. They argued forcefully against the idea of 'symbolic and graphic traditions' throughout the early phases of the Palaeolithic, because the works are just points lost in the immensity of time and space, with no likely link between them or with those of the final Pleistocene. They claimed that only iconic images, as a 'repeated motif', could lead to the concept of resemblance that was necessary for the whole enterprise of the production of symbols to become established. Finally, they placed this phenomenon at the start of the Upper Palaeolithic, which they saw as a period of fundamental change, in a clear break with the earlier periods.

According to Davidson and Noble (1987: 125), image and word share some characteristics: 'a picture of a bison is not a bison, and the word 'bison' is neither a picture of a bison nor a bison.' These are 'objects' which represent other 'objects', and whose function is thus representation.

In the emergence of language and graphic representation, the two authors distinguished a number of processes. The production of 'nonsemantic marks' (incisions or spots of colour on bone or stone), with no particular meaning, leads to the 'discovery of the representational capacity' of these marks. Identities and similarities are perceived between marks, and then between marks and objects or creatures. The fact that certain marks may resemble something lies at the origin of conscious image-making. On this point they were in agreement with Whitney Davis (1986), but their originality lay in bringing language into the process. They thought that the perception of resemblance implies the existence of language or a system of simulation: to take note of a resemblance 'depends on a capacity to reflect upon what is perceived. And such reflection can only be delivered through language, or at least some system of simulation. To see a resemblance requires a capacity to represent to oneself or to others what the character of one's perceptual experience is, or is akin to' (Davidson & Noble 1989: 130).

To simulate things and beings, to create resemblances, can be achieved through mimicry (this is one of Breuil's hypotheses). 'If... gesture and posture could indicate a bison by mimicry, then a trace, as "frozen gesture", would be directly perceptible as looking like a bison' (ibid.); hence gestural communication preceded language. 'The act of freezing a gesture fixes the image in a place and makes it persist in time... it establishes a perceptible relationship between the maker, the depiction and the thing itself...

Theories, chimps and children

it allows copying, transporting and recopying. It is this kind of complex that starts to look more like language. It is our hypothesis that this is the way in which communication was transformed into reflective language' (ibid.), emerging from the repetition of lines with shared meaning.

The capacity to produce a motif makes possible both figurative representation and the creation of abstract layouts with no reference to the surrounding real world; it leads to the installation of codes, and systems of coded images. The capacity to make intentional images and give them meaning, turning them into symbols, seems to have come into being in the first half of the Upper Palaeolithic.

According to Davidson and Noble, the emergence of language through graphic representation provided the behavioural context in which natural selection would favour the greatest vocal diversification, that is, the development of articulated language (and this is perhaps what accelerated the disappearance of Neanderthals). Unfortunately, such a point of view is far too speculative to be convincing; it arouses somewhat similar reservations to Leroi-Gourhan's theory. However, it is worth bearing in mind the pertinent criticism of the concept of an 'artistic tradition' that several authors – and especially Alexander Marshack – have tried to distinguish, in order to group arbitrarily the disparate and isolated productions of the Lower and Middle Palaeolithic around the world. But where Davidson and Noble's question is concerned – i.e. what meaning can an isolated work have? – we shall not give an answer that is as categorical and negative as theirs. We consider that in the Middle Palaeolithic, long before the Upper Palaeolithic, the rhythm of productions and manifestations of a 'cult' type accelerated in the direction of increasingly symbolic behaviour.

Moreover, the transition from 'nonsemantic marks' to 'semantic marks', linked to the recognition of the marks' capacity for representation, which was sometimes accidental at the start, is an interesting idea; but it's not new since, as we have seen, Luquet (1926) and Breuil (1926, 1952) had already put it forward a long time ago. As for language's precise role in this process, it remains uncertain; the jump from mimicking a bison to drawing a depiction of the animal, and from gestural language to articulated vocal language or a graphic language, appears mysterious. Most researchers favour the very early emergence of a kind of language that then evolved gradually, like all the other cognitive capacities of humans. It is possible that, quite independently, the emergence of figurative art helped or temporarily accompanied this evolution, but the hypothesis is just begging the question.

An even more categorical position was developed by Emmanuel Anati (1989, 1997), who proposed a complete assimilation of language and art. He considered that, at its start, world rock art was a 'visual language' that was both unique and universal. The various artistic expressions of the earliest periods display very similar typologies throughout the world, the same thematic choice and the same type of associations. As for style, rock art only offers a limited range of variables. It was therefore, in his view, legitimate to speak of a single visual language, one logic, one system of associations of ideas and a universal symbolism, constituting the very essence of the mental structure of these *Homo sapiens* who left their imprints on rock surfaces on every continent. The universal nature of visual language led him to suppose that there are roots common to all our different cultures.

In this point of view, the hypothesis clearly outweighs the facts. The supposed homogeneity of the world's first arts is seen in such general terms that it is barely meaningful: the juxtaposition of the figurative and the abstract, the frequency of synecdoche, the presence and sometimes the association of animal and human figures and geometric signs, as well as an obligatory technical commonality, since there are a limited number of ways of making images. One could add a careful adaptation of art to the topography of landscapes and the forms of relief. But the first creators used common tools that were provided by their 'human nature' to give free rein to all the culture, all the beliefs they carried in them. As we shall see, their productions were extraordinarily varied from the start, each one obeying different evolutionary laws and processes. What identity or commonality could we detect between the sculptures of Hohle Fels and the Panaramitee petroglyphs, between the mammoths of Arcy-sur-Cure and the external sanctuaries of Asturias, between the faces of Cleland Hills and the sculpted bear of Tolbaga, and so on? In addition we should not confuse technical commonality with stylistic commonality. Finger-flutings, for example, whose production was known at a very early stage, were used in all periods and throughout the world (Lorblanchet 1992). This attempt at homogenization of a diachronic phenomenon which is the reflection of worldwide cultures is totally unacceptable.

Art and modern humans
Another way of asserting the biological foundation of art is to closely associate its emergence with the appearance of modern humans. Denis Vialou (1995) expressed this opinion as follows: '...the [earliest] *sapiens* brain has frontal lobes that are practically as developed as ours and clearly

more so than those of earlier humans. Through this fact and the analysis of the frontal lobes in the development of thought, it seems probable that there is a correlation between the frontal lobes of prehistoric *sapiens* and their symbolic activity, which grew increasingly strong until the actual emergence of art.'

An even more radical position, in the sense of a close coincidence between the appearance of art and that of modern humans, was presented by Anati (1989, 1997). According to him, '*Homo sapiens* produced art', bringing about a veritable 'revolution' around 40,000 years ago in their 'way of thinking, logical mechanism, capacities for abstraction and synthesis'. But how, then, can one evaluate objectively, and archaeologically, most of these mental capacities, such as the 'logical mechanism' or the 'spirit of synthesis'? Anati went as far as envisaging a perfect coincidence between the geographical and chronological diffusion of *Homo sapiens* and that of art, resulting in the idea of an original and unique centre for both, or at least a single process of diffusion.

These ideas are quite widespread, especially in Europe. We shall simply make a few short remarks about them. The data of modern Palaeolithic archaeology should be able to qualify the abstract concept of 'revolution' (Anati's term) or 'creative explosion' (to use the term coined by Pfeiffer 1982). But in fact research is ceaselessly revealing the huge time-depth of art's origins. In addition, the appearance of *Homo sapiens sapiens* was not always accompanied by that of art, since the first modern humans seem to appear in East Africa and the Near East about 100,000 years ago, whereas in these regions the emergence of art is – on present evidence – more modest and later in date than elsewhere. Even if one were to accept the hypothesis of an African and Near Eastern 'cradle' of *Homo sapiens sapiens*, it is impossible to do the same for the 'cradle of art'. On the contrary, excavations and radiocarbon dating show that the appearance of art in the world is a highly diachronic phenomenon that occurs in a variety of cultural contexts, certainly in a world inhabited by *Homo sapiens sapiens* and Neanderthals, but it is clear that, within these societies, the appearance of figurative art and its development responded to diverse and complex mechanisms that cannot be reduced to purely biological phenomena, exclusively attached to one particular type of human. The diffusion of modern humans and that of art are not as closely linked as was believed by Anati and a whole European school of prehistory.

The massive changes that took place during the Holocene are not explained by biology either: the artistic degeneration and the probable disappearance of art in certain European Mesolithic cultures, such as

the Sauveterrian, does not imply the disappearance of modern humans. During that same period, art was bursting forth in other cultures. Moreover, the invention of agriculture, as important for humanity as that of art, was not linked to anthropological evolution either. In addition, if absolute dates from Australia are correct, up to twenty millennia seem to have passed between the peopling of that country by modern humans and the appearance of a fully constituted art. Finally, several authors have pointed out that certain ethnographic societies (for example, some groups in New Guinea) have no art, even though they are modern humans. It is important to stress the existence of multiple *non-biological* factors which explain the variability of human societies as recorded by archaeology.

The staggered appearance of figurative art began in a period when the planet was occupied by *Homo sapiens sapiens* and, in places, by the last Neanderthals; but, based on that objective fact, it would be an exaggeration and incorrect to attribute the entire paternity of art's emergence to the appearance of a new type of human, given that this birth could only have come about after a long gestation that started from a cognitive basis developed through the millions of years of human history.

Current interpretations:
the socio-economic foundations of Pleistocene art

In the 1980s an appealing theory about the appearance and evolution of Palaeolithic art was put forward by a number of authors (e.g. Conkey 1983; Gamble 1982; Pfeiffer 1982). It claimed that art is an essential element in systems of communication between human groups, a 'visual mode of information transmission'. A true 'social marker', art can be used to demarcate the extent of communication systems and social territories.

In Australia
Joseph Birdsell (1953) and Norman Tindale (1974) showed that there is a relationship between the size of socio-linguistic territories and ecological conditions in Australia. The drier and more arid the climate, the more difficult the survival conditions and the vaster the territory. The tribes in Australia's central desert have territories that are five to fifteen times bigger than those of the tribes on the coast where resources are more abundant and the population is denser. The extreme survival conditions

demand strong cohesion between the groups; they induce social mechanisms of closeness, with the accent on links rather than differences. In Australia, it is clear that a situation like this leads to the adoption of similar visual markers, that is, the adoption of a similar style of rock art. By contrast, in a favourable environment, where the population grows, where there are social conflicts, the tribal territories shrink in size, local social identities are established and a regionalization of styles appears. Such mechanisms certainly seem to explain the general characteristics of Australia's rock art, which is marked by a stark contrast between the relatively homogeneous art of the desert or semi-desert zones of the interior and the stylistic mosaic of the tropical coastal zones, which are rich and densely populated.

A mechanism of this kind has been applied to the chronological domain in an attempt to explain the evolution of Australian styles through time. Hence the styles with a vast geographic distribution, such as the Panaramitee tradition and, farther north, during the Pleistocene, the dynamic Mimi and Bradshaw figures (dubbed 'Boomerang style' by Darrell Lewis), have been seen in relation to a hostile natural environment linked to the increased aridity during a large part of the Ice Age, whereas the post-Pleistocene return to milder conditions in the north corresponded to a dense peopling of the northern coasts accompanied by movements of populations and ethnic conflicts linked to the reduction of land through marine transgression (Lewis 1988). The splintering of styles thus reflects a bitter competition for resources and the declaration of identity of local groups in reduced territories.

This explanatory system is convincing at a general level. It especially underlines the fundamental influence of ecological context on culture, and on art in particular. But although it may shed light on the distribution of styles and art forms in space and time, its usefulness for explaining the emergence of art on the Australian continent is by no means clear. So we need to seek a different mode of explanation.

According to Josephine Flood (1997), the birth of Australian art around 40,000 years ago was a ritual response to a profound change in the natural environment – the decisive importance of this factor is thus asserted once again. When the first pioneers penetrated the virgin territories of Australia about 60,000 years ago, the natural conditions were favourable to settlement. The climate was less hot than today, so evaporation was weaker and water resources were greater, including in the centre of the continent, which was a region of lakes (Willandra). The vegetation was lusher, and supported an abundance of animals, characterized by

the presence of big species (giant kangaroos; the marsupial *Diprotodon*, which weighed two tons; the giant emu-like *Genyornis*, etc.) which were easy prey. These factors helped the peopling of the whole of Australia to happen relatively rapidly; it may have taken 2000 years, according to the theoretical calculations of researchers. Pleistocene sites are spread throughout Australia, including in Tasmania, which was joined at that time to the continent by an isthmus.

Flood's (1997: 143) hypothesis is that the Panaramitee tradition was 'developed as a result of the resource crash following extinction of the megafauna in central Australia soon after first human penetration of the core of the continent'. It is possible that the early disappearance of the biggest animals in the centre of the continent, under pressure from hunting and bush fires, may have been accelerated by the drying of the climate at the start of the Late Pleistocene, corresponding to the Glacial Maximum. Based on its present-day function, rock art seems to have always constituted a means of influencing the supernatural forces that control the world; painting or engraving is the equivalent of a prayer. Flood remarked that the Panaramitee 'which is part of the living art tradition of central Australia today is closely concerned with maintenance of natural species and "hunting magic"' (ibid.: 143) and that, therefore, the same may have been true at the start of this immense tradition, some 40,000 to 50,000 years ago! Archaeology is forced to put forward hypotheses like this, if only to give direction to new research.

Can such a huge chronological distance allow one to envisage such permanent functions and meanings? The very few depictions of extinct species in Panaramitee art do not exactly support Flood's hypothesis. One should not forget that there seems to have been a gap of almost 20,000 years between the first arrival of humans in Australia and the start of a fully constituted and dated art, a long period during which the use of red ochre appears to have been continuous. Of course rock paintings may have existed which have left no trace. As in Europe, the appearance of art could coincide with that of *durable* art, that is – in this case – with the technique of rock-engraving, which itself perhaps had a ritual meaning.

The precise role played by humans in the disappearance of Pleistocene species in Australia (the bones of which are rarely found in habitations) remains to be determined, and the same applies to the rhythm and stages of this disappearance. It seems to have been gradual, spanning the whole of the final Pleistocene. So the dramatic nature of the extinctions, implied by Flood, has not been demonstrated; nevertheless her hypothesis

Theories, chimps and children

remains of interest. It links the birth of art to a certain population density permitted by the original richness of the environment, and to a period of tension, of intensive struggles for survival in a 'changing' environment – but were humans conscious of the change? – which could have been disturbed again by the arrival of new waves of immigrants. In Australia's vastness, several centres for the appearance of art may well have existed in different periods.

The stress linked to various struggles for survival was perhaps the trigger or driving force of the artistic phenomenon, since in Australia it may have provoked not only a birth but a blooming of styles, at the start, and then at the very end, of the Upper Pleistocene. So here we have a theory in total contrast to the old ones that saw a relationship between art and comfort linked to abundance: today we have moved from art seen as a superfluous leisure activity to art perceived as a vital activity.

In Europe

Several authors have highlighted the importance of socio-economic factors in the birth and evolution of European Palaeolithic art (Straus 1992; Jochim 1983; Gamble 1986; etc.). It was Brian Hayden (1993) who developed this theory with the most detailed arguments. Like most of his colleagues, he centred on an ethnographic comparison between North American hunter-gatherer societies and the hunter-gatherer societies of the Middle Palaeolithic and early Upper Palaeolithic of the Aquitaine-Cantabrian region.

In the present-day world, Hayden distinguishes two types of ethnographic hunting societies. First, there are 'generalized (or common) hunters', living in an environment with rare and fluctuating natural resources supporting a fairly low human population density. This situation of scarce and unpredictable resources leads to the formation of an egalitarian, non-competitive society, based on sharing and on cooperative alliances for long- and mid-term survival. These groups are opportunistic hunters and gatherers, and have a nomadic way of life. The lack of competition and ownership of private resources, and the egalitarian social structure explain the absence of any need for distinction and, consequently, the absence of art. Many Mousterian groups in southwest Europe were, in Hayden's view, good examples of such societies of egalitarian, non-competitive and opportunistic hunters, incapable in particular of amassing food reserves.

Secondly, there are 'complex hunter-gatherers', using a richer territory with abundant resources and hence with a high human population

density. They display a greater ability for acquiring and storing resources. Their semi-nomadic way of life, with reduced mobility marked by long stays in large base camps and short external expeditions, is based on the exploitation of seasonally abundant resources and on the amassing of large-scale reserves. Animal migrations could produce a seasonal abundance and a great quantity of dried meat, stored in anticipation of the future. The model for these societies (which can be applied to those of the Aquitaine-Cantabrian Upper Palaeolithic) is provided by the archaic cultures of North America, and especially of the Northwest Coast and northern Alaska (whale groups), which are socially stratified, rich and competitive.

Hayden stressed the importance of economic competition for ownership of resources within societies of complex hunters. Competition leads to social stratification, with the emergence of chiefs controlling resources and collective work; some groups and some families thus own the territory that produces the resources, or control the movement of these resources (they may, for example, claim ownership of exotic products, or of fishing and hunting sites, such as fords on animal migration routes). Competition also leads to a constant quest for social status and the demonstration of all forms of collective and personal power; and art is the visual means by which power, group adherence and social status can be displayed and asserted.

According to Hayden, as on the Northwest Coast of America, everything in the Upper Palaeolithic societies of southwest Europe indicates the existence of private property: the possession of portable carvings that require work of a high technical level, exotic jewelry, and even the burials with their grave-goods, which reveal a particular social status.

The splendour of the portable art displays its social status: 'Mural art may have been related to status display in a less direct fashion, either depicting classes of group totemic animals or group myths, or the acquisition of animal allies in personal visionary experiences during initiations into groups' (Hayden 1993: 138).

Hayden's interpretation contains some attractive elements, and it shows once again the essential importance of economy and society in the appearance and development of art. It is true – as we shall see later – that population density seems to have increased considerably from the Middle to the Upper Palaeolithic, and that it never ceased to grow throughout the latter. The presence, too, of vast seasonal resources (such as the meat that was available during the migrations of reindeer from the plains of

Theories, chimps and children

Aquitaine to the slopes of the Massif Central and the Pyrenees, following the great valleys, or those of salmon in all the rivers of the Atlantic coast) and the development of a more seasonally structured (and perhaps more planned) economy during the Upper Palaeolithic are widely accepted, as is the expression of a certain seasonality in parietal and portable art. But other aspects of the theory remain questionable.

The precise role played in the cultural domain by an economy of abundance does not appear to find general agreement among researchers. Michael Jochim (1983) too considered the Magdalenian painted caves of the Périgord as ritual and symbolic assertions of territorial ownership. He saw them as a reflection of a happy and peaceful integration of human groups in a favourable environment. He thus had a more idyllic view than Clive Gamble of human relations, and of a flourishing natural environment. For Gamble (1986) – even in environments and periods of abundance – parietal art shows the extent of the intensity of competition between populations and their physical and social environments. He argued that the essential and dazzling use of social and territorial markers (i.e. cave paintings) reveals tensions, problems of integration in social units and a constant distrust, a permanent alertness in the face of the whims of an unpredictable environment. What is important for most ethnoarchaeologists of the American school, who make it a kind of postulate, are the tensions and competitions between groups and within groups that are generated by an abundance of resources.

The model proposed by Hayden is, moreover, too theoretical. In his evident desire to dramatize the contrast between the societies of the Middle and Upper Palaeolithic, he had an excessively schematic and reductionist perception of the way of life and intellectual capabilities of the Mousterians, and failed to take the archaeological data properly into account. The Mousterians were not wandering groups, going around vast territories in a thoughtless and disorganized quest for their resources. All the work by researchers in this domain shows that, on the contrary, they had strategies for acquiring raw materials and food that were well thought out and based on deep knowledge of the natural environment. The technology of their toolkits was complex, including woodworking, and their hunting, which was by no means reduced to occasional scavenging, was often specialized, seasonally organized, and revealing of a developed social structure (the presence of leaders directing the hunt) with killing sites devoted to a single species (for example, the bison or aurochs at La Borde, Mauran, Coudoulous, etc.). Many other sites display a faunal diversity that reveals hunting techniques similar to those of the Upper Palaeolithic.

Doubtless the most awkward aspect of Hayden's theory is not its excessively categorical and superficial nature, but the fact that it appears, in its broad outlines, to be a transposition of present-day political models. It is amusing to read that the Mousterians were too egalitarian to make the effort to produce works of art, and that they had no desire to distinguish themselves because the work of one should benefit others. Hayden seems to be trying to convince us that the liberalism and capitalism of the Upper Palaeolithic, based on free competition and private property, were a marked progress over the dismal Mousterian kolkhozes!

Hayden's theory is interesting, but it cannot be accepted unreservedly, and needs a great deal of qualification. The Mousterian groups of southwest Europe, especially in the Périgord, were already highly developed societies, which tried to adapt to a changing environment by multiplying – long before the Aurignacians – ritual and symbolic activities, as revealed by the diversification of tools and behaviours that are often dubbed 'non-utilitarian' (especially the cult of the dead and the intensive use of pigments). It is by no means certain that this region's Neanderthal groups correspond perfectly to the 'generalized' hunter-gatherer type defined by Hayden. In a later chapter we shall highlight the exceptional abundance of black manganese oxides in a region delimited by the Dordogne and the Vézère that corresponds to the area of maximum population density at the end of the Mousterian. The presence of a kind of artistic activity among the Mousterians is highly probable. Not only must paintings on perishable supports (wood, animal and human skin) have existed, but it is now clear that the first tentative steps in the tradition of parietal paintings on rock surfaces exposed to daylight date back to this period. We also know that this is when people first symbolically took possession of the dark caves in Périgord, Quercy and elsewhere, as we shall explain later (in reference to the caves of La Roche-Cotard, Toirano, du Renne, Cougnac and Bruniquel, as well as several North Spanish caves), and sometimes produced rudimentary parietal art. The rich and permanent occupation of the famous site of La Ferrassie (Dordogne), dedicated for millennia to ritual, sepulchral and artistic activities, suggests that this region was doubtless one of the earliest European artistic centres, because there is a clear continuity from Mousterian burials and cupmarked stones to Aurignacian engraved blocks (see Chapters 7 and 8): the same supports, the same marks and sometimes the same cupmarks are found on them, underlining the permanent symbolic utilization of one place for tens of millennia. The roots of the Périgord's Aurignacian art, engraved or painted on blocks or walls, are thus doubtless Mousterian.

Theories, chimps and children

The emergence of art, like that of the cultural assemblage of the Upper Palaeolithic, was already under way in the Mousterian; it was inscribed in the deep history of the general evolution of cultures; and it took place in different parts of the world, at different times, in different cultural groups.

So from Hayden's theory we shall retain the importance accorded to the socio-economic context, and we share his opinion that it is impossible to conceive the great Palaeolithic works of art without a developed economic base. The arrival of the Aurignacians – doubtless bringing new strategies for acquiring resources, new beliefs and myths, and perhaps more structured social organization corresponding to an increase in population and in ethnic tensions – was the external element that crystallized and precipitated an evolution that had already been in progress for millennia. Unfortunately many aspects of this long maturing remain a mystery.

The socio-economic models that have been put forward to try and explain the birth of art in Australia and Western Europe are useful, but they need to be qualified and adapted, and they do not answer all our questions. We accept that the emergence of art implies a certain abundance of resources, but these were fluctuating resources in a changing environment that provoked ethnic tensions and uncertainty about the future, which led to an intensification of rites and the invocation of supernatural forces.

Two periods could have offered the most favourable conditions for the birth or rebirth of art: the late Middle and early Upper Palaeolithic and the time of Holocene upheavals that marked the change from an economy of predation to one of production. It was indeed in these two principal moments – around 60,000–40,000 and 10,000–7,000 years ago – that current archaeological data indicate evidence for the first organized artistic manifestations, especially in the domain of parietal art.

In reality, these phenomena are highly complex. Even if they follow general rules, they cannot be reduced to a single mechanism, although this is what most prehistorians try to do.

Theories of artistic evolution

The importance of the different factors that played a role in the development of art varies according to the authors concerned. Several have tried to seize art's development in its continuity from the start, so as to

discern a global evolutionary model. Two opposing and radical theoretical positions have been expressed, which mutually reinforce each other.

The first theory supports a gradual artistic evolution spanning the hundreds of millennia of the Palaeolithic and the whole of the Old World (Africa, Asia and Europe). It sees this evolution as a continuous movement marked by 'traditions' that led directly to the different artistic categories of the Upper Palaeolithic (tool decoration, figurines, parietal art, etc.). This school of thought emphasizes continuity, and systematically considers the early works as evidence for 'symbolic behaviour'. Hence any discovery of items before the Upper Palaeolithic that can be qualified as 'non-utilitarian' is thus interpreted in terms of 'symbolism'. To make up for discontinuities and the rarity of these documents, the quest for homogeneous and uninterrupted artistic *traditions* leads to a constant emphasis on the role of taphonomy – that is, all the phenomena that make possible the conservation of remains, and which obviously affect our knowledge and perception of the origin of art. There is an effort to define a *trajectory of art*, from the start to the Upper Palaeolithic and beyond, presented as a growing complexity of works and styles, in which the abstract precedes the figurative. Finally, the school's interpretative models highlight the socio-economic foundations of the phenomenon of art's appearance.

The second theory, which could be called 'revolutionary' because it stresses the break that seems to mark, in the view of its proponents, the arrival of the Upper Palaeolithic, seen as a revolution, tends to minimize everything that preceded that period, and to place the beginnings of art at the very end of the Mousterian at the earliest. It too proposes an artistic trajectory, but this time a much shorter one (400 centuries instead of hundreds of millennia). The trajectory is characterized by a rise towards naturalism, implying simple or rudimentary stylistic beginnings, while, in parallel, schematic and abstract signs were also developed. In its explanatory models, this school, of which Leroi-Gourhan was a precursor, highlights the biological and psychological foundations of art, which it considers to be primarily linked to the arrival of modern humans.

In reality, these different points of view seem to be excessively simplistic. The birth of art was a complex phenomenon in which a great variety of factors played a role – and it was both gradual and splintered, 'biocultural', like the origin of language and all of human history. The two positions tend to homogenize the processes involved in the birth and development of art, by reducing the disparities and spatio-temporal distances that they imply. Thus, for example, Anati (1989, 1997) ignored

the heterogeneity of the cultural contexts, dates, places, styles and themes that characterize the birth of art in the world, and claimed that it was legitimate to speak of a single visual language. The linguistic theory of a 'mother tongue', proposed by Merritt Ruhlen (1994), can doubtless be seen between the lines in these proposals, but in the domain of art (as in that of linguistics) this attractive idea ought to be backed up with arguments based on facts, whereas it seems to beg the question, being purely theoretical, and turns its back on reality.

Another way of homogenizing the data, commonly practised by both schools, consists of systematically establishing relationships between facts that are far removed from one another in time and space, and distinguishing 'symbolic traditions' and 'stylistic trajectories' with the aim of constructing a unitary model of artistic evolution. Was there really – as has been claimed – a 'tradition of female statuettes' from the little Israeli nodule of Berekhat Ram to the 'Gravettian Venuses' of Europe, when several hundred millennia and thousands of kilometres separate these specimens? Can one distinguish, as we shall see, an 'Acheulian semantics' in the 'feline with geometric signs' from Bilzingsleben, which would thus be a rough draft, three hundred millennia in advance, of the model defined by Leroi-Gourhan for Upper Palaeolithic art, a model that is widely disputed today? Do these approaches not simply project the interpretative theories of the Upper Palaeolithic onto the products of the Lower and Middle Palaeolithic, implying immense time spans without intermediate stages – an approach denounced by Davidson and Noble (1989)?

A linear evolution – a growing complexity of artistic forms going from abstract to figurative, culminating in a general rise towards the naturalism that is considered the pinnacle of progress and the height of human achievement – characterized the stylistic chronologies of Breuil and Leroi-Gourhan in the domain of European Upper Palaeolithic art. It has been vigorously contested (e.g. Lorblanchet 1992; Ucko 1987; Bahn & Vertut 1988; Bahn 2016). Peter Ucko (1987), for example, aptly attributed this theory of artistic progress to a fault in the archaeological method itself, which automatically 'classifies documents in evolutionary sequences' in order to 'put some order into the mass of facts', as Leroi-Gourhan wished to do. So should one now see the phantom reappear – at the scale of the Pleistocene, with a time span of hundreds of millennia and over the entire globe – of a uniform artistic evolution, with a 'trajectory', a continuous and directed movement?

The hypothetical relationships woven between distant pieces of evidence bring about a kind of 'smoothing' of the artistic phenomenon,

in the mathematical and statistical sense of the term, based on the idea that the missing stages existed but have disappeared. The rarity of artistic evidence during the Pleistocene is all too real; it needs to be mentioned from the outset. Our inventory – as will be shown in this book – leads us to note that the whole assemblage of documents upon which all theories about art's origins are constructed comprises a total of about twenty collected fossils and curious stones, a dozen sites with collected pigments in the Lower Palaeolithic and forty in the Middle Palaeolithic, four protosculptures, less than a dozen pieces of jewelry in the Middle Palaeolithic and forty in the Châtelperronian and contemporaneous cultures, twenty-five stones with markings, and seventy-five bones with incisions. Hence, leaving aside tools and functional aesthetics, which are harder to take into account, for the whole world and for 2 million years, only about 200 pieces of evidence bear witness to an aesthetic sense, and many of them are questionable. So, to use an excessively theoretical but nevertheless significant calculation, we have an average of one piece of 'artistic' evidence every 10,000 years!

It is impossible to judge with any precision the importance of the role of conservation of vestiges in the poverty of such a panorama. The 'gradualist' school is certainly right to stress that the data are partial and probably biased. Bahn and Vertut (1997: 26) analysed the different reasons for this distorted information, pointing out that many examples have probably been ignored and lost during excavations because they did not attract the attention of specialists: 'taphonomic distortion... increases with age. ...The earliest abundance of any form of archaeological evidence... should never be interpreted automatically as the earliest occurrence of a phenomenon. The further back in time we look, the more truncated, distorted and imperceptible will the traces of "art" appear.' But archaeologists have great difficulties in going beyond such pertinent remarks! How does one use negative data? We know that many artistic manifestations used perishable supports: the Australian Aborigines show us this every day. However, if rock art or portable art had existed and flourished in the Lower Palaeolithic, it is probable that at least some of it would have come down to us. There is no reason to think that statuettes and decorated objects of the same type as those of the Upper Palaeolithic could have been eliminated in the archaeological layers, which have yielded numerous bone fragments and sometimes even wooden implements.

The probable Mousterian examples of body-painting and painted animal hides have certainly disappeared, but a stone block with

Theories, chimps and children

cupmarks has survived at La Ferrassie (see Chapter 7). Other blocks bearing engravings or paintings could have been preserved in the same way. Evidence for parietal paintings in rockshelters, badly preserved like those of the Aurignacian of the Périgord and the Swabian Jura, could be detected one day, if they existed. Since the work of Denis Peyrony, almost 100 years ago now, excavators have remained vigilant, but sadly without success.

Given the fact that more than 85 per cent of cave paintings have not yet been dated objectively (Lorblanchet 1995), it is not impossible that radiocarbon might one day assign a few underground parietal figures to the end of the Mousterian, although this is the limit of that dating method's range. However, as we shall see in Chapter 8, calcite dating (using the uranium-thorium method) has now begun producing results in some North Spanish caves, which makes it virtually certain that Neanderthals were making red discs and perhaps even hand stencils, while the walls of the French cave of La Roche-Cotard were clearly decorated with fingermarks and some spots of red ochre in the Middle Palaeolithic.

There is no doubt that some evidence has irremediably escaped us, but nevertheless we can assume that the contrast between the abundance of artworks in the Upper Palaeolithic and their rarity in the vast periods that preceded it is not entirely due to erosion or a lack of prehistorians, but is above all a cultural phenomenon. So it seems necessary to avoid excessively speculative positions, and to take into account the whole diversity and complexity of the phenomena involved in the birth and development of art.

Chapter 2

Finding art in nature: the first stirrings of an aesthetic sense

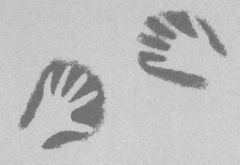

For several hundred millennia, humans have been interested in strange-looking stones found in nature, and especially in fossils, the petrified animal forms of which were sometimes identifiable by the first humans – shells, for example – and which often present geometric shapes with an astonishing symmetrical structure. There are a number of very early examples of an attraction to such curiosities.

An Acheulian handaxe from West Tofts (Norfolk, England) has the fossil of a bivalve shell, *Spondylus spinosus*, on one side (FIG. 5, PL. IV). It is clear that the piece was manufactured around the fossil, taking care to preserve it intact in a central position. Kenneth Oakley (1981: 208) put forward the hypothesis that the fossil constituted a kind of blazon that distinguished the tool's owner. He pointed out a second handaxe from the Middle Acheulian of Swanscombe (Kent, England), dating to around 200,000 years ago, which likewise has a fossil at its centre – in this case, a perfectly preserved echinoid (FIG. 5). Oakley also mentioned – again from the Middle Acheulian at Swanscombe – two flakes of Upper Jurassic flint formed from the fossil coral *Isastraea oblonga*. This particular type of flint contains myriad little coalescent starlike shapes, which produce a beautiful effect (FIG. 5). The material had been

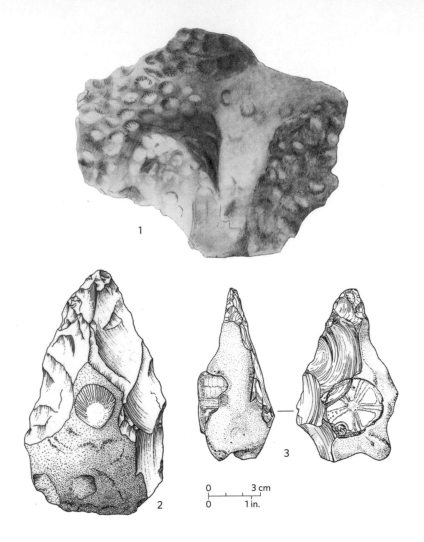

5. (1) Middle Acheulian fossil coral (*Isastraea oblonga*) flake from Swanscombe (Kent, England); (2) Acheulian handaxe from West Tofts (Norfolk, England), with a bivalve shell at its centre; (3) another from Swanscombe, with a fossil sea urchin.

transported almost 200 km (125 miles) to the site, and was harder to work than the local flint.

Also in England, a group of small fossils of *Coscinopora globularis*, naturally perforated, was found in gravels near Bedford in the late nineteenth century. They were attributed to the Lower Palaeolithic because of their position in the alluvia and some scholars thought they had been collected by humans and used as jewelry (Roe 1981: 281) (FIG. 47). However, a recent critical reassessment of putative Acheulian beads from northern Europe found that the evidence was inconclusive (Rigaud et al. 2008).

The Acheulian industry at Saint-Just-des-Marais (Oise, France), dating to more than 100,000 years ago, contained a fossil sea urchin *Micraster* from geological outcrops of the Cretaceous period. This plano-convex flint had been picked up, transported over a long distance and then worked into a circular scraper (FIG. 6). The retouch around the edge preserved the fossil's general shape, as well as the central radiating bands forming a decorative layout that was scrupulously respected by the toolmaker, who took care that the removals of material did not go too close to the centre or affect the object's natural symmetry (Oakley 1971).

In the five Lower Palaeolithic examples just mentioned, the fossils were not only collected but also used or involved in the manufacture of tools. But this was not always the case. The Acheulians of Combe Grenal (Dordogne), for instance, brought a Rhynchonella brachiopod of the genus *Terebratulina*, of the Upper Cretaceous, back to the site, but did not modify it in any way (Demars 1992: 186).

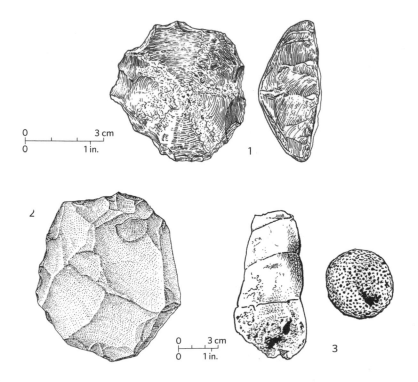

6. (1) Acheulian circular scraper from Saint-Just-des-Marais (Oise, France), shaped from a Cretaceous fossil sea urchin; (2) Mousterian quartzite scraper from Schweinskopf-Karmelenberg (Germany), with a brachiopod imprint; (3) coralline *Chemnitzia* gastropod (left) and coral madrepore (right), from the final Mousterian of the Grotte de l'Hyène (Yonne, France).

Finding art in nature

Utilitarian vs non-utilitarian

Prehistorians are impregnated with western materialism, and this doubtless disqualifies their views on the origins of art and of humans themselves. It leads them to project onto prehistoric societies the concept of specialization in human activities: the religious was confined to certain moments in life, certain places and days of the week, whereas most of our everyday tasks, which have taken over almost all our time, are considered to be utilitarian and material tasks. Hence a highly reductionist image has emerged of a technological and ecological prehistory in which people are limited to being flint-knappers striving to adapt to their environment.

Ethological comparisons help us to conceive a totally different side to prehistoric people and perhaps people in general, where the western separation of the notions of 'utilitarian' and 'non-utilitarian' is meaningless. It is amusing to note that those researchers who so vigorously reject the word 'art' (because they feel its modern connotations of 'play' are inadequate for prehistoric societies) nevertheless feel able to differentiate between 'utilitarian' and 'non-utilitarian' behaviours. This may be useful language for prehistorians, but not for prehistoric people.

In reality, in non-western traditional societies and very likely also in prehistory, everything is both utilitarian and symbolic and spiritual. The 'pure' non-utilitarian and utilitarian do not exist. Making a tool and using it are always acts linked to beliefs and rites. Art is a game, but one that is vital for the group's survival.

In the Middle Palaeolithic, human interest in fossils continued. A nummulite from the early Mousterian site of Tata (Hungary), dating to c. 100,000 BP, seems to have a cross engraved on both faces. This small, perfectly circular, brown and shiny fossil is an 'exotic', brought in from elsewhere. A fracture divides it into two, and each face in fact only has a single engraved line that crosses the natural fracture to produce the form of a cross. 'The act was apparently intended to make the image of a "cross" on each face, though a "cross" is what we, in our culture, see, while in the Mousterian it may merely have been an 'effect' that was intended, the double over-crossing of natural lines' (Marshack 1991: 47–48).

Several other examples are known: a fragment of fossil resin discovered in the Micoquian levels of Kůlna cave (Czech Republic)

may simply have been brought to the site as a curiosity, or perhaps even to be used as an adhesive in the hafting of certain tools (Valoch 1996); a fossil shark tooth was discovered in the Levalloiso-Mousterian of Darra-I-kur (Afghanistan) (Dupree 1972); and again from Combe Grenal, this time from the Mousterian levels, comes another Upper Cretaceous brachiopod fossil, a Zeillerinae specimen of the genus *Terebratulina* (Demars 1992: 186). Elsewhere a big Cardium fossil (*Plagiostoma striatum*) was found by Denis Peyrony in Level C of the Lower Mousterian of La Ferrassie (FIG. 7). Although it came from the local Coniacian limestone, its association with tools shows that it was collected and brought to the shelter by the Mousterians. The open-air site of La Plane (Dordogne) yielded a rich industry of the so-called Mousterian of Acheulian Tradition (Kervazo et al. 1989), including a flint flake that, on one face, has a well-preserved *Pecten* shell in a central position, and on the other the more discreet partial imprint of another bivalve (FIG. 8). In reality it is a frost-shattered plaquette whose edges were crudely retouched, not to make a tool, but simply to give the fossil an almost central place on the piece and thus show it to advantage; the provenance indicated by the excavators is the Campanian flint bed in the Belvès region (Lot-et-Garonne). The 'evolved Denticulate Mousterian' of the Grotte de l'Hyène at Arcy-sur-Cure (Layer 15), dating to around 35,000 BP, gave Leroi-Gourhan a coralline *Chemnitzia* gastropod and a

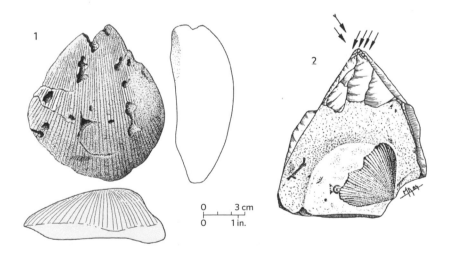

7. (1) Fossil Cardium (*Plagiostoma striatum*) shell collected by the Mousterians of La Ferrassie shelter (Dordogne, France), excavated by Denis Peyrony; (2) large burin (probably Aurignacian) on a flint flake featuring a fossil (*Rhynchonella vespertilio*).

Finding art in nature

8. The La Plane flake – not a tool, but a natural
plaquette that has been crudely modified to give
the fossil shell a central position.

spherical coral madrepore. They were placed beside two nodules of iron
pyrites and a bola, so this may be a 'symbolic' deposit (FIG. 6).

In Germany, the Mousterian habitation site of Schweinskopf-
Karmelenberg, one of the late Middle Palaeolithic sites in the former
volcanoes of the Eifel, yielded a side-scraper of Devonian quartzite that
has the imprint of a fossil brachiopod on its dorsal surface: the only
side-scraper known in this material, it is an exotic imported as a finished
product (FIG. 6). Given its state of ancient corrosion, it does not seem to
have been used, and the fact that it was decorated with a fossil provides
the only possible reason for its being kept at the site by prehistoric
people (Schäfer 1996). In the Mousterian Levant, from the caves of Skhul
and Qafzeh, Ofer Bar-Yosef (1992) reported a few seashells, but because
of the strong salinity of the sea these would not have been edible – so
they must have had a non-alimentary function. As with the collection
of fossils, it was doubtless the shapes and colours of the shells that
interested the Mousterians.

The Upper Palaeolithic Châtelperronian culture (45,000–40,000 years
ago) saw the last Neanderthals continue to gather fossils and minerals,
a practice that would then persist through all periods up to the present.

Hence, in the cave of La Roche-au-Loup (Merry-sur-Yonne), a fossil sea urchin identical to that from Saint-Just-des-Marais published by Oakley was carved into a bifacial side-scraper (PL. V). It was associated with a small block of galena (Poplin 1988). Leroi-Gourhan also reported, from the Châtelperronian of Arcy-sur-Cure, a fossil crinoid with a natural hole. This could have been used as a bead or pendant, since it was associated with a whole series of ornaments with artificial perforations in the same layer.

When all is said and done, the above list of finds is astonishingly short for such an immense span of time and space. So one can wonder whether similar fossils, as well as minerals and various exotic rocks, have always managed to attract the attention of archaeologists in the course of their endeavours, because it seems that not all objects recovered have always been fully published. It is possible that the list would be richer if all data had been recorded properly. But there are sufficient examples to show that for hundreds of millennia humans have been intrigued by the strangeness of fossils, picking them up, bringing them back to their dwellings and sometimes turning them into tools.

A recent experiment presented five orang-utans with objects of different brightness, colour and shape, and found that they were particularly responsive to the most visually striking, bright and colourful objects; but they showed absolutely no tendency to preserve them (Borel et al. 2016).

The attention of the first humans likewise seems to have been seized by the shape, colour and more or less symmetrical and geometric structure of fossils, as well as their texture, their sometimes shiny appearance, the pleasure of touching their smooth surfaces, the density of the material, and the fact that many of these stones are astonishingly heavy in the hollow of the hand. The collection and sporadic utilization of such objects are significant acts which tell us that the first humans had a sense of aesthetics, and that they were even endowed with a certain delicacy of touch. Their behaviour seems very close to our own, as we continue to pick up shells, fossils and other natural curiosities. Today we know how fossils and minerals were formed, and yet despite our science they still fill us with wonder. It is hard for us to imagine the impact that these natural formations could have had on our ancestors. From the start they must have pondered the question of how they were produced, and this doubtless led them into the domain of beliefs, myths and symbols.

Oakley rightly pointed out that the fragments of *Isastraea oblonga* used by the Acheulians of Swanscombe evoke a starry sky and that,

Finding art in nature

in traditional folklore, they are called 'starry stones' or 'thunder stones', while Cretaceous sea urchins are called 'shepherd's crowns' or 'fairy loaves'. The supernatural is spontaneously linked with these strange 'gifts' from the firmament that *Homo erectus* shaped as they wished while scrupulously respecting them. The mastery of these first craftsmen, knapping around a fossil without damaging it, compels our admiration.

François Poplin has published some interesting remarks about the use of fossils, showing, for example, that the Acheulians of Saint-Just-des-Marais had fully adapted to the material by making a circular side-scraper from the outer edge of an urchin, whereas, many millennia later, the Châtelperronians of Merry-sur-Yonne, by working only one side of the same type of fossil to make a side-scraper with only one active edge, 'had refused to submit to the radial symmetry of the echinoderm, preferring an arrangement that is more consistent with our own'. But can one really see a 'decisive step', a progress, in this 'liberation' in terms of the demands of the support? Moreover, should we, like Poplin, consider that the transformation of a fossil into a tool signifies a change in its status, and that the 'value of use shatters the object of curiosity'? On the contrary, we think that use confirms the power of a fossil that 'decorates' a tool, by endowing it with a supernatural capability, that is, a new and magical efficacy.

Collecting raw materials for toolmaking

The hard stones used by prehistoric people to make their tools were mostly siliceous rocks. The one that was most used in all periods was flint, found in the form of nodules or plaquettes in sedimentary rocks, or as pebbles in river alluvia. Less often used, but still quite common, were quartzite (a hard sandstone with a siliceous cement that comes from outcrops, blocks and pebbles) and various volcanic rocks such as rhyolite, phonolite and basalt. Throughout prehistory, people's attitudes to raw materials were often complex – never opportunistic but well planned, and culturally meaningful.

The search for the sources of raw materials, the territories and provisioning strategies employed, the production sequences of tool manufacture, and the ways in which tools were used – these are all research subjects today and provide a huge amount of information about the relationships between prehistoric people and their environments through the filter of their cultures. Lower and Middle Palaeolithic

people often used the raw materials available in their immediate environment; their abundance locally is reflected in the size of the pieces and in the economy of the work. The production of flakes and of waste is much greater when materials are plentiful. When they are scarce, knapping is much more careful, waste is limited, and successive resharpenings reduce the size of the pieces. In the earliest periods, people often settled in the immediate proximity of raw material sources. In the Middle Palaeolithic raw materials usually came from a radius of about 20 km (12 miles) around the occupation sites, but some desirable materials were acquired from more distant sources, sometimes more than 100 km (60 miles) away. According to Jean-Michel Geneste (1988), the 'exploitation area' of a habitation consisted of three concentric areas: a zone of 'site activities' around the camp, in which local materials made possible the manufacture *in situ* of tools that met immediate needs; a 'zone of daily activities' that extended over a much bigger area, in which the nuclei were made that were brought back to camp, where they were used to make actual tools; and finally a third, more distant zone comprised the 'area of travelling activities' in which tools were made from foreign materials and then transported over a long distance, brought back to the site in a fully finished state.

The determinism of raw material sources needs to be qualified. People gradually succeeded in freeing themselves from geological constraints by transporting materials, and doubtless also through barter and exchange, over great distances. Moreover, the manufacture and use of tools, in hunting societies as in all traditional cultures, are symbolic activities par excellence, linked to beliefs and myths. Even in very remote periods, human needs were probably never purely material. Among Australian Aborigines, myths only deal with what is profitable or harmful to society (Elkin 1964). The formation of rocks usable for tool manufacture is among all the natural phenomena that they explain; other myths even guide this manufacture. The provisioning, working and use of stone tools are thus sacred acts that update the works of the Dreamtime heroes. These acts are often accompanied by traditional rites and songs.

In all periods of human history, the collecting, transportation and utilization of exogenous rocks, difficult to work and from distant sources, show that aesthetic concerns often outweighed directly functional requirements, comfort and efficacy. A rock that came from a distant land or tribe must have been a precious thing – and it must have been filled with magical power. Flint and other common rocks certainly

constituted prehistoric people's basic materials, but from very early times, just as they were attracted by the diversity of shapes and colours of fossils and minerals, the same was true of the mineralogical variety of rocks, their appearance and colours, their textures, and their different degrees of workability.

Not only were particular kinds of rock destined for the manufacture of particular tool types, but also it seems that prehistoric people went beyond the technological vocation of stones and wanted to diversify their raw materials by varying colours and sources. Their toolkits often contain a sparkling palette with an infinite variety of shades of yellows, reds, browns and blacks; in some cases one also finds white, blue and green, and flints with brightly coloured stripes or graduated shades, as well as glossy or grainy rocks. Prehistorians, as was doubtless also the case for prehistoric people, can appreciate, for example, the effect produced by the juxtaposition of golden-yellow jasper side-scrapers and jet black Cretaceous flints. In the Oldowan industries of Tanzania, for example, the frequency of tools made from magnificent blocks of green lava shows that at a very early date hominins already appreciated the colours of the materials they used. And Jan Jelinek (1978) reported that the Australians and Native Americans take into account not only the quality of their raw material but also its aesthetic appearance, with the Aborigines preferring stones of beautiful colours for making their spear points. Another notion to which we shall return, because we consider it important and because it also involves aesthetics, is the mastery of knapping, the technical and formal perfection of well-made tools – which were not necessarily more effective than less accomplished tools.

We can agree with the prehistorian Jacques Tixier that 'the aesthetic value appreciated by our twentieth-century eyes and brains is a problem to be handled cautiously,' and it is doubtless important to avoid 'an aestheticism that is close to litholatry' (Tixier et al. 1980). But a researcher's caution should not become an exaggerated scepticism; the beauty of most prehistoric toolkits is readily apparent at first glance, so obvious that it must often have been desired. We should not forget that the attraction to beautiful tools and materials, which shows the taste of a collector and master-craftsman, contributed to the foundation of prehistoric science and to the meeting of prehistorians and prehistoric people: it cannot be denied that some of their dispositions are naturally similar.

The beauty of some toolkits can be stressed once again by quoting these lines by Tixier (1958–59) about the Aterian of Aïn Fritissa (Morocco), which, with more than 3,000 pieces, is one of that culture's richest

assemblages, the Maghrebian equivalent of a final Mousterian dating to about 40,000–30,000 BP: 'The variety and beauty of the glossy materials used, the remarkable technical purity of most pieces and the exceptionally successful working make this the ideal series for a display case.' The author stresses 'the variety of colours of the raw materials worked by the Aterians of Aïn Fritissa: flints in nodules or plaquettes presenting a wide range of colours: pale grey-mauve, translucent, caramel, sometimes very translucent, buff-coloured, mottled grey, "curdled milk" white, purple-violet, coal black, white mottled with pink, red and "verdigris" jaspers, buff-coloured with a ferruginous patina veined with blue, yellow, green and rust, chalcedony, argillite... the artisans of this series unquestionably chose their raw materials; they not only sought rocks that could be worked well, but also those which were pleasing to the eye. Flint of very high quality was abundant, but that did not prevent them seeking rocks that were harder to knap, such as jaspers, argillites or chalcedonies...'.

The 'feast' for the eyes, hand and mind expressed in these lines by Tixier, relishing the work of his distant prehistoric colleagues, is the perfect counterpoint to the caution evoked earlier by the same author. It is difficult not to consider such sparkling assemblages as the 'palettes' of the first artists.

Jasper

The multicoloured jaspers – speckled ochre-yellow or with black, brown and red veins – of which countless pebbles litter the western slopes of France's Massif Central, and the riverbeds that flow down from it, were commonly sought by the Mousterians of the eastern edge of the Aquitaine basin. They were used in particular in the famous Corrèze sites of Chez Pourré-Chez Comte and La Chapelle-aux-Saints.

At the site of Fontmaure (Vienne), with its Mousterian of Acheulian Tradition and Typical Mousterian, excavated by Dr Pradel, the toolkit is heavily dominated by an opal jasper of local origin. It is likely that it was the jasper source that determined the location of the habitation. This superb multicoloured material, that transformed every object produced into a veritable jewel, comes from the siderolithic sand on which the Mousterians settled at a relatively late stage in their evolution. 'But there were great knapping difficulties, with an inopportune break often leading to a change from one colour to another' (Pradel 1950). It is clear that the Fontmaure Mousterians rated beauty over solidity in their raw material. However, for the manufacture of spear points, which needed to withstand shocks, they opted for the flint from Le Grand Pressigny (Indre),

Finding art in nature

a honey-coloured material that was more homogeneous and resistant, but equally splendid – and which later, in early protohistoric times, would be involved in long-distance trade (PL. VI, VII).

Some other rocks that were even rarer, more precious and difficult to obtain, with bright colours and exceptional mineralogical qualities – such as rock crystal, obsidian, chalcedony, agate, topaz and opal – also attracted toolmakers long before the Upper Palaeolithic.

Rock crystal

Rock crystal, also called hyaline quartz (not to be confused with milky vein quartz), is extremely hard. Clear as glass, it is found in the form of crystals of pure silica that cover geodes and fissures of the crystalline bedrock in the Massif Central, the Pyrenees and elsewhere, or as rolled pebbles in river alluvia. Although often deeply fissured and not much use for knapping, it was sought and used here and there, but almost continuously, for hundreds of millennia.

Throughout the Old World the sporadic use of rock crystal has been recorded during a great deal of the Acheulian, but, like fossils, the material was often brought to habitations and kept in its unmodified natural state. Rock crystal was mentioned in the form of fragments retaining facets in Gudenus cave (Austria), where they were accompanied by a tool made from the same material; and six unmodified crystals of hyaline quartz, 7 to 25 mm (0.28 to 1 in.) in length, have been found in the Lower Acheulian of Sangi Talav (India) (d'Errico et al. 1989) (FIG. 9). Fragments of quartz crystals have also been reported at the open-air Acheulian site of Gesher Benot Ya'aqov (Israel), where their presence could be due to human activity (Goren-Inbar et al. 1991). In China, there are about twenty fragments of crystal prisms and a prism with all its facets intact in the Lower Palaeolithic material from Zhoukoudian (Pei 1931).

However, although it is an exceptional case, the use of hyaline quartz for making a tool as elaborate as a biface appears in the Early Acheulian in the industries from Erg Tihodaïne (Morocco). A crystal cordiform handaxe in the Bardo Museum from this site, dating to 700,000 years ago, was mentioned by Tixier. The manufacture of a foliate biface in rock crystal by the Micoquians of Kůlna cave (Layer 7a) in Moravia (Valoch 1996) confirms that Lower and Middle Palaeolithic people did not merely bring these curious stones to their habitation sites, but sometimes transformed them into elaborate tools.

The frequency of rock crystal increases in Mousterian sites, and it was more regularly worked into tools. The industry of the Laborde

9. (Above) On the left, a Mousterian point made of slightly smoky rock crystal, from Chez Pourré-Chez Comte (Corrèze, France), and on the right, Lower Acheulian crystals (hyaline quartz) from Sangi Talav (India) (scales show 1 cm above and 0.5 in. below); (below) assemblage of Mousterian side-scrapers and a bola in rock crystal from Chez Pourré-Chez Comte.

shelter (Solignac, Haute-Loire) includes some very beautiful side-scrapers made from small rolled alluvial pebbles of hyaline quartz. In the abri Lartet (Montgaudier, Charente) half a dozen tools, especially points, were also made from crystal. The material is mentioned too in the site of Sergeac (Dordogne) (Bourdier 1967) and in the Charentian Mousterian of La Baume Bonne (Basses-Alpes) (Bottet & Bottet 1947: 162). But it was primarily in the Mousterian of Corrèze that rock crystal was used to manufacture particularly well-made tools, at La Chapelle-aux-Saints and especially Chez Pourré-Chez Comte, where about fifty pieces are known, most notably a very fine series of side-scrapers and a few points, sometimes even in smoky crystal, very beautiful in appearance (Lalande 1869) (FIG. 9).

Finding art in nature

Outside France, the material's presence is mentioned in the Mousterian of Scladina cave (Andenne, Belgium) where 'a rock crystal on the habitation's floor shows the Neanderthals' interest in objects of aesthetic or symbolic value' (Otte 1996: 273), and in the Micoquian of Kůlna cave (Czech Republic) which has yielded a beautiful point made from this material (Jelinek 1978).

It is clear, then, that *Homo erectus* sometimes collected prismatic crystals of hyaline quartz, worked them exceptionally well and transformed them into handaxes; then the Neanderthals used this material a little more often for the manufacture of a few tools. As with fossils and certain minerals it is probable that they attributed some magical or symbolic value to this material, which was more beautiful than workable. The taste for rock crystal was maintained in the Upper Palaeolithic, as well as in other periods and other parts of the world. Solutrean laurel leaf points in sparkling rock crystal are exceptionally beautiful and can be classed among the finest works of art of prehistory. They have been interpreted as 'ritual objects' (de Givenchy 1923).

With regard to the discovery of a piece made of rock crystal in the Magdalenian of the cave of Isturitz, R. de Saint-Périer (1930: 47) remarked: 'It is possible that this rock was sought by Palaeolithic people not only for its brilliance but also because they associated its possession with a magical power. It is known that the sorcerers of some present-day peoples, especially Australian tribes, use crystals of hyaline quartz to cast spells on their sick patients to cure them.'

Obsidian and rare stones
Another very beautiful rock that was used in the Lower and Middle Palaeolithic, and then in the Neolithic and Protohistory, when it was an object of long-distance Mediterranean trade, is obsidian. This dark-coloured volcanic glass, very homogeneous and very fine, linking a splendid appearance with perfect workability, was used in different periods in the volcanic parts of the world where it was accessible. The favourite material used from 1.4 million years ago onwards by the Acheulians and then the Middle Palaeolithic people of Melka-Kunturé (Ethiopia), for example, was obsidian. Louis Leakey even envisaged an exchange system in East Africa for the fine obsidian handaxes of Kariandusi (Kenya).

Jacques de Morgan (1927) stressed 'the exceptional quality of Armenia's obsidian; it occurs in layers 20 and 40 cm (8 and 16 in.) thick, it is compact, flakes easily, produces blades as sharp as glass, and has

an infinite variety of colours. Some blocks are transparent and barely smoky, others are jet black, while others still are transparent but filled with black inclusions. Finally there is a type that often comprises a black glass with red veins, or a totally red variety.' This author presents a series of Mousterian side-scrapers, points and discs from open-air sites on the slopes of the Alagheuz volcano. More recently the cave of Erevan, in the same region, has yielded a rich Typical Mousterian industry in seven layers, all of its pieces made of local obsidian (Ljubin 1988). In the Georgian cave of Kudaro I, Ljubin's excavations revealed an industry dating to between 700,000 and 500,000 years ago, which included one exceptional piece: a small limace (slug) of obsidian, the origin of which was around 100 km (60 miles) from the site, implying an unusual case of transportation (Bosinski 1996). On the other hand, in Europe and the rest of Asia, obsidian scarcely seems to have been used in the Lower and Middle Palaeolithic. There are no obsidian sources in France.

Among the precious and rare stones reported from a few sites, one can mention a magnificent topaz in the Mousterian of Sergeac (Dordogne) and an opal in the Lower Palaeolithic of Zhoukoudian (China), where jasper was also used (Jia Lan Po 1978). To this list of curiosities one could add the pumice stones from the Acheulian and Quina-type Mousterian of Combe Grenal (Dordogne), which may have appealed because of their astonishing lightness and their various other properties (Demars 1992).

Pigment use in the Lower and Middle Palaeolithic

In the Old World, humans and their direct predecessors have been using pigments in different ways for several million years; this usage then spread when the rest of the planet was colonized. The pigments used in prehistory were mostly red or black minerals, the use of red pigments preceding that of black. The red pigments were derived from a wide variety of substances containing iron oxides, for which prehistorians employ the generic name 'ochre', with colours ranging from yellow and brown to red (Couraud & Laming-Emperaire 1979; Audouin & Plisson 1982; Onoratini 1985; Masson 1986; San-Juan 1985, 1990a,b). The only plant colouring that could have been used and which also leaves traces in early sites is wood charcoal, which would later be utilized in the parietal art of the Upper Palaeolithic. Unfortunately, in archaeological contexts it is practically impossible to distinguish between the remains of a fireplace and charcoal that could have been used as a pigment.

Finding art in nature

Lower Palaeolithic pigment finds

The earliest known brightly coloured stone found at a prehistoric site comes from Makapansgat, South Africa (Dart 1974; Oakley 1981; see also Bahn 1999). It is a cobble of jasperite (a variety of jasper), discovered in a layer dating to 3 million years ago. It must have attracted attention not only through its colour but also for its strange shape, evoking one or more human faces (PL. XII). It seems to have been what prehistorians call a 'manuport', because only being transported by a hominin for a distance of several kilometres can explain its presence at the site; it may have been picked up and moved by an Australopithecine. So it is possible that an attraction to red minerals was deeply ingrained in the biological behaviour of humans, and was also to be found among various primates, perhaps even before the emergence of true humans.

In East Africa, in the cradle of humanity comprising the Ethiopian plateau and Tanzania's Olduvai Gorge, two discoveries are worth mentioning. First, at the Acheulian site of Gaded, dating to 1.5 million years ago, Clark and Kurashina (1979) reported the presence among the tools of eroded fragments of basalt which, when rubbed, produce a red pigment. They suggested that *Homo erectus*, even in such a remote period, may have experimented with pigment use. Secondly, two red nodules were discovered by Leakey (1958) at Olduvai Gorge in the evolved Oldowan of Bed II (DK II). More than 1 million years ago these pieces were brought to the site by *Homo erectus*. They show no trace of utilization. Analysis later showed that they are not red ochre, as Leakey had thought, but a naturally reddened volcanic tuff. These fragments were doubtless simply picked up as a curiosity, their colour having attracted the attention of the hominins.

In South Africa, pieces of haematite or red ochre appear to have been carried into sites such as Wonderwerk cave up to 800,000 or 900,000 years ago (Flood 1997: 138). Recent analyses of materials from that cave and other sites have revealed definite but irregular use of haematite pigments (specularite) from at least 500,000 years ago, such use becoming widespread and regular by 300,000 BP, with possible evidence for pigment transport over considerable distances (Watts et al. 2016). Much later, about 300,000 years ago, ochre is again found in various Acheulian contexts, not only in Africa but also in India, in particular at Hunsgi (Karnataka), where several remains of pigments were reported by Hasmukh Sankalia (1978). One haematite pebble bears striations and use-wear facets, although one cannot know the specific origin of these striations, nor on what kind of support or rock the nodule was rubbed – was it to obtain a little powder, or to draw a mark?

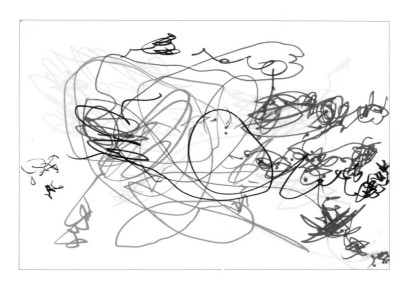

I. (Top) Marks produced by Congo the chimpanzee in the 1950s as part of an experimental study by Desmond Morris. While ape art bears a superficial resemblance to abstract art, there is no conciousness of a creation, and no intention to communicate.

II. (Bottom) Children's art: 'doodles' by a two-year-old child.

III. Acheulian handaxes from Nadaouiyeh (Syria), 500,000–400,000 BP.

IV. (Left) Acheulian handaxe from West Tofts (Norfolk, England).

V. (Above) Fossil sea-urchin shaped into a Châtelperronian side-scraper, from La Roche-au-Loup cave (Merry-sur-Yonne, France).

VI. Two Mousterian discs of multicoloured jasper.

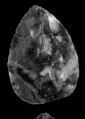

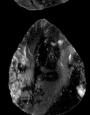

VII. (Far left)
Mousterian side-
scrapers in a variety
of materials and
colours from Le
Grand-Pressigny
(Indre et Loire,
France); (left)
Mousterian handaxes
in blond jasper.

VIII. (Above) Quartz bola from
the Acheulian of Isenya (Kenya);
(right) Acheulian bola from La
Baume Bonne cave (Alpes-de-
Haute-Provence, France).

IX. Pierced scallop with traces of paint from the Mousterian of Antón cave (southeast Spain), 50,000–37,000 BP.

x. Paint equipment from Blombos cave
(South Africa): two shell containers holding
an ochre-rich compound, 100,000 BP.

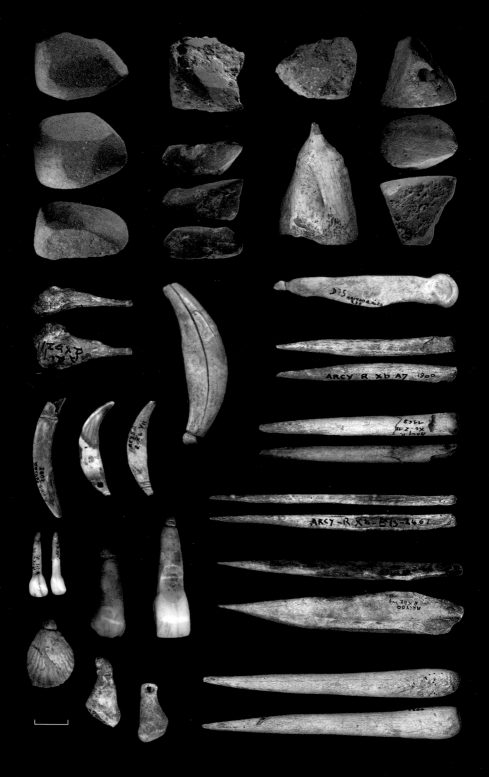

XI. Châtelperronian artifacts from Arcy-sur-Cure (Yonne, France) (scale = 1 cm or 0.4 in.).

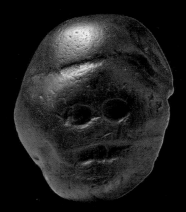

XII. (Left) The Makapansgat cobble, collected and moved by a hominin around 3 million years ago (c. 5 × 8 cm or 2 × 3 in.).

XIII. (Below) Engraved ochre from Blombos cave (South Africa), 100,000–75,000 BP (c. 8 cm or 3 in. wide).

XIV. (Bottom) Beads from Blombos cave, 75,000 BP (scale = 1 cm or 0.4 in.).

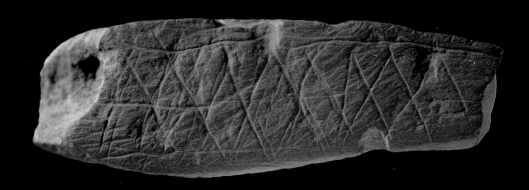

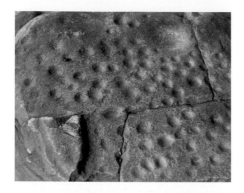

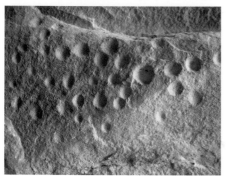

XVII. Ibex from Les
Fieux cave (Lot, France)
with pecked outline and
associated with isolated
and dispersed cupules.

XV. (Top) Cupules at the
Jawoyn site (North Arnhem Land,
Australia), *c.* 3–5 cm or 1–2 in.
in diameter.

XVI. (Bottom) Cupules on the
south wall of Daraki Chattan
cave (Madhya Pradesh, India),
the largest with a diameter
of *c.* 5 cm or 2 in.

XVIII. Partial remains of a black animal and a series of red patches beneath it, which could be large spat dots, from abri Blanchard (Dordogne, France). The lower image has been digitally enhanced using image editing software.

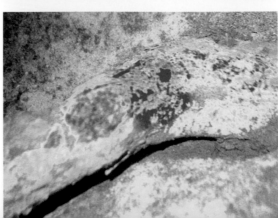

XIX. A patch of red ochre found in a tight crawlway at La Roche-Cotard (Indre-et-Loire, France), and likely to be of Neanderthal origin. The lower image has been enhanced using DStretch.

XX. Imitation and utilization of bear clawmarks by Gravettians in the Combel gallery at Pech-Merle (Lot, France): five red rubbed hands (a) are associated with bear clawmarks (b) and two engraved incisions (c); the scene dominates the entrance of a narrow crawlway (d).

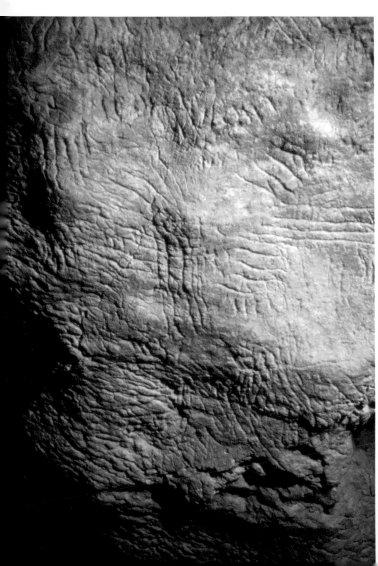

XXI. Cave-bear clawmarks at Fumel cave (Lot-et-Garonne, France).

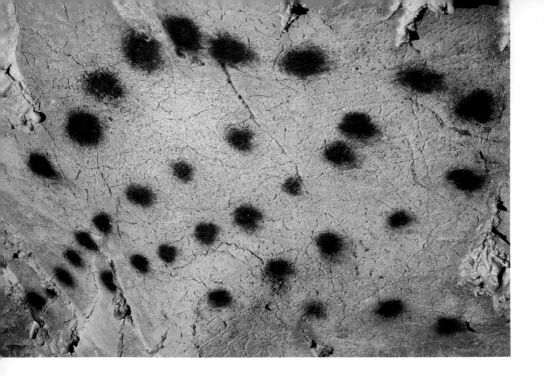

XXII. (Above) Sprayed dots on the ceiling of the Combel gallery at Pech-Merle (Lot, France).

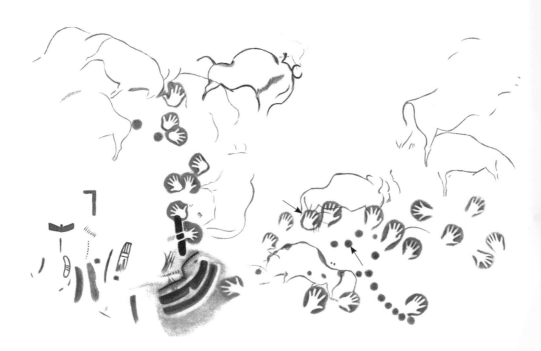

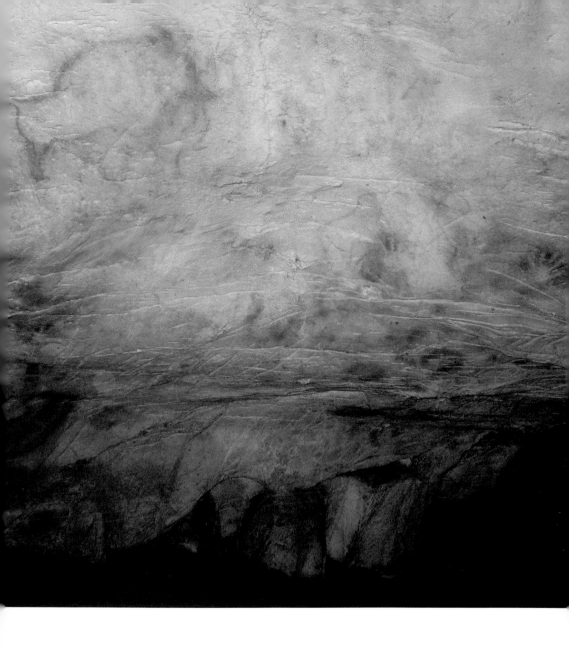

XXIII. (Above and left) The panel of the hands at El Castillo (Spain). The location of the new U-Th dates by Pike et al. (2012) is marked on the recording at left.

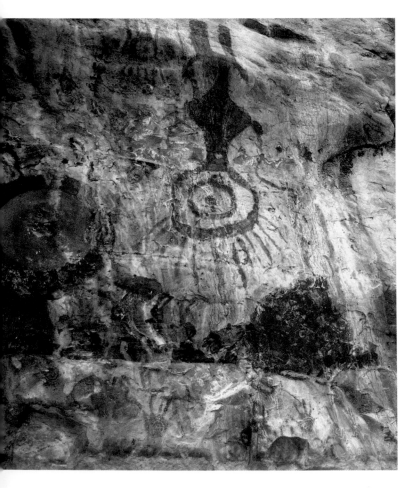

XXIV. (Above) Painting of a babirusa (pig-deer) and a hand stencil (top right) at Leang Timpuseng (Sulawesi), dating to at least 35,400 years ago.

XXV. (Left) Paintings at Caverna da Pedra Pintada (Brazil), possibly more than 10,000 years old.

XXVI. (Above)
A panel of small
red figures at Perna
(Brazil), dating to
more than 10,000
years ago.

XXVII. (Left)
Figures at Toca da
Bastiana (Brazil),
dated using various
techniques but with
inconclusive results.

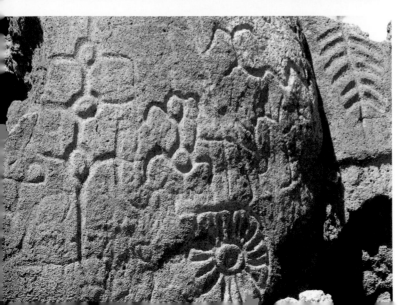

XXVIII.
Petroglyphs
at Winnemucca lake
basin (Nevada, US),
produced between
14,800 and 10,200
years ago.

XXIX. Recording of the spotted horse panel at Pech-Merle by M. Lorblanchet.

A Stone Age site at Nooitgedacht near Kimberley, South Africa, has yielded a ground ochre fragment with an estimated date of over 200,000 years ago, and pieces of pigment have been recovered from Zimbabwean shelter deposits of more than 125,000 years ago. The site of Pinnacle Point in South Africa has yielded fifty-seven pieces of pigment, some of them scraped, dating back to 164,000 years ago (Marean et al. 2007; Watts 2010). Over 300 pieces of pigment, weighing dozens of kilos, have also been recovered from the Zambian site of Twin Rivers, dating to between 400,000 and 200,000 years ago. They vary in colour (brown, red, yellow, purple, blue and pink), were obtained locally, and 3 per cent of them show signs of having been ground or rubbed to make powder – indicating the systematic collection and processing of pigment (Barham 1998, 2002).

In the same period in Europe, one can mention a plaquette of red ochre modified ('reworked') by humans at the site of Ambrona (Spain), doubtless in the early Riss around 300,000 years ago (Howell 1966; Bordes 1992). A collection of seventy-five pieces of ochre was discovered in the two layers of Terra Amata near Nice, dating to about 380,000 years ago (de Lumley 1966). Their colour ranges from yellow to red and brown. Most of them have traces of artificial abrasion, and were clearly introduced to the site by the occupants, since they do not occur naturally in the vicinity. It would seem that the raw material, yellow limonite, was brought to the site and burned in fireplaces and thus transformed into red ochre. A few fragments of ochre have also been found in the Acheulian levels (Nos 57 and 58) at the cave of Combe Grenal (Demars 1992: 186).

Middle Palaeolithic pigment finds
Yellow ochre was reported at La Micoque (Dordogne) in Layer 3 (ibid.: 189), a level of Riss age (around 200,000 years ago), according to François Bordes (1992), who attributed its industry to an archaic Mousterian. Likewise dating to the Riss glaciation (more than 150,000 BP), in the site and hut of Becov, in the Czech Republic, Jan Fridrich (1976) discovered a large quantity of red ochre powder scattered over the site, a quartzite grindstone that had been used to prepare this material, and a fragment of striated pigment (FIG. 10). The use and treatment of ochre are particularly clear here (Marshack 1981).

In the Danube valley, the open-air site of Tata in Hungary yielded a plaque of polished ivory (11 × 5.5 cm or 4.3 × 2.2 in.) taken from a mammoth molar; this curious object, which also bears traces of red pigment on one of its faces, evokes Australian *churingas* in the minds of some scholars. It dates

Finding art in nature

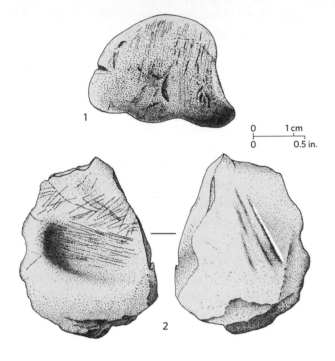

10. (1) Red ochre nodule from Becov (Czech Republic) showing use-wear striations; (2) small block of red ochre from Qafzeh cave (Israel), with a cupule on one side produced by multiple scraping striations.

to around 100,000 years ago, and analysis seems to show that the paint was already on the object at that time (Marshack 1988a).

As in Europe, the use of colouring materials continued in Africa in the Middle Stone Age: in levels dating back more than 125,000 years the use of ochre has been reported in Bambata and Pomongwe caves in Zimbabwe (Klein 1978), as well as in Swaziland, where Adrian Boshier and Peter Beaumont (1972) mentioned the existence of mines for the extraction of specularite, a material rich in haematite; the same authors indicate that this type of extraction continued in the region, with the ochre mine of Lion Cave dating to 43,200 BP. The hunters of Klasies River Mouth cave in South Africa, who seem to be the world's oldest modern humans despite having a Middle Palaeolithic culture, also used ochre – one engraved piece dates to between 100,000 and 85,000 years ago (d'Errico, García & Rifkin 2012).

The most important evidence to have emerged from southern Africa in recent years, however, comes from Blombos cave, which has yielded

more than 8,000 pieces of ochre, many with signs of use, and several with geometric engravings on them, dating to around 100,000–75,000 years ago (PL. XIII). The site has also produced a 100,000-year-old ochre processing workshop, consisting of two toolkits used for the production and storage, in shell containers, of an ochre-rich compound (Henshilwood et al. 2002, 2009, 2011) (PL. X). But Blombos is not unique in Africa: a piece of engraved ochre has also been found in a Middle Stone Age context in the rockshelter of Klein Kliphuis (Mackay & Welz 2008), although it is younger than the finds from Blombos, while some apparently deliberate geometric engravings feature on a few of the 9,286 pieces of ochre (weighing 15.4 kg or 34 lbs in total) from the Middle Stone Age site of Sibudu in South Africa (Hodgskiss 2014).

There is evidence too for the actual mining of haematite in southern Africa from around 52,000–47,000 BP onwards – indeed it is estimated that 100 tons were mined at the site of Ngwenya alone, dating to about 43,200 years ago (and there was likewise mining in Hungary from 32,000 BP – see Mészáros & Vértes 1955). Recently, analysis of residue on a stone flake from a 49,000-year-old layer at Sibudu has revealed a mixture of ochre and milk that was almost certainly a pigment (Villa et al. 2015). And in Namibia, the deep levels F and G of Apollo 11 cave, dated to more than 48,000 years ago by radiocarbon, contain a few fragments of pigment, including a pebble with traces of red paint and some bits of ochre with use-wear facets (Wendt 1976). At Olieboomport in the Transvaal, specularite and crayons of red ochre have been radiocarbon dated to more than 33,000 BP (Dart 1968).

Most recently, the Porc-Epic cave at Dire Dawa (Ethiopia) has been reported to have yielded 4,213 ochre fragments in layers dating to about 40,000 BP, together with ochre-processing tools such as grindstones, that were used to produce ochre powder of different coarseness and shades. All these materials were concentrated in one area of the site which thus seems to have been devoted to this activity, an indication of behavioural complexity at this time (Rosso et al. 2016).

In Europe, in a period corresponding to the last interglacial and the start of the last glaciation, between about 100,000 and 40,000 years ago, there was an unprecedented expansion in the use of pigments. In Mousterian contexts (or of Mousterian type – like the proto-Charentian of Becov or the Taubachian of Tata) finds of pigment fragments multiply greatly.

In central Poland, in Raj cave (Kielce), in a Quina-type Mousterian dating to between 70,000 and 60,000 BP, an abundance of ochre is associated with several sandstone or granite grindstones that have

polished surfaces and traces of colouring material. Janusz Kozlowski (1992: 35), who described this site, also recalled the debates caused by the dating of a limonite mine in Hungary, the Balantolovas mine, with extraction shafts that some authors had classed as Middle Palaeolithic without conclusive proof, and that could be much more recent.

In Ukraine, in the Dniester valley, the hut floor in Layer IV of Molodova 1 (dating to earlier than 44,000 BP) contained a Levalloiso-Mousterian industry, some powder and fragments of red ochre, and a mammoth shoulder-blade that was both engraved and painted red (Tchernych 1965; Paunescu 1989). It has not been fully established that the striations and patches of colour visible on the latter are intentional and constitute true 'decoration' – indeed a recent analysis has shown that the marks are natural and/or recent (Nowell & d'Errico 2007). Although this piece cannot be considered to represent the start of a cultural tradition on the Russian plain, one is reminded of later finds, especially the mammoth bones and shoulder-blades decorated with red paintings and engravings found in the Upper Palaeolithic mammoth-bone huts at Mezhirich and Mezin (Ukraine). It should also be mentioned that from the Pavlovian of Dolní Věstonice (Moravia), between 29,000 and 22,000 BP, comes a mammoth shoulder-blade with bunches of parallel striations, covering a burial (Klima 1954; Valoch 1996).

When Pierre-Yves Demars (1992) drew up an inventory of the Périgord sites excavated by Bordes that had yielded ochre, he showed that it was especially in a recent phase of the Mousterian, between 70,000 and 40,000 BP, in the Charentian facies, and in the Mousterian of Acheulian Tradition, that the use of ochre, and even more often of manganese, spread. Indeed, it seems that black minerals (iron and manganese oxides) first began to be used in the Mousterian. The Mousterians at Tabaterie in the Périgord seem to have been the first to use kaolin, a white colouring material (San-Juan 1990b). Colouring materials are in fact fairly systematically present in the recent Mousterian sites of Western Europe. Examples include L'Ermitage (Vienne), La Quina (Charente), La Chapelle-aux-Saints (Corrèze) and, in the Périgord, Caminade, Le Moustier, La Ferrassie, Combe Grenal, Pech de l'Azé II and IV, Gare de Couze, Combe Capelle, Blanchard II, Roc de Marsal, La Rochette (a striated ochre plaquette) and Vallon des Rebières. Slightly more recent Châtelperronian examples include Saint-Césaire (Charente-Maritime), the cave of Les Cottés (Vienne), which yielded a reindeer shinbone containing colouring material, and Arcy-sur-Cure (Yonne), which contained 18.5 kg (40.8 lbs) of ochre blocks, many of them with signs of wear and scraping. Some of

the latter were in a hearth, suggesting that Neanderthals were already heating them to change their colours (Baffier & Girard 1998: 27).

It was also in the Mousterian that the ritual association of ochre with burials appeared: at Le Moustier, a Neanderthal skeleton was powdered with red ochre; and two bits of ochre seem to have been deposited next to the head of the man of La Chapelle-aux-Saints. This practice then spread in the Upper Palaeolithic and became a feature of many later prehistoric cultures.

Le Moustier and Pech de l'Azé

We can underline the importance of pigments in the Mousterian by focusing on two famous sites: Le Moustier and Pech de l'Azé.

In 1921 Denis Peyrony, having mentioned the presence of pigments, especially blue-black manganese, in numerous Mousterian sites of the Périgord (FIG. 11), described a small limestone slab (23 × 18 cm or 9 × 7 in.) from the early Mousterian of the lower rockshelter of Le Moustier (Dordogne). On both of its faces this piece has brown patches and sinuous bands of manganese oxide forming a 'kind of drawing that is very hard to decipher'. Was it really an intentional 'drawing' or traces left by some kind of pigment preparation? He wondered: 'So the Mousterians were commonly using mineral pigments. Was it for make-up? Body-painting?

11. Mousterian black manganese nodules from Layer H of Le Moustier rockshelter (Dordogne, France), excavated by Denis Peyrony. (IN: incisions; SS: striated areas; NS: natural striations.

Finding art in nature

Drawing on rock walls? Decorating their portable objects? All these questions have orientated my work towards a search for rock paintings by Neanderthals. So far my investigations in Mousterian shelters have been fruitless, as atmospheric agents have destroyed the drawings if any existed.' In his later publication of the site (1930), Peyrony even ventured to claim that this piece was 'a very archaic Mousterian painting, that represents the first rudiments of art by our primitive ancestors.'

The object is in the collections of the National Museum of Prehistory in Les Eyzies. We have been able to study it at leisure, and have discovered that it is actually a plaque of very dense sandy Coniacian limestone (24.5 × 19 × 7 cm or 9.6 × 7.5 × 2.8 in.) with traces of a thick black pigment on both its faces (FIG. 12). The pigment only survives here and there, on rough and protuberant parts of the stone, which indicates that it is definitely a humanly made deposit and not a spontaneous colouring through natural impregnation, for example. There is no visible organization of the black traces, and it is certainly not a 'painting' in the sense used by Peyrony. Moreover, the surface of the coating, which is especially abundant on one face in a natural central depression, is polished and shiny, which seems to be linked to rubbing or polishing by a relatively hard object.

So the interpretation one can give this piece is that it was a palette, its sandy texture making it a suitable 'grater' upon which blocks of manganese oxide were rubbed. This method doubtless made it possible to use nodules of pigment that were too small for direct painting. It would seem that objects or tools which needed to be marked or painted were rubbed on the black patches, and this made the protruding parts polished and shiny. It is not impossible that, despite a weight of 2 kg (4.4 lbs), the block itself was rubbed onto large areas that were to be painted. In any case this block from Le Moustier shows the preparation of a black pigment that was then used as 'paint'.

In the Mousterian of Acheulian Tradition of the cave of Pech de l'Azé I (Dordogne), dating to between 60,000 and 50,000 years ago, Bordes reported 'more than a hundred small scraped blocks of manganese oxide, sharpened to a crayon form. The polish on some indicates that they were rubbed on a soft surface like skin. Were they used to decorate leather? Or, more probably, were they used for body-painting? If so, then Mousterians must have had light skin.' He also reported a bit of red ochre and even traces of yellow ochre (Bordes 1954–55).

In 1952 Bordes had already described the various forms of the blocks of manganese oxide from Pech de l'Azé: 'a very few rough blocks, numerous ovoid or rounded blocks, sometimes flattened, polished by soft

12. Limestone plaque (24.5 cm or 9.6 in. across) from Layer G of Le Moustier rockshelter (Dordogne, France), excavated by Denis Peyrony. The object has a central depression (dotted line) and a black coating – grey in places – of manganese dioxide pigment (stippled areas), and has retouched edges.

Finding art in nature

rubbing against a skin, and a few intentionally sharpened crayons'; he also noted 'a flat stone with traces of pigment which could have been used as a pestle'; and finally small fragments of bloodstone which seemed unused. Bordes then expressed an opinion similar to that of his predecessor Peyrony: 'It seems difficult to think that these pigments were used for anything other than body-painting or perhaps painting animal hides, either garments or tents. So we would thus be faced with the first known artistic manifestations.'

This interpretation marked an important evolution in prehistorians' opinions about the cognitive capacities of Neanderthals, an evolution that has not stopped progressing even today. We have now moved far from the pessimistic views of some early twentieth-century specialists – such as the serious doubts of Dr Henri Martin, who remarked: 'Will we one day find definite paintings made by Neanderthals? I dare not think so, knowing the frontal brain of those scarcely human beings, in which the attenuated high-minded areas cannot respond to artistic feelings' (Martin 1926).

Demars (1992) noted that most of the pigments from Pech de l'Azé come from the Mousterian of Acheulian Tradition. In Level 3 he counted 218 fragments of manganese and 23 of ochre. However, a more recent inventory has revealed more than 500 pieces of manganese dioxide (black/blue) and iron oxide (red), scores of which were rounded or polished into a 'crayon' shape, as if they had been used on some soft surface – perhaps human or animal skin (d'Errico & Soressi 2006; Soressi & d'Errico 2007; d'Errico 2003, 2007: 128; Dayet-Bouillot & d'Errico 2016).

Further examples

On the Iberian peninsula the use of pigments by Mousterians was much rarer than in southwest France. No pieces of colouring materials have yet been discovered in the Mousterian of Portugal, despite the late survival of that culture, but in southeast Spain Aviones cave and Antón rockshelter have yielded not only seashells used as necklaces but also 'paint cups' dating to 50,000–37,000 BP: Antón has a pierced scallop painted with orange pigment made of yellow goethite and red haematite collected 5 km (3 miles) away (PL. IX), while Aviones has two pierced cockleshells painted with red haematite (Zilhão et al. 2010).

In the Cantabrian region, a piece of used haematite and a plaque of limonite were reported in the Charentian Mousterian of Axlor (Basque country; de Barandiarán 1980); the lower levels of Cueva Morín also contained a series of fragments of red ochre (González Echegaray 1988). It has been reported that in Layer 20 of the huge site at the entrance of

the cave of El Castillo, excavated by Hugo Obermaier and then Victoria Cabrera Valdès, there were four nodules of red and yellow pigments, one of which has traces of scraping. The Mousterian layers of the La Viña shelter (Asturias) gave Javier Fortea (1994) a total of about forty ferric minerals which may have been used as pigments, while the Quina-type Mousterian of Level VI in the back cone of the cave of Llonín (Asturias) contained a nodule of red ochre with scraping striations, as well as a few other bits of local minerals which may or may not have been used by Neanderthals.

The Middle Palaeolithic sites of Germany do not appear to have yielded any pigments, but Pre-Aurignacian decorated ochre crayons are known from Piekary (Poland) (d'Errico & Vanhaeren 2008). At the Dutch site of Maastricht-Belvédère, concentrations of a haematite-rich liquid have been found in a layer dating to 250,000–200,000 years ago; the ochre must have been imported from dozens of kilometres away (Roebroeks et al. 2012). Moreover, fifty-one fragments of a black pigment, brought from 40 km (25 miles) away, have recently been identified in a late Middle Palaeolithic layer at Scladina cave, Belgium (Bonjean et al. 2015). In Italy, a Mousterian layer dating to around 48,000 years ago at Fumane cave has yielded an ochred fossil marine shell that was probably worn as a pendant (Peresani et al. 2013; Dayet-Bouillot & d'Errico 2016), while the Romanian cave of Cioarei contains a concentration of ochre in Mousterian layers, dating to 52,000–45,000 years ago, and also stalagmite tops which were used as ochre containers, and a spherical geode painted with ochre (d'Errico 2003; Cârciumaru & Tutuianu-Cârciumaru 2009; Cârciumaru et al. 2015).

The development of the use of pigments can also be tracked in the Mousterian of the Near East. The cave of Qatzeh (Israel) contained more than seventy fragments of red or yellow ochre, all from sources within 8 km (5 miles) and all unworked except for one nodule (Hovers et al. 2003). The latter, which was 'in layer XVII in immediate proximity to the skeleton discovered in 1965, is a block in the form of an irregular tetrahedron, 4 to 5 cm [1.6 to 2 in.] wide'; it has a cupule and traces of scraping (FIG. 10), suggesting the production of powder for painting. The presence of grooves on the block could have been caused by the rubbing of a pointed object used for tattooing. Moreover, Burial 8 in the same site, dating to 92,000 BP, contained two pieces of ochre; this deposit next to human bones probably corresponds to an offering (Vandermeersch 1969, 1981). In the shelter of Nahr Ibrahim (Lebanon) the remains of a fallow deer had been buried and powdered with red ochre (Solecki 1975).

89

Such an association of fallow deer bones and ochre is certainly symbolic; Alexander Marshack even considered that this discovery revealed a symbolic relationship with animals from the Mousterian onwards, which foreshadows the animal art of the Upper Palaeolithic.

Beyond the Old World, the use of pigments spread out from Asia into new lands as they were colonized by people. In Australia, pigments have been dated to the start of human occupation, 60,000 years ago; for example, the shelter of Nauwalabila I (Deaf Adder Gorge, Arnhem Land) has yielded several fragments of haematite, including a block weighing 1 kg (2.2 lbs) with polished facets and striations; they were used for painting, and have been dated by optically stimulated luminescence (OSL) to between 60,000 and 53,000 BP (Roberts et al. 1994).

Assessing the pigment inventory
The archaeological concept of the 'use of pigments' implies a connected series of actions: first the identification and choice in the field of a relatively rare material with exceptional properties; then its collection, its appropriation by humans; and finally its transportation to the dwelling. A fourth and fifth phase sometimes comprised the treatment of the collected substance, and then its utilization. We exclude here the pigments that occur in abundance and thus are not rare and do not need to be transported – for example local red sandstone in sandy regions, or the remains of a clay-floor reddened naturally by a fireplace which, in some cases, is not easy to distinguish from a goethite burnt *in situ* to produce haematite. The inventory of sites that have yielded pigments has no absolute value – it is merely indicative, but suffices to show the chronological and geographical distribution, and the variety of uses, of colouring materials.

Another imperfection of the inventory is the rarity of physico-chemical analyses of pigments discovered during excavations. Yet the mineralogical diversity of these materials would make such analyses extremely useful; they would sometimes make it possible to locate a point of origin, and thus to measure the transportation distance required – in other words, they would reveal the relative levels of interest and importance that prehistoric people attached to these astonishing stones.

Nevertheless, we can sum up our review of the main discoveries of pigments in the world's Lower and Middle Palaeolithic sites with the following remarks: pigments were used throughout the Old World by *Homo erectus* for hundreds of millennia, first by evolved Oldowans and then by Acheulians; the first pigments brought into habitations were

red ochre, and it seems that black oxides of iron and manganese were 'discovered' later by the Mousterians; a relatively 'sudden' and general rise in pigment use took place at the end of the Middle Palaeolithic between 70,000 and 40,000 BP, in South Africa, the Near East and Europe, and it was at this time that Australia was colonized – the first settlers of that continent already had technical mastery of red ochre and were doubtless doing some kind of painting; and lastly the ways of using colouring materials were highly varied and evolved through time.

During the first hundreds of millennia of the Lower Palaeolithic, there was only simple and occasional collecting of 'red stones' along with other natural curiosities, particularly minerals and fossils, perhaps occurring during searches for materials for toolmaking. It was the Acheulians who, in around 400,000 to 300,000 BP, began to use ochres brought back to their dwellings. Coloured stones were sometimes scraped to obtain powder, or rubbed on a hard surface like stone, or a supple one like animal or human skin – hence the presence of striations and use-wear facets on some fragments of ochre. It was also the Acheulians who seem to have been the first to heat certain ochres, transforming the material. The calcination of ochre was later attested in the Mousterian, from when, for example, 'a yellow-red ferruginous sandstone from the Mousterian of Acheulian Tradition at La Ferrassie shows traces of combustion and was associated with remains of ashes and bits of burnt bone', indicating that it had been in a fireplace (San-Juan 1990b). Pigment grinders – millstones and palettes (pebbles or blocks of limestone, sandstone or quartzite), doubtless linked to a more systematic and major production of powder – appeared around 150,000 BP in Eastern Europe.

The Mousterians then took a particular interest in colouring materials. They diversified their collecting, adding black products of manganese and iron, which they often turned into crayons (small sharpened nodules), and also diversified the uses of ochre since, for the first time, they sometimes associated it with rites and burials. This intensification and general diversification of the use of pigments, from the Ferrassie-type to the Quina-type Mousterian, and then to the Mousterian of Acheulian Tradition (Demars 1992), foreshadows the artistic explosion at the start of the European Upper Palaeolithic.

It is worth emphasizing the use of black by the Mousterians: the inventories drawn up by San-Juan (1985, 1990b) and Demars (1992) and the general results of our own research combine to show that this is a cultural phenomenon of a specific space and time. It was primarily the Quina-type Mousterians and the Mousterians of Acheulian Tradition

of the Périgord who specialized in the use of black pigments. The lists established for this region and these cultures show that 90 to 99 per cent of the pigments found in the sites of the second half of the Middle Palaeolithic of the Périgord are *black*, whereas, in the same region, this percentage switches over to red ochre in the Châtelperronian and Aurignacian (the appearance of parietal paintings seeming to accompany the end of the predominance of black). These highly cultural phenomena can be interpreted as evidence for a symbolic usage of pigments, contrary to the opinion of Chase and Dibble (1987), who reject any symbolic or ritual function for these materials in an exaggeratedly critical way. Outside this zone, and especially in the Mousterian of Eastern Europe, it is red ochre that dominates, whereas no evidence for pigment use has yet been found in the German Middle Palaeolithic. In the whole of the Iberian Mousterian, including its most recent phases, the use of colouring materials seems to have been quite modest (in Cantabria), or exceptional or totally absent (Portugal and southern Spain). Moreover, when pigments were used by people in Iberia, they were always red, as in the rest of Europe and the world. The Mousterian of the Périgord, through its intensive use of colouring materials, remains a chronological and geographical exception.

In the current state of our knowledge, no parietal or rock painting in the world has been dated to the Lower or Middle Palaeolithic, and the occasional red traces visible on a few objects from these periods do not suffice to establish the existence of true portable painting or a portable art implying painting of the kind the Upper Palaeolithic displays unquestionable examples of after 35,000 BP. A few tools and some pieces with traces of ochre have been reported from various sites – the ivory blade from Tata (Hungary), for example, or a red-stained pebble at Apollo 11 (Namibia) – but it is impossible to know if these objects were intentionally ochred and 'decorated' or if they were simply stained through accidental contact with ochre. Some Quina Mousterian side-scrapers, with their characteristic scaly retouch, seem to have been used simply as pigment-graters (Beyries & Inizan 1982); and some tools of the Levantine Mousterian, at Hayonim for example, are also coated with ochre (Bar-Yosef 1992).

The use of the pigments for painting is hypothetical: on the basis of ethnographic comparisons and the discovery of 'crayons' with more-or-less polished use-wear facets, a few authors have argued for – with no unquestionable proof – the existence in some Mousterian groups of body-painting or paintings on animal skins, of which nothing remains.

The polishes, shininess and fine striations on many nodules naturally lead one to envisage that they were rubbed against a soft material – skin or leather – as Bordes thought. These hypotheses seem especially valid in the area of greatest Mousterian demographic density, southwest France. It is certainly not impossible that the last Mousterians, with an increased population, wanted to assert that they belonged to a group – their cultural and personal identity – by developing this type of decoration. Perhaps they also manifested this same desire in the manufacture of the very first jewelry, the ritual burial of their dead, and especially through the diversification of the styles of their lithic industries. Both red ochre and black manganese oxide (or wood charcoal which left no material evidence) may have been used for painting, but the symbolism of black must have been very different from that of red.

Raymond Dart (1968) stressed the general symbolism of red ochre by pointing out that the word 'haematite', often used as a synonym for it, is derived from the Greek *haema,* designating blood – the English word 'bloodstone' is also equivalent to red ochre. According to Dart, red ochre is considered to be the blood of the Creator / Earth Mother, and is one of the brightest and commonest symbols of humankind; he also pointed to ochre's numerous medicinal uses and all the curative virtues attributed to it in traditional societies.

The importance of red ochre in human evolution has been highlighted by Ernst Wreschner. He claimed that it is not surprising that red was the first pigment used because, amid all the others, this colour seems to have been the subject of a quasi-general human 'preference' that doubtless has a genetic basis. Moreover he emphasized red's universal symbolic charge, frequently associated with danger and death, blood and life, and often, in the past, with procreation, mothers and the Earth Mother. The transformation of yellow ochre to red ochre when heated has probably always been considered a magical operation that further strengthened this material's power. Pigments are not banal substances. So it is likely that the intensification and diversification of the use of ochres and other pigments during the hundreds of millennia of the human past illustrate the cognitive and symbolic development of people: 'The perception of red, the ability to discriminate colors, led to actions that resulted in new experiences and learning. Part of the cognitive process is the endowment of objects – in this case ochre – with meaning. The creation of relationships resulted in social and cultural structures. One such relationship might be body-painting, which could, as a signal device, have contributed to group coherence' (Wreschner 1980: 633).

Finding art in nature

It is also possible to envisage – in the Middle Palaeolithic as in certain present-day hunter-gatherer societies – a polysemic use of colouring materials: 'In the matrilineal cultures of Central Africa, for instance, the colour red may signify father, woman, man, mediator, certain categories of relatives (i.e. in-laws), rainbow, morning, birth, emotions, sexual desire, mystic power, transitory stages in rites of passage, and so on, according to the situation and context in which it is used' (Jacobson-Widding 1979).

Such use of pigments, as well as their intermittent presence in burials (i.e. in a ritual context) should not make us forget that these substances, which were doubtless powerful socio-cultural symbols, may have had other functions in everyday life where their religious or magical nature was less obvious, though cannot be entirely ruled out. Experiments have shown, for example, that manganese could have been useful in lighting fires (Dayet-Bouillon & d'Errico 2016: 117). The Aboriginals of Tasmania also use ochre mixed with seal fat as a protection against the cold (Flood 1983). And Christina San-Juan showed – at least for the Upper Palaeolithic – the abrasive properties of red ochre in the making of perforations, the manufacture and polishing of tools in bone or reindeer antler, as well as its role in portable engraving. The tool's coating of pigment made the engraver's work easier.

In addition, several authors have pointed out the use of red ochre in hide-tanning: 'some functional analyses show that prehistoric scrapers and spatulas may well have been used to work dry ochred skin. Ethnography confirms the technical use of ochre for preserving organic materials and protecting them from vermin. Five weeks of experimentation have shown that ochre contributes very effectively to the treatment of animal skin and confirms the qualities attributed to it' (Audouin & Plisson 1982). The spreading of ochre over living floors and the impregnation with ochre of some archaeological layers may also lead one to think of hide treatment or a sanitizing of the floor, perhaps even a symbolic protection of the dwelling, because in a prehistoric and ethnographic milieu it is impossible to exclude theoretically the symbolic dimension of the simplest everyday acts. When addressing such behaviour, or any other questions relating to the use of pigment, one needs to avoid a point of view that is too simple or too partial.

Chapter 3

Can we see art in the first tools? Polyhedrons, spheroids and handaxes

Marks on two animal bones from Dikika, Ethiopia, are thought to have been made by stone tools, some 3.4 million years ago. The manufacture of the first recovered and recognized stone tools around 2.7 million years ago in East Africa (in the Awash valley, Ethiopia) by *Homo habilis* or Australopithecines implies an intellectual project from the outset. These flakes and worked pebbles constitute the basic elements of the 'Pebble Culture' or Oldowan. The necessities of working the stone limited opportunism: they had to choose pebbles of suitable size and shape, in a rock that could be worked. This implies the projection of a mental image of the desired object onto the raw material. Actions and the shapes produced were then repeated identically for more than 2 million years.

Simple flakes were joined by choppers – pebbles with a more or less sinuous cutting edge obtained by removals on one side – and chopping tools (or bifacial choppers) with a cutting edge obtained by removals on both sides. In this already standardized industry, more developed forms were to appear alongside the common types: pebbles or stone nodules worked on their entire surface known as polyhedrons and then, a little later, handaxes.

Polyhedrons and bolas

Polyhedral stone balls, tending towards a spheroid shape, are found throughout the Lower and Middle Palaeolithic, from the Oldowan to the Acheulian and Mousterian; prehistorians call them 'polyhedrons', 'sub-spheroids', 'spheroids' and 'bolas' (PSSB). Polyhedrons are crude spheres with big flakes removed from the whole surface of the block, pebble or nodule, which originally had a rounded shape. They are often around the size of an orange, and weigh from several hundred grams up to a kilogram or more. Bolas, on the other hand, are almost perfect spheres whose surface is entirely pecked and regularized by hammering. The bola is virtually contained in the polyhedron, which is an approximate sphere, or on its way to becoming one. So the PSSB constitute what prehistorians call a 'production sequence'; this is why sites yield polyhedrons or spheroids or bolas, or several of these types together. However, it seems that polyhedrons follow the migrations of *Homo erectus*: they are alone at the oldest sites (Aïn Hanech in Algeria, for example) (FIGS 13, 14), but were then accompanied by bolas, which became more numerous in the course of the Acheulian, while the proportion of polyhedrons declined; finally the bolas became almost exclusive in the late Mousterian.

Polyhedrons have been discovered in many Lower Palaeolithic sites in East Africa (Olduvai Gorge Beds I and II, Gadeb, Melka Kunture, Chesowanja, and in the Acheulian of Isimila, Isenya – PL. VIII – and Olorgesailie); in North Africa (Aïn Hanech, Gafsa); in South Africa (Sterkfontein, Cave of Hearths); in the Near East (Ubeidiya, Latamne,

0 3 cm
0 1 in.

13. (1) An Acheulian bola from Vailly-sur-Aisne;
(2) a polyhedron from Aïn Hanech (Algeria),
dating to around 2 million years ago.

 Chapter 3

14. Polyhedrons from Aïn Hanech (Algeria),
excavated by Camille Arambourg in the 1940s.

Joub Janine, Qesem cave, Revadin, Bezez cave, Hummal, etc. – Bar-Yosef
1995, Barkai & Gopher 2016, Le Tensorer et al. 2011); in India (Singui-
Talav – Gaillard 1993); in Indonesia (Java); in Eastern Europe (Béroun,
Mladec – Valoch 1996); and throughout Western Europe (particularly in
France in the loess of Achenheim, on the terraces of the Parisian region,
at La Baume Bonne in the Basses Alpes – PL. VIII – where they are
contemporary with the Riss glaciation, etc.).

As mentioned above, during their long history these faceted balls
were gradually perfected and transformed increasingly frequently into
bolas. The latter appear alongside polyhedrons in the Lower Acheulian of
Olduvai, more or less at the same time as the first handaxes; they can be
considered as an improvement introduced by *Homo erectus*. They abound
throughout the African Acheulian (Melka Kunture, Isenya, the alluvia of
the Mékrou in the Niger basin, at Sidi Abderrahman, etc.), and then in its
prolongation into the Middle Palaeolithic (El Guettar in Tunisia), in the
Acheulian and Mousterian of the Near East, in Asia (Zhoukoudian and
Dingcun in China, for example), and in Indonesia on Java (Ngandong,
Sangiran, Sambungmachan). They are also found in the European
Acheulian, most notably in the Somme gravels where they were reported

Can we see art in the first tools?

by Boucher de Perthes, on the terraces of the Aisne valley, and then in great numbers throughout the western Mousterian (Grotte de l'Hyène and Grotte au Loup in the Yonne, Grotte de l'Observatoire in Monaco, Grotte des Cottés in the Vienne), in a series of famous Charente sites such as La Quina (which yielded more than a hundred), Le Placard, Jonzac, Petit-Puymoyen, Grotte à Melon, Grotte de Gavechou, Grotte des Fadets; and in Corrèze sites such as Chez Pourré-Chez Comte, the industry of which includes a rock crystal marble that is like a small 'bola' (PL. VIII). The Périgord has also yielded some bolas at Combe Grenal, and they occurred at Pair non Pair; and lastly Émile Cartailhac reported them in the Iberian Peninsula (Barkai & Gopher 2016; Bar-Yosef & Goren-Inbar 1993; Bordes 1961; Brézillon 1968; Camps & Chauchan 2009; Chavaillon et al. 1979; Gaillard 1993; Leakey 1971; Le Tensorer et al. 2011; Norton et al. 2009; Texier & Roche 1995; Sahnouni et al. 1997; Sémah 2001; Simanjuntak et al. 2010).

The functions and uses of polyhedral balls
The existence of these stone balls at the dawn of humanity is in itself a phenomenon of great importance, although they are enigmatic objects, as shown by the fluctuating terminology that has been applied to them. They were first reported by Boucher de Perthes, the father of prehistory, in the first half of the nineteenth century (1847); he considered the stone balls from the Somme's Quaternary gravels to be 'symbols' because 'some of them required too much work to be simple missiles'.

In 1904 Paul Raymond wrote 'I don't know what these polyhedrons are!' It seems that prehistorians have always found this a hard nut to crack: sometimes they saw them as nuclei that had provided flakes, and sometimes as hammerstones, or even as a kind of pestle for preparing edible plants, but also as 'missiles' or 'slingshot'. The Acheulian of Sidi Abderrahman (Morocco) yielded bolas that are 30 cm (12 in.) in diameter and weigh more than 10 kg (22 lbs) (Tixier, pers. comm.), which simply cannot be 'missiles'. Nevertheless, the simplistic, functional interpretation of 'thrown projectiles' continues to be presented (e.g. Wilson et al. 2016); one wonders why hominins would spend weeks, if not months, on shaping these objects, merely to throw them away, when a naturally shaped stone would have served just as well!

The term 'bolas' – the name of the stone missiles used by the gauchos of the Argentine pampas – is attributed to those prehistoric pieces with the most perfect spherical shape and a regular and smooth surface; they are the same size as a mandarin or small orange. The true Argentine

bolas are sophisticated weapons that comprise multiple extremely tough, plaited thongs, which, at both ends, pass through a small perforated stone ball, wrapped in an animal-hide bag. The forces and shocks they undergo during hunting demand enormous toughness, as well as the use of stone balls that are not too heavy (around 50 g or 2 oz) and have a central perforation so they can be solidly fixed to the end of the thongs (FIG. 15). These characteristics do not really correspond to those of the objects which prehistorians have called 'bolas'. Some more cautious authors prefer a descriptive terminology that involves the manufacturing technique: 'faceted spheroids' or 'pebbles with multidirectional working'.

Several researchers have carried out experiments that have enabled them to trace the phases of development of polyhedral balls, and to reproduce them exactly. For example, based on the industries unearthed in excavations at the site of Isenya in Kenya, the experiments of Pierre-Jean Texier and Hélène Roche (1995) led them to the following conclusion: 'Polyhedrons, subspheroids, spheroids and bolas are the result of the same concept, the quest for a volume that is more or less regularly distributed around a virtual point (centre of balance) whose image is specified by the choice of support and by the project envisaged. Hence one passes from a vague mental image (polyhedron) to a clear mental image (bola), from a non-stabilized model to a stabilized one, from a centre of balance to a true centre of symmetry. The object is obtained by the controlled reduction of the support. The sequence of manufacture can be considered as a linear sequence leading from a block of raw material to a perfect sphere....

15. Present-day bolas used by the gauchos of the Argentine pampa (c. 6 cm or 2.4 in. diameter); these are pierced and of fairly uniform small size, unlike the prehistoric bolas.

Can we see art in the first tools?

The technique used is direct percussion of the stone which leads to hammering at the end of the sequence (spheroids and bolas).'

Two years later, Mohamed Sahnouni, Kathy Schick and Nicholas Toth (1997), basing themselves on the study of the material from Aïn Hanech (Algeria), carried out an identical experiment, but it led them to a different conclusion: that these shapes could 'simply be exhausted cores from flake production'. Like Texier and Roche they noted that: 'these experiments also highlight that there is a continuum from simple limestone core forms (choppers, polyhedrons) to these heavily reduced cores (spheroids) in the process of core reduction.'

But can these objects really be a simple 'by-product' of flake manufacture? The production of a polyhedron or bola by hammering yields flakes of gradually decreasing size, resulting in tiny, unusable flakes. Moreover, Camille Arambourg (1950) noted the isolated location of polyhedrons in the upper layer at Aïn Hanech: 'it is remarkable that nothing is associated with these objects – no flakes, no irregularly broken or angular lithic debris.' Their spatial distribution in the site seems to distinguish them from other tools (Arambourg 1950). In other sites, such as Qesem cave (Israel), the polyhedrons and bolas are made of limestone, whereas the tool industry is of flint (Barkai & Gopher 2016). So the production of flakes was doubtless neither the only nor the main function of these objects.

When they are discovered in excavations, polyhedrons and bolas are sometimes grouped, and sometimes broken into two halves (for example at Qesem, or at La Quina and Jonzac in France), which makes their function even more of an enigma, especially for those prehistorians who class them as simple tools with a material function. The breakage of some of these bolas is caused by violent shocks – were these intentional or accidental breaks that occurred during their manufacture, which demanded a great deal of percussive work? Limestone can easily break spontaneously.

Can we see art in polyhedrons and bolas?
Polyhedrons and bolas present the following essential characteristics. First, they are stone objects (limestone, or hard rocks such as quartz, quartzite, flint, etc.), and they are found throughout Africa and across large parts of Eurasia. Secondly, they appear in the very first industries, alongside flakes and the first tools – that is, several hundred millennia before handaxes – and they are present throughout the Lower and Middle Palaeolithic. Thirdly, no other tool requires as much time and effort in

its production as a spheroid or a bola. The manufacture of a bola needed far more work than that of a handaxe, even a particularly fine one; the latter could generally be obtained in an hour or two, and sometimes less. Experiments have shown that, depending on the material support, making a bola might take four hours for a piece in limestone (Sahnouni et al. 1997), but up to several days or even weeks for very hard rocks such as quartz, flint or rock crystal. In order to obtain these spherical shapes, a specific aim, defined beforehand, was tenaciously pursued for a long time, with the successive use of different techniques – knapping, flaking, hammering. Hence the notion of time, of maturation, of reflection, substituted that of immediacy, which characterized the manufacture of many tools meant to meet a more direct need. Lastly, the function of polyhedrons and bolas remains an enigma: no trace of use-wear has been detected on these pieces.

These objects highlight the delicate and general issue of the interpretation of prehistoric data, and the crucial problem of the image that all researchers of prehistory project more or less unconsciously onto the objects they study. In this case we have a choice between two approaches, two opposing points of view:

- On the one hand, according to the materialist point of view, polyhedrons and bolas are 'by-products' of the first and oldest working of stone. They are supposedly artifacts produced automatically, unintentionally; they only had an external utility, and had no use in themselves. Yet when one sees such magnificent stone spheres that are the result of long, hard labour (FIG. 13, PL. VIII), it seems difficult to accept such a reductionist and negative view.

- On the other hand, a more spiritualist point of view invites us to think that these objects mark the first quest for symmetry by prehistoric people, and the first geometrization of the shapes they produced, trends that would be developed in all later lithic industries, as we shall see. We feel that this approach is more correct.

One can imagine early humans fracturing pebbles to extract sharp flakes, but then gradually becoming conscious of their creative power and, changing their objective, passing from the spontaneous production of flakes to the long thought-out creation of a beautiful object that

Can we see art in the first tools?

materialized the concept of the sphere – in mastering the material, and imposing an ideal form onto the stone, the craftsman found achievement in the pleasure of creating a symbolic and aesthetic form. Such work and its result became 'timeless'.

We can even put forward the hypothesis that these could be disinterested, perhaps even 'useless', forms, existing beyond immediate material needs. This was before 'the marriage of the beautiful and the useful', to use a phrase coined by Régis Debray in 1992 (p. 169), before the rise of the functional beauty of tools that, in prehistory, was marked by the arrival of the handaxe. The quest for beauty in the manufacture of polyhedrons and bolas was expressed not only in their shape but also in the technical achievement of working with stones that were increasingly hard to shape and increasingly beautiful, such as the white quartz of the Acheulian bola from Isenya (Kenya) and the rock crystal example from the Mousterian of Chez Pourré-Chez Comte (Corrèze) (PL. VIII).

These objects bring into play the domain of individual pleasure, or play, but also of a collective symbol related to the sacred that was transmitted to the whole of society and which, in fact, was transmitted for hundreds of millennia through every continent, passing from the Lower to the Middle Palaeolithic, from one human form to another, from *Homo habilis* to *erectus*, and then to the Neanderthals. Thus polyhedrons and bolas, as links between people and between periods, had a universal value.

Even in the extreme poverty of their beginnings, people were not limited by the demands of survival. From the start they were not trapped in the world of subsistence, but were declaring their existence. They immediately extended their first elementary tools (flakes) into a higher project: the shaping of a volume in stone foreshadowing all later sculptures. In expressing the power of the mind over matter, polyhedrons and bolas seem to mark the emergence of the spiritual dimension of humankind; indeed they can be considered 'aesthetic productions', 'objets d'art' or 'works of art'.

Handaxes

These tools, also known as bifaces, are almond-shaped, worked on both faces, and have a tapering point and a generally rounded base that is sometimes not worked and reserved for gripping. With a cutting edge all around, they can be made from a nodule, a block, a pebble or a big flake, and their size ranges between 5 and 30 cm (2 and 12 in.) long, and their

weight between a few dozen and a few hundred grams, sometimes even exceeding a kilogram. The first handaxes were derived from worked pebbles: removals from all round the pebbles produced discoid choppers, and supplementary removals then gradually transformed them into handaxes (Isaac 1977). One can also envisage the origin of polyhedrons in the same process.

Handaxes appear in the early Acheulian of East Africa, at the site of Olduvai (Bed II), around 1.4 million years ago. However, some very crude forms, known as 'protobifaces', have been reported in Oldowan industries at an earlier date; from around 1.7 million years ago, it appears that contemporaneous populations of *Homo erectus* were producing handaxe industries and flake/chopper industries in different times and places. Hence handaxes joined the flake and pebble industries but did not make them disappear. The proportion of handaxes varies enormously from one site to another: at Isenya (Kenya) they were so numerous, according to Tixier, that more than thirty per square metre were discovered in some places during the excavation; other assemblages, on the other hand, have none at all.

Nevertheless, the handaxe is the 'type fossil of the Acheulian' (Chavaillon 1992). *Homo erectus* took this spectacular invention, along with the flake and worked-pebble industries, on their colonial journey through Eurasia. The first handaxes thus appear in the Near East before 1 million years ago (Ubeidiya), and in Western Europe around 700,000 years ago. The handaxe tradition developed greatly in India, but remained rare in East Asia (a few examples are now known from China). In a reduced form, it persisted till the end of the Middle Palaeolithic – particularly, in Europe, in the Mousterian of Acheulian Tradition and the eastern Micoquian. The biface tradition, strictly speaking, then ended, but various foliate points perpetuated the technique of bifacial working, which reappeared several times during the Upper Palaeolithic and in later prehistory (Otte 1995). In its typical form, the biface is – along with the chopper and polyhedron-bola – the tool that has the broadest and longest use in human history.

The precise functions of these tools – the model for which was passed on through millennia and continents – remain uncertain. Use-wear analysis provides little information: ancestors of the modern Swiss Army knife, handaxes were doubtless multi-purpose tools, used for cutting, scraping, piercing and bashing. They were generally handheld, but a few rare specimens seem to have been hafted. This hafting may simply have improved the hand's grip, or it may have facilitated the fixing of a lighter piece to a shaft (Tixier & de Saint-Blanquat 1992).

Can we see art in the first tools?

The longevity of handaxes, their universality, the care taken in making them and sometimes transforming them into real works of art, as well as the quantity and often the quality of raw material that their manufacture demanded, may appear surprising if one takes into account the ease with which more specialized and more impressive tools such as flakes, scrapers and points could be obtained – tools whose production was equally abundant in some periods. As many scholars have already pointed out, the handaxe therefore did not merely meet material needs: some socio-religious requirements must have played an essential role in its longevity.

The first specimens are crude pieces with a more or less sinuous cutting edge, made with a hard hammer (a quartz pebble, for example); then, from the Middle Acheulian onwards, the pieces become finer, their outlines become more elegant, the retouch lighter and the edges straighter. The use of a soft hammer of organic material (antler or bone) from at least 500,000 BP lies behind this progress.

An astonishing variety of materials was used to make bifaces: all kinds of siliceous, volcanic and even calcareous stones, with very different grains and colours, were employed. Some were even made in compact elephant bone by the Acheulians of Italy, at Malagrotta, Castel di Guido and Ranuccio (Radmilli 1984), and by the Early to Middle Palaeolithic people of Germany, at Rhede and perhaps Bilzingsleben (Mania 1990); the use of this material, which is not very suitable for working, being relatively soft and offering far less resistance than stone, suggests that the solidity and efficacy of the tool were not the goal being sought. Perhaps these handaxes were votive or symbolic implements whose value was linked to that of the animal providing the raw material, or to the prowess of the craftsperson working an exceptional material.

Many specialists have drawn up classifications of bifaces, but one of the most used is that of Bordes (1961); it is very detailed, since it comprises more than twenty different types derived from four essential forms (oval, discoid, cordiform, triangular). The Acheulians and Mousterians did not adopt all these models indiscriminately. The forms they preferred were the cordiforms and ovals with all their variations, in different proportions from site to site, whereas the triangles and discs are rarer. (It should be noted that the circular form is also found in other tools: some nuclei (flint cores) are discoid, and there is a limestone disc with a diameter of 22 cm (8.5 in.) in the Mousterian of La Quina (Henri-Martin 1957) (FIG. 16), as well as other discs in the Acheulian of India at Bhimbetka and Maihar). The passage from one form to another was often gradual; there were numerous modulations and intermediate shapes.

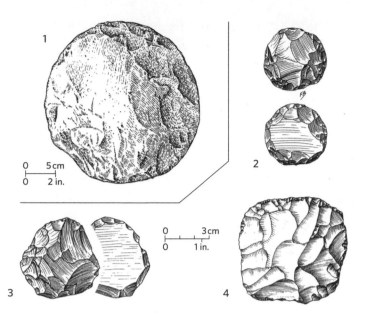

16. The circle and the square in the French Mousterian: (1) a large limestone disc from La Quina (Charente); (2) a flint disc from Pech de l'Azé (Dordogne); (3) a flint disc from the abri Chadourne (Dordogne); (4) a square flint handaxe, a rare type, from Fontmaure (Vienne).

This is why Bordes based his typology on precise measurements and quantified reports that fixed objective limits between the types.

The extensive range of biface forms shows the pleasure that prehistoric people took in playing with shapes; it also reveals their technical prowess. There are variations not only of outline but also of thickness – some massive pieces, with a sometimes triangular (trihedral) cross-section, were made with a hard hammer, whereas thanks to the soft hammer elongated almonds became 'long ovates' and slender cordiforms became 'amygdaloids'; others with concave edges turned into 'Micoquian lanceolates', while others stretched into 'ficrons', and so on. In the manufacture of handaxes, *Homo erectus* was referring to ideal geometric forms comprising curves, derived from the circle and oval, or straight lines like the triangle, but not including quadrilaterals: there are no rectangular handaxes. However, a biface from Fontmaure (Vienne) shows that the Mousterians were not completely ignorant of the square (FIG. 16). The perfect symmetry that characterizes most handaxes reflects, according to Thomas Wynn (1985), an ontogenetic process that is inherent to the nature of the human mind. This astonishingly modern characteristic probably shows that modern humans have been gestating for a very long time.

Can we see art in the first tools?

According to R. R. Schmidt (1936), the handaxe was based on the model of the human hand: 'With the onset of symbolic thought, a bifacial hand axe was perhaps subconsciously visualized as representing a third hand, a hand that unlike the flesh-and-blood original had the capability to cut and skin the carcasses of the animals scavenged or hunted' (Oakley 1981: 208). Such symbolism is plausible. Apart from the approximate morphological resemblance to the hand, there is also a functional similarity: the tool's functions extend the hand and make it more effective. But as the same is true of any tool, this can only be a very general symbolism. And in actual fact the resemblance to the hand is imperfect, since the hand is asymmetrical while the handaxe is symmetrical.

So instead we think that, in creating handaxes, *Homo erectus* sought above all to incarnate mental plans in hard materials; even before making a tool, they simply created a shape. Shape preceded function. According to Jean-Marie Le Tensorer (1998), 'man shapes material to give it a satisfying shape. From the start, this shape tended to be very symmetrical. The craftsman became an artist; symmetry is never necessary for a tool's function, it is an aesthetic complement.'

It is clear that the first shape that was sought and obtained in the making of polyhedrons was the sphere; it was probably from the manufacture of a sphere that the handaxe's creators produced the circle, oval and triangle; by gradually decreasing the thickness of the pieces, they moved away from the three-dimensional space of the polyhedron towards the two dimensions of a flat shape imposing itself through an outline.

Roche & Texier (1991) and Texier (1996) showed clearly that the handaxe is constructed on the principle of a double symmetry: 'a morphology is sought through the simultaneous development of two convexities so that the one is the image of the other, forming *a plane of bifacial equilibrium*.' The two planes of symmetry are perpendicular. The thinning of the piece, especially using a soft hammer, gives priority to the plane of bilateral equilibrium, i.e. the outline. This priority of the outline highlights a major evolution: man made a silhouette that he mastered perfectly; with his antler hammer he already *drew* an abstract shape – round or angular, an oval, an almond, a heart or a triangle (FIG. 17). A sculpture tending towards a drawing, the handaxe bears witness to *Homo erectus*'s capacity for abstraction; it also shows that abstraction lies at the origin of art.

The dialectic of volume and plane adopted by *Homo erectus* in the manufacture of their tools can be found throughout the Palaeolithic until the figurative art of the Upper Palaeolithic, with its statuettes,

17. A stunning triangular Mousterian of Acheulian Tradition handaxe (21 cm or 8.3 in. high) from the site of Salle-sur-Lède (Lot-et-Garonne, France).

its decoration of cylindrical weapons and tools, and its animal profiles on cave walls that fully integrate the shapes of the rock. Yet two-dimensional art and the more tyrannical reign of the plane are seen from the start of Palaeolithic figurative art in the fine engravings on flat surfaces of bones (shoulder-blades), in Magdalenian bone cutouts, and in the modelled parietal paintings and engravings suggesting volume in *trompe l'oeil*, that is, giving the plane a depth it lacked by means of a graphic trick.

An exceptional Acheulian site in the Syrian desert, Nadaouiyeh Aïn Askar, excavated by Le Tensorer and his team (1997, 1998), has yielded more than 10,000 handaxes – the only tools from the site (PL. III). They evolved through five successive Acheulian stages in twenty-five archaeological levels. The oldest, dating to 500,000–400,000 BP, combine formal perfection with splendid material; Le Tensorer (1998) rightly considers them 'the early beginnings of art' and declared, with perhaps too much restraint, 'there is unquestionably a concern for aestheticism in these pieces. The functional component is probably combined with a spiritual component insofar as the craftsman shapes the material to give it an ideal form that he judges necessary, whereas it is not functionally an advantage.' Whatever their functions and their age, the early handaxes of Nadaouiyeh are gems of astonishing modernity; they are eternal works of art.

Can we see art in the first tools?

It was *Homo erectus* exhibiting this aesthetic refinement, even though the physical appearance of this species – going by a skull fragment discovered in the excavation – could be called 'archaic' (so there is little correlation between skull shape and handaxe shape!). Codified and standardized, handaxe production obeyed strict rules; the results were the expression of a culture and human group that sought difficulty and purity of form by exclusively specializing in the manufacture of bifacial tools. But at Nadaouiyeh the concern for beauty was relatively 'ephemeral' and only expressed itself from 500,000 to 400,000 BP – that is, for only 100,000 years! After 400,000 years ago, handaxe-making was much less careful, sinking into routine; the pieces are thicker and less standardized. According to Le Tensorer this is 'an impoverishment of the tool's symbolic function to the benefit of functional efficacy'. So did the Acheulians of Nadaouiyeh turn for a while into good materialists like we are today?

Another of Le Tensorer's opinions is worth mentioning here: the perfect symmetry of this exceptional site's handaxes raises the idea that 'man made the tool in his image', that 'creativity is an attempt to humanize the inert'. This proposition recalls that of Schmidt and Oakley, who considered the handaxe as a third hand, as well as Poplin (1988), who highlighted 'the extracorporalisation of the tool', remarking that 'our being extends itself in the artificial extension it installs in the material it shapes'.

It is obvious that most traces of early 'art' are gone for ever – song and dance, hairstyles, body-painting, tattoos and scarification – as are any artworks made with perishable materials such as wood, bark or feathers (though we have some evidence for a Neanderthal use of feathers). Inevitably, therefore, we can only see art's origins in what little has survived – in other words, stone tools. The choice of materials (the type and colour of stone, and its ease or difficulty of working) and the variety of forms (from polyhedrons, balls and bifaces to circles, ovals and squares) are all we have on which to base our conclusions. Like it or not, the very earliest evidence for art is written in stone – but also sometimes in bone, as we shall see in the next chapter.

All work and no play? Looking at marks on bones and stones

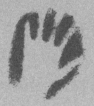

Not all marks on bone and stone were made by man, but of those that were, how can we decide whether they were intentional and, if so, were they aesthetic or symbolic?

First traces: marks on bones

Tertiary Man?

As early as 1860, French palaeontologist Édouard Lartet took an interest in the marks made by the first humans on animal bones, either to detach the flesh or to break them and eat the marrow, or to shape them and turn them into tools. He declared to the Academy of Sciences in Paris: 'These marks can provide the most direct and least questionable evidence for the antiquity of man and his contemporaneity with long extinct species.' A few years later other researchers used the same evidence and the same arguments to try to push back the origin of humans and even establish their existence in the Tertiary period, long before the glaciations of the Pleistocene. The presence of man was invoked by incisions on the bones of elephants, rhinos, hippos, horses

18. Drawing by Gabriel de Mortillet of a rib bone from the Falun de Pouancé (Maine-et-Loire, France); it comes from a large Palaeogene marine animal (*Halitherium*), the incisions made by shark teeth rather than by a human ancestor.

and marine animals, found in deposits and sand quarries in the Loire basin, Massif Central and Italy.

The international congresses of anthropology and prehistoric archaeology in Paris, Brussels, Lisbon and Budapest, as well as the reports of the Academy of Sciences in Paris around 1870–80 featured animated debates about marks on bone. The greatest names of the time took part – Lartet, Cartailhac, de Mortillet, Evans, Lyell and Worsaae. By the end of the nineteenth century a typology of human marks on bone had been developed: it included sawmarks, notches, cutmarks, incisions, impressions, scratches – each with a precise definition – which one had to strive to distinguish clearly from striations, incisions, notches and removals of material produced on bones by animals and various other natural causes. Gabriel de Mortillet remarked in 1885 that non-human marks on bone 'are important to study because they have led many observers astray, including some of the most distinguished' (FIG. 18). So from the very start of their discipline, prehistorians were confronted by the delicate problem of interpreting marks observed on the bones of extinct animals.

In addition to incised bones were the apparently 'shaped' bones, supposedly 'knapped' flints and traces of 'fire' that had been found in early geological levels (Miocene or Pliocene, now dated to between 23 and 2.6 million years ago) associated with an extremely archaic fauna. Specialist opinions were divided on this subject, but 'Tertiary Man' lived for a while, supported by some 'fine minds', before more detailed studies and general progress in prehistory finally demonstrated that the so-called flint tools had been produced by natural phenomena, that the traces of fires were probably from spontaneous vegetation fires, and that the bones had

been fractured by natural actions. As for the striations they sometimes displayed, it appeared that these could be due to mechanical phenomena inside sediments, especially the rubbing of blocks during landslides (solifluction); moreover stones and flints themselves bore comparable stigmata. They could also be due to bites from carnivore jaws, or from rodents, while the incisions on the bones of marine animals were caused by the cutting teeth of the great sharks of the Tertiary era.

The very fact that some of the best-informed minds of their time could be deceived should make us all the more cautious today in our reading of the same phenomenon. Marks on bones still arouse equally lively debates, and some of the most distinguished of us doubtless continue to be led astray in their interpretations. Today these enigmatic marks are only rarely invoked to support the antiquity of man, but they have achieved particular importance in another domain: some people consider them to be intentional engravings, that is, evidence for a very early origin of art and symbolic thought.

The first scientific studies of marks on bones

Some of the earliest prehistorians endeavoured in the 1860s to establish criteria to differentiate natural marks on bone from those produced by man – Lartet, for example, cut modern bones with a metal saw to see how the marks compared with those on ancient bones. He found that metal produced a totally different effect, whereas flint knives matched precisely. In Belgium, Édouard Dupont likewise investigated the differences between damage done to bones by carnivores and the butchery marks and fractures made by humans; and in 1863 the British geologist Charles Lyell tried to distinguish cutmarks on bone from those inflicted by porcupines (Bahn 1996a: 118, 122)!

However, it was Dr Henri Martin who, with his keen powers of observation and exemplary rigour and caution, was the first to develop a truly scientific approach to prehistoric bone-working. The excavations he carried out from 1906 to 1936 at the famous site of La Quina (Charente), the eponymous site of the Charentian facies of the Mousterian, yielded a great quantity of bones of horses, bison, reindeer and so on, associated with human bones and a rich lithic industry of the Middle Palaeolithic and early Upper Palaeolithic (FIG. 19). In the course of his patient research, Martin examined thousands of bone pieces, striving to decipher the marks they bear, and to understand the natural and human actions they had undergone.

By recording the slightest incisions produced on bones by flint knives when detaching meat – i.e. the 'butchering striations' that follow

All work and no play?

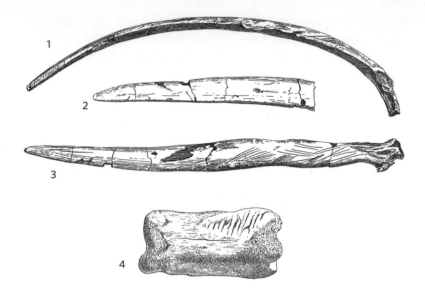

19. Examples of enigmatic Mousterian human marks (some perhaps accidental) on animal bones from La Quina (Charente, France): (1–3) left tenth rib of a bovine (posterior edge, internal surface (truncated) and external surface); (4) phalange of a large cervid with traces of human intervention.

defleshing – he saw the elementary techniques of butchery used more than fifty millennia ago. He observed not only fine striations of a particular type produced by scraping bone with a flint blade, but also separate striations perpendicular to the axis of the piece, on either side of the bone's convex part. He also noted that the deepest scratches on the epiphyses were made by cutting muscles and tendons, while those visible on diaphyses must have facilitated bone breakage to extract the precious marrow.

Through his interest in the transformation marks on the pieces, he defined the makeshift tools made in bone by Neanderthals – picks, points and smoothers – and then meticulously recorded their less obvious use-wear marks. These showed that certain bones – particularly bison humeri and horse and cervid phalanges – were used as 'mallets' and others as 'anvils' ('these bones struck or were struck'), and others as 'retouchers' or 'compressors' for flint-knapping. He also studied the natural traces produced on bone by the bites and gnawing of carnivores and rodents.

Among these countless traces that reveal a practical utilization of bone, or the action of purely natural phenomena, he observed more astonishing marks that seemed to bear witness to human preoccupations of a different order. There were regularly spaced notches on some pieces,

most notably a horse tibia, which perhaps had a 'decorative' function, and a bovid shoulder-blade with regular incisions. Martin wrote of the latter in 1910: 'The bone's two faces bear very fine lines.... One finds a certain parallelism between the different elements and an absolute straightness in their direction. However, some lines were renewed over quite a lot of their course.... This is the first time I have encountered such precise marks on the bones of La Quina; these long and fine cutmarks do not correspond to defleshing striations, which are pointed at both ends and almost always accompanied by scraping. The parallelism, the regularity and the fineness suggest a purposeful action and not a recoil or an out-of-control flint. This piece, like three others found previously in the same site, has signs that are hard to interpret but which can today be classed as intentional marks.'

These pieces were then also examined by the Abbé Breuil and compared with an engraved bone that Peyrony had just discovered in a burial in the rockshelter of La Ferrassie (Dordogne). This bone was 12 cm (4.7 in.) long and covered with a series of parallel striations evoking a 'decoration' (see FIGS 33, 34). These finds of apparently 'engraved' bones in the Mousterian levels of two famous sites occurred at the very time when the first Mousterian burials were being unearthed, not only at La Ferrassie in 1909 but also at La Chapelle-aux-Saints (Corrèze) and Le Moustier in 1908. The existence of Neanderthal rites thus burst forth into plain sight, and the presence of 'intentional engravings' provided complementary evidence of the symbolic capacities of Middle Palaeolithic people. At La Quina, Martin also described perforations in a series of bison and reindeer phalanges, as well as a fox canine, which led him to envisage the existence of ornaments in the Mousterian, to which we shall return in Chapter 6.

Although these various artifacts have unfortunately not been subjected to new analyses with modern methods, they are still the subject of discussions and controversies, of peremptory and gratuitous declarations, unsupported by any experimentation. For example, the Quina shoulder-blade, which has become a classic in studies of the origins of art, was considered a 'cutting board', a support for cutting hides, by the American researcher Alexander Marshack, although he did not rule out a ritual meaning.

Martin's approach stood out because of the absence of bias, which enabled him to examine the documents with great liberty, and also the fact that he was a specialist with great experience. He considered each piece in its context, and compared it with hundreds of other specimens from the same site with similar or different marks. This systematic

All work and no play?

but unselective approach is, alas, not always found among modern researchers, who have more highly developed methods available to them but who look through space and time in search of the piece that will support their theory.

Martin recognized the fragility of any limit between utilization marks and intentional, decorative marks, or those which met some other intellectual or spiritual need, since the regular layout of incisions is not always meaningful. 'Regularly spaced' incisions may be the traces of a utilitarian action; moreover, the spacing can be more or less 'regular'. Only comparison and archaeological context can shed light on the interpretation of each piece, yet nevertheless that interpretation often remains pure conjecture.

In the tradition of Martin's research, Pei Wen-Chung, excavator of the famous Palaeolithic site of Zhoukoudian in China, worked with the same rigour and critical mind, and in 1933 he published a copiously illustrated work on *The Role of Animals and Natural Causes in Bone Breakage*. Using numerous examples from the site, which had just yielded the first skeleton of *Sinanthropus* (now *Homo erectus*), the author presented a wide variety of marks made on early prehistoric bones by carnivores and rodents contemporary with these bones, and by the dissolving action of waters that infiltrated the archaeological levels (FIG. 20). In this book one learns that flat bone surfaces, such as some skull fragments, sometimes bear a maze of bear clawmarks: 'If we look carefully at these scratches we observe that they are often grouped in clusters of two or three parallel lines. This is characteristic of the action of a carnivore's claws.' He observed the same phenomenon on long bones and added: 'It seems to be a rule that carnivores scratch bones transversally to their longest axis.'

First under the direction of the Abbé Breuil and then alone, Pei strove to answer the question of how to recognize human actions on a bone fragment. He judiciously felt that 'it would be interesting to study the opposite: how to recognize the action of non-human causes that could give a fossil the appearance of a human implement?' He thus described in great detail the characteristics of rodent bites, which left 'facets like those made with a knife', and presented several striking examples of various bones or deer antlers gnawed by different rodent species such as the porcupine, for instance, which can even create kinds of tubes and beads from long bones by gnawing them at both ends.

Pei described the bite-marks of large and medium-sized carnivores like bears and hyenas, which produce dimples, round cupules or perforations with the points of their canines or the cusps of their molars, as well as

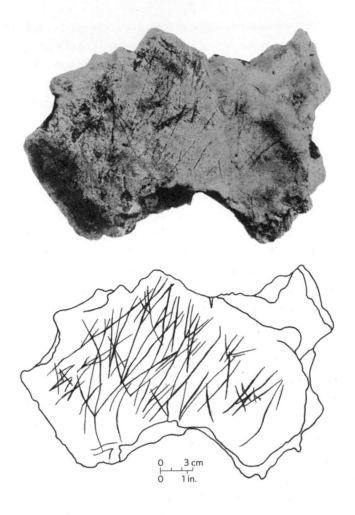

20. Fragment of rhinoceros skull from Zhoukoudian, which, according to Pei Wen-Chung (1933), displays lines that are probably carnivore clawmarks.

dotted and nibbled surfaces. When the canines slide on a bone's hard surface, they leave scratches and incisions that are sometimes parallel and regularly spaced. Pei also studied the vermiculations made by microbes or plants, the imprints of roots, and chemical dissolving by infiltrating water, which can expand the foramens in bone and create perforations, sometimes even colouring bone as if it were painted. And he described bones that were rolled, worn, polished by natural agents, as well as those that were broken or scratched by mechanical effects inside sediments, phenomena that are now called 'trampling'. Finally, and with humour, he presented incisions made by carnivore teeth that resembled

All work and no play?

'inscriptions in Chinese characters', and vermiculations on a wolf tibia similar to an 'engraving depicting an ostrich with its egg'! Many present-day palaeontologists and prehistorians doubtless continue to mull over the teachings of Pei, who was the first to denounce clearly all the traps that marks on bones can inflict on any specialist seeking the 'origins of art' and of 'symbolic thought'.

And yet, a few decades ago, one of the most famous researchers fell into just such a trap. In 1969, in a Mousterian level of the cave of Pech de l'Azé II (Dordogne), François Bordes discovered a little fragment of long bone with an incomplete perforation, the bone having been broken on the side after being perforated. In the publication of the piece, accompanied by drawings and macro-photos of the hole, Bordes noted: 'The perforation is clear... one can easily see the parallel striations cut by the turning flint. Whatever the function of this object (pendant, strap softener, etc.) it is a new entry in the still limited catalogue of Mousterian bone tools.' This bone was subsequently considered almost systematically as a 'piece of jewelry', and was cited by numerous prehistorians who were trying to highlight the intellectual and aesthetic capacities of the Neanderthals. But, as we shall see below, progress in research has finally cast serious doubt on this kind of perforation.

In 1969 Bordes also published – in the same paper as the above-mentioned perforated bone – a fragment of bovid rib decorated with 'intentional engravings' from the same site, but from a much earlier level than the Mousterian – an Acheulian level (Riss I) dating to about 300,000 years ago! The publication was illustrated with a photo and drawing of the piece, the latter admirably precise and aesthetic, by the professional draughtsman and prehistorian Pierre Laurent. This tracing, of unsurpassable quality, had obviously required very long and very detailed observation (FIG. 21).

The main 'engraved' motif is a kind of V made up of two approximately parallel lines 'which were not drawn with a double-pointed tool'; they 'are continued to the right by an undulating line'; then, below, one sees a 'very elongated rectangle made of lines with a U-shaped section'. Bordes also described 'transverse lines', 'oblique lines', 'undulating fine lines', and then various 'transverse striations' that may be 'defleshing striations'. He concluded that 'it seems established, through the form of the lines, that on this bone there is something other than accidental incisions. There seems to be an intention there, but we obviously cannot know its meaning. An amusement of an idle hunter, or a first attempt to depict something? Doubtless we shall never know.'

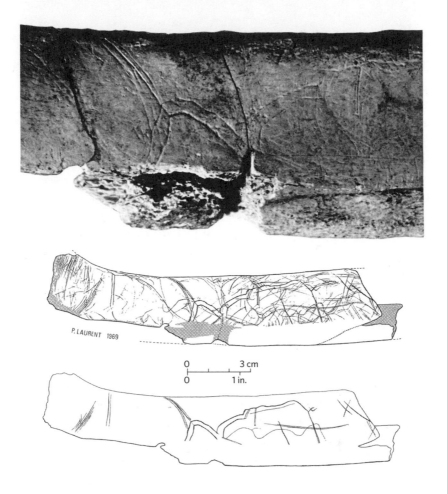

21. This fragment of bovine rib from Pech de l'Azé (Dordogne), dating to the Acheulian (*c.* 300,000 BP), features various lines that have been interpreted as engravings (F. Bordes 1969); the detailed tracings below were made by Pierre Laurent. The clearest marks are in fact the natural imprints of blood vessels (d'Errico & Villa 1997).

Despite the author's prudence in his text, and the inextricable nature of the 'lines' faithfully recorded in Laurent's drawing, this object was regularly cited for the next twenty years by specialists who unanimously considered it as the oldest assemblage of intentional engravings, attesting to an unexpected intellectual level in *Homo erectus*. The notoriety of Bordes and Laurent ensured that few people doubted the authenticity of these 'engravings', and the bone, on display in the National Museum of Prehistory in Les Eyzies, was successively examined by numerous prehistorians. Hence this 'engraved Acheulian bone from Pech de l'Azé II' became something of a reference document.

All work and no play?

In 1977 Alexander Marshack published a detailed study and an interpretation of the bone in a general article devoted to what he called the 'meander as system' in Palaeolithic art. For more than a dozen years already, this author had been using a method based on the detailed analysis of documents of Palaeolithic art by means of an optical microscope and high-magnification macro-photos. His examination of the Pech de l'Azé bone confirmed – and went well beyond – the observations of Bordes. His first remark was that one needed to see the piece 'upside down': 'Microscopy suggested that this image had been made in reverse from the way it had been published.' Marshack's microscope, which was considered authoritative, seemed 'to verify the intentionality of the image'! He distinguished a series of graphic units, straight or curved lines made with different techniques (double lines, clusters of marks, etc.), that made up an 'intentional sequence' of marks, made one after the other. 'This Acheulian "composition", if it could be considered a "composition", could be tentatively interpreted. Since we have no input of language or semantic content, we can assay an analysis of the cognitive, conceptual, and symbolic strategies. There is a sequence and an accumulation which, section by section, shapes what seems to be a meandering or serpentine image' (1977: 292).

Marshack thus discovered in the 'Acheulian engravings on the bone from Pech de l'Azé II' the origin of a vast and long-lasting tradition of the meander, of which he saw numerous pieces of evidence, in both portable and parietal art – from Altamira, Lascaux, Gargas, Pech-Merle, Rouffignac, Ardales, Parpalló, La Pileta and Romanelli. This tradition, which spanned the hundreds of millennia of the Palaeolithic and Mesolithic across the whole of Europe, implied the existence of 'language... at a level adequate to maintain and explain the symbol-making tradition. My analysis of the Pech de l'Azé bone and my study of Mousterian symbolic materials from different European sites have suggested that vocalized language of a certain level of complexity must have existed in the Mousterian and perhaps earlier' (ibid.: 299). According to Marshack, the draughtsman's gestures, often repetitive and spread through time, were more important than the motifs themselves. All these images constituted 'iconographic acts of participation in which a water symbolism or a water mythology played a role'. This kind of marking could even be an 'unreal river of a shamanistic journey or effort'. It was '"iconographic" but not really representational. It is an iconographic element in a participatory, ritual, ceremonial, mythical or narrative complex' (ibid.: 316).

The meeting of the microscope and the strange grooves on the bone from Pech de l'Azé, and their comparison with countless other marks in European prehistory, thus led to the origin of art and language, to shamanistic travel and dreams. But the main conclusion to note from Marshack's hypotheses is the apparently 'intentional' and 'sequential' character of the marks on this bone.

Progress in the study of marks on bones
During the time when the different interpretations of the Pech de l'Azé bone were published, the study of natural or anthropic marks on bones, undertaken by palaeontologists and prehistorians, was making important progress. Researchers were carefully studying the location, orientation, distribution and morphology of these traces, applying increasingly sophisticated methods based on microscopy. Experimentation made it possible to reproduce the morphological characteristics of the marks, and the experimental reproductions were then analysed themselves with a microscope and compared with the prehistoric finds (FIG. 22).

In the Ukraine, for example, a Mousterian layer at Molodova, more than 40,000 years old, yielded a mammoth shoulder-blade decorated with little pits, patches of colour and notches that seemed to form complex

1 Row of vertical or oblique parallel striations (La Quina, Bilzingsleben)

2 Row of parallel striations (Variation Esquicho Grapaou)

3 Series of deep lateral incisions (Schulen)

4 Row of double or triple lines (Lartet, Petit Puy Moyen)

5 Row of bunches of lines of unequal length at regular intervals (La Quina, Lartet)

6 Row of hooked lines (Morin)

7 Row of angular incisions (L'Ermitage)

8 Row of angular incisions with one curved side (Lartet)

9 Converging striations (Bilzingsleben)

10 Long fine incisions in all directions (Bilzingsleben, La Quina, Lartet)

11 Series of fine straight parallel incisions crossing each other (La Quina)

12 Bunches of curved incisions (Combe Grenal)

22. The main types of enigmatic marks on bone in the Lower and Middle Palaeolithic.

All work and no play?

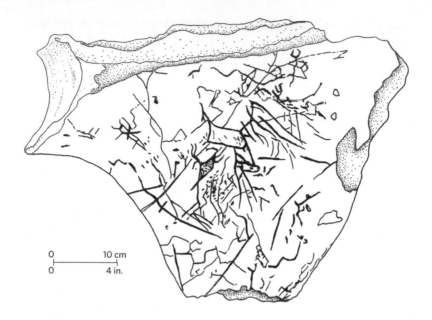

23. Mammoth shoulder-blade from Molodova 1 (Ukraine),
with a network of fine striations (once interpreted as
intentional incisions) and patches of red ochre.

patterns including cruciform and rectangular shapes (FIG. 23). Some
Soviet scholars (e.g. Frolov 1981: 63, 77; but see Kozlowski 1992: 36) saw
among the marks the outline of an animal, but a more recent analysis
involving microscopy and some experimentation has shown that the
marks on this piece (and several other incised bones from the same site)
are in fact natural and/or recent (Nowell & d'Errico 2007).

It had become clear at this time that the marks produced on bones
by sediments and different natural phenomena (chemicals, worms, roots,
etc.) or by accidental trampling could be distinguished through their
anarchic layout. Those made by people, on the other hand, were located
at particular points on the bone, and generally had a characteristic
organization. Three different types of traces could be identified: those
of rodent teeth, forming broad, parallel flat-bottomed grooves; those of
carnivore teeth, often sinuous, with a rounded section, a smooth base and
constant width; and those produced by the cutting edge of stone tools to
detach flesh, noteworthy for their V-sections, their pointed extremities
and often parallel longitudinal striations inside them (e.g. Shipman
& Rose 1983). For his part, Lewis Binford (1981) used ethnographic
comparisons to distinguish three categories of cutmarks on the carcasses
of prey: traces of skinning, dismemberment and filleting.

Experimentation and marks on bones

One of us (ML) has been able to study in some detail the incisions on two bones from the Mousterian of the abri Lartet (excavated by Louis Duport) and one from the Grotte de l'Ermitage (excavated by Louis and Henri Pradel) (FIGS 24, 25). These fragments display bunches of

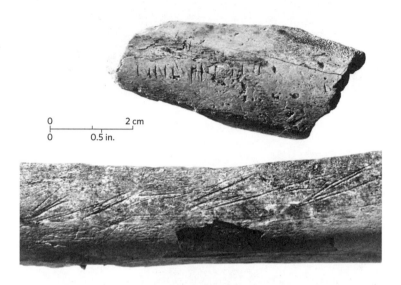

24. (Top) A fragment of a large long bone from abri Lartet (Montgaudier, Charente), with a series of parallel transverse incisions (Quina-type Mousterian); (above) long bone with series of incisions in the form of horizontal Vs, from L'Ermitage cave (Lussac-les-Châteaux, Vienne) (evolved Mousterian).

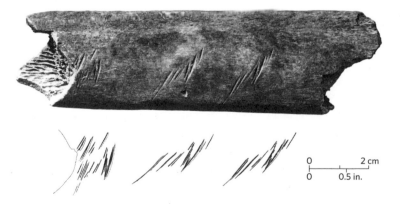

25. A bone from abri Lartet (Montgaudier, Charente) with repeated incisions made with the same tool; (below), a tracing of the incisions (Quina-type Mousterian).

All work and no play?

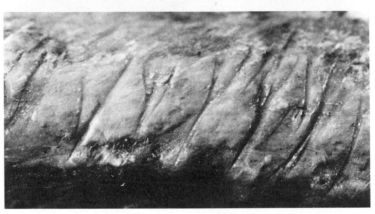

2 6. Marks left on a bovid rib by experimental defleshing
(scale in upper photo shows 1 cm above and 0.5 in. below).

striations that seem to be organized in the shape of an inclined V
that is repeated at more or less regular intervals over the length of the
bone diaphysis.

In order to compare these Mousterian striations with those left by a flint
during defleshing of a bone, we carried out an experimental defleshing
of a bovid rib, using a slightly denticulated side-scraper of Mousterian
type. During this operation, in order to remove the flesh that still strongly
adhered to the bone after cooking, we used gestures combining sawing
from top to bottom and scraping from right to left. This led to the
appearance on the fresh bone of slightly inclined striations, often angular
in shape, identical to the V-shaped striations observed on the Mousterian
bones (FIG. 26).

Scanning electron microscope photographs (at x200 enlargement) of the Mousterian bones from Lartet and L'Ermitage as well as of the experimental bovid rib were then taken at the CMES (Faculty of Sciences at Toulouse) with the help of Bernard Lavelle. They revealed the existence of fine striations inside the flint traces, on both the Mousterian bones and the experimental one (FIG. 27). These are the tool's signature – they are repeated in all the incisions on each bone, which shows that the operation was entirely carried out with the same tool, and hence that in the various cases they are very probably traces of defleshing and not intentional symbolic incisions.

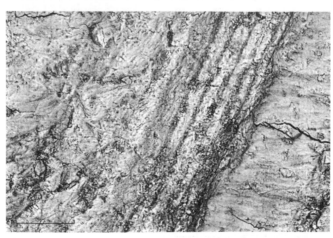

27. Scanning electron microscope photographs of marks on bone: (top) detail of a Mousterian incision on a bone from the abri Lartet; (above), the internal striations in the experimental marks made by defleshing a fresh bone (scale in both photos shows 100 μm or 0.004 in.).

All work and no play?

In parallel, and following research by the Soviet prehistorian Sergei Semenov (1964), use-wear analysis – the analysis of the function of prehistoric tools – was also making huge progress and being extended to all kinds of tools made of different materials. By using microscopes, use-wear analysts could observe the traces left on artifacts by their utilization (in particular striations or micro-polish, as well as various deposits and residues). These traces were then compared with those obtained during experiments on reproduction tools used for cutting or scraping different materials such as wood, bone, hide and meat (Keeley 1980; Vaughan 1983). This work contributed fundamental information about the ways in which prehistoric people made and used their tools, and on the phenomena of deterioration that the tools then underwent. The discipline advanced particularly after 1970 thanks to the development of the scanning electron microscope, with observations made not only on the pieces themselves, but most often on latex imprints or varnish replicas (d'Errico et al. 1984; Anderson-Gerfaud et al. 1987). The technique was also extended to the study of wear on the surfaces of teeth and striations on enamel, which yielded new information on prehistoric subsistence (Puech 1976).

The technological study of prehistoric portable art was also developed at this time by prehistorians, with some European researchers following in the pioneering footsteps of Marshack. While the long studies by Léon Pales (e.g. 1969) of the engraved plaquettes of La Marche presented a protocol for the decipherment and reading of Palaeolithic engravings that greatly influenced all subsequent work, the studies by Henri Delporte and Lucette Mons (e.g. 1980), Gerhard Bosinski and Gisela Fischer (1974), and more recently Michèle Crémadès (1989), Francesco d'Errico (1994) and Carole Fritz (1999) adopted a more strictly technological approach. This involved analysing and experimentally reconstituting the *gestures* of the Palaeolithic engravers, in order to establish the *genesis of the engraved motifs*: finding the direction in which the lines were made, knowing whether they were made with a single movement or several, determining the interval of time that separated them, knowing if they constituted a single graphic event or a cumulative project, and disentangling the superimpositions and the whole micro-history of the marks with retouching, nicks, breakages, successive positions and changes of tool. For these technologists, 'the gestures rather than the engravings represent the tangible product of the engraver's motivations because they organize these motivations in time and space. The gesture can become a means of tracing the engraving back to its meaning' (d'Errico 1994).

Both Marshack and d'Errico made particularly important contributions to the modern study of traces on bones; both used the microscope and sometimes called on ethnographic comparison; and d'Errico regularly carried out experimental verifications of his observations. Experiments of this kind continue today, studying marks left on defleshed bones with stone tools, and using the scanning electron microscope (see box).

Bilzingsleben

In 1988 a crucial event occurred in the history of the study of marks on bones and the origin of human graphics. Dietrich and Ursula Mania published four large bone fragments, discovered during their excavations of the rich open-air site of Bilzingsleben in the Thuringian basin (Germany), and featuring 'deliberate engravings by *Homo erectus*'. This aroused a major international debate that illustrates the methodological level and the mindset of research on the origin of art and thought at this time.

The bones were found in immediate proximity of three circular dwellings in workshop areas marked by agglomerations of stone flakes and bones around a central anvil, and the site is dated to 230,000–350,000 BP, approximately contemporary with the level of Pech de l'Azé that yielded the famous 'engraved rib'. Each piece bears a number of incisions:

- Artifact No. 1, 39.5 cm (15.6 in.) long, is a spall from an elephant tibia, one end of which was used as a percussion tool, while the other is pointed with a tip rounded by use. So it may be a 'decorated tool', but such an interpretation requires confirmation. On its thinner edge, this bone has seven divergent lines, 2 to 7 cm (0.8 to 2.8 in.) long, adjoining a series of equally divergent and regularly spaced incisions, 3 to 4 cm (1.2 to 1.6 in.) long. This fan-shaped arrangement was destroyed at one end by the bone fracturing when used for percussion (FIG. 28).

- Artifact No. 2 is the flat distal end of a large mammal's rib, 28.6 cm (11.3 in.) long. The convex outer surface has seven linear incisions, 2 to 6 cm (0.8 to 2.4 in.) long, spaced irregularly (the spaces also being between 2 and 6 cm) and each consisting of three single lines of an overlapping order at the ends, forming together one straight mark, and showing retouches by the engraver's tool.

All work and no play?

- Artifact No. 3 is a triangular flake from a compact elephant bone, 14 cm (5.5 in.) long, with one retouched edge. On its flat upper surface there is a group of five divergent lines, 5 to 7 cm (2 to 2.8 in.) long, and, at the base, the remains of three parallel incisions.

- Artifact No. 4 is a flake from a long bone, 11.4 cm (4.5 in.) long; on its convex upper surface are a total of thirty lines, 2 to 5 cm (0.8 to 2 in.) long, among which one can distinguish a series of seven parallel lines separated by regular intervals of 0.3 cm (0.12 in).

The authors made a number of observations: the marks seem to be organized into two types of motif, either series of convergent lines or series of parallel lines; the marks are arranged either in the direction of the support's long axis (1, 3), across it (1, 3, 4) or at an angle (2); there are single fine linear incisions, double incisions obtained with a double-point (3), and linear marks obtained with repeated incisions (2); there seems to be a certain technological homogeneity, which leads one to wonder if the incisions were made by the same tool or the same person (the Manias stressed the fact that some decorations were done in a single technological action and that these were certainly not accumulated marks, except perhaps on Artifact No. 3, which displays two different techniques); finally, all the pieces were found in knapping workshops, that is, in the parts of the site that reveal the most intensive technological activity, in immediate proximity to anvils, amid flakes of flint and bone linked to knapping and tool manufacture.

Without describing them, the Manias also mentioned the existence in the same site of a quartzite slab engraved with an arc, and an elephant tarsal that could be decorated with a double rectangle (FIG. 29). They also noted that another researcher, Günter Behm-Blancke (1987), thought he could recognize a variety of geometric motifs and even an animal depiction among the numerous incisions on bone from Bilzingsleben, but the Manias believed his reading to be erroneous and that these were simply wear traces. Rudolf Feustel had also seen an animal depiction in one of the engravings on bone from the site (Bahn & Vertut 1988: 208).

The authors interpreted the lines on Artifact Nos 1–4 as 'deliberate engravings' linked to non-utilitarian activity that was 'probably symbolic'. They saw them as proof 'that *Homo erectus* had gained the faculty of abstract thinking' and also proof of the existence of language (1988: 95).

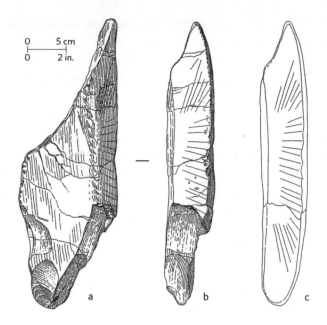

28. Fragment of elephant tibia (Lower Palaeolithic, 230,000 to 350,000 BP) from Bilzingsleben (Germany), with sequences of apparently organized incised lines (a and b are tracings by Dietrich Mania (1988), and c is a reconstruction of the bone fragment and engraved motif according to Mania's interpretation).

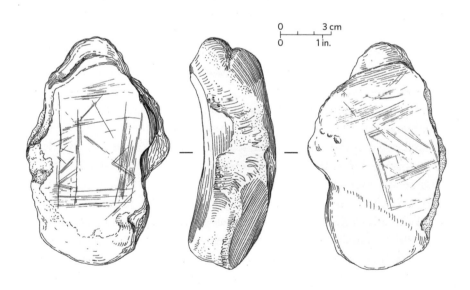

29. Lower Palaeolithic elephant foot-bone from Bilzingsleben (Germany), with striations on both sides, including a double rectangle on its concave surface.

All work and no play?

Several specialists who discussed this important discovery at the end of the 1988 article accepted these conclusions (Bahn, Bednarik, Marshack), while others (Davidson, Davis, Halverson) partly rejected them.

Among the prehistorians in favour of a symbolic reading of the Bilzingsleben marks, one of us (PB) reckoned that such evidence was significant because more and more such pieces were turning up; there are doubtless far more of them, but their rarity shows that many must have passed unnoticed. Robert Bednarik pointed out that the marks are not the result of chemical erosion, aeolian abrasion or carnivore gnawing. He also argued that they cannot have been produced by testing the cutting edge of stone tools, or by rubbing the bones against a hard surface, and that the bones cannot simply be 'cutting boards', that is, a support on which one placed a hide to cut it with a blade, as certain Eskimos do. He stated that the marks are in a long tradition of non-utilitarian acts and various productions of 'signs' (use of pigments, perforated objects, collecting fossils, etc.) which foreshadow and precede the figurative art of the Upper Palaeolithic.

After his initial support of the Manias' conclusions, Marshack actually studied the Bilzingsleben engraved bones, reporting his findings in 1991. He first declared that microscopic examination had modified his point of view of these pieces. On Artifact No. 1, the set of convergent lines on the right now seemed to him to be made up of natural fractures and not engraved lines. So the motif is much simpler than what was proposed by the Manias and by all the other researchers. Next, he envisaged that the regular straight lines on Artifact No. 3 were made by cutting a skin on a bone support. He compared the lines with those on the shoulder-blade from La Quina, which he likewise believed had been used as a support for cutting skins.

He then gave a list of his microscopic observations and his interpretations of various pieces which, in his view, attested to the symbolic capacities of *Homo erectus* and the Neanderthals and to an origin of ornaments before the Upper Palaeolithic: the engraved fossil of Tata (Hungary), perforated-bone pendants from Bocksteinschmiede (Germany), perforated teeth from La Quina and Bacho Kiro (Bulgaria), and a 'natural pendant' from Prolom (Ukraine). He stressed the Neanderthals' ability to cut skins, haft tools and use red ochre. All this would shed light on, and reinforce, the symbolic interpretation of the Bilzingsleben incised bones.

In Marshack's view, it is the usage of the piece that is meaningful: 'It is the *behaviour*, not the image, that may have been symbolically relevant' (1991: 55). He believed the argument was less interesting than the evolution of his method of analysis, which henceforth seemed more critical than the

one adopted at the time of his study of the so-called 'meander tradition' based on the Pech de l'Azé bone: he declared that 'rapid, and relatively cursory, "touristic" investigation of certain artifacts' is not enough, and stressed the requirement of a thorough analysis based on a detailed examination through the microscope. He showed how this type of analysis can modify the interpretation of an object by sometimes revealing aspects that are invisible to the naked eye. All this is illustrative of an increasingly cautious and rigorous position in current research into the 'origin of art'.

Further interesting observations were made by Marshack in the same 1991 paper: for example, microscopic examination appears to demonstrate that the Mousterian bones of Cueva Morín (Spain), which were thought to be engraved, in fact only have 'natural fractures'. Similar analysis also made it possible to reject the supposed 'intentional engravings' on bones and pebbles from the Middle Palaeolithic of Kůlna (Czech Republic) and from several Italian Mousterian sites.

The specialists who rejected the Manias' interpretations of the Bilzingsleben material made four main points:

- They wondered if the incisions are indeed the work of hominins, and if they are really 'intentional engravings' (Phillip Habgood);

- They rejected the notion of 'rhythmic sequences'. Iain Davidson asked 'Can one produce more than one line in anything other than a sequence?', using the term employed by the Manias and supporters of the symbolic interpretation. He also wondered why this 'sequence' should be interpreted as 'rhythmic';

- They rejected the notion of a 'symbolic tradition'. The marks on bones and the other objects considered to be evidence for 'symbolic thought' are so rare, so varied and so scattered in time and space that there is doubtless no link between them, and it is scarcely possible to imagine that they could have had a common meaning;

- Davidson, along with Whitney Davis and John Halverson, agreed that sporadic markings on bones certainly seem to have existed for more than 300,000 years, but minimized their importance by refusing to accept that they had any meaning. In their view these were 'just marks', 'self-sufficient marks',

All work and no play?

and not 'semantic marks' (filled with meaning), which would appear much later, at the start of the Upper Palaeolithic. For these authors, the claim that the marks 'indicate abstract thinking and language seems... less inference than a leap of faith based on the gratuitous assumption that the markings "*must* have conveyed information of some form"'. They do 'imply some sense of rhythm and symmetry', but 'rhythmic activity and repetitive behaviour are virtually universal animal characteristics: they need not be mindful, purposive or even conscious.... The marks may be simple repetitions of an essentially meaningless action having no symbolic intent or function, but giving a "protoaesthetic" pleasure based on motor rhythm and visual symmetry.' Their function was not to transmit any information, nor a particular 'concept of the world'.

The Manias responded that many prehistorians accept the Bilzingsleben markings as 'deliberate engravings'. They noted that everything at the site indicates that *Homo erectus* had 'a comparatively developed ability to act consciously. For instance, the method of splitting elephant longbones by repeated application of a wedge along a straight line implies planned behaviour. The meticulous production of regular engraved patterns on the hard surface of bone tools cannot be equaled to the playful patterns infants and nonhuman primates might produce, and which postulate no culture' (Mania & Mania 1988: 105).

There was in fact more to come from Bilzingsleben. In 1990, new bone fragments with striations – some of which were interpreted as 'engravings' – were published by Dietrich Mania in a fine monograph. Then, in 1991, he published a bone with an animal engraving associated with signs. Mania distinguished three categories of bone marks in the assemblage of material: 'traces of utilization' (including defleshing), 'intentional drawings' (isolated or grouped) and finally an 'animal engraving accompanied by signs'.

The 1990 book was illustrated by numerous drawings and photographs of stone and bone pieces showing disorganized striations in which the author – doubtless correctly – saw 'traces of utilization', i.e. non-intentional marks (pp. 152–53, 158, 160, 162–63, 165–68, 174, etc.). In contrast, in a chapter devoted to 'cultural activities' one finds not only the objects published and discussed in 1988, but also descriptions of several other pieces, most notably the aforementioned elephant tarsal (FIG. 29), with seemingly geometric motifs in the form of a double

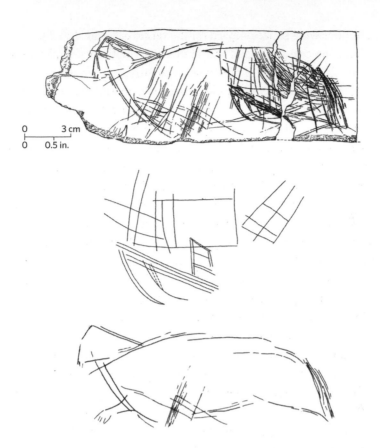

30. The Lower Palaeolithic 'feline bone' from Bilzingsleben
(Germany): (top) tracing of the lines at the bone's extremity; (centre)
separate tracing of the geometric signs supposedly superimposed
on the 'feline'; (bottom) separate drawing of the 'feline'.

rectangle (with internal chevrons that look 'decorative') incised on both
faces. The book also highlights the 'archaic ritual behaviour' of the *Homo
erectus* of Bilzingsleben, who intentionally broke and dispersed the bones
of the dead in certain parts of the site; so one can legitimately wonder if
this context can direct the reading of the marks on animal bones towards
a symbolic meaning.

Mania's 1991 article, which added a new dimension to the
Bilzingsleben finds, described an elongated bone bearing a tangle of
lines that Mania identified as a 'feline engraving associated with signs'.
The 'characteristic' head of the 'lion' was emphasized with a double
line and the tail was 'supple and tucked up'; the clearest detail was 'a
leg' with claws (FIG. 30). But the most astonishing fact is that a series
of geometric signs made up of rectangles, crosses and arches attached

All work and no play?

to straight lines were superimposed on the feline drawing. In this 'association of animal and signs', Mania saw a 'semiotic system'. Moreover, from the whole assemblage of bone marks at Bilzingsleben he drew up a true 'typology of signs' comprising 'arches', 'crosses', 'right angles', 'quadrilaterals with a more or less partial infill', 'linear bands', 'ovoids', 'oval bands with an opening' which could be 'vulvas?', and so on; in his view, 'the semiotic system of *Homo erectus* could be the basis of the Upper Palaeolithic semiotic system', since it already included all the categories of signs recognized in the Upper Palaeolithic. Mania then tried with some difficulty to find intermediate examples, especially marks on bone or stone from Ehringsdorf, Taubach, Tata and Vertesszöllös, in order to establish a hypothetical filiation over hundreds of millennia between the 'arts' of the Lower Palaeolithic and the Aurignacian.

However excellent the work carried out at the site of Bilzingsleben, which is of great importance for human history, Mania's method for reading the marks on bones needs to be vigorously denounced. The subjectivity of his analysis shows once again how the study of art origins can suffer from a lack of scientific rigour. For a start, it is astonishing that the description of the site's most interesting pieces is based entirely on graphic tracings, while the photographs of these same pieces are placed elsewhere or are not accessible. Whenever possible a tracing must be accompanied by a photograph of the object, and even several photos of details or photos taken from different angles. A tracing is incomplete and tendentious when it does not form part of the inseparable couple – photo and graphic tracing, at the same scale, placed side by side. Where such documentation is possible, the absence of such an association is truly regrettable.

If one tries with some difficulty to confront, for example, the tracing of the feline with the little photo of the piece placed in a different part of the article (plate 38), it appears that the bone has not been fully depicted – the right edge of the drawing bears no resemblance to reality, it has been artificially delimited; and some incisions near the left edge (after the so-called 'feline head') do not appear in the tracing. The aim of the incomplete depiction, where the support has been arbitrarily cut off, is certainly to isolate the motif to make it more clearly visible, but it already removes it from reality.

It is obvious too that, if one has Upper Palaeolithic signs in mind, it is easy to look at tangles of lines and extract motifs that resemble geometric signs. A cross is nothing more than two lines cutting each other at right angles, and a rectangle is two parallel lines cutting two other parallel lines

at right angles. A right angle is one particular case in the infinite variety of angles produced by a junction of two lines; 'arches' and 'loops' are particular kinds of curved lines. Even the quadrilaterals on the elephant tarsal could be traces left on a bone support by repeated actions carried out in different directions to cut hides, tendons or pieces of wood. Some very simple isolated motifs including curves can also be the result of various actions intentionally or accidentally using the bone as a support.

One can even wonder whether, in a tangle of lines, one could really *not* find the simple forms that have just been described: they can be produced by the fortuitous arrangement of sufficiently numerous lines and, when these forms are isolated, they can be the result of various actions affecting the bone surface. Moreover, the classification of the marks by the excavator as either 'utilization traces' or 'engravings' shows clearly that the limit between these two categories is far from precise. Today the cutting blocks of butchers, chefs and housewives, and every other tool used as a support or for protection in cutting or sewing or any work on organic materials, offer a multitude of polymorphous marks. At first glance one can often make out series of parallel lines, right angles, quadrilaterals, and sometimes also curves. Just as Molière's Monsieur Jourdain was speaking prose without knowing it, we are probably doing 'semiotics' without wishing to (and Monsieur Erectus probably did so too!).

The reading of the feline that has been proposed is particularly tendentious, despite a degree of caution shown by the author's intermittent use of the conditional tense. The bone has an accumulation of marks aligned on the support's long axis; only two excrescences at one of the extremities (on the left in FIG. 30) could be seen as parts of a body: a kind of appendage interpreted as a 'head' and a narrower and more open motif interpreted as a 'paw'. In reality, it is by no means clear that the former is a 'head', its outline made up of straight lines crossing at right angles. With its five short parallel lines, one could see the 'paw' as a hand, but it is highly possible that it is simply an entirely fortuitous collection of lines, a *lusus naturae*. In addition, the highly characteristic long tail of a feline is replaced here by a broad cluster of curves and straight lines that defy all identification. Nothing in this accumulation can objectively be seen as an animal, and even less as a 'feline'. If one really had to distinguish a figurative motif, one could just as well turn the bone to the vertical and then imagine an anthropomorph with an extended arm and hand (in contrast to those of Upper Palaeolithic art which so rarely have arms and hands), but this reading is as filled with fantasy as the feline.

All work and no play?

Mania also asserts that the geometric signs were 'superimposed on the animal', that they were engraved after it and are associated with it. If that were so, it would represent the main characteristic of Upper Palaeolithic art but 250,000 years in advance. But no proof has been provided of either the real existence of these signs or of their superimposition on the lines of the supposed feline. A detailed study of this piece remains to be done, using macro-photos and a microscopic examination of the superimposition of lines, and leading to an authentic tracing. For the moment, the interpretation of the lines is impossible, and we consider the comparisons of the 'typologies of the signs and semiotic systems of the Lower Palaeolithic of Bilzingsleben' with those of the Upper Palaeolithic of Western Europe as decidedly premature; all of this lacks any scientific basis.

As an experiment we applied to the Bilzingsleben 'feline bone' the method that geologists use for the statistical study of the orientation of faults, each line being assimilated to a fault, except, of course, for the very curved ones (FIG. 31). Two main perpendicular orientations appear, which have a slight inclination in relation to the main axis of the support, while a different orientation follows the main axis exactly. These simple data hardly seem to argue for an animal engraving. Instead they appear to indicate that a general relationship exists between the bone's shape and the incisions, which are mostly straight lines that are preferentially orientated in a transverse or longitudinal direction. This could be linked to utilitarian actions in which the bone served intentionally or accidentally as a support; in any case, only taking the whole of the piece into account, and not its truncated representation, can provide a precise and objective base upon which to build interpretations.

31. Orientation of the lines on the 'feline bone' from Bilzingsleben (Germany); the horizontal line is the bone's longitudinal axis. A few preferential orientations appear.

Methodological problems

The incised bones of Bilzingsleben aroused fascinating debates on the cognitive capacities of modern man's predecessors, and no doubt they pose some problems that cannot be categorically resolved. Researchers formed two opposing groups, with some favourable to the concept of a long graphic tradition preceding and announcing Upper Palaeolithic art, and the others denying the reality of such early beginnings. However, the complexity of the issues raised by the interpretation of marks such as those from Bilzingsleben, along with the growing sophistication of observation techniques, have generally made prehistorians increasingly prudent and rigorous in their approach to the first traces left by people on animal bones.

It was within this context of doubt and caution that the art historian James Elkins (1996) dared to challenge the utility of microscopic examination, which he called 'close reading', even though this technique is widespread in all observational sciences. The primary attack on Marshack's method also had emblematic value, since that scholar was the first (starting around 1964) to systematically undertake microscopic examinations of marks and to raise the method to a high level. Despite a few extreme and provocative aspects, Elkins' point of view was very interesting.

He rebelled against the fact that, in modern works on prehistoric art and the graphic forms that preceded it, 'close reading' had become a sort of universal panacea, an 'intangible concept', a synonym for accuracy and insight that risks making us almost completely forget the importance of 'evidence or theory'. The universality of close and detailed reading by means of increasingly efficient optical instruments is accepted without taking account of the fact that *it is theory that determines what we see and the way we see it*. The subjectivity of this method, which is generally presented as infallible, is also based on the fact that it eliminates even closer readings, with even more powerful instruments. The 'reading distance' and the type of instruments used are merely the result of choice.

Elkins' critique of Marshack's work seemed severe, but could not disguise that researcher's enormous contribution to the study of Palaeolithic art at the very time when the structuralist theories illustrated by the work of Max Raphaël, Annette Laming-Emperaire and André Leroi-Gourhan were locking art into a perfectly closed system. Whereas in their interpretative system each decorated cave, each engraved object, tended to appear as an instantaneous and rigid composition, produced in a single event, once and for all, and whereas the themes – not the

All work and no play?

details of the figures – henceforth attracted the attention of prehistorians, Marshack's splendid macro- and micro-photos were opening up new horizons; they revealed the hidden and mysterious beauty of the works, the importance of the *detail* in the figures and of the artists' *gestures*. In undertaking the exploration of a previously neglected domain, they renewed the way prehistorians looked at Palaeolithic art, and brought the focus back to the documents themselves, restoring their dynamism and their sense of life and humanity. They showed that many works had been produced gradually, sometimes by different hands, that they had been used in ritual activities, and bore the stigmata of re-use. Time had played an essential role in their manufacture and utilization. These creations were 'time factored'.

Although paying some homage to Marshack's work, Elkins rightly criticized the systematic aspects of his approach, and his tendency (like Leroi-Gourhan) to resort to a single explanatory system. Marshack doubtless went too far in declaring that each series of marks was made by a different tool and in seeing systems of cyclical notations everywhere. Elkins also denounced Marshack's subjectivity in often speaking of his microscope in whatever way he pleased, using the instrument to establish his ideas and personal preconceived theories, striving to give the impression that it was the microscope and not the researcher doing the interpreting. There is indeed a strange hiatus between the image produced by the instrument and the reading given of it.

Marshack was too rigid in contrasting notation and decoration – in his view the same motif could not have both characteristics at once. With a certain amount of scorn, he rejected everything that seemed to him to be careless, due to chance, or rapidly made with the same tool, as 'pure decoration', whereas he considered notation to be a meticulous, attentive accumulation of mnemonic and ritual marks with a specific aim, extending over a long period and implying the use of different tools. He was too systematic in detecting changes of tools and always tried to define chronological sequences.

In addition, his interpretations were not based on a truly scientific method involving the adoption of hypotheses that were successively analysed, tested and rejected, and the use of statistical techniques. Elkins reproached Marshack for not explaining the reasons for his choice of 'reading distance', and for according an illusory importance to what he called 'internal analysis', that is, close study going beyond eyeballing, of elements that make up a motif, as if the depth of this kind of analysis necessarily guaranteed access to meaning. Elkins also castigated

Francesco d'Errico's method, the use of a scanning electron microscope, whereas Marshack used an optical microscope: 'For a while it seemed as if the problem of Paleolithic notation would come down to the atomic scale in its search for dependable criteria' (1996: 197), and as if the optical characteristics of a microscope lens decided the minimal observation distance and consequently its validity and precision.

For Elkins, what was questionable was not the criteria that make it possible to identify changes of tools or measure the time spent by the engravers, or the slowness with which marks were made, but rather the underlying conceptual basis of each piece of research; each level of reading has its own aims, its own limits, each responding to a particular need, strategy or hypothesis. He therefore concluded that 'close reading' was 'pathological'; he rejected the 'myopic precision' of the microscope user who is unconscious of his hypotheses and claims.

This perhaps exaggerated piece of criticism had the merit of inviting researchers to think about their method and to establish their theoretical basis with greater rigour. Various researchers responded vehemently to Elkins' criticisms; all stressed the utility of close reading, but most recognized that Elkins was right about one important point. According to Davidson, 'the answer will surely come from better thinking rather than better looking'; according to White, 'microphotographs... are *visual arguments* which can be countered by other visual arguments'; and d'Errico declared that 'what matters to us is not the level of observation or how carefully objects are studied but what questions we ask and what interpretive principles and analytical means we possess to answer them.'

In their responses to Elkins' attacks, Marshack and d'Errico emphasize the existence, underlying their research, of theories and models, which both of them derived from ethnographic comparisons in the study of systems of notation and information accumulation through time among preliterate peoples. The application of these models and the verification of these hypotheses then inevitably lead to the technological study of marks, which requires the use of the microscope and experimentation.

Elkins certainly failed to demonstrate that close reading was dangerous or 'pathological' – the use of the microscope remains useful. But, in reminding us that the rigour of the researcher counts more than the means utilized, his critique allowed present-day research into marks on bone to distance itself from a method and from scientific giddiness. As we shall see, microscopic analysis is not infallible: applied to the same motif by different researchers, or by the same researcher at different times, it can lead to radically different interpretations.

All work and no play?

Returning to Pech de l'Azé

A few months after presenting a talk on the 'system of the meander' at an Australian congress in 1974, illustrated in particular by micro-photos of the Pech de l'Azé bone, Marshack suddenly began to doubt the validity of its Acheulian 'engravings'. Examining a Mousterian bone from Cueva Morín (Spain) that bore incisions likewise interpreted as engravings but also considered to be partly natural by Joaquín González Echegaray and Leslie Freeman, the discoverers, he found that in reality they were indeed natural grooves that sometimes became canals penetrating the bone, reappearing some millimetres ahead. He attributed them to chemical or bacterial action, without seeking a specific explanation, and declared: 'It may now also be necessary to re-examine Bordes' bone from Pech de l'Azé' (letter to Freeman, 1 May 1975). Despite this scepticism, his first interpretation of the marks on the Pech de l'Azé bone as symbolic lines initiating the 'meander tradition' was finally published in 1977.

It was d'Errico and Paola Villa (1997) who definitively solved the enigma of the marks on the Pech de l'Azé bone, demonstrating that they are networks of natural grooves, sometimes curved or straight, single or multiple, which are simply the impressions of blood vessels on the bone's surface. These grooves have a U-section whose walls contain tiny holes, as revealed by a scanning electron microscope; these perforations correspond to the capillary vessels entering the bone. Sometimes the grooves themselves enter the bone. Moreover, the same kinds of grooves had been observed by these authors on other bovid bones from Pech de l'Azé and other Palaeolithic sites, as well as on modern bones. On the Pech de l'Azé rib, a whole secondary network of fine incisions – parallel or with different orientations, and with a sharp section – covers the bone's anatomical structure. It was caused by trampling – or in other words, strong mechanical erosion.

Moreover, in the Pech de l'Azé fauna the authors discovered a bovid sacrum with, on its ventral face, a radial system of U-shaped grooves that are likewise imprints of blood vessels displaying openings of capillary canals. The same phenomenon, observed on a sacral vertebra from the Lower Palaeolithic of Stránská Skála (Czech Republic), had been interpreted as an organized assemblage of engravings. It is therefore clear that the bones from Pech de l'Azé, Morín and Stránská Skála display natural vascular grooves and not engravings made by people. (It is worth remembering that, already in 1983, Shipman and Rose had pointed out that vascular grooves on bovid bones could resemble traces of defleshing.)

Current complexity in the study of marks on bones
In order to understand the problems posed by the study and
interpretation of marks on bones, and to try to find out if they are
intentional marks filled with meaning and hence foreshadowing the
creative expansion of the Upper Palaeolithic, they need to be placed in
a historical context, tracing the evolution of ideas and of observational
techniques. From Tertiary Man to marks left by animal teeth, from
symbolic meanders and shamanic travels to imprints of blood vessels,
there have been many different stages and examples of trial and error
in a research topic that today has moved beyond the early certainties.
Hesitations, doubts and errors are now expected, and through both errors
and triumphs each scholar makes a personal contribution. What is needed
today is great modesty, great caution and many questions.

Looking back at the history of the study of marks on bones, the
first lesson is that *every piece poses a specific problem*: only a rigorous
approach can hope to solve it – a long and detailed study involving both
photographic and optical analysis, often using the microscope, and if
possible experimentation, which makes it possible to reproduce the
observed facts and confirm the validity of one's interpretations. We now
know that deciphering a panel of engravings or an incised bone is not
an exercise comparable to reading clouds, inkblots, rock-shapes or cave
concretions! *Homo erectus* and successor species were doubtless already
artists, but demonstrating that claim requires a minimum of caution and
method. Modern analyses have put an end to the learned hypotheses of
the specialists who investigated the Pech de l'Azé bone. Shouldn't we all
learn a useful lesson in modesty and prudence from this affair?

The rapid eyeballing of a piece no longer suffices, which means that
very few incised bones have as yet benefited from the level and type of
study that would make possible an interpretation based on a perfect
knowledge of the document. Hence many researchers' positions on the
origin of graphic creations remain more or less statements of principle.
Having said that, most authors remain cautious. González Echegaray
(1988), for example, showed that some grooved bones from Cueva Morín,
despite their great resemblance to the finger flutings (macaroni) of the
early Upper Palaeolithic, were doubtless 'produced by natural causes....
[For some pieces] we cannot be absolutely certain that there is convincing
evidence for decorative intent. On the other hand, these artifacts cannot
all be so easily dismissed' (1988: 39). Hence the prehistorian often hesitates
between several interpretations. In the same way, Piero Leonardi (1976),
in a long article on European pre-Upper Palaeolithic incisions, constantly

All work and no play?

used expressions such as 'bones *in all probability* incised intentionally', '*probably* intentional incisions', 'we *cannot rule out* that they are intentional', 'some of these incisions are due *in all probability* to defleshing of the bone', 'while others *seem* intentional', etc. Such formulae speak volumes about prehistorians' uncertainty about marks on bones (FIG. 32).

Faced with a bone bearing incisions that *a priori* do not appear to have been produced by a banal domestic activity, the researcher needs to try to answer a succession of questions: (1) are they human or natural traces (animals or other)?; (2) are they intentional marks or accidental traces?; (3) if they are traces, what action can explain their formation?; and (4) if they are marks, are they the expression of abstract and symbolic thought or was there some other motivation behind them? We have described above the traps that one encounters in interpreting marks on bones; the

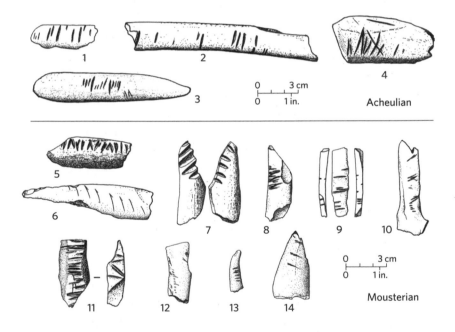

32. Examples of incised bones from the Lower and Middle Palaeolithic: (1–3) abri Suard (La Chaise de Vouthon, Charente), Upper Acheulian, Riss III (*c.* 150,000 to 200,000 BP); (4) Sainte Anne Polignac (Haute-Loire), Upper Acheulian, Riss III; (5) Kebara cave (Mount Carmel, Israel), Mousterian (*c.* 60,000 BP); (6) Cueva Morín (Cantabria, Spain), Typical Mousterian, Level 17, Würm II (*c.* 60,000–70,000 BP); (7) Le Moustier (Dordogne, France), Layer J, Typical Mousterian; (8–10) abri Lartet (Montgaudier, Charente), Quina-type Mousterian (*c.* 50,000–70,000 BP); (11) Cotencher cave (Switzerland), Late Mousterian (40,000–45,000 BP); (12) L'Esquicho Grapaou cave (Gard), Quina-type Mousterian (*c.* 50,000–70,000 BP); (13) La Quina (Charente, France), Quina-type Mousterian, reindeer antler; (14) Le Petit Puymoyen (Charente), Quina-type Mousterian (*c.* 50,000–70,000 BP).

Chapter 4

experience acquired during a century of research often makes it possible only to answer the first question. But what criteria can be used to answer the other three? How can one know if the incisions are *intentional* or *accidental*? How can we know if they are *symbolic, play, decorative* or if they were produced with some other intention and if so, what?

A great variety of gestures linked to very varied motivations can produce the *same* incisions, which are generally simple. Let us recall, to take one example among many, that a bone can be deliberately marked with the cutting edge of a flint tool or, with the same gesture and the same tool, accidentally incised when cutting strips from an animal hide placed on the bone: in both cases, the incisions obtained are identical. How does one then choose between these two actions, which doubtless imply very different mental processes? Similarly, it is difficult to distinguish between butchery traces made on a *fresh* bone still covered with flesh, and marks deliberately made on a *dry*, defleshed bone.

In the early twentieth century, Henri Martin had stressed the difficulty of making a distinction between accidental traces, decorations and signs, and he had shown that transverse striations in tiers on a diaphysis that look like 'decorative notches' could actually be nothing more than the accidental stigmata of using the bone. So an apparently 'organized' character is not in itself sufficient to demonstrate that incisions are intentional and symbolic.

The *location of the striations* on the bone can sometimes provide a useful indication for their interpretation. Incisions that are exclusively located on the epiphyses, at points where muscles and tendons are inserted, lead one to consider them as butchery marks. Unfortunately, defleshing striations are also produced on diaphyses when meat consumption includes a thorough cleaning of the bone. The *technique and depth of the incisions* can provide more information: deep incisions obtained by repeated passages of the tool can reveal a wish to affect the bone, either to mark it – sometimes with notches, formerly called 'hunting tallies' (La Quina) – or to attempt sawing, perhaps for simply utilitarian purposes (Grotte Vaufrey).

The *typological analysis of the motifs* made up of the striations highlights two essential characteristics. First, they are 'non-figurative'. Apart from one specimen at Bilzingsleben, which is very doubtful and almost certainly to be dismissed, they do not present any natural form that is identifiable by a modern prehistorian. In short, they do not seem to show any intention of depiction. Secondly, the vast majority of striations are made up of straight incisions, generally with a V section, less often a U.

All work and no play?

Some are regular, of uniform width, while others, which taper at their extremities, represent the rapid movement of the operator's hand (this can be accentuated in places by the curve of the surface on some bones).

The superimposition and intersection of these simple lines can accidentally produce complex, geometric 'motifs' that are not intentional at all: clusters of parallel lines left by a specific and repeated use of the La Quina shoulder-blade may have fortuitously created a kind of 'grid'. The multi-line pseudo-'rectangles' on a piece from Bilzingsleben could be the result of a series of banal linear incisions made in four episodes by turning the bone in the hand, but did these operations have a real graphic intention? This is by no means certain. One also needs to be extremely cautious when dealing with clusters of curved lines: at Quneitra, Israel (Rabinovich 1990), a magnificent structure of concentric lines on a Mousterian bone has been attributed to a carnivore trying to keep the bone between its claws and its jaws. So the interpretation of such simple and rare motifs is always delicate.

The 'happy few'

There are four pieces that particularly stand out from the mass of Middle Palaeolithic marked bones, from La Ferrassie, Bacho Kiro (Bulgaria), Turské Maštale (Tetin, Czech Republic) and Border Cave (South Africa). The first two pieces offer the most striking proof of the graphic capacity of some Neanderthals, although there are some other compelling examples too, such as from Prolom II cave in the Crimea, where the Middle Palaeolithic layers have yielded a large number of perforated bones as well as a horse canine marked with five parallel lines and a saiga phalange bearing a fan-like engraved motif (Stepanchuk 1993; see Bahn 2016: 28–29 for other examples) (FIG. 33).

- La Ferrassie: the regularly spaced parallel lines on the 'La Ferrassie bone', discovered by Louis Capitan and Denis Peyrony, combine to form an original, apparently 'decorative' motif that is clearly intentional; this is troubling in a Mousterian context. Bones decorated with close-set parallel striations, oblique or horizontal, are found in several Aurignacian sites, especially in the Aurignacian II of the shelter of La Ferrassie itself, the abris Castanet, Blanchard and Cellier (Dordogne), the cave of Aurignac (Haute-Garonne), in the Châtelperronian levels of the caves of Arcy-sur-Cure (Yonne) and, apparently, in the cave of Les Cottés (Vienne). Very similar to the La Ferrassie bone,

these pieces sometimes have lateral notches. The tradition then persists on bone rods or spear points throughout the Upper Palaeolithic, especially in the Solutrean (Le Placard), the Magdalenian (Laugerie-Basse, Teyjat, Lortet, Gourdan, etc.) and the Romanellian (Polesini in Italy) (Chollot-Varagnac 1980). They have sometimes been seen as 'hunting tallies'. Peyrony (1948) saw them as 'a kind of account book identical to those used in the past by our bakers' (FIGS 33, 34).

· Bacho Kiro: this bone fragment, from Layer 12 in the cave, displays a motif made up of broken lines created one after another, and not with one continuous line. In a Mousterian context dating to more than 47,000 years ago, this is a find as exceptional as the La Ferrassie bone – indeed, it is totally unique at this stage of human evolution (FIG. 33).

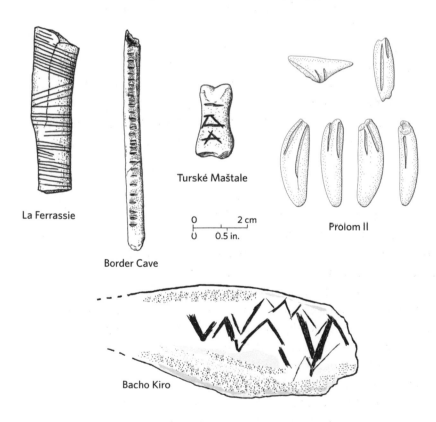

La Ferrassie

Border Cave

Turské Maštale

Prolom II

Bacho Kiro

0 2 cm
0 0.5 in.

33. The 'happy few': the Lower and Middle Palaeolithic bones with striations organized into geometric motifs that can be considered intentional and symbolic.

All work and no play?

- Turské Maštale: a geometric motif decorates this red deer phalange, from the last chamber of the cave (FIG. 33). It was found by Jaroslav Petrbok in a layer attributed to the Middle Palaeolithic (Riss-Würm Interglacial or early Würm), and in any case 'pre-Aurignacian'. Although its cultural attribution is uncertain, the bone, described and illustrated by Jiří Neustupný (1948), bears one of the oldest known geometric decorations, doubtless contemporaneous with that of Bacho Kiro. It is 3.5 cm (1.4 in.) long, and its posterior face was entirely flattened, while the anterior face has an incised decoration made up of four horizontal lines arranged transversally, and two nested chevrons. It seems that the two upper horizontal lines were obtained with two successive incisions. This decoration could be a complex intentional design made up of the association of transverse and oblique parallel lines – that is, the combination of a grid and chevrons. The use of chevrons also appears at Bacho Kiro.

- Border Cave: this baboon fibula, decorated with twenty-nine regularly spaced incisions, came from a level older than the early Upper Palaeolithic, dated by radiocarbon to about 38,000 BP (FIG. 33). By this time the site had already been long frequented by proto-Cro-Magnons (Beaumont 1973).

When studying these and other incised bones, it is critical that in addition to the examination of the marks themselves, one should also take into account the different contexts of each piece.

Firstly, the *palaeontological context*. All the bones bearing striations that have been discovered at a site need to be considered, in order to appreciate better the exceptional nature of some of them, and to judge better the originality of each layout of lines. Such a global approach would make it possible to perceive more fully the diversity of marks on bones, which generally cover all the stages from simple striations to complex ones; from straight striations to curved ones; from single striations to double, triple, quadruple or multiple ones; from those that intersect at right angles to clusters of lines; from anarchic and tangled striations to organized ones, convergent or laid out in more or less parallel fashion; and spaced regularly or irregularly. All types and all layouts seem to be present in the same archaeological layers, even if a few particular groups are repeated. Only a global statistical

study would make it possible to verify whether – among the millions of gestures made by Mousterian and Acheulian hunters to butcher their prey every day, work bone material or use it in various ways that are hard to imagine today – occasional apparently 'organized' layouts,

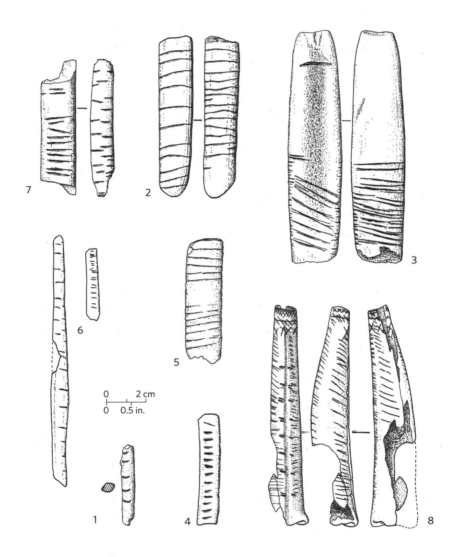

34. Incised or notched Mousterian and early Upper Palaeolithic pieces: (1) Cova Beneito (Alicante, Spain); (2) Aurignacian II of La Ferrassie (level of flattened losange points); (3) Aurignacian of the abri Blanchard (Dordogne), reindeer antler smoother with lateral notches; (4) Aurignacian of the abri Cellier (Dordogne); (5) Aurignacian, Aurignac cave (Haute-Garonne); (6) Châtelperronian, Arcy-sur-Cure (Yonne); (7, 8) Châtelperronian (or Aurignacian), Grotte des Cottés (Vienne); 8 is a reindeer cannon bone used as a flask for ochre.

All work and no play?

which may look astonishing when separated from their context, were spontaneously produced. The selection of these rare pieces may give them an artificial importance and a misleading meaning. So it is necessary to take all the data into account, both rigorously and objectively. The multidisciplinary study (both palaeontological and archaeological) of marks on bones could be illuminated – as was, for example, the taphonomic study of the Mousterian animal bones of Quneitra (Israel) – by comparisons with the various ways in which living animals today, either rodents or zoo carnivores, modify bones (Rabinovich 1990).

Secondly, the *palaeo-ethnographic context* of pieces should be analysed scrupulously. Although this is not always a determining factor, it would be good to ask if the bones with exceptional marks come from a particular location in the site or if they are mixed with other vestiges, and especially with food waste bearing simple defleshing striations. The marked bones from Bilzingsleben, which captured the attention of the excavators, seemed to be associated with a workshop, and an incised bone from the abri Suard (Charente) appeared to be near a reindeer-antler structure of unknown significance (Debénath & Duport 1971). Unfortunately, in both cases, the precise relationships of the marked bones with the structures are uncertain.

It was on 19 September 1909 that Capitan and Peyrony discovered 'the bone presenting fine intentional grooves' at La Ferrassie, among the bone remains assembled above the skeleton in Neanderthal Burial No. 1. They specified that the bone was definitely in the reddish-brown Mousterian layer in a clearly established stratigraphy, made up of undisturbed layers of different colours. The decorated bone therefore seems to be Mousterian, like the burial. Capitan and Peyrony suggested that it was intentionally associated with the latter, which thus gave it the function of a kind of 'offering' and a specific symbolic role. Although the association between bone and burial remains hypothetical, its location and decoration make this object a quite remarkable element in a Mousterian context (Peyrony 1934).

One final point to make is that all the marks we have discussed above, including the most organized – the layouts of parallel lines, tiered lines, and so on – are found on 'the faunal remains of the rich sites of all periods till the Neolithic', without prehistorians being tempted in these later contexts to attribute any kind of symbolic meaning to them at all; this was the case, for example, in Fumane cave (Italy), where a collection of marked bones was published with photos taken with an electronic microscope (Bartolomei et al. 1992).

In summary, there is no doubt that *Homo erectus*, the Neanderthals and the proto-Cro-Magnoids, for several hundred millennia, produced striations on countless bones for extremely varied reasons, the commonest of which were butchering prey and defleshing bones. Among these striations, some that appear more complex and more organized have sometimes been interpreted as 'intentional and symbolic', with no formal or objective proof having generally been provided to support such a hypothesis. However, a few exceptional pieces – the decorated bone fragments listed above, from La Ferrassie, Bacho Kiro, Turské Maštale, Border Cave and Prolom II – introduce into this domain some geometric graphisms which may be symbolic. They attest that some Neanderthals and pre-*sapiens* were close to the threshold that marks the appearance of the great art of the Upper Palaeolithic.

Striations and incisions on stone

Incised lines are generally less numerous on stone than on bone, but the same doubts as for marks on bone apply to these incisions, which are mostly very hard to interpret. Some can be explained by natural causes: landslips and other natural processes (such as glacial solifluction) lead to rubbing against other rocks, and trampling of prehistoric floors has the same effects on stone as on bone. Animal clawmarks are also a possible cause, but on the other hand gnawing and biting can fortunately be eliminated from the list of phenomena that might explain marks on stone, as can the defleshing striations that are so common on bones. When the striations are regularly arranged deep grooves, human action can sometimes be envisaged, but it is then difficult to know if they are stigmata from a utilitarian operation, or marks with a graphic – perhaps even symbolic – intention.

Enigmatic striations on stone have been observed in Lower Palaeolithic sites, for example at Olduvai Gorge (Tanzania), where Mary Leakey described a round phonolite cobblestone with a groove and an area of pecking (1971: 269). In the Acheulian of Terra Amata (Nice), dating to around 380,000 BP, three incised pebbles were presented by Franck Bourdier (1967) and Piero Leonardi (1976) as intentionally marked pieces; but at the same site, microscopic analysis has revealed other lines on a limestone chopping tool, which were at first thought to be engravings, but which in reality were natural marks caused by the presence of fossils in the material. So the risks of error are obvious.

All work and no play?

In the nearby Upper Acheulian of Lazaret (Nice), eighteen pebbles and several fragments of bone diaphyses display traces of crushing and little striations, which the site's authors' monograph interpreted – with a high degree of probability – as objects 'used by fishermen and cobblers to protect the palm of their hands from needle points. Placed in the hand, these pebbles or bones served as a support as well as protection against injury when prehistoric people were trying to pierce tough materials such as hides, for example.' Their location inside the dwelling, in areas for rest and work, argues in favour of this interpretation (de Lumley et al. 1969). This hypothesis, based on ethnographic observations, as well as on experiments and practice, can doubtless be extended farther. Many domestic tasks, such as cutting with flints or piercing hides – the abundant and varied working of organic materials, knapping, retouching, resharpening the cutting edges of stone tools (which can easily injure bare hands) – require protection and a point of support, which could be either pieces of wood (long disappeared) or the pebbles and bone fragments that today bear the stigmata of such use.

Other uncertain incisions on pebbles are known from the end of the Lower Palaeolithic at Baume Bonne (Basses Alpes, France), Markkleeberg (Germany) and the Grotta dell'Alto (Italy). And at the Grotte de l'Observatoire in Monaco a limestone bifacial side-scraper, dating to the Acheulian, also has striations (Boule & de Villeneuve 1927) (FIG. 35). A close examination of the excellent photograph that illustrates this tool in the publication of the Observatoire cave seems to show that some of these lines are deep V-shaped grooves whereas others, made earlier, are fine incisions. All these marks intersect at right angles and are laid out geometrically, so they seem to be intentional; they also occur on the tool's retouched edge, and were thus made after it was shaped. However, a direct study of the piece would be needed in order to be more certain.

In the Mousterian, marked stones seem to become a little more numerous; one can cite a few tools the cortex of which bears lines that look engraved, notably a side-scraper from the site of Hermiès (Somme) (FIG. 35). This tool was described by the excavator Victor Commont (1916) as a side-scraper made 'from a flint nodule that had been used previously as an anvil' – which rules it out as a portable engraving. But it was nevertheless presented by the author in order to show the difficulties of reading these pieces that are open to different, and often opposing, interpretations.

35. Examples of incised stones from the Middle Palaeolithic:
(1) Temnata cave (Bulgaria), engraved schist dating to *c.* 50,000 BP;
(2) Hermiès (Somme), incised Mousterian side-scraper with
cortex; (3) Grotte de l'Observatoire (Monaco), Mousterian; (4)
Isturitz cave (Pyrénées-Atlantiques), 'Mousterian earlier than
typical', quartzite bifacial cutter with incisions.

Other finds include a bifacial implement made from a quartzite pebble
from the cave of Isturitz (Pyrénées-Atlantiques), which has a series of
incisions that were considered to be 'glacial striations' (Saint-Périer 1952)
(FIG. 35); basalt or limestone pebbles from the Mousterian of the cave
of Combe Grenal (Dordogne), with fine incisions in all directions; from
Hungary a fossil with an incised line from the Middle Palaeolithic of
Tata (Marshack 1991) and a pebble with two deep, parallel and polished
grooves from the open-air Mousterian site of Erd (Gábori-Csánk 1968);
and a strange little semi-spherical sandstone pebble from the Charentian
Mousterian (Layer VIII) of the shelter of Axlor (Biscay, Spain), with, on its
flat side, a cross-shaped engraving (de Barandiarán 1980; García-Diez
et al. 2013) (FIG. 36).

All work and no play?

36. Semi-spherical sandstone pebble from Axlor (Biscay, Spain) with a cross-shaped engraving (Charentian Mousterian).

Amid this unconvincing and generally little-studied assemblage, three pieces stand out as being perhaps more significant for research into the origin of art – more serious candidates for the list of engravings that predate the Upper Palaeolithic. At least one is unquestionably engraved:

· In the Temnata cave (Bulgaria), an engraved fragment of schist, dated stratigraphically to about 50,000 BP, came from a transitional layer between the Middle and Upper Palaeolithic. It is decorated with 'two series of parallel lines arranged in two registers; a first series of twenty-one short lines on an edge, and a second register of twenty-one longer lines; all are V-shaped incisions made with the same tool' (Crémadès et al. 1995) (FIG. 35).

 This piece is truly exceptional: the homogeneity of the incised lines, the regularity of their length and of the spaces between them, and of their techniques of execution, as well as their general tendency towards parallelism and occupying the whole space available on the two faces in question, together unquestionably make this an 'engraved stone' that can be compared in every way with the portable artworks of the Upper Palaeolithic. Direct examination of the object, which one of us (ML) was able to undertake thanks to Michèle Crémadès, led us to agree fully with her reading, and to consider that the engraved schist of Temnata is indeed, in her words, 'one of the oldest graphic manifestations on stone in Europe'.

 Its cultural context was specified by the authors of the study: the object was in a layer located between a Mousterian level (dated by thermoluminescence (TL) to 67,000 ± 11,000 BP) and

an Aurignacian, among the earliest in Europe, dated by TL to around 46,000 ± 8000 and 45,000 ± 7000 BP. It was associated with an industry that had both Moustero-Levalloisian and Upper Palaeolithic characteristics (standardized blade production) and which could be derived from the Mousterian tradition of foliate points in the Balkans.

- At the site of Brno-Bohunice (Czech Republic), an engraved pebble dating to 42,000 BP was found in a Bohunician transitional layer associated with a lithic industry of Levalloisian technique comprising Upper Palaeolithic elements. The presence of these elements (carinated scrapers) has led many prehistorians to place the Bohunician at the very beginning of the Upper Palaeolithic (Valoch 1976; Farizy 1990; Kozlowski 1992) (FIG. 37).

 According to Karel Valoch (1996: 135) it is a limestone pebble (7.1 × 6.2 × 3.4 cm or 2.8 × 2.4 × 1.3 in.), brought to the site from elsewhere, and with possible engravings. The right half of the flat upper plane is strewn with more or less parallel grooves running obliquely from the edge to the centre. The lower extremity has a few straight lines drawn across it. The upper part of the thick left edge has a shape evoking a vulva in which probably natural fissures were completed by grooves. The whole surface of the pebble, and consequently all the grooves, underwent later corrosion. So the origin of the grooves and striations is difficult to evaluate.... In view of the pebble's

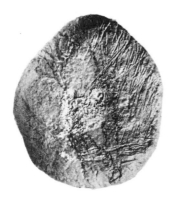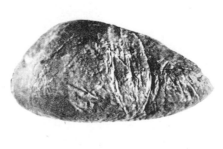

37. Limestone pebble with multiple incisions from Brno-Bohunice (Czech Republic), Bohunician in date (between 42,000 and 38,000 BP).

All work and no play?

physical condition, it would seem there is little chance of being able to demonstrate that the lines were intentional.' So unfortunately in this case the object's state of conservation does not enable us to know if, as at Temnata, we are faced with an 'engraved stone'.

- The third specimen is a 'flint cortex' with organized lines, discovered in the open-air site of Quneitra (Israel) (FIG. 38). The associated industry was a Levantine Mousterian dated here by electron spin resonance (ESR) to about 53,900 ± 5900 BP. This date places the site in the period during which Neanderthals and modern humans lived side by side in the region, adopting the same Mousterian culture.

The piece comprises a small plaque, 7.2 cm (2.8 in.) long, with concentric lines; the underside 'contains a number of fractured flint nodules surrounded by a relatively loose conglomerate containing tiny seashells and sand' (Marshack 1996: 357). The lines making up the 'decoration' comprise four central concentric 'incisions' laid out at regular intervals: 'Analysis suggests that the lower and upper arcs may have been incised first... and that the two inner arcs may have been more lightly incised later.' Microscopic analysis enabled Marshack to detect 'tool strokes' and find that each mark is in fact 'a broken line made up of a series short incisions'. This central area was surrounded at left and right by curves and more or less

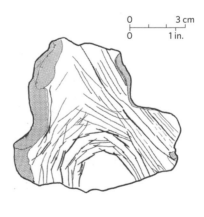

0 3 cm
0 1 in.

38. Piece of flint cortex from Quneitra (Israel) with nested semicircles and straight lines (Middle Palaeolithic).

straight lines that, in places, are interrupted by the stone's edge. Marshack considered that this was a 'symbolic composition' and 'the earliest known depictive image'. The intention was to produce a programmed and controlled geometric image.

This interpretation seems plausible, since the chrono-cultural context places the find at the end of the Middle Palaeolithic in a phase marked by a slow accumulation of the beginnings of Upper Palaeolithic art. However, the geological origin and constitution of this plaque remain unknown; one might wonder if it is not simply a stalagmitic concretion, the internal concentric structure of which was exposed by phenomena of erosion. In order to be totally convincing, the technological study of the lines should have been based on an in-depth mineralogical and petrographic study of the support, but unfortunately that was not done. Be that as it may, even if this motif were natural (which remains to be demonstrated), its presence at the site proves that people were interested in this curiosity.

Few examples of portable engraving are known from the early Upper Palaeolithic or from Eastern Europe. One of the earliest is the geometric motif on a plaquette from the Châtelperronian Grotte du Loup in Corrèze (Leroy-Prost 1984: 45), and a late Mousterian limestone slab from the cave of Tsonskaïa in the Caucasus has a cross engraved on it (Frolov 1981: 63, 77; 1977/9: 153–54, 85). However, the later Upper Palaeolithic of Western Europe – and especially the Magdalenian period – has yielded a huge abundance of engraved stones, primarily in the form of flat plaquettes, many of which were deliberately broken (see Bahn 2016: 133–35).

In sites such as Parpalló, Foz do Medal, Enlène, Gönnersdorf and Labastide there are many engraved plaquettes (over 5,000, 1,260, 1,150, 500 and 50 are known respectively), but there are hundreds more without engravings in some of these sites. Enlène (Ariège, France) has tens of thousands of plaquettes, brought in from a source some 200 m (650 ft) from the cave; excavation has shown that an area of over 5 sq. m (50 sq. ft) of cave floor was paved with them, no doubt a measure against humidity, and this paving includes engraved specimens (Bégouën & Clottes 1981: 42; 1983; 1985). A similar area of cave floor at Tito Bustillo (Asturias) had eighty-three plaquettes, twenty-five of which bore engravings ranging from animal figures to simple incisions (Moure Romanillo 1985: 103). At the late Magdalenian open-site of Roc-La-Tour I (northernmost France), thousands of schist plaquettes were brought in as paving,

All work and no play?

but only about 600 fragments (10 per cent) have engravings (Rozoy 1985, 1988, 1990). Similarly, at Gönnersdorf (Rhineland-Palatinate), several tons of schist plaquettes were brought to the open-air site as elements of construction and as foundations for structures; only 5 to 10 per cent of them were engraved, and these seem to be distributed at random among the others (Bosinski 1973). This suggests that the engravings lost all value once a ritual had been performed and they had been broken and dispersed; or simply that they never had any ritual significance, and were done simply to pass the time, for practice or for storytelling.

Another possibility is that some sites were sanctuaries: certainly this was the interpretation of a grouping of engraved blocks at La Madeleine in Dordogne (Capitan & Peyrony 1928; Tosello 2003a: 447). At Parpalló (Valencia) there are thousands of plaquettes, but the living space is not big, so here it is possible that they were ex-votos placed in a sanctuary, since the cave itself resembles a giant vulva (Barandiarán 2006: 169). Perhaps the strongest candidate, however, is Bédeilhac, where there are hundreds of little plaquettes that were turned into simple figures by the addition of an eye or muzzle; since some are brilliant and others terrible, it seems likely that many different people of varying ability were involved, and this has been interpreted as an entire community making popular art, for ceremonies that took place 700 m (2300 ft) inside the cave, and with each person making their own ex-voto (Sauvet 2004).

Where engraved stones are concerned, it should be noted that, although it is the fine figurative examples that tend to get published, there are far more that are undecipherable, either because they are tiny fragments, or because they are non-figurative. At Roc-La-Tour I (Ardennes), for example, about 600 small engraved fragments have been recovered, but there are only twenty-five 'readable' figures so far (Rozoy 1990).

Other stones have a confused mass of superimposed lines (as on the slabs of La Marche in Vienne, or the pebbles of La Colombière in Ain). Experiments have shown that a fresh engraving is very visible due to the presence of white powder in the incisions; when this is washed off, the effect is like wiping chalk off a slate, and a new engraving can be made, quickly and easily (Bosinski 1973: 41; Rozoy 1988: 176; Russell 1989a, 1989b: 242–47; Tosello 2003b). This suggests that some of the engravings only had significance for a very brief time, and that the 'associations' of superimposed animals on a given surface are not necessarily meaningful; on the other hand, there were plenty of stones available, and each figure could easily have had one to itself if desired

(as is generally the case at Enlène, for example), so the superimpositions may indeed have had some significance.

Study of the La Madeleine stones led the excavators to see lots of practising and corrections in the engravings, which they therefore called 'feuilles d'étude et croquis' (studies and sketches). Some juxtaposed drawings can be very different in execution, indicating different artists at work – sometimes both are expert, sometimes not, so their conclusion was that this was an 'Ecole d'Art' (Capitan & Bouyssonie 1924; see also Tosello 2003a: 32–33, 39). At La Marche, on the other hand, studies point to the absolute mastery of the morphological and mechanical properties of the stones – the selection of flat surfaces, the adaptation of figures to the shape available, and of course the superb quality of the images themselves. There are no mistakes, and the hands responsible were both practised and skilful (Mélard 2008: 194–98).

In short, the study of marks on bones and stones has progressed enormously since the days of the early pioneer scholars, and the use of experimentation and of new technology has revolutionized our view of the antiquity and variety of non-utilitarian marking by early humans.

All work and no play?

Figuring it out: pierres-figures and the first carvings

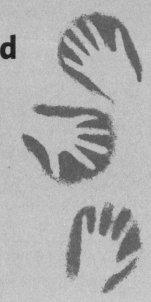

The publication between 1847 and 1864 of the three volumes of *Antiquités Celtiques et Antédiluviennes* by Boucher de Perthes constitutes one of the foundation stones of prehistoric archaeology: it confirmed the existence of a fossil man who was contemporaneous with extinct animal species, laid the foundations of the stratigraphic method, and distinguished the two major periods that today we call the Palaeolithic and Neolithic. From the start Boucher de Perthes attributed well-developed cognitive capacities to early humans, and he took great interest in 'pierres-figures' (unmodified natural rock and stone forms). He collected 'an incredible number of different stones in whose shapes he thought he could recognize signs and symbols of past times. But alongside his eccentric views concerning pierres-figures, and the origins of art and language, his book does contain observations and conclusions and even the broad outline of the method that prehistoric archaeology was to accept and develop' (Laming 1964: 160).

Many prehistorians who are anxious to be objective certainly consider Boucher de Perthes' albums to be 'eccentric', and when they encounter pierres-figures in their research, they put them aside disdainfully. It is clear that the signs and symbols in the flints and stones that Boucher

de Perthes collected in the alluvia, sandpits and peat bogs were mostly creations of his imagination. He saw them as preconceived conscious productions, whereas in fact they were just the kind of natural forms that stones or some worked flakes can take on. For the most part, there is absolutely no human intervention in their production or their shapes. He even included in his collections some curious objects that he fully accepted were 'not worked' and did not result from human intervention, but may have been collected by 'antediluvian man' simply because they had evocative shapes.

Certainly Boucher de Perthes was a pioneer in turning the attention of researchers to astonishing objects that can sometimes be important. He recommended that all debris should be collected, even if it is not spectacular, and this quest for exhaustivity was to develop in modern prehistoric research, going beyond the previously selective interest in what were called 'type fossils'. His work also posed some fundamental questions: Starting in which period did early people have the same psychological reactions as modern humans? When did they start being intrigued by curiously shaped objects, and did they too collect them, just as many of us spontaneously still do today? And how can one objectively identify human intervention on these pieces?

A comparison between a sample of the pieces collected and illustrated by Boucher de Perthes and a series of little soft-limestone statuettes from Kostenki in Russia (after Abramova 1995), dated to between 30,000 and 20,000 years ago, is presented in FIG. 39. In both series we can see the same approximate, stylized, evocative shapes displaying the main characteristics that make possible a rapid identification of the depicted subject. So the Palaeolithic statuettes are not so far removed from the natural objects collected by Boucher de Perthes, but in the case of Kostenki the statuettes were found in the course of excavations in archaeological layers, and they are sculptures, or in other words pieces shaped by man.

Modern research is based on a few essential criteria for proving the existence of human intervention: the certainty that an object was transported to the discovery site and/or the presence of traces of retouch on a natural object. Prehistoric people collected curiously shaped stones, not only pierres-figures but also fossils, shells and precious stones. When these were not retouched and modified, it is the transportation to the dwelling that distinguishes them and gives them the status of archaeological remains of interest to researchers because they illustrate human behaviour.

39. (Top) Examples of pierres-figures collected and illustrated by Boucher de Perthes that, in his view, are 'figures and symbols of the antediluvian period'. (Above) marl limestone statuettes from Kostenki: (1) bison statuette from Kostenki 4; (2) mammoth statuette from Kostenki 1 (second complex); (3) rhinoceros statuette from Kostenki 11; (4, 5) polymorphous heads from Kostenki 1.

In order to highlight the difficulties encountered by prehistorians when faced with pierres-figures, we present a second example in FIG. 40. The open-air Palaeolithic site of Les Pradas (Laval-Saint-Roman, Gard) has been explored for many years by Jacqueline Hochapfel-Altes, who has collected 1,600 pieces that she has deposited at the Museum of Alès, where one of us (ML) was recently able to examine them; they remain unpublished. This is a flintworking site on a hill where there are flint outcrops in the Stampian limestone, according to geologist Jean-Joseph Blanc. The abundant industry, which comprises choppers, chopping tools, side-scrapers, points, denticulates, Levallois nuclei, and so on, belongs to the 'Middle Palaeolithic with a bit of Gravettian' according to Sylvain Gagnière and Jean Combier (pers. comm.), who have studied the material (there are certainly a few Gravettian points among the material

in the Alès museum). Among this site's abundant waste flakes and flint tools, Hochapfel-Altes has collected numerous pierres-figures. For example, there are small 'weathered natural nodules of pyrite/marcassite, transformed into limonite of the upper Aptian', according to Blanc, who is studying the site. One of them looks astonishingly like a female statuette (FIG. 40, NO. 1).

40. Pierres-figures (1–3) collected from the site of Les Pradas (Gard, France) by Jacqueline Hochapfel-Altes, compared with examples (4–6) of real female statuettes: (1) 'natural ferruginous concretion from the Aptian', according to J. J. Blanc, geologist at the University of Montpellier; (2) natural flint nodule from the local Stampian (J. J. Blanc); (3) small, flaked block of flint, retouched by prehistoric people according to Hochapfel-Altes; (4) limestone statuette from Weinberg (Bavaria, Germany); (5) ivory statuette from Khotylevo II (Russia); (6) decorated ivory statuette from Mezin (Ukraine).

Figuring it out

Another equally remarkable object is a small flint nodule that is also from the Aptian layers, at the top of the hill (FIG. 40, NO. 2). It not only has a shape that evokes two breasts (at top), but also massive buttocks with a light groove separating them. Finally, and perhaps even more surprisingly, there is a little block of flint (8 cm or 3 in. long – FIG. 40, NO. 3) that bears traces of removals of material, especially at the two ends, which are more slender than the central part; here again we have the general shape of a female statuette.

By way of comparison, FIG. 40 also illustrates statuettes from Weinberg (Germany, NO. 4), Khotylevo II (Russia, NO. 5) and Mezin (Ukraine, NO. 6), all three of which have thinned extremities and a broader central mass that suggests breasts and buttocks. These three statuettes are made of limestone and mammoth ivory, and were discovered in the course of excavations in Gravettian levels (dating to around 25,000 BP), or a little later at Mezin. They bear a striking resemblance to the three pieces from Les Pradas – but should we consider the Pradas pieces to be 'Palaeolithic figurines'?

The arguments in favour of an identification of this kind can be summarized as follows: the general shapes of the Pradas objects and the statuettes; the presence of the Pradas objects amid Palaeolithic industries (Middle and Upper Palaeolithic, and especially Gravettian, the principal period for statuettes); and the presence of traces of removals of material from the small flint artifact. But there are two main arguments against any acceptance of the Pradas objects as statuettes: they were discovered on the ground, on the surface and in the open air, and not in well-dated archaeological levels like most of the statuettes; and they are in local materials – nodules of pyrite/marcassite, which abound in this place for geological reasons, and flints from the natural outcrops exploited at the site. The flint we have singled out (FIG. 40, NO. 3) could simply be a waste flake, a kind of stub resulting from the intensive working of a block, and not the purposeful carving of a figurine. When all is said and done, there is no proof that the Les Pradas pieces are the result of deliberate choices, nor of transportation, nor of conscious working by prehistoric people. In fact we have absolutely no certainty either way, and this is doubtless what makes such finds really interesting to archaeologists. Since the remotest periods, people have taken an interest in natural curiosities; prehistorians and prehistoric people are quite alike... but in the course of evolution prehistorians have acquired the ability to have doubts!

Caution should always be advised, but it is worth recalling here the statuette of Monpazier (Dordogne), which was likewise discovered

in a surface site, among Upper Palaeolithic worked flints. It is crudely worked in an iron concretion, iron hydroxide with a limonite base (like some nodules at Les Pradas), but some of its apparently carved features, especially a large vulva, are particularly convincing (Clottes & Cérou 1970; Delporte 1979: 78).

First figurines?

The South African Makapansgat 'pierre-figure', described earlier (p. 64, PL. XII), is our earliest possible evidence of the long history of collecting natural forms. Such curious objects, sometimes retouched by humans, led to the domain of sculpture.

An Acheulian female statuette?
During excavations in 1981, a little pebble of volcanic rock that was to trigger an international debate was discovered by Naama Goren-Inbar at the open-air Acheulian site of Berekhat Ram (Israel). The archaeological layer containing the object, interpreted as a 'statuette' by the discoverer and several other specialists, yielded a Levallois industry with side-scrapers and handaxes, which also included a few burins and end-scrapers. Its age is estimated at around 280,000–250,000 BP. In fact the level is sandwiched between two basalt flows, the upper one dated by a radiometric method to 233,000 ± 3000 and the lower one to 800,000 years ago (Goren-Inbar 1986).

The object in question is a small nodule, 3.5 cm (1.4 in.) long and 2.5 cm (1 in.) wide, roughly ovoid in shape and weighing 10.33 g (0.36 oz) (FIG 41). Its general yellow-brown colour is due to the presence of iron oxides. The material it is made from has been identified as a fissured volcanic scoria which, according to Andrew Pelcin (1994), would have acquired its grooves and its oblong and aerodynamic form when it was ejected by an eruption; in his view it is an entirely natural object and not a 'figurine'. Another vulcanologist, Sergiu Peltz, claimed the object is a fragment of an agglomerate of basaltic lapilli tuff that has been retouched and worked by humans – in which case it is indeed a statuette (Goren-Inbar & Peltz 1995). It is certain that the stone is of local volcanic origin, and that it was found in a gravel containing numerous other pieces with the same composition.

The debate about the material was then replaced by one about the object's morphology: several researchers (Goren-Inbar 1986; Goren-Inbar & Peltz 1995; Marshack 1997; d'Errico & Nowell 2000) consider it a kind

41. The Acheulian 'proto-figurine' from Berekhat Ram (Israel), dating to around 280,000–250,000 years ago. It is a largely natural volcanic nodule, just 3.5 cm (1.4 in.) long, but there has been much debate over the extent to which it was modified by early humans.

of 'pierre-figure', retouched by humans to accentuate its resemblance to a female outline. This interpretation highlights the cognitive capacities of *Homo erectus*, and the very ancient origin of symbolic non-utilitarian behaviour and of plastic figurative expression. With all its theoretical implications, this reading resembles that of the 'feline bone' of Bilzingsleben by Mania (1991) (see pp. 131–34). In contrast, several other specialists expressed scepticism regarding this position (Chase & Dibble 1987; Davidson 1990). The debate was interesting because, once again,

Chapter 5

it highlighted general methodological problems and posed the fundamental question of the objectivity with which the archaeologist looks at exceptional discoveries. It is clear that our ways of looking depend on hypotheses and *a priori* theories.

In the current state of research, one should favour the opinion of those very few prehistorians who have examined and directly studied this remarkable piece (Goren-Inbar 1986; Marshack 1997; d'Errico & Nowell 2000). Goren-Inbar sensibly provided a precise, full-size drawing; it is the small size and modest appearance of this little pebble (which could have passed unnoticed by prehistoric people and prehistorians alike) that astonish one immediately, an impression that is somewhat betrayed by the macro-photos that increase its visual impact. She distinguished three artificial grooves: one horizontal and two longitudinal on either side of the piece. In her view the transverse groove demarcates a rounded mass that represents a 'head', whereas the lateral grooves, perpendicular to the first, highlight protuberances that represent 'arms'.

Marshack (1997) carried out a detailed microscopic examination of the nodule, and published excellent colour photographs with his description. According to him, there is 'a slightly rounded head at the rear but a relatively flat "face" in front'. The groove accentuating the 'neck' is straight at the back and curved at the front to highlight the 'chin'. The end of the neck groove from the rear arcs upward and passes over the neck groove coming from in front, which angles downward, in a kind of mismatch. In the mass of the 'head', Marshack saw a slightly convex 'face' flanked by two small lateral masses depicting 'hair'. The 'chest and shoulders' were partially scraped and flattened, the right arm was bent at the elbow. On the left side, however – in contrast to Goren-Inbar – he felt there was no 'arm'. All these traits suggested a crude image of a heavy, large-bosomed woman.

The photographs showed a few troubling details, such as some parts of the neck, or the mismatch of the ends of the groove in front of and behind the neck (FIG. 42), which seem to show a localized artificial deepening of the horizontal groove; yet no internal striation that could confirm this impression can be seen in the groove. The scraping marks on the chest and shoulders are also invisible. Marshack's article did not eliminate from the mind of the reader (who has no access to the real object) a general impression of subjectivity due to the fact that, despite their quality, most of the photos are hard to read, and the description includes anatomical terms (head, arm, chest, hair, etc.) which implicitly suggest from the start that this is a 'female figurine', whereas this should have been demonstrated through an objective analysis, using neutral terms.

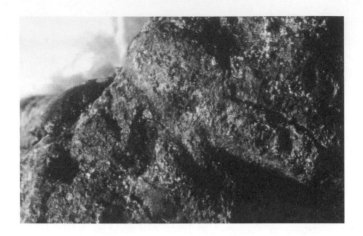

42. The neck of the Berekhat Ram proto-figurine. Marshack's close-up photos revealed much fine detail, but interpretation of the object remained largely subjective.

On looking at the images and information supplied by these experienced specialists, one cannot help but be amazed not only at the extraordinary age of this 'statuette' but especially at its strange resemblance to the Gravettian 'venuses', which are likewise characterized by a massive, stocky appearance and accentuated sexual traits. Indeed, an oval cavity, probably formed by a bubble in the volcanic material, can be seen in the stone's front; it even appears in Marshack's drawing; should one interpret this as a 'vulva', which would complete the similarity to the Upper Palaeolithic figurines?

How can one explain this general resemblance? Could humans maintain or rediscover the same symbolic image of woman over hundreds of millennia? The persistence of handaxes, themselves symbolic forms, and the presence of Upper Palaeolithic tool types (scrapers and burins) in the layer with the 'statuette', show that models can be transmitted over gigantic chronological distances. Or is this simply a phenomenon of convergence? Here we are reaching the limits of science. We also need to be wary of the uneasy feeling that we are unconsciously projecting the models of the Upper Palaeolithic onto the products of their remote ancestors... perhaps even onto an anonymous, humble little pebble that was not asking for that much.

Marshack's basic conclusions were subsequently tested by a scanning electron microscope analysis, combined with a methodologically rigorous experimental and comparative study that confirmed that the object, albeit not necessarily a figurine, was indeed modified by humans, and probably

took between 15 and 30 minutes to carve (d'Errico & Nowell 2000). It is worth noting here too that a different Acheulian 'figurine', a 5.8-cm (2.3-in.) piece of quartzite from the Moroccan site of Tan-Tan, is in fact entirely shaped by weathering and has no clear trace of human modification (see Bednarik 2003).

The 'mask' of La Roche-Cotard

In 1976 Jean-Claude Marquet undertook a series of important excavations on a slope of the Loire valley at La Roche-Cotard, near Langeais (Marquet 1976). Over several decades this multidisciplinary work revealed four Mousterian habitations extending over the whole top of the slope: they were named La Roche-Cotard I to IV. La Roche-Cotard I (also known as the cave of Achon) had first been excavated in 1912 by François D'Achon. The shelter of La Roche-Cotard II contained an occupation level that subsequent research was to characterize as a Typical Mousterian with Levallois flaking. Perfectly *in situ* within this level, and accompanied by some fine side-scrapers, there was 'an astonishing little block of flint' (FIG. 43). It is a greenish local flint and its edges seem to have been retouched here and there. 'On one of the flat faces of the block there

43. The 'mask' of La Roche-Cotard, produced by the insertion of a bone splinter through a natural hole in a slightly retouched piece of flint (10.4 × 9.4 × 4.1 cm or 4.1 × 3.7 × 1.6 in.).

Figuring it out

is a natural hole that is oval in cross-section (22 × 17 mm [0.9 × 0.7 in.]) inside which was placed a flat bone splinter, 75 mm [3 in.] long and 16 mm [0.6 in.] maximum width', thus forming what look like bone 'eyes' in a stone face. A recent analysis of this bone by Stéphane Madelaine, a palaeontologist at the National Museum of Prehistory in Les Eyzies (Dordogne), has specified that it is 'a splinter from the diaphysis of a reindeer radius-ulna'. It has a bevelled break at one end, and a transverse break at the other. Marquet noted that 'this splinter cannot have inserted itself into the hole' and that it was blocked there by infiltrated sand. However a recent tomographic examination of the object, carried out by Paris's National Museum of Natural History, has revealed the presence of small pebbles inserted between the bone and the flint to perfect the wedging of the splinter in the cavity (FIG. 44).

44. (Top) Tomographic cross-section of the 'mask' of La Roche-Cotard, showing the bone splinter fixed in place with small pebbles (scale shows 1 cm above and 0.5 in. below.); (above) position of retouches (arrows) on the edges of the 'mask'.

Chapter 5

A careful examination of the object has, moreover, revealed the existence of retouch on the outside edge of the piece, slightly rectifying the original shape of the flint block and giving it the trapezoidal appearance of a human or animal face (FIG. 44). According to Marquet, this object is unquestionably 'a result of human action'. Its very strange aspect makes one think of a mask on a human face or an animal face (feline?), and recalls the Magdalenian 'mask' from the cave of El Juyo in Cantabrian Spain. It can be classed with the natural curiosities brought back to a habitation by Mousterians, and having been modified to accentuate its anthropomorphous nature, this natural curiosity was finally transformed into something 'figurative'.

Recently the Mousterian dating of La Roche-Cotard and its famous 'mask' has been made more precise. After a first radiocarbon determination dated the layer to more than 32,000 years ago, two further radiocarbon results have now dated it to more than 40,000 years ago. However, an OSL result dates the layer containing the mask to 75,600 ± 5800 BP: 'It is this date that must be retained because we are beyond the reliable limit of radiocarbon dating' (Marquet & Lorblanchet, in press).

The 'statuette' of Srbsko

In the Czech Republic, the fourth cave in the hill of 'Chlum' at Srbsko in Bohemia has yielded, in a fairly poor level attributed to the Proto-Aurignacian, and corresponding to a phase of relative warming, a piece carved from a bone of a large mammal. According to Jiři Neustupný (1948), this is a very primitive statuette, 'one of the oldest art objects, not only in Bohemia but in Europe'.

Discovered by Jaroslav Petrbok, it was described by Neustupný as follows: 'A broad and deep circular groove divides the bone into two unequal parts, the upper part being smaller than the lower. This upper part, regularized by some incisions, is cylindrical and ends in a flattened surface. The lower part gets thinner towards the base and has a few incisions. Unfortunately it is very damaged and hard to reconstruct.... It is 95 mm [3.7 in.] high, and the diameter of the upper part is about 80 mm [3.15 in.].'

Neustupný's interpretation of it as a 'statuette' was based firstly on the fact that 'no practical use of such an object can be envisaged, but on the other hand its general appearance recalls the essential traits of the human body. The upper part could be the head, the lower part the trunk.' Doubtless the most convincing argument is the troubling resemblance to the series of very primitive ivory statuettes of the early

Upper Palaeolithic, and made of mammoth metacarpal in the Pavlovian of Předmostí (Moravia), yet these are more recent in date (twenty-seventh millennium BP). Clearly this piece demands a modern direct analysis to demonstrate that it is indeed humanly made.

The bear head of Tolbaga

The open-air site of Tolbaga (southern Siberia), excavated by Mikhail Konstantinov, yielded a cold fauna along with an industry with a few Middle Palaeolithic characteristics (Levallois flaking, side-scrapers) and some Upper Palaeolithic tools (blades, burins, etc.). Bones from the site have been dated by radiocarbon to 34,860 ± 2100 BP and to 27,210 ± 300 BP.

A bear-like head carved on the process of the second vertebra of a woolly rhinoceros from Tolbaga has been described by Zoya Abramova (1990, 1995). The sculpture, which admirably uses the bone's natural shape, was made with a stone implement that broke and left numerous traces on the bone's surface, especially marks of cutting and scraping. 'It is a realistic image: the outline is characteristic of a bear, and has its expressive details; the muzzle is animated, slightly turned-up, and the lower lip sticks out a little' (Abramova 1995) (FIG. 45). This piece displays amazing mastery; attributed by Abramova to the thirty-fifth millennium, it is thus one of the world's first realistic depictions.

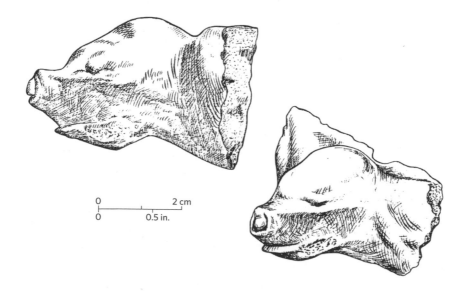

0 ———————— 2 cm
0 ———— 0.5 in.

45. Bear head from Tolbaga (Siberia), carved with
considerable adeptness from a woolly rhinoceros
vertebra perhaps as early as 35,000 years ago.

Chapter 5

Apart from certain tools, handaxes, polyhedrons and bolas, human creations in three dimensions are extremely rare throughout the world. The four pieces examined above belong to the Acheulian, Mousterian and Proto-Aurignacian, and a trend towards the figurative seems to be visible in them – particularly in the most recent, the bear-like head from Tolbaga. In all four cases, one is seeing an occasional exploitation of natural forms that have barely been retouched and completed. The same phenomenon can be observed in the exceptional manufacture of the Acheulian tool from Saint-Just-des-Marais (Oise) that closely adapted to the structure of a fossil (FIG. 6). However, most of these pieces arouse reservations and doubts.

Figuring it out

Jingles and bangles: the origin of music and decorated bodies

The evidence that has come down to us of the earliest art unquestionably represents only the tip of the iceberg. Although it cannot be proved (unless a waterlogged, desiccated or frozen Palaeolithic site is discovered one day, in which everything is preserved), it is virtually certain that a great deal of artistic activity involved perishable materials that are gone for ever: work in wood, bark, fibres, feathers or hides; figures made in mud, sand or snow; and, of course, hairstyles, tattoos, scarification and body-painting (which, through finds of red ochre in living sites and in graves, is thought to have very remote origins). We do, however, have copious evidence of jewelry, and somewhat rarer examples of early musical instruments.

Perforated bones and teeth

Perforated animal bones were long considered to be manufactured objects, that is, to be real 'pendants' that revealed a taste for jewelry in the Lower or Middle Palaeolithic; indeed, they seemed to confirm the symbolic capacities that were first revealed by marks on bones. But discussions very soon began about such perforations, because in general it is far from

easy to establish with certainty whether a hole in a bone is natural or was made by humans. A naturally perforated object could still, of course, have been used as jewelry – but it is worth recalling here the astonishing group of naturally perforated fossil shells found in 1894 in the alluvia of Bedford (see above, p. 50, and FIG. 47, NO. 7), stratigraphically dated to the Lower Palaeolithic, and which was thought to have been used as jewelry because some of the orifices were enlarged and showed traces of black material – but the discovery lacks too many details and the evidence is now considered inconclusive (Roe 1981: 281; Rigaud et al. 2008).

Between 1907 and 1910 Henri Martin reported several perforated bones from the Mousterian levels of the site of La Quina (Charente), notably a bison phalange and a reindeer phalange, which were considered 'pendants', as well as an Arctic fox canine with a round hole on only one side of the root and a longitudinal fissure (FIG. 46, NO. 1 and FIG. 47, NO. 1). Martin pointed out straight away that this kind of perforation can also be made by carnivores gnawing and grinding bones. Hence he dismissed several other deer phalanges bearing traces of bites. But despite his care, it is by no means certain that the few pieces he retained were really produced by humans, and they have led to much debate (e.g. Taborin 1990).

In 1908 Alexis Favraud described four perforated fragments of reindeer antler in the Mousterian of the cave of Petit-Puymoyen in the same region as La Quina (FIG. 46, NO. 7). He stated that 'in three examples, the hole completely traverses the antler, while in another it stops in the middle, but a second hole was begun opposite. These holes are more or less circular, slightly oval, and quite well calibrated. The bad condition of these pieces prevents one seeing the trace of the flint that must have been used for the work. The perforated antlers must have been taken from a living animal because a bit of the skull is still attached. A piece of rib also has a perfectly circular hole that stops in the middle.' The published drawings do not enable one to know whether the perforations in this unusual material are truly artificial; such pieces need to be reexamined using modern methods.

A different kind of perforated bone came from the Tayacian levels of the cave of Fontéchevade (Charente) (Henri-Martin 1957). In this case, it was sections of deer bone diaphyses, a few centimetres long, apparently cut by grooves made with a burin, the medular cavity having been hollowed into a funnel shape to form a tube (FIG. 46, NO. 6). We should recall that Pei Wen-Chung had shown that such tubes, fairly abundant in the Lower Palaeolithic of the Chinese cave of Zhoukoudian, were also produced by porcupines, followed by a natural dissolution of the spongy bone (see p. 114). Thus the pieces from Fontéchevade also need a modern analysis.

Jingles and bangles

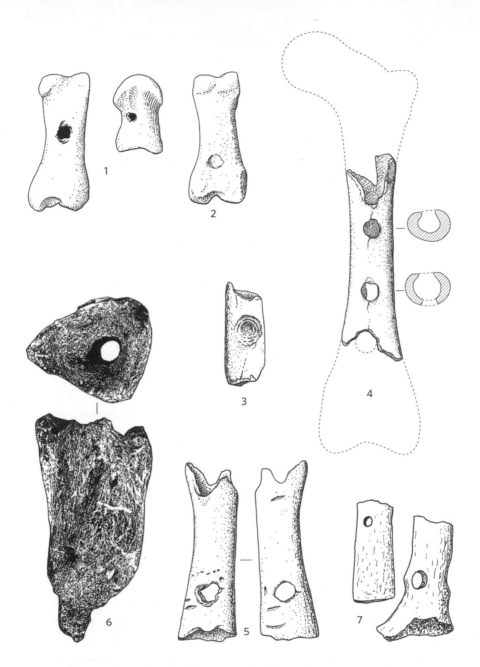

46. Naturally perforated animal bones of the Middle Palaeolithic: (1) reindeer
phalange from La Quina (Charente, France), with perforation made by carnivore teeth;
(2) reindeer phalange from Combe Grenal, with incomplete perforation; (3) fragment of
rib from Haua Fteah (Libya), with incomplete perforation by carnivores; (4) bear femur
with multiple perforations (a 'pseudo-flute') from Divje Babe (Slovenia); (5) young bear
femur with natural double perforation from Divje Babe; (6) bone diaphysis with (likely)
natural perforation from Fontéchevade cave (Charente; Tayacian period); (7) perforated
fragments of reindeer antler from Petit-Puymoyen (Charente; Mousterian).

According to Jean-François Tournepiche, however, who recently had access to the pieces from Petit-Puymoyen and who is also very familiar with the material from Fontéchevade, none of these elements is the result of human work (pers. comm.). The antlers from Petit-Puymoyen, which belong to young animals, have honeycomb-like perforations in the spongy part that seem to be the work of bone-eating insects or molluscs, while on the deer antlers from Fontéchevade the sectioning, sometimes by rodents (beavers?) uncovered the spongiosa, which was later hollowed out by chemical erosion.

When François Bordes (1969) published the 'engraved' bone from the cave of Pech de l'Azé II (see pp. 116–19), he included in his article a perforated bone from the typical Mousterian of the same site. This was a small fragment of bone diaphysis, probably deer, with a round perforation 8.5 mm (0.3 in.) in diameter that opens laterally on one edge of the piece. The author saw no trace of any use, but noted that on the inner faces of the perforation 'one can easily see the parallel striations cut by the turning flint tool'. A few years later the experimental study by Lawrence Keeley (1980) of use-wear traces on tools showed that the Acheulians and Mousterians perforated antler and bone, so the existence of pendants in the Lower and Middle Palaeolithic seemed to be a probability.

During the subsequent debates aroused by the incised bones from Bilzingsleben (see pp. 125–34), the supporters of a very early origin for symbolism and art supported their theory with the existence of a certain number of perforated bones that they interpreted as jewelry; a very lively discussion then ensued about several supposed pendants. A wolf caudal vertebra and metapodial from the German site of Bocksteinschmiede, dating to the early Würm (around 110,000 BP) (FIG. 47, NO. 5), were thus considered to be pendants by Marshack (1988a, 1991), whereas Davidson (1988) saw them as bones gnawed and perforated by carnivore teeth. The same difference in interpretation was expressed about the pierced phalanges and canine from La Quina (FIG. 46, NO. 1 and FIG. 47, NO. 1). Where the latter is concerned, the perfectly round hole and the presence of a fissure prolonging it had been interpreted as a proof of an 'attempted perforation' by the Mousterians, one that was rapidly abandoned since it only involved one side of the tooth; completion would have threatened to break the piece into two halves. But these same characteristics, together with the absence of any of the preparative striations and toolwork that are often seen, by contrast, on the pendants of the Upper Palaeolithic, are invoked to claim that such round holes were made with direct pressure by an animal bite, and not by a human rotating something. The same

Jingles and bangles

doubtless could be argued for the reindeer phalange with a bilateral perforation from La Quina (judged to be unconvincing in Taborin 1990).

In 1990, Phillip Chase described a deer phalange found in recent coyote faecal matter; next to some clear gnawing marks, this bone had a round perforation that was clearly the trace of the animal's bite. Then, on the basis of the work of Antony Sutcliffe, which showed that the gastric juices of present-day hyenas produce great quantities of perforations on bone during digestion (perforations that are visible on regurgitated bones), and also on the basis of experiments by Christiane Denys et al. simulating predator digestion, Francesco d'Errico and Paola Villa (1997) studied the bones from the cave of Bois Roche (Charente). They showed that this small cave, frequented by humans in the Middle Palaeolithic, was actually a hyena den, and that the 400 bone fragments they studied display perforations and various modifications due to partial digestion and regurgitation by hyenas. These regurgitated bone fragments often include one or several holes, sometimes incomplete, circular or oval, with very regular edges. Moreover, the holes have a cylindrical cross-section, contrary to Upper Palaeolithic jewelry where the perforations are conical or biconical. The surface of the bones is also corroded, pocked with small cavities, and the attack on the bone material by gastric acids and enzymes reveals the bone's fibres. Bordes had observed these 'striations' on the surface of the hole in the Pech de l'Azé specimen, but had interpreted them incorrectly. Villa and d'Errico found these same traces of gastric corrosion and perforation on the pieces from Pech de l'Azé and Bocksteinschmiede (at least the metapodial), as well as one from Kůlna (Czech Republic), previously interpreted as pendants.

So it is now well established that Palaeolithic carnivores produced a much greater number of perforated bones and pseudo-pendants – by biting bones or digesting them – than the Mousterians and Acheulians themselves. However, the pertinent observations of Sutcliffe, Chase, d'Errico and Villa clearly do not rule out the hypothesis that some bone perforations may be of human origin; they simply invite prehistorians to be extremely cautious in their interpretations. In any case they show the need for an in-depth study of every piece, first examining the hypothesis of an animal origin of the perforations before concluding that one is in the presence of an 'item of jewelry' (or a 'musical instrument')!

In her study of Palaeolithic jewelry, Yvette Taborin (1990) showed that 'except in the case of a bear tooth from La Rochette which is partly grooved', the Mousterians seem to have been ignorant of techniques of suspension because 'the need to suspend bone objects did not exist'.

The piece from La Rochette (Dordogne) is indeed exceptional. Found in a Mousterian level, it is a bear canine with, on the internal and external faces at the level of its neck, a deep broad groove. The groove is not circular and cannot be confused with the wear facet produced by the rubbing of the opposite canine, because it is transversal instead of oblique, as in wear facets, and here two faces are involved instead of one. Parallel striations caused by the use of a flint during the manufacture of the groove were not observed, but the use of the piece may have made them disappear. Although the authors concluded that this tooth was a Mousterian amulet, any interpretation should be held in reserve until the piece has been subjected to an in-depth study with modern methods.

A similar case, which likewise illustrates the problems of distinguishing natural marks from man-made grooves, occurred at the Mousterian cave of Sclayn (Belgium), where two cave bear incisors from c. 120,000 BP were claimed to have incised grooves between the crown and the root, and thus to be man-made pendants (Otte et al. 1985). However, a detailed study by an archaeozoologist subsequently showed that the teeth had not been worked, and the grooves were produced by natural wear (Gautier 1986).

According to Taborin (2004), jewelry and perforated teeth make a timid appearance in Western Europe in the Châtelperronian. The Châtelperronian levels of the Grotte du Renne at Arcy-sur-Cure (Yonne) yielded twenty-six perforated objects (FIG. 47, NOS 8–11; PL. XI) – including wolf and fox canines made into pendants by incising a groove around the top, at least one sawn reindeer incisor, a bone fragment with a wide carved hole, a sea fossil with a hole bored through its centre, and a fossil shell with a groove cut around the top; these can safely be attributed to Neanderthal craftsmanship, since they come from a Châtelperronian layer (c. 36,000 BP) containing a Neanderthal temporal bone. They were carved and pierced using Neanderthal techniques, and were not stolen, traded or copied from the work of newly arrived Cro-Magnons (such objects become spectacularly widespread in the Aurignacian). Indeed a new study of ancient proteins and mtDNA has proved that the Arcy bones are indeed from Neanderthals (Welker et al. 2016), a conclusion supported by the discovery of further perforated ornaments from other Châtelperronian sites such as Quinçay, Roc de Combe, La Roche-au-Loup and Cavallo (Baffier 1999: 91–98; Baffier & Girard 1998: 23; d'Errico et al. 2007; Granger & Lévêque 1997; Hublin et al. 1996; Marshack 1988a, 1988b, 1990; Poplin 1983: 62; Zilhão 2007). Hence, despite their apparent lack of interest in animal bones and teeth during the Mousterian, the

Jingles and bangles

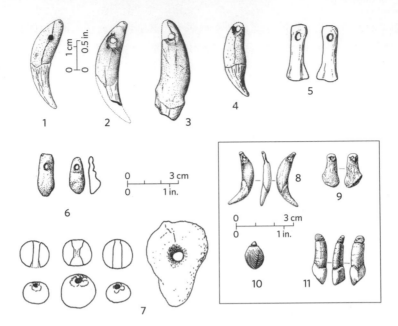

47. Perforated teeth and bones: (1) Mousterian fox canine from La Quina (Charente, France), with natural perforation on one side; (2, 3) Proto-Aurignacian (before 42,000 BP) ornaments made from (2) fox canine and (3) bear incisor, from Bacho Kiro (Bulgaria); (4) perforated fox canine from Cova Beneito (Spain); (5) Micoquian perforated seventh or eighth caudal wolf vertebra, from Bocksteinschmiede; (6) two pendants – an ivory blade and an imitation of a stag tooth in antler – dated to 44,300 ± 1900 and 39,800 ± 900 BP, from Istallöskö cave (Hungary); (7) naturally perforated fossils (*Coscinopora globularis*) found in Lower Palaeolithic gravels at Bedford (England), some of which, with enlarged orifices, may have been used as ornaments; (8–11) examples of Châtelperronian ornaments from the Grotte du Renne at Arcy-sur-Cure (8 = fox canine, 9 = reindeer phalange, 10 = fossil rhynchonella, 11 = bovid incisor).

Neanderthals, who were responsible for the Châtelperronian culture, did manage to create the first series of Western European jewelry before they became extinct. Moreover, to the south of the Châtelperronian area, the Cova Beneito (Alicante, Spain) has yielded two exceptional pieces: Level D1, dated to between about 38,800 and 30,000 BP, and attributed to a late Mousterian, contained a bone with tiered parallel notches and a fox canine with a perforated root (Iturbe et al. 1993) (FIG. 47, NO. 4).

In Eastern Europe it was the Pre-Aurignacians who invented jewelry, in a period that is even earlier than the Châtelperronian: fox and bear teeth in Layer 11 of the cave of Bacho Kiro (Bulgaria) are older than 42,000 BP (FIG. 47, NOS 2, 3), and a pentagonal pendant and an imitation stag canine made of deer antler come from Layer I in the cave of Istallöskö (Hungary), dated to 44,300 ± 1900 and 39,800 ± 900 BP (Kozlowski 1992) (FIG. 47, NO. 6). This jewelry is thus found in the oldest

levels attributable to the Upper Palaeolithic throughout Europe, and these layers are apparently contemporaneous with other European sites inhabited by late Mousterians or Châtelperronians.

Weighing up the evidence

It is possible that natural objects, and notably fossils, with natural perforations were sometimes picked up and used as pendants. But although a few Lower and Middle Palaeolithic elements with a perforation or other characteristic traces from Petit-Puymoyen, La Rochette and Fontéchevade (and Repolusthöhle and El Greifa) have not yet been subjected to a detailed modern analysis, and some perforated shells from the Near Eastern Mousterian are being studied (e.g. at Qafzeh, as we shall see), it is certain that the number of pieces that can be interpreted as Acheulian or Mousterian jewelry is extremely small.

Primarily dating to between 45,000 and 35,000 years ago, the beginnings of bone jewelry and the technique of perforating bones and teeth are the work, in Western Europe, of the last Neanderthals – in the late Mousterian or the Châtelperronian – and in Eastern Europe, of the first modern humans, that is, the very first Aurignacians. Research, though, is increasingly revealing that bone-working developed in the Middle Palaeolithic and that it was already known in some Lower Palaeolithic sites. So the ideological and technological foundations necessary to the appearance of jewelry existed towards the end of the Middle Palaeolithic. Once again we see that all human evolution is very slow and gradual.

The appearance of manufactured jewelry is an important stage in human evolution, because ornaments have a symbolic and social function· they represent the group or the individual, and distinguish them from others. They are meant to be seen and identified by everyone. Jewelry is therefore a form of communication, transmitting a message, and it implies a structured society. It also displays technical knowledge and, especially, a particular attitude towards the natural world and animals, which are no longer seen only as a food source, but which belong to the domain of 'signs'.

Like the interpretation of marks on bones, that of perforated bones highlights the frequent lack of rigour of certain passionate advocates of the great antiquity of symbolic expression. Should one follow Marshack (1991), for example, when he declared – without the slightest possibility of verification – that even naturally perforated objects, and notably the shells pierced by worms at Bocksteinschmiede, or a bear's inner ear-bone with its auditory canal from the cave of Prolom II (Ukraine), had

Jingles and bangles

symbolic value and could have been considered as 'natural pendants' by Neanderthals or *Homo erectus*?

The claim that such objects were sometimes endowed with a symbolic value and could have – in Marshack's terms – 'provided a conceptual "model" for beads made of other materials' is just one hypothesis among others. In each case it remains to be verified whether these elements were really brought to the site, or if natural processes can explain their presence. Identical problems were encountered by Goren-Inbar et al. (1991) when describing two tiny crinoid fossils, 3.5 mm (0.14 in.) in diameter, with natural central holes like all fossils of this type, discovered in the open-air Acheulian site of Gesher Benot Ya'aqov (Israel). The authors explained with some objectivity that erosion and flow phenomena brought the fossils to the site. In a situation where no human intervention can be detected, one obviously cannot consider these objects as 'beads'. Here we are at the limits of interpretation and speculation, and the authors of the paper were fully aware of this.

The archaeologist must always strive to make a clear separation between hypothesis and observation. It is certainly possible that a period of latency and formation of the idea and technology of jewelry, perhaps inspired by various natural phenomena, may have existed for dozens, even hundreds of millennia, but the history of jewelry only begins with the first perforation that is unquestionably attributable to humans. The existence of the technique of perforating bones (or indeed shells, as we shall now see) is not enough in itself to demonstrate the existence of jewelry, which starts when the act of perforation was repeated on identical supports, and ceased to be accidental and became meaningful – in other words when a range of evidence shows that perforated objects were hung and worn.

Perforated and decorated shells

Despite the uncertainties surrounding the fossil shells from Bedford (see p. 50), definite shell beads from early periods have been found in other regions. There are Middle Palaeolithic specimens from Israel and Algeria: two from Skhul, dating to 135,000–100,000 BP (FIG. 48); and one from Oued Djebbana, more than 40,000 years old (Vanhaeren et al. 2006; d'Errico et al. 2009). Marine shell beads, dating to 41,000–39,000 years ago, have also been reported from Üçagizli cave (Turkey) and from Ksar'Akil (Lebanon) (Kuhn et al. 2001). Israel's Qafzeh cave has yielded a number of *Glycymeris* shells collected from the Mediterranean shore,

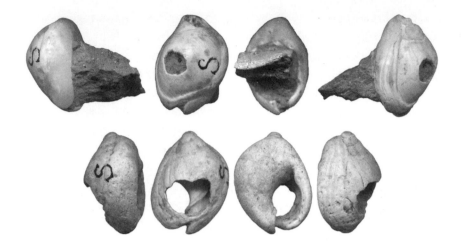

48. Two Middle Palaeolithic perforated shell beads from
Skhul (Israel), each shown from four different angles.
They date from around 135,000–100,000 years ago.

about 30 km (20 miles) away. The perforations are natural, but several show traces of having been strung, and a few have ochre stains on them (Bar-Yosef Mayer et al. 2009). The Grotte des Pigeons (Morocco) has also yielded 82,000-year-old shell beads, and other examples are known from North Africa (Bouzouggar et al. 2007). The southern part of that continent has also provided some important examples, such as possible shell beads from the Middle Stone Age layers of Sibudu cave, South Africa, dating to 70,000–60,000 years ago (d'Errico, Vanhaeren & Wadley 2008), and a perforated *Conus* shell with an infant burial at Border Cave, dating to *c.* 74,000 years ago (d'Errico & Backwell 2016).

However, some of the most important evidence has been found in the South African Blombos cave, where more than forty perforated shells of one species, *Nassarius kraussianus* (tick shells), were found in a layer dating to 75,000 BP (PL. XIV). They had been collected 19 km (12 miles) away, and their perforations were heavily worn. Analysis and experimentation showed that they were clearly man-made beads and had been worn as necklaces (Henshilwood et al. 2004; d'Errico et al. 2005; d'Errico & Henshilwood 2011; Henshilwood & d'Errico 2011).

In the Far East, a number of perforated objects are known, including a freshwater shell bead from Shuidonggou 2 (Yi Wei et al. 2016), dating to at least 34,000–33,000 BP. As far as decorated shells are concerned, a freshwater mussel shell from Trinil (Java), dating to at least 430,000 years ago, has been found to bear geometric engravings (Joordens et al. 2015)

(FIG. 49). Recently, the cave of Jerimalai, in Timor-Leste (island Southeast Asia), has yielded worked and pigment-stained *Nautilus* shells in a layer dating to 42,000–38,000 BP (Langley et al. 2016), and also hundreds of *Oliva* shell beads dating back to c. 37,000 BP (Langley & O'Connor 2016). In Africa, an important collection of 270 pieces of ostrich eggshell, incised with abstract designs (mostly parallel lines), has been recovered from Diepkloof rockshelter, dating to c. 63,000 BP (Parkington et al. 2005; Texier et al. 2010); and eggshell beads dating to more than 40,000 BP have been recovered from Enkapune Ya Muto in Kenya (Ambrose 1998).

In the Upper Palaeolithic only a few species of shells were selected: primarily small, globular gastropods (such as *Littorina* and *Cypraea*) that could easily be sewn to clothing; long forms (such as *Dentalia* or *Turritella*) that could easily be strung; and a few scallops (*Cardium, Pectunculus*) (Taborin 1985, 1993, 2004; Desbrosse et al. 1976; Vanhaeren 2010).

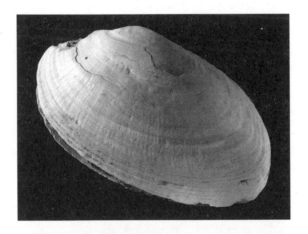

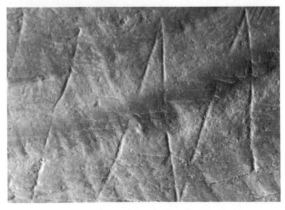

49. The engraved Trinil shell (c. 10 cm or 4 in. wide).

Many of these species are inedible, and their function was clearly decorative rather than nutritional (the same is true of several seashells found in Mousterian layers in Amalda cave in the Spanish Basque country, as well as in Cantabrian sites; they too are assumed to have an ornamental purpose; Imaz 1990: 270–74). Most Upper Palaeolithic specimens were perforated with a pointed tool, and they are often found in considerable quantity, even in early sites – there were 300 in the Aurignacian Cro-Magnon burial alone (and hundreds more in other burials), while living-sites such as Isturitz (Pyrénées-Atlantiques) or the abri Blanchard (Dordogne) contained hundreds of periwinkles. Fossil shells were also utilized, and sometimes came from great distances – for example, those at Mezin (Ukraine), a site dating to 21,000 years ago, came from a distance of 600 to 800 km (375 to 500 miles) (Soffer 1985). The shells of land molluscs were rarely used, no doubt because they are thinner and more fragile.

Research shows that Dordogne sites (such as Laugerie-Basse, abri Pataud and abri Castanet) generally yield a high proportion of species from the Atlantic, particularly those that are common along the coast of Charente, but shells from the Mediterranean are also clearly represented. One finds the same ratio at the Atlantic end of the Pyrenees; but sites in the Central Pyrenees, such as Lespugue, at a distance of 200 km (125 miles) from either coast, contain a more even ratio, while further to the east, in Ariège, the proximity of the Mediterranean is reflected quantitatively in the shell collections (Bahn 1977: 252–53; 1982), although even here Atlantic shells dominate slightly. This is no doubt because all rivers in the French Pyrenees (apart from those at the eastern extremity), like those of Dordogne, flow out to the Atlantic, and this must have determined to a considerable extent the movement of people and materials.

It is theoretically possible that all the shells came inland in an exchange network involving 'maritime peoples', for whom we have no evidence whatsoever thanks to the drowning of the coastlines of the last Ice Age through the rise in sea level since that time. Certainly, a great deal of exchange went on: for example, Mediterranean shells have been found at the German site of Gönnersdorf, 675 km (420 miles) inland, and it is unlikely (though possible) that the site's occupants travelled to that coast for them. It has been argued (Taborin 1985) that the great number of shells in the sites of Blanchard, Castanet and La Souquette means that this clutch of Aurignacian sites represents a market centre for exotic materials. Equally, however, it could simply mean that these sites were centres of production, or the habitations of those who specialized in working these materials: there is ample evidence throughout the

50. One of three elaborate burials at Sungir (Russia), dating to
c. 30,000 BP. Some 3,000 mammoth ivory beads, probably at the time
of burial strung into lengths and attached to garments, adorn the body.

Upper Palaeolithic for craft specialization, and for repeated contact
with the coasts that involved not merely vague 'exchange networks' but
also probably the seasonal movements of people, following herds, and
dispersing or coming together in certain places at different times of year
(Bahn 1982, 1977).

In the past it was often assumed that the shells served as pendants
and earrings or, in groups, as necklaces or bracelets. However, it is evident
from finds such as the burials at Grimaldi on the Mediterranean coast,
or those of Sungir in Russia, that many were probably attached to caps
and clothing. The three burials at Sungir (c. 30,000 BP) yielded only a
handful of perforated shells, but had about 3,000, 5,000 and 5,400 beads
of mammoth ivory on them, arranged in rows across the forehead and
temples, across the body, down the arms and legs, and around the ankles
(FIG. 50). Rather than being sewn onto garments one at a time, it is far
more likely that the beads were strung on lengths of sinew, which were
then attached to the clothing. It has been estimated that a Sungir bead
would have required about forty-five minutes for its manufacture (cutting
the tusk, drilling the hole, and so on), which means that each body had
2,625 hours of 'bead-work' buried with it (Bader & Lavrishin 1998; Soffer
1985: 259); in addition, the very standardized and uniform appearance of
these objects suggests that they were produced by only a few people.

In Western Europe, far more Upper Palaeolithic ivory beads are known
from living sites than from burials; only the context provided by a burial
can indicate an ornament's true function, but it is likely that most of the

182 Chapter 6

finds from occupation sites were also attached to clothing. Some idea of the production sequence involved in beads can be gained from the Aurignacian material at Blanchard, which includes pieces at different stages of manufacture: small prepared rods of ivory were divided into sections, separated into pairs, and then worked into a dumb-bell form and perforated, before the final shaping (most are round or basket-shaped) (Pond 1925; Otte 1974; Hahn et al. 1995).

Other types of bead include fish vertebrae, which were sometimes strung together as necklaces, as in an example from a burial at Barma Grande (Taborin 1982). It is worth noting that ornamentation of this kind is by no means restricted to Europe: for example, it will be recalled (see pp. 178–79) that shell beads are now known from very early sites in southern and northern Africa and the Middle East. Perforated bone beads and shell beads are also known from the late Pleistocene of Australia (Devil's Lair, Mandu Mandu Creek), while the Upper Cave at Zhoukoudian, China, dating to 18,000 years ago, yielded over 120 decorative items such as pierced vertebrae of carp and other fish, perforated seashells, animal teeth, small pebbles and engraved/polished bone tubes cut from the leg bones of birds; many of the perforations are coloured red, suggesting that whatever thread they were strung on was dyed (Jia Lanpo 1980: 52; Atlas 1980: 114–15).

As with any other category of portable art, there is a marked differentiation in the distribution of ornaments: many sites in Europe (including some burials) have none or a few, and others have hundreds. As mentioned above, this probably reflects the presence of specialized craftsmen, as well as the varying functions of different sites (including clothing manufacture?), and perhaps even, where rich burials are concerned, some form of incipient hierarchy. This is particularly true of wealthy child burials, such as at Sungir or in the case of the La Madeleine infant, who was interred with over 1,000 shell beads (Vanhaeren & d'Errico 2001) – the children are unlikely to have earned this prestige during their lifetime.

Other aspects of differential distribution have emerged from a major study of more than 3,300 objects of 157 types of Aurignacian jewelry from 98 sites. No less than fifteen regional groups were identified, but they were not dependent on availability of materials – for example, most of the mammal species whose teeth were used in southwest France also lived in Italy, but their teeth were not used there; and human teeth, on present evidence, were only used in southwest France in that period. So clearly the differences are purely cultural (Vanhaeren & d'Errico 2006).

Jingles and bangles

The origins of music

Where music is concerned, dance and song leave no traces at all, and stretched-skin drums and instruments made from reeds or wood, for example, will have disintegrated. Nevertheless, as we shall now see, there may be evidence for music-making as far back as Neanderthal times.

A number of perforated bones found in prehistoric sites of different periods have been interpreted as 'whistles' or 'flutes', some more convincing than others. A few shaped, polished and engraved bird-bone tubes have also been found that have no holes, but which have been interpreted as trumpet-like 'lures' for imitating the call of a hind in the rutting season – one fine example from the Magdalenian site of Saint-Marcel even has a series of what look like cervid ears engraved on it (Allain 1950). In addition, many perforated reindeer phalanges have been interpreted as whistles in the past, though often the hole was made – or at least started – by carnivore teeth or other natural breakage (see p. 171); those which were intentionally made do produce a shrill, powerful note. For example, Lartet found one at Aurignac in 1860, and managed to get a strident sound out of it (Dauvois 1989, 1994; Harrison 1978). Recently, microscopic analysis of a perforated reindeer phalange of about 20,000 years ago from Romania has shown traces of human manufacture of the orifice, as well as ochre (Cârciumaru & Tutuianu-Cârciumaru 2011). A few definite whistles in bird bone are also known, such as the Magdalenian specimens from Le Roc de Marcamps in Gironde (Roussot 1970: 9–10; Morley 2013: 100–5) (FIG. 52, NO. 3). A bird-bone whistle, dating from around 23,000 years ago, is also known from Davant Pau in northeast Spain (Ibáñez et al. 2015). We can also speculate that perforated shells might have been used as ocarinas.

Neanderthal musicians?

In Layer 8 of the cave of Divje Babe I (Slovenia), which yielded an industry attributed to the Mousterian, excavators found a diaphysis of a young bear's femur with perhaps four perforations on its front, only two of them complete. The level in which this object was unearthed has been radiocarbon dated to about 45,000 years ago (Turk 1997). The bone, 11.36 cm (4.47 in.) long, has been damaged by erosion, and has fractures and very worn ends. Its two complete perforations, slightly oval, are 7 and 9 mm (0.28 and 0.35 in.) in diameter (FIG. 46, NO. 4).

Apart from the holes, whose origin is subject to debate, the piece displays no trace whatsoever of human work – no flint marks for the

making of the holes, for example. Could such marks have been obliterated by erosion? Two contradictory hypotheses have been presented by prehistorians to explain the formation of the perforations: either this bone was gnawed and bitten by large carnivores and the holes were made by powerful premolars on only one side of the bone, or the perforations were made by humans, thus making this the oldest musical instrument currently known anywhere in the world.

With exemplary objectivity and method, these two hypotheses have been tested (Turk 1997). Various methods of perforation – drilling, cutting, sawing and filing, as well as striking with a flint to remove bone flakes – were employed on fresh bones, and the experimental perforations were compared with those on the Divje Babe bone. The different procedures were found to leave clear traces, none of which can be seen on the piece in question. It was therefore concluded that it is impossible to decide with certainty if this is an intentionally pierced bone or one pierced by a hyena's strong teeth.

It was acknowledged that the cave was, above all, a den for large carnivores (bears, hyenas, etc.) and that perforated bones are often found in such contexts. Moreover, the cave of Divje Babe itself has yielded other long bones, illustrated in the study, which display vestiges of holes – but in those cases they were accompanied by various other traces of gnawing and biting, whereas these are invisible on the supposed 'flute' (FIG. 46, NO. 5). It was also recognized that the mastery of the technique of multiple perforation has not been proved before the Upper Palaeolithic, and thus, if this bone was indeed perforated by humans, it would constitute an isolated and exceptional piece.

In reality, the abundance of carnivore bones in this site and the presence of other bones that were more clearly perforated by carnivores call for the greatest caution in interpretation, especially as natural perforations by gastric juices have also been observed on regurgitated bones in hyena dens (d'Errico & Villa 1997; d'Errico et al. 1998). Even if one imagines that phenomena of erosion have erased all trace of human work – but negative evidence is no proof – the most likely interpretation is certainly that the Divje Babe bone was perforated by hyena teeth, and that it is not a Mousterian flute. Having said that, the hypothesis of the existence of a flute in that period cannot be dismissed *a priori*, in view of the unquestionable examples from the Upper Palaeolithic (which do display very clear traces of fabrication and use), but it would be simply astonishing in a cultural context characterized by the absence or extreme rarity of intentional bone perforations. In order to establish the existence

Jingles and bangles

51. Implement made of elephant bone, thought to
be engraved, from Schulen (Belgium), and dating
to around 50,000–40,000 years ago.

of a musical instrument in the Mousterian, we need indisputable
evidence of a kind not provided by the Divje Babe object (see also Morley
2006, 2013).

Another 'musical instrument' from the open-air site of Schulen
(Belgium) has been described by Dirk Huyge (1990). Although it has no
perforation, this object merits description as it shows the difficulties
encountered by prehistorians when they try to establish the origins of
one form of artistic expression. The bone is a big fragment of elephant
tibia or femur with more than a dozen parallel grooves, and it was found
associated with an archaic fauna and a lithic industry characteristic of a
Charente-type Mousterian, datable to 50,000–40,000 BP. The grooves are
close together, parallel and arranged transversally, and are grouped at one
end of the bone, which had been cut through obliquely beforehand. Some
of them contain longitudinal internal striations. Moreover, the grooves
and the surfaces between them are smooth, as if polished by use (FIG. 51).

All these characteristics lead one to imagine that this could be a very
crude musical instrument, a 'rasp', of a type well known to ethnologists
and archaeologists in Eastern Europe, the Near East, America and Africa,
where notched bone pieces dating from the Upper Palaeolithic to the
present day have been interpreted in this way. In support of his theory,
Huyge cited a fragment of reindeer antler with deep notches from
Layer IV of the Grotte Vaufrey (Dordogne), but in fact nothing proves
that these marks had any connection with the production of sounds.

The human origin of the grooves observed on the Schulen bone has been disputed by d'Errico (1991). Observing the photo of the piece, he reckoned that 'such a morphology renders [the marks] more similar to traces produced by repeated action of a carnivore's teeth than to the action of a lithic cutting edge'. By way of comparison, he presented a bone from Montgaudier with clear traces of gnawing by animals and transverse grooves which he felt to be identical to those of Schulen, although they appear far less regular and apparently have no internal striations.

The debate remains open. Huyge reproached d'Errico for interpreting a piece he had not studied himself; and it is true that the interpretation of this type of artifact – so potentially important to human history – is so delicate that it really should be based on a detailed direct examination. However, d'Errico's criticisms must be borne in mind; his main intention was to show that the demonstration that the grooves were of human origin had not been made, or at least that it was insufficient, and that even the presence of the internal striations in the bottom of the grooves was not a determining factor. One cannot therefore firmly conclude as yet that this was a musical instrument.

Upper Palaeolithic music
Some definite musical instruments have survived from the Upper Palaeolithic – about thirty 'flutes' are known, spanning the Aurignacian and Gravettian (around twenty), the Solutrean (three) and the Magdalenian; a few come from Germany, Hungary, Yugoslavia, Spain, Austria and the former USSR, but most are from France, with twenty-two fragments from different layers in the supersite of Isturitz alone (Buisson 1990; Fages & Mourer-Chauviré 1983; Absolon 1937; Morley 2013: 32–98) (FIG. 52, NOS 1, 2). Indeed, the majority of flutes are broken. The French ones are made of hollow bird bones, while the eastern specimens are of reindeer or bear bone; they have from three to seven fingerholes along their length, and are played like penny whistles rather than true flutes. Experiments with replicas by modern musicologists have revealed that, once a whistle-head is attached to direct the air-flow, one can produce strong, clear notes of piccolo-type, on a five-tone scale (Pfeiffer 1982: 181–82; see also d'Errico et al. 2003; d'Errico & Lawson 2006).

In recent years, it is the assemblage of early flutes from the caves of southwest Germany that has come to the fore: Hohle Fels has one made from a griffin vulture bone, as well as two made of ivory (FIG. 53); Vogelherd has also yielded an ivory specimen; Geissenklösterle has two specimens made of swan bone, and also the most remarkable ivory

52. French Upper Palaeolithic flutes: (1, 2) examples from Isturitz cave
(Pyrénées-Atlantiques); (3) whistle or lure from Le Roc de Marcamps
(Gironde); (4) Gravettian flute from Pair non Pair (Gironde).

example, found in more than thirty fragments which, when reassembled, revealed that it had been carved in two halves, which were then joined together (Conard 2007; Conard et al. 2009).

A number of oval objects of bone or ivory with a hole at one end have been interpreted as 'bull-roarers' (also known as 'rhombes' or 'bramaderas'), a type of instrument that makes a loud humming noise when whirled round on a string – experiments have shown them to be particularly sonorous in caves. A very fine example made of reindeer antler comes from the cave of La Roche de Birol (Dordogne) (Morley 2013: 105–9) (FIG. 54). Very much more tenuously, the well-known parietal engraving in the cave of Les Trois Frères of a 'sorcerer' with a bison-head has often been interpreted as depicting a musical bow: but since the lines go to the figure's nose rather than mouth, then, if it were a musical instrument, it would have to be a nose flute! In any case these enigmatic marks could be all manner of things (Bahn 2015).

As for percussion, a number of mammoth bones painted with red ochre from the site of Mezin, near Kiev, dating to about 21,000 BP, have been claimed to be musical instruments – a hip-bone xylophone (osteophone?), skull and shoulder-blade drums, and jawbone rattles –

and have been played by Soviet archaeologists, who even cut a record of their jam-session (Bibikov 1981; Lister & Bahn 2007: 131). However, some doubt has been cast on whether the supposed marks of surface damage, polish and wear on these objects really exist.

Finally, there are possible lithophones in a number of caves: 'draperies' of folded calcite formations often resound when struck with a hard object (wooden sticks seem to produce the clearest and most resonant notes), and this seems to have been noticed by Palaeolithic people, since some of the lithophones are somewhat battered, and are decorated with painted lines and dots (Dams 1984a, 1985, 1987: 60, 193–95; Glory 1968: 55–56; Lorblanchet 2010: 178, 266, 330; Morley 2013: 115–21). Apart from Nerja and possibly Tito Bustillo in Spain (de Balbín et al. 2003: 94) and Escoural in Portugal, and a couple of cases in the Pyrenees (Le Portel has draperies and columns bearing traces of ancient blows, while the Réseau Clastres has numerous broken concretions; Dauvois & Boutillon 1990), all known examples are in the Lot region of France (from Pech-Merle,

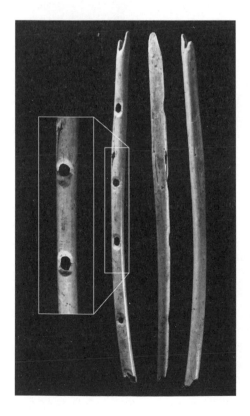

53. Hohle Fels flute
(c. 20 cm or 8 in. long).

54. Bull-roarer from Lalinde
(c. 18 cm or 7 in. long).

Jingles and bangles

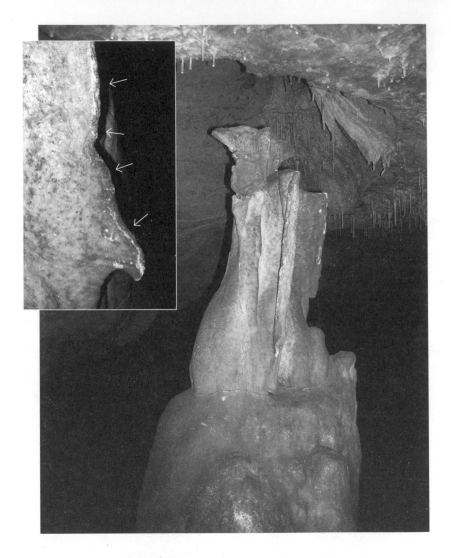

55. Lithophone in the cave of Les Fieux (Lot, France), on a 3-m-
(10-ft-) high pillar in the main decorated chamber. On its edges
the resonant draperies display many patinated traces of percussion
(indicated by the white arrows in the detail).

Les Fieux, Roucadour, etc.); moreover, most of them are in or near
significant chambers that could have held large audiences (FIG. 55).

As yet we have no proof that Neanderthals played lithophones, but in
view of all their other aesthetic activities and the growing evidence that
they were exploring and decorating caves, it is extremely likely that they
would have been aware of, and perhaps exploited, the acoustic phenomena
encountered in these environments.

The first art in the landscape: dots and lines

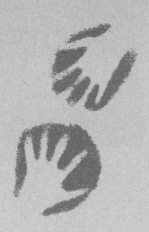

The research carried out for many years in Syria by Jean-Marie Le Tensorer and his team has recently revealed that early people had permanent settlements in the Syrian desert 1.8 million years ago. Despite difficult environmental conditions, the human occupation was as dense from the start in the inner sectors of the desert as it was in the more humid coastal regions.

The site of Aïn al Fil, in the region of El Kown, has yielded an Oldowan industry: Layer L2 in this site, 'dated immediately before the Oldowan palaeomagnetic episode', contained – in association with the industries of this early Palaeolithic – a dozen limestone cobbles bearing circular man-made hollows or cupmarks, known as cupules (Le Tensorer et al. 2015). These cobbles are 10–15 cm (4–6 in.) in length and thickness, decorated with one to three cupules that are 2–4 cm (0.8–1.6 in.) in diameter and 1–2 cm (0.4–0.8 in.) deep. *Homo erectus* or early *Homo ergaster* made them by pecking, traces of which are still clearly visible at the base of these small depressions (FIGS 56, 57). This is our earliest evidence of the discreet but unquestionable emergence of the long tradition of a form of 'art' that was soon to spread through the landscape, on rock outcrops in Africa, India, Europe and later Australia, becoming

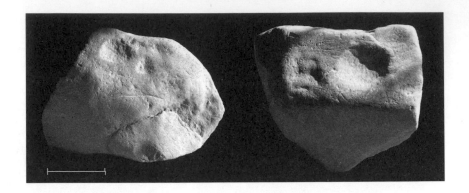

56. Two examples of cupules on small limestone blocks from Layer L2 at Aïn al Fil (El Kown, Syria), dating to 1.8 million years ago (scale shows 5 cm above and 2 in. below).

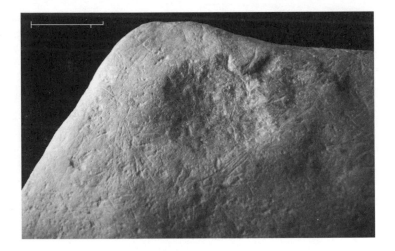

57. Detail of a cupule at Aïn al Fil showing traces of pecking in the base of the small depression (scale shows 3 cm above and 1 in. below).

the earliest rock art in the world, and ensuring the humanization and socio-cultural marking of inhabited territories.

The cupules of Aïn al Fil are of the simplest and most classic type, and their technique of fabrication is clear. They were found in a layer with clear stratigraphy and so, in contrast to many other examples, their dating is scientifically assured. With them, approaching 2 million years ago, the 'history of art' quietly began; we shall now try to follow its development in other parts of the world, while acknowledging the difficulties of the investigation.

Indian cupules

Bhimbetka

The magnificent site of Bhimbetka is located in the centre of India, at the northern edge of the Vindhya chain, about 50 km (30 miles) from the city of Bhopal (Madhya Pradesh). Picturesque ruin-like outcrops at the site, dominating the basin of the Betwa, a tributary of the Narmada, occupy the top of a sandstone escarpment covered with dense vegetation. In these rocks, which are among the oldest in the world, erosion has carved cavities of all shapes and sizes. There are about 700 rockshelters, more than 500 of which contain rock paintings that are primarily attributable to the Mesolithic, Neolithic and historical periods. The site has one of the greatest collections of rock images in the world, and in its landscapes, its rocks, its painted shelters and its wealth of archaeology it is fully comparable to the great assemblages of tropical Australia. Yet there is one important difference with Australia: Bhimbetka was occupied by people long before Australia, in the Lower Palaeolithic, hundreds of thousands of years ago, at a time when the existence of rock art was already possible.

A series of excavations were carried out between 1972 and 1977 in a dozen decorated shelters at Bhimbetka by Vishnu Shridhar Wakankar (1975), Virendra Nath Misra and Yashodhar Mathpal, and Malti Nagar (1977). Most of these excavations yielded a succession of industries from the Lower Palaeolithic to the Mesolithic, often ending with more recent remains. The most complete stratigraphies were found in shelters III F 23 and III F 24, located about 100 m (330 ft) apart. Only shelter III F 23 gave rise to a detailed publication (Misra 1985). In contrast, the excavation of the enormous III F 24, known as Auditorium shelter, which contains some interesting painted panels – Mathpal recorded 103 figures – was only presented in some incomplete reports.

Auditorium shelter is about 40 m (130 ft) long, with a ceiling 17 m (55 ft) high; it has four entrances and a cross-shaped plan, due to the network of orthogonal fissures. In the centre one can see a group of blocks, the biggest of which is 3 m (10 ft) long and 2.5 m (8 ft) high. The visitor entering from the east and approaching this rock is faced with a vertical surface on which Wakankar noted the presence of eight cupules that, in his view, could be the marks left by being struck with a gong hammer. This imposing feature, at the heart of a cavity that still echoes like a church, was named Auditorium Rock or Chief's Rock.

More recently, Robert Bednarik attempted to overturn the archaeological data accepted for the cupules in this shelter as described

by Wakankar, Misra and Mathpal, and repeatedly attributed some of them to the Lower and Middle Palaeolithic. In a series of articles (1992, 1993, 1994a, 1995a, 1996, 2012) he proposed a very early date for the Chief's Rock, basing his arguments on the following observations (see Lorblanchet 1999: 195–202): the absence of traces of percussion in certain cupules; the exfoliation of one of the cupules (so that, in Bednarik's view, the age of Cupule 5 must have been several dozen millennia, and could easily be more than 100,000 years); and the presence of calcite on a cupule, as also found in the Middle Palaeolithic layer uncovered by Wakankar's excavation in the same shelter, around 12 m (40 ft) to the south. Then, applying his 'microerosion method' (see overleaf), Bednarik estimated that the degree of microerosion was such that a Holocene age for some of these cupules was out of the question.

In 1990, moreover, at the southern edge of the trench opened by Wakankar's excavations, Bednarik discovered a large block bearing a big cupule partially surrounded by a groove. He considered both features to be artificial, but as they displayed no traces of hammering he ascribed to them a very great antiquity, as for the hollows on the shelter's central block. He also noted that the cupule and groove were about 1.5 m (5 ft) beneath the shelter floor, deducing that the new cupule block was covered by the Middle Palaeolithic level discovered by Wakankar in 1972; he thus considered it to be a remnant of the shelter's original Acheulian fill. Extrapolating, he therefore felt able to attribute the cupules on the Chief's Rock to the Acheulian. In the course of another visit in 1994, Bednarik discovered – 2 m (6.5 ft) from the block and cupule in question, and at the same level – three prehistoric tools (including one handaxe, and a quartzite cleaver stuck into a lateral fissure of the rock), and considered them to be evidence for the Acheulian fill of the shelter, thus confirming the Acheulian date of the cupules and the groove.

These arguments by Bednarik illustrate the difficulties in dating the oldest examples of rock art, and they arouse profound scientific doubts for the following reasons:

- The eight cupules on the Chief's Rock are traditional cupules in which one can observe traces of inner pecking. Some display a contrast with the surrounding rock. They belong to different periods that are impossible to specify. They are above ground, with no link to an archaeological fill, and the shelter was frequented for 500,000 years! They are at hand-height for a man standing on the present floor.

- The use of the flaking and fissuring of the rock support in the attempt to date the cupules is risky and subjective.

- The use of the so-called 'microerosion' dating method (see overleaf) is invalid. Observations and measurements of erosion carried out by Bednarik in Russia in a periglacial environment and on geologically different rocks, invoked by the author to establish a 'calibration curve', cannot be applied with any relevance to a tropical Indian environment.

- The author's entire argument is based on dangerous extrapolations, because his discoveries post-date Wakankar's excavation by more than twenty years, and they seem to occur outside of any stratigraphy. The floor and other features could have been modified by arrangements made for the site's protection; for example, the section revealed by the excavations has been walled in.

It is especially notable that there is no precise location available – on a plan or in Wakankar's stratigraphy – for the remains discovered (both cupules and artifacts). No drawing of the remains and finds has been published, and some of the so-called 'Acheulian' pieces could not be extracted from the fissure they were stuck in. There is also no scale on certain photographs. The big cupule and groove attributed to the Acheulian are not visible at the site today and it is not known exactly where they were discovered: Bednarik indicates that they 'were excavated in a rich Acheulian occupation deposit *directly covering them*' (2001: 18) but Indian prehistorian Giriraj Kumar states that 'the stone block bearing deep cup marks and a meandering line is *partly buried* in the Acheulian sediments' (Kumar 2001: 64). The exact location of a discovery of this importance should have been published, as well as a photo showing *in situ* the stratigraphic position of the block in question, bearing the cupule and the groove, in order to establish clearly the relationship of the block with the section left by Wakankar.

During the research by one of us (ML) in Auditorium shelter in 1993–97, the trench left by Wakankar's excavations was still open; only the stratigraphy had been sealed and protected by a wall. At the bottom of the southern part of the trench we observed a big block that must originally have been covered by the excavated archaeological levels, and which bore *natural* cupules and grooves. These seem very similar

Microerosion

Developed by Robert Bednarik in the early 1990s, the microerosion
(or 'micro-wane') technique offered the attractive prospect of non-
destructive direct dating of engravings, cupules and other 'deductive'
marks on rock. When such a mark is made, a new rock surface is
exposed to the effects of the atmosphere and environment, resetting the
erosion clock. Using rock surfaces of known ages by way of calibration,
microscopic examination of erosion on rock grains and crystals
(particularly of their 'wane', the degree to which their edges have been
rounded) supposedly would allow a mark of unknown age to be dated.
But unfortunately this method has no scientific validity, and it has already
led to some spectacular errors.

Shortly after the discovery of the open-air engravings of Portugal's Côa
valley, when the country was wondering if the dam that threatened
to drown them should be stopped, Bednarik (1995b) carried out
an assessment of the antiquity of these engravings. He applied his
microerosion method, which revealed to him that none of the engravings
attributed to the Palaeolithic could be earlier than 6500 BP and that most
dated to around 3000 BP. This work therefore denied the exceptional
nature of these numerous engravings in the Côa valley. João Zilhão (1995),
in a highly objective and critical analysis of the dating methods used at that
time, and in particular of microerosion, recalled that, according to Bednarik
himself, 'schist and other rocks of low metamorphism (slate, phyllite) are
not well suited for microerosion analysis' (because of the small size of the
crystals). Yet despite his own statements, Bednarik applied his method to
the schists and micaschists that bear the Côa engravings.

Moreover, in order to compare and calibrate his results, Bednarik used a
calibration curve he had earlier produced on the granites of Lake Onega
in Russia! The microerosion method was thus applied in the Côa on
schists, a rock that does not suit this kind of analysis, and by employing
a calibration curve established 7,000 km (4,350 miles) from Portugal in a
different climate and on lithologically different rocks. Needless to say, the
Palaeolithic dating of most of the Côa engravings has now been definitively
confirmed by the numerous discoveries of associated Palaeolithic living-
sites, the stratigraphic covering of engravings by Palaeolithic layers, and
the numerous radiocarbon dates for these levels. Fortunately the dam
project was cancelled, and research is able to continue.

The erroneous utilization of the microerosion method, as carried out in Portugal, is regrettably still being repeated today in India and Africa – erroneous for the same reasons, particularly the application of foreign calibration curves to different rocks and in different climates. The dates obtained in these conditions have no value whatsoever. Bednarik has even attempted to date marks on rocks in Tasmania using a calibration curve established in the Italian Alps, and the utter lack of scientific credibility of this supposed dating method has recently been set out in some detail (Field & McIntosh 2009: 18; 2010).

to the so-called 'Acheulian' cupule and groove discovered by Bednarik in the trench. The rock in question is Precambrian Vindhian quartzitic sandstone that has undergone an intense metamorphism, and which, according to the geographer Shankar Tiwari (1984), is responsible for the formation of a 'cuesta' (or escarpment) dominating the surrounding plains; the roofs of the shelters at Bhimbetka are formed of the same material. From the Lower Palaeolithic onwards, this metamorphic sandstone, with its fine grain, siliceous cement and conchoidal fractures, was regularly used by the prehistoric inhabitants to make their tools. All the blocks bearing cupules (Chief's Rock and the others), which have all fallen from the ceiling, belong to this formation.

On the block from the trench of Wakankar's excavation we noted, on its two faces, at least six big cupules, 10–20 cm (4–8 in.) in diameter and 2–7.5 cm (0.8–3 in.) deep, associated with grooves and smaller cupules that were not very marked (1–2 × 1 cm or 0.4–0.8 × 0.4 in.) (FIG. 58). Regardless of their size, none of these cupules displays the slightest trace of artificial pecking; their bottoms are mainly smooth, but even when irregular in places the surface looks just like the surrounding rock. There is a very strong contrast between the physical appearance of these hollows and that of the authentic pecked cupules of Chief's Rock. The absence of traces of pecking is not evidence for 'antiquity', it is simply the sign of a natural origin of these cavities – these are *natural* cupules. The grooves, likewise natural, are from 15–20 cm (6–8 in.) long, 1–2 cm (0.4–0.8 in.) wide and an average of 1 cm (0.4 in.) deep, and were formed from fissures.

The abundance, shape, location and characteristics of the cupules on this rock lead one to think that they were caused by erosive phenomena working on its heterogeneous structure. In several places one can see the rock peeling like an 'onion skin'. This exfoliation, accentuated by

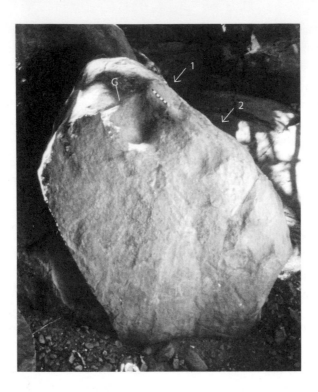

58. Auditorium shelter block (1.1 m or 43 in. high) with large natural cupules (1 and 2); it is located in the trench that resulted from the extension of the Wakankar excavation. One of the cupules, the larger upper one, is partially surrounded by a groove (G), which is likewise *natural*.

the presence of salts and thermal and hydric variations, results in the detachment of lenses of sandstone and explains the formation of natural rounded cavities, reminiscent of the much more pronounced 'Tafoni' or 'honeycombs' that are more common in granitic rocks. These phenomena of alveolarization exist in different parts of the world and are well known to geologists (Bellair & Pomerol 1965: 190–91).

We have examined the case of the Bhimbetka cupules – some artificial, others natural – in some detail in order to emphasize the problems involved in the identification of the first manifestations of rock art and to highlight the in-depth multidisciplinary scientific studies that are required in order to avoid the traps into which archaeologists can so easily fall. In their recent attempts at dating at Auditorium shelter and at Daraki Chattan, using a variety of different methods including microerosion, even Kumar and Bednarik admit that 'we encountered a variety of problems while employing these methods and could not obtain satisfactory results' (2012: 1161).

Daraki Chattan

At the border between Madhya Pradesh and Rajasthan in India, a great cliff dominates the landscape of the Chambal valley. In this cliff there is a vertical cleft, the cave of Daraki Chattan, in which Kumar has studied and published a total of 500 cupules, scattered over both walls of the cavity (2015). As at numerous locations across India, he has reported the presence of open-air sites of Acheulian type in the vicinity, especially on the edge of the cliff at the top of the hill (1995).

It is a narrow cave, 12 m (40 ft) in length, 8 m (25 ft) high and 1 m (3 ft) wide in the middle, taking the form of a corridor sloping towards the entrance. The cavity was originally open at both ends and in the ceiling. One of us (ML) found that the corridor has been invaded by rubble, which has largely come from outside, with the biggest blocks having finally sealed the openings to the rear and above. In this fill, Kumar found a few artifacts that he attributes to the Acheulian, as well as some more recent pieces. The only significant endogenous rubble elements in it are three flaked-off wall fragments that bear a few cupules (FIGS 59, 60).

59. Daraki Chattan cave (Madhya Pradesh, India): the entrance of the cave is a simple narrow crack in the escarpment, and scree covers the ground both within the cave and outside its opening.

The first art in the landscape

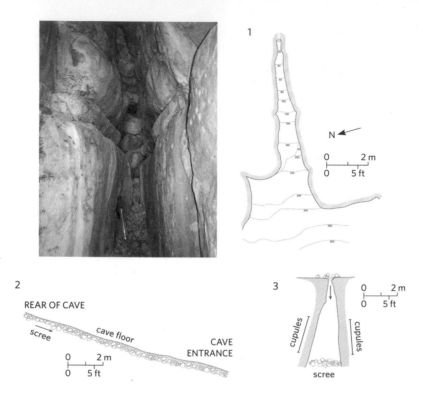

60. The rear of Daraki Chattan cave is sealed by natural blocks (green walking stick = 70 cm or 28 in. long); some cupules are visible on the walls. The plan (1) and sections (2, 3) of the cave show the invasion of scree from outside.

In his first publications about the site in 1995–96, Kumar noted: 'The floor deposit bears some scrapers and other tools of Middle Palaeolithic and Acheulian traditions. Some of them might have been brought in by rainwater from the hill above.... Acheulian and Middle Palaeolithic tools have also been found on the hill above the cave.' He himself observed water flowing in the cave (1995; 1996: 41–42). In 2002 Kumar again mentioned, in the course of his excavation of the site, that 'Finished microliths and chips in chert and chalcedony also appear casually which seem to be intrusions by natural agencies from the top of the cave which is open at its mouth.... The excavated sediment does not show any layers in stratigraphy.... The soil is brown which remains almost unchanged in the excavated sediment' (2002: 10).

The absence of stratigraphy and the intrusive pieces seem to indicate that the cavity's fill comprises a mixture of earth, blocks and Palaeolithic artifacts that come in large part from the exterior, and from the dominating plateau on which open-air sites are known. Yet despite

the fact that most of the deposit is clearly exogenous, as can be seen at first glance when one visits the site, both Kumar and Bednarik (2012) believe that the cupules and the artifacts attributed to the Acheulian are associated, and hence they conclude that the cupules of Daraki Chattan are Acheulian or of Acheulian Tradition, that they date to at least 200,000 years ago, and thus constitute the oldest rock art in the world.

The two authors finally carried out a few attempts at OSL dating in the fill, but these only yielded recent dates of no interest (Kumar & Bednarik 2010). Attempts at uranium-thorium (U-Th) dating by the Physical Research Laboratory of Ahmedabad (India) were no more successful and did not produce conclusive results. In 2012 Bednarik pushed back the age of the cupules even further: he noted that they are dated to the Lower Palaeolithic, with the site 'dominated by choppers resembling those of the African Oldowan predating the Acheulian' (2012: 150). Despite various publications in international journals, this site has unfortunately never been subjected to a true geological or sedimentological study, and the pieces found in the unstratified fill have not been drawn or properly and scientifically studied in detail by specialists in the Lower Palaeolithic.

The cave is open to the squalls of the monsoon, which produce veritable torrents of water and mud in its corridor, sloping down to the exterior; and with a seasonal span of 40 °C it is also exposed to formidable differences in temperature that cause the walls to flake. Any relationship between the cupules and the artifacts attributed to the Acheulian (or an even earlier period) seems to be very difficult to establish: these cupules therefore remain undated. In the current state of research, we must discard Daraki Chattan from the list of sites that can claim a Pleistocene origin for the cupule tradition.

Morajhari and Ajmer
In order to demonstrate further the difficulties of studying cupule sites, we shall briefly mention examples from two other Indian sites in Rajasthan. First, at Morajhari, in the district of Ajmer, two enormous balls of granite, whose surfaces are covered by cupules of different sizes, have been discovered. These softened and polished cupules show no contrast in colour with the surrounding rock, but according to Kumar examination through a binocular magnifier reveals the presence of crushed areas, confirming their artificial origin. Since these rocks give off a crystalline sound when they are struck, Kumar interprets them as 'musical drum rocks' (like the Chief's Rock in Auditorium shelter at Bhimbetka). No associated tools are present. Kumar has put forward the hypothesis of

The first art in the landscape

a Palaeolithic age for these cupules, but prudently concluded: 'To prove this assumption we are in need of some solid archaeological evidences...' (Kumar 1998)!

Secondly, on a vein of white quartz close to the town of Ajmer, Kumar and Bednarik (2002) mention more than twenty cupules on this very hard material, mainly on horizontal surfaces but with a few on a vertical wall. These cupules of different sizes certainly seem to be artificial, as was shown by the examination of one with a binocular magnifier, which revealed traces of percussion. However, the attempt at dating carried out on one cupule by the microerosion method was highly problematic: the use of a calibration curve obtained on other materials in other parts of the world (China and Australia) can only produce highly uncertain results (see pp. 196–97). The final result was that the studied cupule supposedly dates to the early Holocene, but was reused and hammered again a few millennia later.

While we cannot agree with this analysis, these two examples, as well as Bhimbetka and Daraki Chattan, serve to illustrate both the interest and the difficulties involved in the scientific study of cupules; doubtless existing and new techniques for dating and other types of investigation will be perfected in the future.

African cupules

Peter Beaumont and Robert Bednarik have recently turned their attention to a dozen Pleistocene art sites south of the Sahara, seven of which are very important (2012b). Some are famous because they contained important elements in their stratigraphy: the cave of Apollo 11 and its painted plaquettes from the early Upper Palaeolithic; the cave of Blombos and its mobiliary engravings from the Middle Palaeolithic; and the cave of Wonderwerk and its incised plaquettes, some of which come from Lower Palaeolithic levels. A number of open-air cupule sites also feature in the research, and the two authors (2012a) have proposed a chronology for these open-air remains:

- The first rock art phase, dating to the Lower Palaeolithic, is entirely non-iconic. It is characterized by big worn cupules at Nchwaneng and Potholes Hoek that date back to around 400,000 years ago; these cupules are scattered in disordered groups.

- The second phase comprises smaller cupules dating to the Middle Stone Age, more than 50,000 years ago, especially at Nchwaneng.

- The third, Holocene phase is marked by the emergence of petroglyphs associated with cupules at the sites of Nchwaneng and Klipbak.

Thus, according to these authors, the long tradition of cupules preceded iconic rock art, which was only to appear in the Upper Palaeolithic, and developed especially during the Holocene (in parallel with the cupule tradition, which continued until recent periods).

The authors also mention an apparently progressive reduction in cupule size over the millennia. The oldest are the biggest; at first they were laid out in disordered groups, and then in organized geometric groups in the Middle Palaeolithic, until finally they were associated with circular signs and figurative petroglyphs. The sites involved are water sources, with beautiful regular quartzite surfaces that were suitable for cupules and then iconic petroglyphs, and generally they contain industries and sometimes levels that have been excavated, dating to the Lower, Middle and Upper Palaeolithic and to the Holocene. But not one of the cupules has been directly dated by stratigraphy, since they are not covered by archaeological levels. Instead they are dated only by extrapolation, that is, by the topographic proximity of the dated levels and industries, and using the scientifically invalid microerosion technique (see e.g. Bednarik 1992; and pp. 196–97).

Sai Island
In contrast to the sites described above, a discovery made on Sai Island in the Nile valley in Sudan provides some real scientific guarantees. In Lower–Middle Palaeolithic levels that yielded a Sangoan industry, and which are dated by OSL to around 200,000 years ago, a sandstone slab was found in the stratigraphy: it bears eight small depressions that can be called 'cupules'. One of them is a big cupmark or grinding hollow, slightly oval, with a smooth bottom about 10 cm (4 in.) wide. This hollow is surrounded by seven small cupules, 1–2 cm (0.4–0.8 in.) in diameter (FIG. 61). The edge of the slab has more recent removals of material that show a later re-use of the object.

The same level also yielded various lithic toolkits along with used fragments of ochre, and cobbles bearing traces of the rubbing and

The first art in the landscape

unworked higher zones

retouch scars

ancient
fracture

0 10 cm

0 4 in.

61. Sandstone slab from a Sangoan level dating to
200,000 years ago on Sai Island (Sudan). A grinding
hollow and seven small cupules are visible.

crushing of pigments; these cobbles were perhaps 'mortars' while the
big cupmark could have been used for plant preparation. The excavators
think that the site of Sai Island and its transitional layers from the Lower
to Middle Palaeolithic show the emergence of modern human behaviour.
They see the cupule-slab from the Sangoan level as evidence for the
existence of 'complex processing of plant food and symbolic pigment'
(Van Peer et al. 2003: 189). Whatever the interpretation of these pits and
hollows, the site provides unquestionable archaeological proof of the
existence in Africa of the technology for the manufacture of cupules
and grinding hollows hundreds of thousands of years ago.

Australian cupules

Cupules have been reported throughout Australia on granites and
sandstones and various metamorphic rocks. Most Australian researchers
believe they are of very great antiquity, and even consider them to be
the oldest form of rock art, earlier than and below paintings; George
Chaloupka (1993: 235) remarked that, in Arnhem Land, 'the most
common of the motifs are the pecked hollows. They are usually grouped
in quite large numbers on vertical walls and occasionally also on ledges
and boulders, and are found even in the hardest surfaces. The most
extensive panel of these hollows is found in the Yuwunggayi shelter
and is covered by several layers of painted images.' In the Kimberley,

Grahame Walsh defined a 'pecked cupule period' that constituted the oldest artistic phase of the region (1994: 33–35), and cupules also appear among the pecked engravings of the Panaramitee (central and southern Australia), which represented one of the oldest phases of Australian rock art (Franklin 1991).

At Jinmium and Granilpi, two localities in the Kimberley 30 km (19 miles) apart, Richard Fullagar et al. recorded and studied twenty-six sites in sandstone outcrops that formed part of the same mythological assemblage or 'Dreaming track'. In the Jinmium shelter, the vertical walls are covered with a great number of cupules, 3,500 in site KR1 and 3,200 in KR2. At Granilpi there are primarily horizontal surfaces and fallen blocks that also bear numerous cupules: 1,117 have been recorded. All these cupules, 2–10 cm (0.8–4 in.) in diameter and an average of 1–5 cm (0.4–2 in.) deep, are linked to symbolic and ritual activities, and differ from the domestic grinding hollows used for food preparation. They are closely related to the topography of the site, and to the mineralogy and natural characteristics of the rock supports.

Most of the cupules must also be very ancient, because they are covered by a variety of rock paintings and engravings, some of which are themselves known to be of considerable age. In 1996 the excavations by Fullagar and his team at site KR1 at Jinmium yielded astonishing OSL dates: the deep level dated by this method to 75,000–58,000 years ago contained a fragment of engraved sandstone bearing at least two cupules of the same type as those decorating the site's walls (Fullagar et al. 1996). These dates unleashed a worldwide controversy, because they again posed the question of the identification of the first inhabitants of Australia (*Homo sapiens* or a variety of *erectus*?). Previously, researchers were agreed that Australia had been colonized by modern humans around 50,000 years ago; yet newspapers were even evoking dates of 176,000 BP at Jinmium (Bahn 1996b)!

A series of new dates, obtained with a variety of methods, finally established that the OSL results had correctly dated the sediments but not the artifacts and human vestiges, which had travelled through the layers following various natural erosion phenomena. The age of the site's human occupation was brought forward to a period between 20,000 and 10,000 years ago (Roberts et al. 1998; Spooner 1998). Here, once again, the Palaeolithic dating of cupules and their interpretation as one of the oldest forms of art were called into question and proved to be wrong.

Some cupules in the Kimberley have been attributed to the Holocene by direct dating of the oxalates covering them (Aubert 2012; Watchman

The first art in the landscape

et al. 1997), and the cupules of Cape York's Laura region have been dated to around 3,000 years ago by the same kind of direct dating: for example, the site of Leichardt (Arnhem Land) dates to 5180 ± 130 BP (Kamminga & Allen 1973: 88; Duncan et al. 2014). There is no doubt that the Australian cupules are spread over an immense time span (PL. XV), and in fact their use even extends down to modern times. Today they still have a special significance for many Aboriginal groups. Charles Mountford in 1976 reported that, according to the elders of the region, the cupules of the Musgrave Range (South Australia) were produced to propagate the creative power of an ancestral being and to increase the population of the natural species associated with this ancestor. The carving of cupules on a rock liberated the *kuranita,* the essence of life, with which the rock was impregnated. 'This *kuranita,* rising into the air in the form of dust, fertilises the living female cockatoos, causing them to lay more eggs' (Flood 1997: 147).

European cupules

In Europe, where cupules are abundant, they are associated with protohistoric megaliths along the whole Atlantic facade, from Scotland to Portugal. Cupule rocks are scattered over the crests of the Pyrenees, the Massif Central and the Alps, especially on granite and micaschist. There are myriad little cupmarks (a few centimetres in diameter and depth), associated with bigger cupules and slightly broader hollows; often they are joined together by channels. Their ritual use is confirmed by the Latin inscriptions of the Roman sanctuary of Panoias (Portugal), which also contains cupules, channels and basins: the cupules were 'consecrated by the late Calp. Rufinus to the gods and goddesses as well as to all the divinities of the Lapiteac'. According to these inscriptions, 'here are consecrated to the Gods the victims who were killed here; their entrails are burned in the rectangular basins and their blood spreads into the round hollows that are placed alongside'.

Many horizontal cupule stones could thus have been rocks for sacrifice or offerings, in which certain cults were celebrated, or used for libations and the pouring of sacred liquids (Lorblanchet 1967; Soutou 1963) (FIG. 62). However, the sanctuary of Panoias and Australian ethnographic examples only give a partial idea of a few recent functions of cupules, the purpose of which must have been both varied and malleable since the origins of humanity.

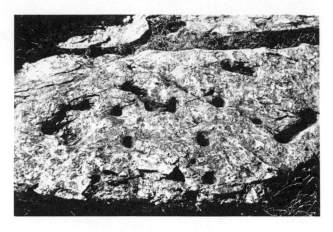

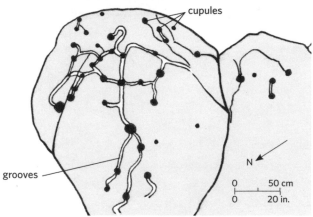

62. Cupules and grooves on horizontal micaschist outcrop in the Cévennes Range (eastern Massif Central, Commune of Sainte-Croix-Vallée-Française, Lozère, France).

Lu Ferrassie

The Middle Palaeolithic site of La Ferrassie in southwest France shows us that cupules have not said their last word about the origins of rock art. In 1921, in this rockshelter in the Dordogne, Denis Peyrony and Louis Capitan discovered seven Neanderthal burials – and another burial was found there more recently. 'Here the term of burial is unquestionable, and one could even conceivably call it a necropolis' (Vialet 2015: 296).

In this assemblage, Burial No. 6 contained a Neanderthal child covered by a stone with cupules on it, dating to about 50,000 years ago. This Mousterian burial, published in 1934 by Peyrony, reveals something remarkable: the stone was inverted, so that the face with the cupules

The first art in the landscape

63. Mousterian Burial No. 6 at La Ferrassie: (above)
plan of the burial; (below) detail of the block with
cupules found covering the burial.

was turned towards the skeleton – it seems likely, therefore, that
there was a link between the cupules and the burial. In other words,
the cupules were associated with an inhumation, and were therefore
symbolic and ritual (FIG. 63).

The block (65 × 46 × 28 cm or 25.6 × 18.1 × 11 in.), conserved and
exhibited in the National Museum of Prehistory in Les Eyzies, is a soft
limestone from the local Coniacian. A new study by one of us (ML)
has shown that it has twenty-nine cupules (FIG. 64). They are artificial,

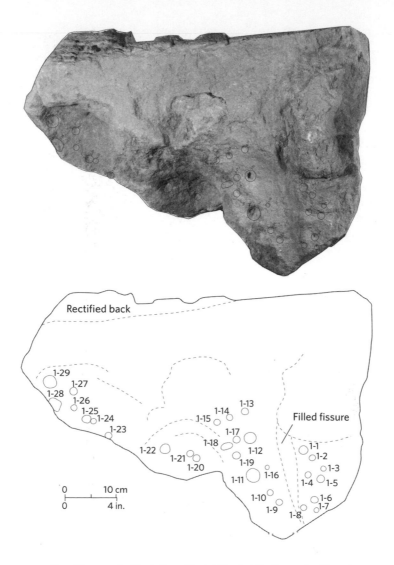

64. The cupule block from Burial No. 6 at La Ferrassie: (above)
orthogonal photograph of the block with orthogonal lighting for the
production of a photogrammetric map; (below) a recording of the cupules.

although today it is difficult to distinguish traces of pecking. As Peyrony
noted, there appears to be a rudimentary organization – some of them
seem to be in pairs, or lines of three. Moreover, these Mousterian cupules
recall those on the block from Sai Island (see pp. 203–4). We note that
the stone has undergone a few recent modifications, no doubt at the time
of its original installation in the museum's showcases: the large fissure
that can be seen in Peyrony's 1934 photo (FIG. 63, bottom) has been filled
in, and the back, which is straight, seems to have been rectified or sawn.

The first art in the landscape

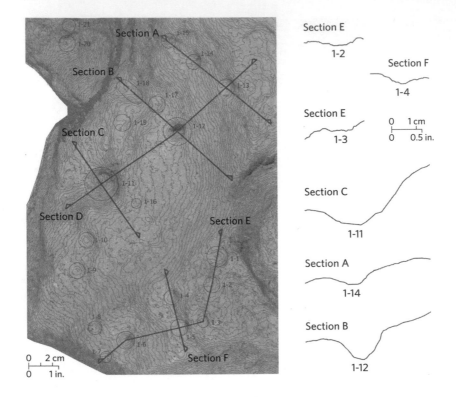

65. (Left) Detail of the photogrammetric recording of the cupule block from Burial No. 6 at La Ferrassie, showing numbered cupules and locations of cross-sections (contours: 1 mm or 0.04 in.); (right) cross-sections of cupules.

Unfortunately we lack detailed indications from Peyrony about the state of the find at the time of its discovery, and about the arrangements made for its installation in the museum.

Our recent examination of this cupule block from La Ferrassie has led to a few new observations. Photogrammetric recording from orthogonal photographs of the block has made possible the production of a cartography of the cupule-bearing surfaces. On these maps, the contours – at intervals of 1 mm or 0.04 in. – have enabled the creation of precise cross-sections of the cupules in order to compare them objectively not only to each other but also to Aurignacian and experimental cupules (see opposite). Analysis reveals that the block's cupules are quite varied in size, but there are two main types: 'big' cupules from 20 to 40 mm (0.8–1.6 in.) in diameter and 8 to 12 mm (0.3–0.5 in.) in depth, the deepest of them having a flat base with differing inclinations (1-11, 1-14, 1-12); and 'small' cupules from 20 to 30 mm (0.8–1.2 in.) in diameter and 3 to 6 mm (0.12–0.24 in.) in depth, with a rounded base (FIG. 65).

Chapter 7

Experimentation at La Ferrassie

In order to test various hypotheses about the creation of cupules in the Mousterian period at La Ferrassie, we produced a series of experimental examples on pieces of Coniacian limestone from the same geological age as the block from Burial No. 6. This yellowish limestone is common in the Vézère valley and in the whole Cretaceous of the Périgord: it has a finely granular and compact consistency, but offers little resistance to human working. Indeed, we think that these mineralogical qualities explain the general distribution – mostly in the west and Périgord but not in Quercy, a region of more resistant Jurassic limestone – of pecked engravings and even Palaeolithic bas-reliefs (Delluc & Delluc 1991; Lorblanchet 2010).

The first observation to emerge from our experiments is the immediate ease of making cupules on this type of rock, a facility that contrasts greatly with the considerable difficulty encountered in the experimental production of cupules on the metamorphic quartzitic sandstones of India carried out by Ram Krishna and Giriraj Kumar (2011: 907-18). In the Indian subcontinent, the hardness of the rock demands thousands of hammer blows to obtain a cupule of the same size and depth as the ancient specimens studied: 'nearly 30,000 strokes by direct percussion technique were needed to produce a small cupule of dimension 32 × 31.5 mm × 9 mm [1.26 × 1.24 × 0.35 in.]' (ibid.: 156).

In contrast, on the Coniacian limestone of the Périgord, only one or two hundred hammer blows suffice to obtain cupules identical to the Mousterian or Aurignacian examples from La Ferrassie. This work requires some precision in handling the hammer in order to repeat the impacts, if possible, at approximately the same point, but the results are rapid and striking: in a few minutes the experimental cupules can reproduce the prehistoric examples in their sizes, shapes and cross-sections.

On experimental Block A (FIG. 66), we reproduced six cupules (Nos 1 to 6) using two types of hammer: a quartz pebble with a rounded point, and a flint knapped into the shape of a Mousterian point with a sharp end (FIG. 67, c). Photogrammetric cross-sections show that the pebble hammer produces fairly broad cupules, from 30 to 40 mm (1.2-1.6 in.) in diameter, with a rounded base, and from 5 to 7 mm (0.2-0.28 in.) in depth (Nos 4 and 5), whereas the sharp point produces slightly narrower and deeper cupules (Nos 2, 3 and 6) (Block A), from 15 to 30 mm (0.6-1.2 in.) in

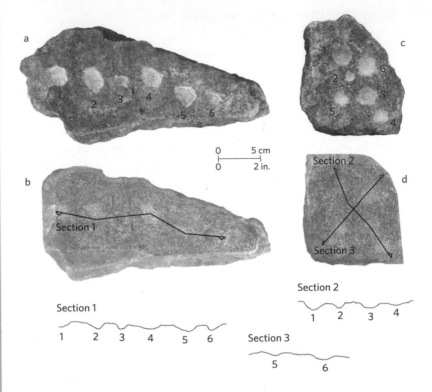

66. Experimental cupules on blocks of Coniacian limestone: (a) photo of Block A, with six cupules; (b) photogrammetric recording of Block A, with cross-section below; (c) photo of experimental Block B, with six cupules; (d) photogrammetric recording of Block B, with cross-sections below.

diameter and 7 to 8 mm (0.28–0.31 in.) in depth. Moreover, in these deeper cupules the base is flatter (especially No. 3, Block B). Cupules Nos 1 to 3 were each obtained with 100 hammer blows, and Nos 4, 5 and 6 required 150. In this first experiment we realized that the type of hammer and the intensity of repetition of percussion produce slightly different cupmarks that are close to the 'big cupules' and 'little cupules' observed on the Mousterian block from La Ferrassie.

On Block B (FIG. 66) the cupules were obtained with 150 hammer blows, but No. 1, the deepest (33 x 11 mm or 1.3 x 0.43 in.) required 200 hammer blows with a quartz pebble. We noted that Nos 2 and 3, produced with the flint point, are among the deepest, and have a flat base. Cupule No. 2 is relatively narrow with steep edges. By contrast, the cupules made with the quartz pebble have a funnel shape and are shallow (Nos 4, 5 and 6, with depths of 4–6.6 mm or 0.16–0.26 in.).

On Block C (FIG. 67) one finds again the two categories of cupule: funnel-shaped and shallow obtained with the pebble hammer (Nos 1, 2, 3 and 5), and narrow, deeper cupules (Nos 4, 6 and 7). The number of hammer blows plays a role in the depth of the cupules, since No. 5 was obtained with 200 blows from the pebble, whereas the shallow examples (Nos. 1, 3, 8 and 9, from 2 to 3.3 mm or 0.08 to 0.13 in. in depth) were produced with only 30 to 100 blows from the pebble. Once again it is noteworthy that the use of a sharp flint point produces narrower and deeper cupules (Nos 4, 6 and 7, from 7 to 8 mm or 0.28 to 0.31 in. deep) than the pebble hammer, which, with the same number of blows, produces shallower results: hence, for example, Nos 5 and 6 have the same depth but No. 5 was obtained with 200 blows from the rounded hammer and No. 6 with only 50 blows from the flint point. The 'flat base' feature also appears here occasionally: cupule No. 4 has a slightly flat base. On all three blocks this phenomenon sometimes occurs in the relatively deep cupules, and there is a simple technical cause: the repetition of blows produces an accumulation of sand in the bottom of the hollow that eventually protects the base, while the

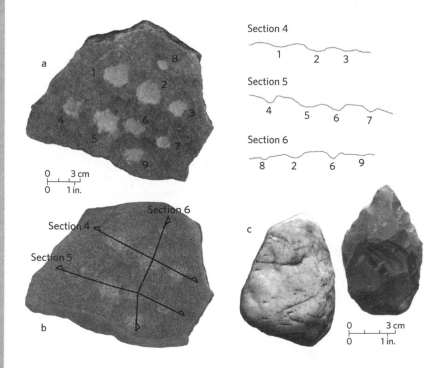

67. Experimental Block C, with nine cupules: (a) photograph of Block C; (b) photogrammetric recording of Block C, with cross-sections shown above right; (c) the two hammers, a quartz pebble (left) and flint point (right), used for the experimental cupules.

The first art in the landscape

sides remain exposed to attack. In this way the cupule becomes funnel-shaped, and its base flattens (but the funnel shape is less pronounced with a flint point).

These experiments give an insight into how different types of cupule, such as those on the block from Burial No. 6 at La Ferrassie, might have been made. In the experiments, differences in cupules were the result of different hammers being used (a quartz pebble and a flint Mousterian point) and different numbers of hammer blows. We can conclude that the big and small cupules on the La Ferrassie block were probably produced with different hammers, and perhaps by different people at different times.

In addition, the cartography and photogrammetric sections show us that the cupules on the La Ferrassie block are identical to the Aurignacian cupules from the same rockshelter, which are clearly artificial and organized. This provides irrefutable proof that the Mousterian cupules were made artificially and not by nature (FIGS 68–70).

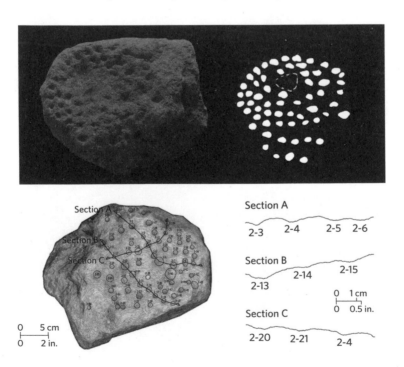

68. Aurignacian cupule Block No. 20 from La Ferrassie:
(above) a photograph of the block and a recording of the cupules;
(below) photogrammetric recording with cross-sections.

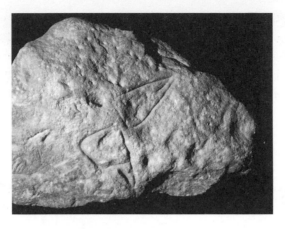

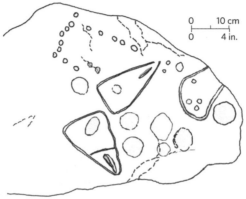

69. Block from the Middle Aurignacian of La Ferrassie
with pecked figurative motifs (vulvas?) and both large
and small cupules, some of them in lines.

Aurignacian levels H and H' (Aurignacian II and III, containing spear points that are flat and lozenge-shaped, and then oval in cross-section) yielded twenty-nine decorated blocks, the majority of which have cupules, either singly or, more often, in groups (Delluc & Delluc 1984a); these cupules are associated with deeply pecked engravings of vulvas or partial crude animal outlines. Block No. 20, from layer H''' (Aurignacian III), is decorated with a group of small cupules, from 10 to 20 mm (0.4–0.8 in.) in maximum diameter and from 2 to 4 mm (0.08–0.16 in.) in depth, made by pecking. Although this block is smaller than the Mousterian one, it has more cupules – sixty-six have been recorded – and they have a very clear organization, forming a spiral around a slight central depression. The cartography and photogrammetric sections (FIG. 68) reveal that they are identical to the small cupules on the Mousterian block from Burial

The first art in the landscape

No. 6; and moreover their homogeneity (they are all small, funnel-shaped and shallow) doubtless implies the preconception of the spiral motif to be produced, and the immediacy of its creation with a limited number of blows for each of them (about fifty). In contrast the production of the cupules on the Mousterian block seems less programmed, more diversified, and probably spanned a longer period.

The small cupules associated with vulvas can be seen, for example, on Block No. 6 (from the same level as No. 20). This block presents different kinds of cupules: some are small (20–30 mm or 0.8–1.2 in. in diameter) and organized in linear motifs, while others are broader and deeper (FIG. 69). From the Aurignacian II levels, Block No. 1 already has engravings of vulvas and segments of animals with lines that are sometimes pecked. Hence the Périgord's first figurative images – made with deep engraving, often with pecked lines that join up cupules, about 35,000 years ago – are sexual images and crude animal segments, notably ibex horns.

From dots to lines

In the Périgord, the cupule tradition, born in the Mousterian levels and Neanderthal Burial No. 6 at La Ferrassie, was developed in the same shelter's upper layers, especially in the Aurignacian levels. The soft Coniacian limestone, which was easy to work, mark and peck, doubtless explains the development of a portable art on blocks in the Vézère valley, which led to the emergence of the first forms of parietal art (engravings and bas-reliefs). As Peyrony (1934: 34) noted: 'already by a phase of the Mousterian, people were tracing in stone some cupules that were absolutely identical to those found in a more recent period, the Aurignacian, and later in Palaeolithic and Neolithic contexts.'

To illustrate this transition from cupules to linear figuration, one need only observe the details of the lines in the supposed vulvas on the blocks from Aurignacian II and III levels at La Ferrassie. For example, on one of these blocks, displayed in the National Museum of Prehistory in Les Eyzies, one can clearly see that the upper part of a vulva is made up of a line of small cupules joined together (FIG. 70). The cupules led to the pecked linear engraving, but one should point out that the first figurative drawings made up of cupules are often still accompanied by lines or disorganized clusters of isolated cupules, as if the cupules had a double role of symbolic marking and graphic technique.

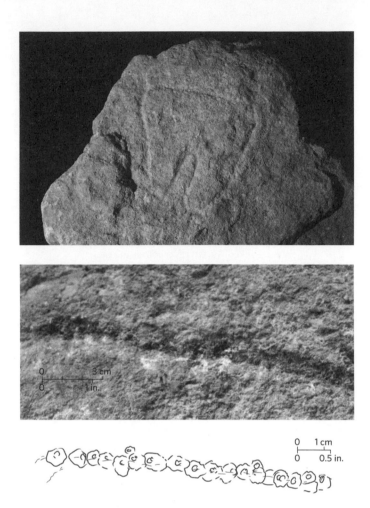

70. Aurignacian block with vulva(?) from La Ferrassie, showing the transition from cupules to linear marks. The figurative engraved motif is made up of a series of small joined cupules; the cupule-line is then regularized and homogenized in order to obtain a deep linear mark.

The shelter of La Ferrassie has also yielded a dozen pieces of portable art on blocks as well as traces of parietal art: 'The exfoliated plaquettes found in different levels show that the shelter's wall was very probably decorated throughout the whole Aurignacian' (Delluc & Delluc 1991: 148).

Blanchard
A decorated Aurignacian block, discovered in 2012 at the abri Blanchard, Dordogne, has only recently been published (Bourrillon et al. 2017). It bears a depiction of an aurochs and a series of small cupules. These cupmarks constitute another example of the tradition of cupule blocks

The first art in the landscape

71. Pecked Aurignacian engraving of a
caprid from Belcayre shelter (Dordogne)
(scale shows 10 cm above and 4 in. below).

in the Vézère valley, as highlighted above at sites like La Ferrassie. The
aurochs figure – as one would expect in the Aurignacian – is simple
and crude, with a distorted outline, and no details; it has a single horn
and its legs are rudimentary or absent. Yet, astonishingly, the authors in
question have attempted to compare this figure with the aurochs images
in Chauvet cave (see p. 231) – where (e.g. on the horse panel) they are
naturalistic and highly sophisticated in style, with both horns and details
such as the ear, eye and mouth. We find it impossible to see the slightest
similarity between the two, other than in the species depicted.

Belcayre

Another example of cupules leading to figurative pecked engraving is
provided by a block of soft Coniacian limestone that was found in the
Middle Aurignacian of the abri du Renne at Belcayre (Dordogne). It is
decorated with a pecked engraving of a caprid (FIG. 71), and this engraving
is made up of a line of crude cupules (Delluc & Delluc 1991: 117–22);
according to the Dellucs, who studied it, 'the outline of the animal was
obtained... by the juxtaposition of big, perfectly individualised pecking
impacts.... This block is well located chronologically, and is one of the
fundamental elements of Aurignacian art' (ibid.: 121).

Les Fieux

A massive calcite concretion in the cave of Les Fieux, in the Lot, has
a group of 110 cupules made by percussion. They are exactly the same
as the cupules on the blocks from the Dordogne's Vézère valley. Their

72. This group of 110 cupules on a stalagmitic block at the cave of Les Fieux (Lot) seems to form the body of an indeterminate animal.

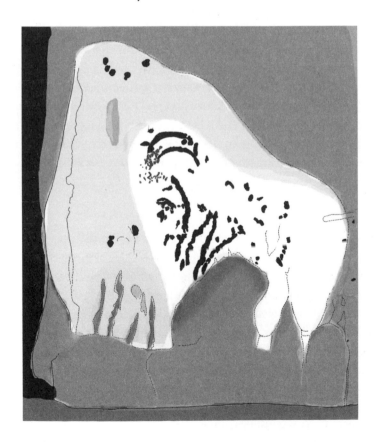

73. Recording of the pecked Aurignacian ibex (c. 1.5 m or 5 ft across) at Les Fieux. It completes a natural shape in the stalagmitic mass, and is associated with cupules.

The first art in the landscape

grouping seems to suggest the silhouette of an undetermined animal body (FIG. 72). The calcite mass – a softer rock than the surrounding Jurassic limestone, which is compact and resistant – played the same role in Les Fieux as the soft Coniacian limestone of the Périgord; these two kinds of rock are very inviting to human tools because of the ease with which they can be modified. The exceptionally suggestive shapes of the concretion at Les Fieux were also very inviting to human intervention.

In the same cave, in another sector of the same stalagmitic mass, the outline of an ibex is made up of lines of coalescing pecked cupules (PL. XVII, FIG. 73). Here we pass from the above-mentioned decorated blocks of the Vézère valley to parietal art and decorated caves. The cupules are organized to form an engraving of an ibex identical in subject and technique to the caprid from the Belcayre block. Comparison with Belcayre shows that the ibex from Les Fieux is also Aurignacian – and this age is confirmed by the discovery of Aurignacian flints in the cave, at the foot of the engraving, and by the fact that, as we saw for the Vézère blocks, the animal is likewise accompanied here by isolated and grouped cupules. But in the cave of Les Fieux there is also a utilization of the natural form of the support, with the animal's whole rear end made up of the stalagmite folds. As we enter the domain of the parietal, from the start a dialogue is established between the engraver and the cave. The pre-existing figure in the rock is confirmed by the engraver, and the ibex seems to stand out from the wall: cave art is beginning (Lorblanchet 2010: 320–33; 2015).

Conclusion: the development of the cupule tradition

Cupules were made over a period of almost 2 million years, across vast areas of Africa, India, Europe and Australia, and feature among the creations of various different human species: *Homo erectus*, then Neanderthals and finally *Homo sapiens*. Like spheroids and bolas (see Chapter 3), cupules – which are hollows, and hence concave and convex forms appeared together – represent a very ancient and long tradition of human productions, and they can be considered to be among humanity's first symbolic and aesthetic expressions. And like spheroids, most cupules do not seem to have a utilitarian function, since they can be found on both horizontal and vertical surfaces. Almost as old as stone balls, they appear 1.8 million years ago at Aïn al Fil, made by *Homo erectus* in the Middle East. They then persist throughout the Lower and Middle Palaeolithic,

as shown by the cupule block from Sai Island, dating to about 200,000 years ago, and doubtless by a few other cupules in India and Africa (although these, alas, have not yet been scientifically dated). In Australia, cupules seem to appear very early in the landscape, and are found on rock outcrops, in rockshelters and in the open air. They also appear in Europe more than 50,000 years ago, in the Mousterian levels of La Ferrassie.

During their long evolution, it seems that cupules diversified and marked the transition from portable to parietal and rock art, and from simple symbolic marks to veritable figurative linear engraving. Through space and time cupules were modified, as their function probably evolved and became complex: at the start there were small blocks with a few cupules, and then during the Pleistocene larger blocks with more examples, and finally cupules took part in the arrival of true rock art. They spread over the landscape, on prominent rocks in the open air where they were sometimes clustered in thousands, and soon they also appeared on the walls of some caves.

For the moment, research cannot date with any precision the time when cupules changed in status, and especially when they moved from portable to parietal art. It is possible that in Africa and Asia some cupule rocks in the landscape may date to the Middle Pleistocene, but as yet we have no scientific proof of this. New dating methods or stratigraphic discoveries are needed.

74. Palaeolithic pecked engravings of horses in the
open air in the Côa valley (Portugal). Thousands of such
engravings were discovered in the area in the 1990s.

The first art in the landscape

The cupules that appear in the Mousterian of La Ferrassie occur as groups of pairs; then, in the same site's Aurignacian levels, they are organized in more complex geometric or figurative motifs, especially sexual images and a first few animal figures. The outlines of the motifs often consist of a pecked line made up of lines of joined cupules obtained by percussion: the cupule – which is a pecked dot – led to the pecked line, and then a deep linear engraving obtained through a regularization and finishing of the pecked line. These different stages, technological as well as chronological, sometimes appear together in the first decorated blocks in the Vézère valley.

This tradition of Aurignacian cupules can also be seen in the deeply pecked parietal engravings of Les Fieux, and then too in other caves of Aquitaine, both Aurignacian and Gravettian, with deep engravings that evoke crude regularized lines, like those, for example, of Pair non Pair and especially in the open-air art of the Côa valley (Baptista 2009) (FIG. 74). It seems that when cupules spread through the landscape, they constituted one of humankind's earliest appropriations of space and their functions diversified; at the start of the Upper Palaeolithic, on the same rock surfaces, they were both self-sufficient symbolic marks (which then continued to recent times) and a means of drawing the very first geometric, human (vulvas) and animal figures. They then played a role in the great development of open-air pecked art that spread over all continents, and of the art of decorated caves that was more limited in space and time.

Chapter 8

The writing's on the wall: the earliest cave art

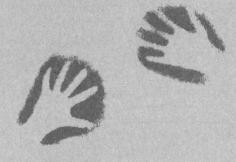

After decades of being ignored or disparaged, the concept of Neanderthal 'art' has at last come into its own, with the wide variety of evidence outlined in earlier chapters. Neanderthals are also thought to have used feathers for decoration (Finlayson et al. 2012), while the Croatian site of Krapina has yielded eight white-tailed eagle talons that seem to have been worn as jewelry (Radovčić et al. 2015). But things are going even farther now: it has been suggested, for example, that Neanderthals may have contributed to, or been responsible for, the artistic tradition that produced the Aurignacian ivory carvings of southwest Germany (Conard et al. 2004: 200; Conard 2005: 83–84); and new U-Th dating of calcite in some north Spanish caves is beginning to make it possible to imagine that Neanderthals produced some simple cave art – such as red dots and hand stencils (Pike et al. 2012). Furthermore, in Gorham's Cave, Gibraltar, it has been claimed that a deeply incised abstract motif found on bedrock is covered by an undisturbed archaeological layer containing Mousterian artifacts and dates to more than 39,000 years ago (Rodríguez-Vidal et al. 2014) (FIG. 75).

In the Loire valley, at La Roche-Cotard, the cave that yielded the well-known 'mask' (FIG. 43), there are four panels of marks that almost

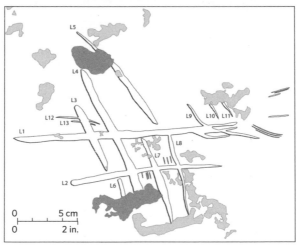

75. Photo and drawing of abstract grooved
markings in Gorham's Cave (Gibraltar),
thought to be more than 39,000 years old.

certainly can be attributed to Neanderthals (Marquet & Lorblanchet 2014). The first panel includes a roughly circular motif made with two fingers on the left and four on the right; the second is triangular in form, 30 cm (12 in.) in height, and features a series of parallel fingermarkings (FIG. 76, above); the third is roughly rectangular, 35 × 25 cm (14 × 10 in.), and is again decorated with up to thirty parallel marks (FIG. 76, below); while the fourth panel consists of circular dots, about 2 cm (0.8 in.) in diameter, probably made by striking the wall's surface with a tool. In a very tight crawlway, moreover, several small patches of red ochre have been found in different places (PL. XIX).

La Roche-Cotard has an exceptional association of Mousterian industries with animal and human parietal traces, and has been the subject of extensive multidisciplinary investigations that will soon make it possible to date all the parietal markings. The excavations, led by Jean-Claude Marquet, have revealed the evolution of the sediments of the slope on which the site is located and their chronology; the little cave of La Roche-Cotard I, at the top of the slope, was inhabited by Mousterians and then filled with slope deposits at the end of the Mousterian. It was only reopened by a stone-extraction quarry in the late nineteenth century.

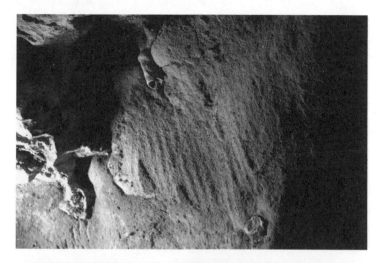

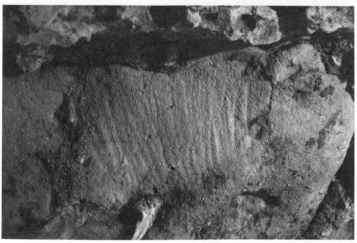

76. Neanderthal fingermarkings at La Roche-Cotard cave (Indre-et-Loire, France): (above) triangular motif; (below) rectangular motif.

The writing's on the wall

Marquet and his collaborators discovered on the walls of this small cavity an abundance of animal clawmarks (cave bear, hyena, feline, etc.) as well as the above-mentioned authentic human fingermarks, traces of pecking, and spots of red ochre. La Roche-Cotard thus presents an exceptional situation in which elementary human traces and various animal traces are found together on the same panels, which allows the researcher to carry out an in-depth comparative study of a type scarcely ever undertaken *in situ*, and to identify the superimpositions and associations of all these traces, and to distinguish clearly what is human and what differentiates human and animal behaviour on a wall: this is a fundamental problem in the birth of art. OSL dates and detailed parietal recordings will confirm these observations, and perhaps La Roche-Cotard will soon be included on the brief list of sites with a few parietal sketches representing humankind's first graphic activities.

Animal and human marks

The comparison and distinction of engravings and animal clawmarks are not just necessary at La Roche-Cotard but also in all studies of parietal art; they pose some interesting and sometimes difficult problems to specialists (Lorblanchet & Le Tensorer 2003) in exactly the same way as marks on bones and stones (see Chapter 4). Just like humans, the animals that frequented caves (bears, felines and hyenas, and small creatures like foxes, badgers and rabbits) left traces of their presence in every period. On the same walls that were painted or engraved by humans, the cave bears who intensively frequented the deep caves in which they hibernated also polished the lower surfaces through their repeated passages, and left a variety of traces on the ground: their 'nests', paw-prints, faeces and marks of sliding, for example. Some of these traces can even be considered ursine 'drawings' when there are innumerable clawmarks, or intentional blows from claws that declare a presence and define a territory.

When studies of the subterranean world have been too rapid and superficial, prehistorians have sometimes confused bear clawmarks with engravings, especially when these clawmarks were produced on a fairly hard rock such as limestone or calcite, because on a support of that type animal claws can leave a narrow, shallow groove that may resemble an incision by a flint. On softer clay surfaces, bears left deep lacerations, and in such cases their spectacular clawmarks leave no doubt about their animal origin.

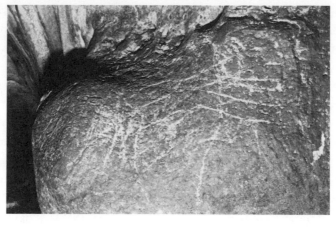

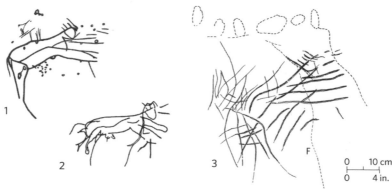

77. The pseudo 'wounded and masked shaman' made up of bear clawmarks in the Combel gallery, Pech-Merle (Lot, France). (Above) Photo of the calcite massif covered with cave bear clawmarks; (1) recording by Amédée Lemozi (1961); (2) drawing by Lya Dams (1984b); (3) recording by Michel Lorblanchet, showing that the figure consists only of bear clawmarks (1989) (F: fissure)

One example of confusion between clawmarks and engravings can be seen in the interpretation that several prehistorians have given of the bear clawmarks in the Combel gallery in Pech-Merle (FIG. 77). In the deep part of this gallery a massive concretion is covered in all directions by clawmarks that criss-cross and cover a good deal of the surface. In 1961, Amédée Lemozi announced that these lines were Palaeolithic engravings, and thought he could see a 'masked and wounded human figure': 'It is possible to see in this type of figure, pierced by lines, an initiation scene during which the initiates or future shamans have to die a ritual death or as an effigy, a prelude to a new, transcendent life. The pecking and the lines seen on this character doubtless represent wounds' (Lemozi 1961) (FIG. 77, NO. 1).

The writing's on the wall

As a faithful follower of Romanian historian and philosopher Mircea Eliade, Lemozi extrapolated his readings onto the object of his study, and was already afflicted by the first wave of shamanism (of which the apogee was the Abbé Glory's 'Ongones theory' in 1964; the second wave, so powerful in the media, arrived more recently from South Africa). The 'wounded' and/or 'masked' man of the Combel then continued his progress through the prehistoric literature. He was to reappear in 1984 in a work by Lya Dams that provided an overview of 'wounded men' in Palaeolithic and Spanish Levantine art, but this time he was endowed with a sex that seemed to confirm that this was indeed a 'shaman' and not a 'shamaness' (Dams 1984b) (FIG. 77, NO. 2)!

In 1989 the recording by one of us (ML) showed that this figure is a pure figment of the imagination (FIG. 77, NO. 3): in reality it is made up of an assemblage of cave bear clawmarks in the calcite, which was softer than limestone (Lorblanchet 1989); those with experience of the subterranean world, such as prehistorians who regularly undertake parietal recordings, know that bears sometimes produce gashes in all directions, and up to several metres in height, including horizontal clawmarks, such as can still be seen in the second cave at Cougnac (Lot) or in the cave of Fumel (Lot-et-Garonne) (Lorblanchet 1999: 42). The 'wounded man' of the Combel illustrates, once again, the dangers of the imagination in the study of Palaeolithic art.

Elsewhere, in the cave of Les Battuts (Tarn, France), two prehistorians (Edmée Ladier and Anne-Catherine Welté) and a speleologist (Jacques Sabatier) thought they had detected some parietal engravings evoking Magdalenian tectiforms, but they rapidly came to realize that these were cave bear clawmarks; they too called attention to the 'clawmarks/ engravings ambiguity' and the risks of confusion that this brings (Ladier, Welté & Sabatier 2003) (FIG. 78). Only complete knowledge of all the natural and anthropic phenomena on the walls of a cave can make it possible to identify a parietal motif with any certainty.

0 10 cm
0 4 in.

78. Cave bear clawmarks that resemble
engraved tectiform signs, from the cave
of Rouffignac (Dordogne, France).

0 | 20 cm
0 | 8 in.

a

c

79. Imitation and utilization of bear clawmarks by Gravettians:
a mammoth in the cave of Aldène (Aurignacian?) formed by bear
clawmarks (C) and an engraved cervico-dorsal line (a).

The situation is all the more complicated because Palaeolithic
people showed a great deal of interest in, and respect for, cave bears:
they sometimes appear to have considered their clawmarks signatures
or property marks which, in turn, in some cases, led to their own
interventions on the walls. Hence, in the Combel gallery once again, one
of us (ML) recorded a panel in a niche that features five bear clawmarks
associated with five red rubbed hands (Lorblanchet 1999: 15) (PL. XX). Here,
the Gravettians imitated the bears' gestures and their clawmarks, which are
covered with red ochre here and there. It is remarkable (and the Gravettians
doubtless noticed it) that a rubbed adult hand, with fingers slightly apart,
leaves a trace identical in size to that of an adult cave bear clawmark.

In the cave of Aldène (Hérault), bear clawmarks were integrated into a
mammoth drawing discovered by Paul Ambert (1972): 'To the clawmarks
that simulate the coat and the limbs, the Aurignacian engraver merely
added 'the animal's outline from trunk to tail, with the whole cervico-
dorsal line' (Sacchi 2003) (FIG. 79). In the same cave a geometric motif,
recorded by Denis Vialou (1979), cuts across the shoulder of a feline:
'It integrates a series of four prints with a circular engraved construction
made with four lines, equal in number to those of the initial clawmark'
(Sacchi 2003). In addition to this circle at Aldène, other designs seem to
have incorporated clawmarks, such as a hand at Bara-Bahau (Dordogne);
and it is thought that some marks on cave walls, at La Croze à Gontran
(Dordogne) and elsewhere, are engraved imitations of these clawmarks
(Delluc & Delluc 1983, 1985: 60).

The writing's on the wall

These interesting examples form part of the delicate dossier concerning relationships between bears and humans in decorated caves, and pose the thorny question of a possible origin of a certain type of parietal art in imitations of clawmarks, as was believed by numerous specialists from Breuil onwards. Be that as it may, La Roche-Cotard now offers attentive researchers a magnificent case study through which to try to understand the dialogue that the first Neanderthal 'artists', some 75,000 years ago, seem to have had with the walls of a small cave in the Loire valley, and with the marks left by animals on the same wall.

Spit painting

Alongside cupules and pecked engravings, the existence of parietal painting – red, black or bichrome – persisted during much of the Aurignacian in the Vézère valley, most notably at La Ferrassie and in the rockshelters of Blanchard and Castanet (Delluc & Delluc 1984a, 1991). Likewise in several Cantabrian caves, including Tito Bustillo, El Castillo, Altamira and Candamo, paintings have been dated to the Aurignacian by a variety of methods (Fortea 2002; Pike et al. 2012). Although some of these chronological attributions – or certain excavation methods – are still a matter of debate, it is nevertheless accepted that parietal painting does appear in the Aurignacian in several European decorated caves, possibly including Chauvet.

In 2012 a team of specialists (geochemists and prehistorians) from various British, Spanish and German institutions, led by Alistair Pike, produced a series of new dates from the calcite that partially covers paintings in eleven caves in Cantabrian Spain (Pike et al. 2012). The U-Th method employed for dating the calcite has been in use for many years, and has now achieved a considerable degree of perfection, to the extent that it is currently considered 'the most reliable dating technique that we have at present for establishing the chronological development of cave art in Europe' (Pike et al. 2016). Pike and his colleagues (2012) found that some caves in their study had been decorated over a span of 20,000 years. For example, calcite over a red horse with a dotted outline on the Altamira ceiling gave a result of more than 22,000 BP, while a red 'claviform' sign nearby gave a result of more than 35,000 BP. At El Castillo one of the lines of red dots has a minimum age of 34,000 BP, another a maximum age of 36,000 BP; and in the El Castillo panel of hand stencils, one has a minimum age of 24,000 BP, another a minimum of 37,300 BP, while a

red disc on the same panel has a minimum age of 40,800 BP (PL. XXIII). Several of the big red dots that abound in the cave of El Castillo are as old as many cupules and contemporaneous with hand stencils; similar dots are also found in the cave of Pech-Merle on a ceiling in the Combel gallery, where they appear to form a big dotted motif (PL. XXII).

These parietal paintings were made with the spitting method – that is, paint being sprayed from the mouth – which is the oldest pictorial technique. It is still used today in Australia, where it has achieved extraordinary dexterity in the rock art of Queensland, often involving negative hands and all kinds of other stencilled motifs (Walsh 1983; Lorblanchet 1988). Like pecked cupules it is a means of automatic marking, or in other words it is repetitive and involves no graphic skill. In parallel with the cupule tradition, spit painting largely developed

The Chauvet problem

It is well established that the majority of Ice Age art in Europe can safely be attributed to modern humans and the Upper Palaeolithic period. But how old is the earliest of that art? Chauvet cave in Ardèche, France, was discovered in 1994, and contains more than 450 painted and engraved images, including some of the finest ever seen. These images were initially and solidly ascribed through their style, content and technique to the Middle and Late Upper Palaeolithic (Gravettian to Early Magdalenian); but radiocarbon dates from a few black drawings subsequently reassigned many of the cave's images to the Early Upper Palaeolithic (Aurignacian). The cave's red images are fairly homogeneous, while its black images are heterogeneous and have been divided into two phases, one of which clearly precedes the red, as shown by superimpositions. The current orthodox view is that Chauvet contains Europe's oldest dated imagery, from about 36,000 years ago. Unfortunately, there are numerous problems with this claim that have repeatedly been presented by a number of specialists, but which remain completely unaddressed by the Chauvet research team. We shall simply summarize them here:

- Despite claims that this is the best-dated decorated cave, with 259 dates produced by a series of different laboratories (e.g. Quiles et al. 2016), only ten of these dates concern the art – the vast majority of the results were obtained from charcoal on the cave floor – and the relatively few dates obtained directly from charcoal

The writing's on the wall

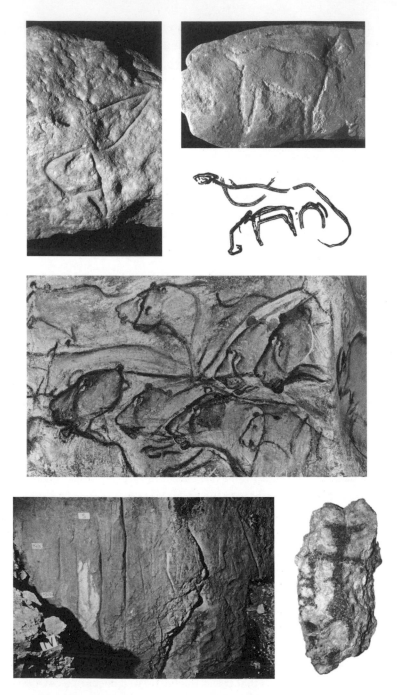

80. If the art at Chauvet (centre) is indeed Aurignacian, it is far in advance of all other solidly dated art from that period. The examples of the latter shown here are from: (above left) abri de Belcayre (Dordogne); (top right) abri de La Ferrassie (Dordogne); (upper right) La Baume Latrone; (bottom left) La Viña (Asturias, Spain); (bottom right) Fumane cave (Italy).

in parietal figures have all, without exception, been produced by the radiocarbon laboratory at Gif-sur-Yvette. This is utterly unscientific – these samples should have been split and sent to different labs (Pettitt & Bahn 2003).

- This is all the more crucial since it has been claimed that the Gif laboratory did not decontaminate the charcoal samples correctly (Combier & Jouve 2012, 2014).

- Almost no Aurignacian occupation sites are known in the entire Ardèche region, and no Aurignacian date has ever been obtained from any other cave in the entire region, decorated or undecorated (Combier & Jouve 2012, 2014).

- The cave's art contains many features that are firmly linked to later phases of the Upper Palaeolithic (Pettitt et al. 2009) – a red claviform sign, an engraved tectiform, animals seen from the front, animated scenes, a Magdalenian-style vulva, the scraping of wall surfaces, and sophisticated use of shading and perspective. In addition, depictions of reindeer are not known in any other Palaeolithic art, parietal or portable, before the Magdalenian, but Chauvet has twelve very naturalistic examples.

- It has been claimed that the cave entrance was blocked by about 20,000 years ago, but this is based on highly dubious reasoning, and in any case there was certainly more than one entrance (Pettitt & Bahn 2014).

- Numerous examples of bear clawmarks deface the images of the red phase and the first black phase, but no such marks deface images of the second black phase. Thus we can infer that cave bears were present in the cave during or after the creation of the red series and the earliest black series, but that they were not present during or after the creation of the second black series. The Chauvet team claim that cave bears did not use the cave after 23,000 years ago, and hence the second black series must be more recent than that (Pettitt & Bahn 2015).

- Attempts have been made to find examples of art of similar age, but the 'dating' of stalagmite, charcoal and bone from Aldène

The writing's on the wall

(Hérault), La Baume Latrone (Gard) and Altxerri B (Spain) respectively may have absolutely no connection with the art on the walls, which therefore remains entirely undated (Bahn 2016: 106).

- The remarkably early dates (around 33,000–32,000 years ago) obtained by the Gif laboratory for some black dots in Candamo cave (Asturias), on which doubt was cast at the time (Pettitt & Bahn 2003), have now been declared unreliable by the laboratory, which has re-dated the same dots to around 22,000–18,000 years ago (Corchón et al. 2014).

The art of Chauvet can be – and was, when first discovered – attributed to the Gravettian, Solutrean and Magdalenian rather than to the Aurignacian. Indeed wide artistic parallels with securely dated art from elsewhere seem to make this the most logical interpretation. However, in the latest desperate attempt to pin the art to 36,000 years ago, it has even been claimed that red marks on the cave wall are a depiction of a volcanic eruption in the region at that date (Nomade et al. 2016)!

If the artworks of Chauvet cave are indeed Aurignacian, then they must be contemporaneous with other works that are perfectly and stratigraphically dated, all of them archaic and rudimentary. Examples include the simple parietal non-figurative markings found in Spain, such as the parallel vertical incisions of La Viña, dated to more than 35,000 years ago (Fortea 1981), which gradually give rise to stylized animal forms; the cupules and pecked engravings of vulvas, a few traces of red and black paintings and a few simple animal images in the Vézère valley (Delluc & Delluc 1991); and the extremely schematic and partial figures and animals from Fumane cave (Broglio et al. 2009). The finger-drawings of the cave of La Baume Latrone, which were recently attributed to the Aurignacian because a charcoal fragment on the floor was dated to that period, include felines and mammoths whose schematic partial and rudimentary style provides a total contrast to that of the Chauvet figures and their technical sophistication (Azéma et al. 2012). If the early dates at Chauvet are valid, then we have surely lost any system of stylistic chronology, of the kind established by more than a century of study of parietal art. Faced with these massive graphic and technical contradictions, research is currently disorientated – which is why there is a dramatic and urgent need for a measured, objective, informed and detailed debate about dating problems, particularly at Chauvet (Pettitt & Bahn 2014, 2015; Lorblanchet 2007, 2014)!

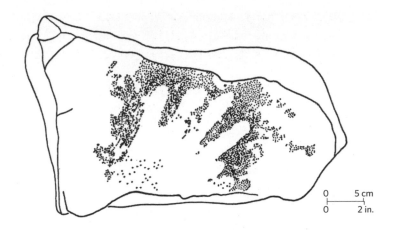

0 5 cm
0 2 in.

81. Hand stencil on a block from the
Gravettian level at abri Labattut (Dordogne).

during the whole of the archaic phase of Palaeolithic parietal art.
The very early dates from El Castillo and Altamira, obtained from non-figurative automatic paintings and spanning a period between 41,000 and 35,000 years ago, pose the following question: since these results provide minimal ages for the motifs beneath, which could be far older, are these early motifs, perhaps including hand stencils, the work of modern humans or the last Neanderthals?

In the European Upper Palaeolithic, the spitting technique seems to spread from the very start of the period – it characterizes the Aurignacian, the Gravettian and then the early Magdalenian at Lascaux, for example. A Gravettian layer in the abri Labattut (Dordogne) yielded a hand stencil on a small limestone block (FIG. 81), which shows the persistence of this motif in the Gravettian (Delluc & Delluc 1991: 163); a series of other direct radiocarbon dates of hand stencils in Spain and France have yielded Gravettian dates between 30,000 and 25,000 BP. However, these images of hands, while commonly attributed to the Gravettian, are doubtless far more ancient (Pettitt et al. 2015).

The great panel of the spotted horses in Pech-Merle has two horses, some black dots and black hand stencils, all of which were made with the spitting technique (Lorblanchet 2010: 105–25) (PL. XXIX). The renovation of the right-hand horse has been dated to 24,640 ± 390 BP by radiocarbon, but the original drawing of these horses with manganese is older. A careful examination of the details in the lines of the horses, and especially the centre of their dorsal profile (FIG. 82), reveals that the outline of the animals was made with a line of big

235

The writing's on the wall

82. Detail of the back of the left-hand horse of the great
panel of the spotted horses at Pech-Merle (Lot, France),
showing how the outline of the horses was made not with
a continuous mark, but rather with a series of sprayed dots.

sprayed dots, the upper part of which was stopped by the artist's hand
being used as a screen to control and guide the pigment. In a major
experiment one of us (ML) reproduced (in a cave) the entire panel,
3.6 m (11 ft 10 in.) long, using the spitting technique, which posed
no particular difficulty.

The spotted horse panel comprises 265 motifs assembled on an
exceptional wall limited by a rocky beak shaped like a horse head. It was
this rock shape that triggered the development of the whole panel. So
here, as at Les Fieux with its cupule ibex, we have an initial invitation by
the cave; the dialogue established between the artist and the cave is the
starting point of the paintings. But at Pech-Merle the graphic composition
is vast, using the entire available surface, and there is a veritable quest
for aesthetic effect, a staging in the centre of a huge chamber in the cave.
There is a search for beauty that goes way beyond the symbolic function
of the figures. The spitting technique, in itself, also had an important
symbolic aspect: there is no more direct 'projection' (in a psychological
sense) than painting with one's own breath, the most intimate part of any
living being.

There is an apparent shared identity between cupules and sprayed
dots: both are autosufficient automatic marks that often form simple
groups or lines, but they may also be organized in vast figurative

compositions. The cupule and the dot, the pecked engraving and the dotted painting, are equivalent. However, Aurignacian painting techniques were not limited to just spitting. For example, the early Aurignacian of the abri Blanchard (Sergeac, Dordogne) yielded – on top of a diffuse red background that may have been spat – a painting of a bovid whose outline was drawn with a black line (Delluc & Delluc 1984b) (PL. XVIII). It seems that line drawing, equivalent to the pecked engraved line, already existed in this remote period. Paint was not simply projected: drawing by direct physical contact with the wall was also developing (ibid.).

Dotted lines could also sometimes be obtained with fingerprints – the fingertips were covered with pigment and then applied to the wall: these small digital dots, isolated or often grouped, were sometimes organized into animal outlines, especially in some Cantabrian Gravetto-Solutrean caves (Covalanas, La Haza, etc.) and more rarely in Quercy: Pech-Merle has a red stag and ibex made up of lines of digital dots (FIG. 83).

83. A stag from Pech-Merle, consisting of lines of dots made with fingertips.

The writing's on the wall

Fingermarkings

In parallel with the cupule tradition and the spitting technique, the tradition of fingermarkings – that is, automatic lines obtained through direct manual contact with the wall – began during the earliest periods of Palaeolithic art, and it was to reappear occasionally in the Magdalenian (cave of Rouffignac, Dordogne) (Lorblanchet 2010, 2015).

The great ceiling of Pech-Merle is covered with mondmilch ('moonmilk'), decomposed limestone forming a very soft clay-like layer in which the slightest rubbing with fingers immediately inscribes a trace. We have here a panel of fingermarkings that extends over a dozen square metres (well over a hundred square feet) (FIGS 1, 84, 85), and which can be dated to the Gravettian, like the whole of this cave's decoration (Lorblanchet 2010: 153–70). Thanks to its softness, this mondmilch is an invitation to drawing. The obliging cave calls to the hand and offers the possibility of immediate and easy production of shapes. Here again one can see the perfect encounter and harmony between the human gesture and the rock's physical qualities, both of which lie behind any creative act.

84. The ceiling of the cave of Pech-Merle, covered in
fingermarkings made in the soft, decomposing surface
of the rock, known as mondmilch ('moonmilk').

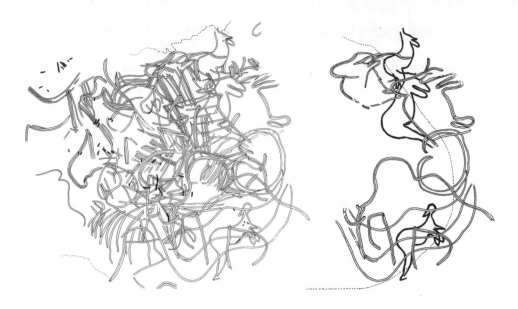

85. Fingermarkings in the ceiling at the cave of Pech-Merle: (left) a general recording; (right) detail of the recording, showing three women and three mammoths.

The centre of the panel, the part that is most easily accessible, is occupied by a tangle of lines in all directions, with no attempt at drawing figures. The Abbé Breuil gave them the derogatory name of 'macaronis' and Leroi-Gourhan called them 'unfinished outlines'. In any case, they are disorganized marks. Our recording of the panel revealed a few animal segments, on the western edge, which seem to stand out from the shapeless magma that occupies the centre; at the edge one can see a first few figurative sketches: a muzzle, then a basic animal body, and finally a very recognizable mammoth profile. In contrast, on the eastern edge of the panel, standing out from the shapeless mass, there emerges a drawing of a woman with hair and hanging breasts, made with one finger and superimposed on a mammoth drawn with two fingers. In fact there are three women associated with an indented circle and three mammoths, which in each case are superimposed on them. This group suggests a symbolic copulation of three female divinities and three mammoth gods, doubtless linked to an allegory of the creation of the living world, with the indented circle itself being a symbol of procreation (FIG. 85).

These fingermarkings can be interpreted as dynamic marks describing the emergence of shapes and figures out of an undifferentiated magma – that is, the birth of the organized world. These mammoth-women are

The writing's on the wall

placed at the edge of the panel, above a dangerous sheer drop. The artist stood on the edge of a block above the void, in a perilous position, in order to put the most complete and most identifiable drawings in the right place, so that they could be seen from afar, from the floor of the cave and by the whole community (Lorblanchet 2010: 153–66). Thus on the ceiling at Pech-Merle an instinctive, easy, rapid dialogue with the rock's soft surface leads progressively to highly symbolic markings.

The diversification of techniques

The traditions of cupules (Chapter 7), spitting and fingermarkings all developed in the most archaic phase of parietal art, reappearing here and there in the Magdalenian, for example at Lascaux and Rouffignac. They are simple techniques that require repetitive automatic gestures, and which can produce parietal images without any particular graphic skill.

In the middle Aurignacian, around 35,000 BP, some extremely rough motifs were painted by spitting or flatwash, for example in the abri Blanchard (Dordogne) and Fumane cave (Italy). Then, at the start of the Gravettian, around 30,000 BP, linear drawing with a crayon of manganese or charcoal seems immediately to achieve an astonishing mastery in the great panel of the Black Frieze of Pech-Merle and in the fine engravings of the cave of Roucadour (Lot): there is nothing clumsy in this ancient art, which develops simply in accordance with particular conventions that underline its originality. Bas-relief also appears in the Gravettian, in the regions of the Coniacian limestone of the Périgord, a soft material that was easy to work, for example in the shelter of Laussel (Marquay, Dordogne). It then developed in the Solutrean at Le Fourneau du Diable (Bourdeilles, Dordogne).

The quest for beauty, in tandem with a spiritual quest, has characterized our species since its birth, but the techniques and themes of parietal art only diversified during the Aurignacian and Gravettian. However, this is also claimed to be the period when the artistic splendour of Chauvet cave exploded on to the scene (see pp. 231–34). Chauvet exemplifies a particular form of parietal art: one that is placed in grandiose underground landscapes, that occupies the whole cave, is on open view and constitutes a scene, filling vast panels in monumental compositions that sometimes present animals that are bigger than life size; for many reasons explained elsewhere, the early dates for the art at Chauvet remain highly anomalous.

A global phenomenon: the appearance of rock art around the world

For a long time it was believed that Ice Age art was an exclusively European phenomenon. Little by little, however, and especially in recent years, it has become apparent that, towards the end of the Pleistocene, artistic activity was under way all over the world. The technical, naturalistic and aesthetic qualities of European Upper Palaeolithic images remain almost unique for the moment, but it is nevertheless true that, at this time (and sometimes even earlier), in other parts of the world, one can see traces of the same phenomenon (Bahn 1987, 1991, 2007, 2016).

The New World

The first piece of Pleistocene art in America was found in 1870, only a few years after such finds in France were authenticated. Unfortunately, the object in question was badly published, and was lost from 1895 until its rediscovery in 1956! This mineralized sacrum (the bone at the base of the spine) of an extinct fossil camelid was found at Tequixquiac, in the northern part of the central basin of Mexico. The bone has perhaps been carved, and definitely engraved – two nostrils have been cut into

the end, so as to represent the head of a pig-like or dog-like animal. The circumstances of its discovery are unclear, but it is thought to be from a late Pleistocene bone bed, and to be at least 11,000 or 12,000 years old (Aveleyra 1965; Lorenzo 1968: 284–85; Messmacher 1981: 94; Schobinger 1997: 30). A mastodon bone, found at Valsequillo, Mexico, dating to perhaps 22,000 years ago, has often been claimed (e.g. Canby 1979: 350) to bear engravings of a mastodon and a large cat; however, careful study has shown that it has only cutmarks, not engraved figures (Lorenzo 1968: 286–88).

Other examples of portable art in the New World are equally vague as to date or authenticity. For example, a bone with an apparent engraving of a 'rhinoceros' (sic) from Jacob's Cave, Missouri, is thought to be of Pleistocene date (Messmacher 1981: 84; Schobinger 1997: 30); some of the numerous incised stones from the Gault site, Texas, are thought to date to the end of the Pleistocene (Lemke et al. 2015); and it has been claimed that an implement made of mammoth ivory, which was found in Florida's Aucilla River, and which bears an incised zigzag design, may be the oldest decorated object yet known from the western hemisphere, more than 10,000 years old (Purdy 1996a: 10; 1996b: 4–5).

A far more extraordinary find, however, has recently come to light in Florida – an engraving of a mammoth or mastodon on a piece of bone from Vero Beach, which may well be the first piece of figurative art from Pleistocene North America (FIG. 86). A whole battery of analyses have indicated that the piece is both ancient and authentic: the bone is from extinct megafauna, and examination with a scanning electron microscope has shown that the engraving's edges are worn, and were not made with metal tools or recently (Purdy et al. 2011; Purdy 2012).

Parietal art, of course, is far more difficult to date. The New World has an abundance of decorated rocks, shelters and caves in many areas, and early dates for rock art have now been obtained in a number of different countries. In North America, radiocarbon and cation ratio ages have been obtained from organic material trapped in the rock varnish covering petroglyphs, some of which are from the late Pleistocene (Whitley & Dorn 1987, 1993, 2012). The varnish on a geometric pattern in Arizona, for example, gave results around 18,000 years ago, while that overlying a bighorn sheep petroglyph from California's Coso Range was dated to more than 14,000 years ago – several other petroglyphs in the Coso Range have given cation-ratio ages of between 19,000 and 12,600 years ago. Moreover, petroglyphs in Wyoming have produced radiocarbon results of 11,650 and 10,660 years ago from the varnish covering them

86. Engraving of a mammoth or mastodon
on a bone found at Vero Beach (Florida, US).

(Whitley et al. 1996; Tratebas 1999). However, all these results remain
highly controversial, not simply because they conflict with the orthodox
but rapidly disappearing North American view that people were not yet
in the New World before about 11,000 or 12,000 years ago, but primarily
because of questions of methodology. Even if the dating of the organic
material in the varnish is accurate, its source, and thus its chronological
relationship with the petroglyphs beneath, is far from certain, and
therefore even the researchers who have produced the dates advise
extreme caution and scepticism.

 In a curious echo of the situation with North American portable
art, two undated petroglyphs on the San Juan River in Utah have been
presented as depicting possible mammoths. If this interpretation is
correct, then they must date to the Pleistocene unless – as is quite
possible – this species survived for some time into the Holocene in this
enormous country (Malotki & Wallace 2011; on the possible survival
of mammoths, see Lister & Bahn 2007: 55). However, doubts have
been expressed not only about the identification of these figures, but
especially about the geological age of the panel, so that the situation
remains unresolved at present (Schaafsma 2013; Gillam & Wakeley 2013).
Elsewhere, in Nevada, radiocarbon dating has recently shown that some

A global phenomenon

petroglyphs in the Winnemucca lake basin, incised into a tufa mound and covered by a carbonate crust, were produced between 14,800 and 10,200 years ago (Benson et al. 2013) (PL. XXVIII).

The Peruvian cave of Toquepala, which has painted red figures of camelids, deer and armed hunters on the wall, was found to contain two small 'brushes' of wool impregnated with red ochre, stratified in levels that may date to almost 10,000 years ago (Julien & Lavallée 1987: 49–50; see also Linares 1988). However, it has been argued (Guffroy 1999: 27) that the position of the brushes is not secure, and that they are probably from Levels 4 and 5, even though they are often attributed to the older Level 10, which dates to 9580 BP). More direct dates have been obtained for rock paintings in several widely separated parts of Brazil and Argentina. In the latter's northwestern province of Jujuy, the deep sandstone rockshelter of Inca Cueva 4 features some geometric motifs on the heavily exfoliated back wall. They were painted on a preparation of gypsum, and analysis by X-ray diffraction has revealed that exactly the same mineralogical composition of pigments and support is found on fallen, stratified fragments of paint, as well as on artifacts, in an occupation level that has been dated by radiocarbon to 10,620 years ago. In other words, the paintings must predate that time (Aschero & Podestá 1986: 40–43; Podestá & Aschero 2012).

In the distant south of Argentina, in Santa Cruz province (Patagonia), two sites have yielded similar evidence. At Los Toldos, excavations in Cave 3 recovered fallen fragments of ceiling bearing red paint, thought to be perhaps from ancient hand stencils, in a layer that has been dated to around 11,000 years old (Cardich 1987: 110). Farther south, at the site of El Ceibo, as occupation layers were dug away, two dark red paintings of guanacos (wild llamas) appeared on the newly exposed rock wall (FIG. 87). Judging by their depth and the age of the layer masking them they must be of similar age to the paintings of Los Toldos (Cardich 1987: 112). Simple linear petroglyphs covering about 16 sq. m (175 sq. ft) of the bedrock floor of Epullán Grande cave, in Argentina's Neuquén province (northern Patagonia), are thought to date back to at least 10,000 years ago (Crivelli Montero & Fernández 1996; Arias et al. 2012).

In Brazil, samples of pigment from red paintings in the sandstone Caverna da Pedra Pintada at Monte Alegre on the Lower Amazon have, through scanning electron microscopy, been found to be similar to samples from the hundreds of lumps and drops of red pigment – as well as two small fragments of painted wall – which were stratified in

87. Paintings of guanacos on a rock wall at El Ceibo
(Argentina), revealed during archaeological excavation.

Palaeoindian levels radiocarbon dated to a period from approximately
11,200 to 10,500 years ago (Roosevelt et al. 1996: 378–80; 1999) (PL. XXV).

In the arid Piauí region of eastern Brazil, rock paintings at the huge
sandstone rockshelter of Boqueirão da Pedra Furada have been dated
to the same period. One fallen fragment, bearing a clear red human
stick figure, was found in Occupation Layer XII; from its position in
relation to layers above and below, dated by charcoal, this level has
been assigned to about 10,000 or 12,000 years ago; another fragment,
bearing two red lines, very probably the legs of a human or animal,
came from a layer dating to around 17,000 years ago. These are therefore
minimum ages for the fallen art (Guidon & Delibrias 1986). At the
nearby shelter of Toca do Baixão do Perna I, direct dating of organic
carbon in a pigment ball fashioned by humans and apparently worn
as an ornament gave a result of 15,250 years ago (Chaffee, Hyman &
Rowe 1993). Likewise at Perna – as at El Ceibo – a panel of small red
figures was exposed by excavation of the layers that had covered it,
and though faded, the images survived burial amazingly well (PL. XXVI).
One fragment of charcoal still adhering to the panel gave a radiocarbon
date of 9,650 years ago, while charcoal from the layer touching the
bottom of the panel has been dated to 10,530 years ago – hence, unless
one envisages artists painting at nose level while lying on the floor, the
panel must be somewhat older than this date (Bahn 1991: 92). Its figures

A global phenomenon

correspond perfectly in size and type to those of similar age at Pedra Furada. Together with art at many other sites in this region, they have been attributed to the 'Serra da Capivara' style, which is thus thought to date back to at least 12,000 and probably 17,000 years ago or more. Independent confirmation of these claims comes from microscopic and spectrometric analyses of paint samples from Pedra Furada and Perna. Natural ochres contain lots of quartz crystals, but prepared pigments have fewer and smaller crystals, and the archaeological samples were clearly artificial, dating to more than 20,000 and probably 30,000 years ago (Meneses Lage 1999).

In recent years, other techniques have been applied to the Piauí paintings and this has led to confusion and a major controversy (Ribeiro & Prous 2008: 299–300). Electron spin resonance (ESR) and thermoluminescence (TL) dating of calcite covering paintings in the Toca da Bastiana gave minimum dates which were extremely early – 30,000 to 50,000 BP (Ayta 2004; Watanabe 2004; Watanabe et al. 2003) (PL. XXVII). Control dating of the same figures in the Toca da Bastiana was then carried out using analysis of the plasma in the paintings, and of the calcium oxalate covering them: the calcium oxalate previously dated to 35,000 gave a result of only 2,540 years ago (a minimum date for the underlying painting), while the pigments were directly dated to 3,730 years ago (Steelman et al. 2001; Rowe & Steelman 2003; Fontugne et al. 2013). The direct dating of four other figures at the same site, as well as of figures at three other sites, gave results between 1,900 and 3,400 BP. But since then, physicists from the University of São Paulo have obtained new, very early dates from more samples – 48,000 (TL) and 55,000 (ESR) years ago at Toca da Bastiana, and 32,000 years ago (ESR) at the Toca do Antonião (Ayta 2004).

The important question of the antiquity of the paintings has still not been settled, since dating by TL and ESR, carried out by Brazilian laboratories on the calcite layers over several paintings, indicates ages between 19,000 and 43,286 BP, whereas radiocarbon mostly produces recent Holocene dates for the same figures. However, a date from the Toca das Moendas indicates a minimum age of 31,860 ± 210 BP for a painting under calcite. These differences show well the limitations of these methods; the presence of recent organic matter has been verified on the walls studied (microscopic algae and lichens, which could contaminate the samples dated by radiocarbon), whereas the sampling of calcite for ESR and TL, carried out by scraping, is apparently also not totally reliable (Isnardis & Prous 2012; Guidon et al. 2012; Rowe 2012).

Finally, paintings in central Brazil (Bahia region) may perhaps depict extinct species such as giant sloths and hippo-like toxodonts (Prous 1994: 90–91); and a crude petroglyph of an anthropomorph in the central Brazilian shelter of Lapa do Santo has been indirectly dated (through radiocarbon and OSL analysis of covering sediment) to between 12,000 and 9,000 years ago (Neves et al. 2012).

Africa

In Zimbabwe, a possible paint palette has been excavated from a layer dating back more than 40,000 years at Nswatugi cave. In addition, at Pomongwe cave fragments of painted stone are known from layers dating to between 35,000 and 13,000 years old, and the same site has yielded granite spalls from the walls, bearing traces of paint, in deposits dating back at least 10,000 years and perhaps even to the fourteenth millennium BP (Walker 1987: 142; 1996: 11–13). At some decorated sites in Tanzania, levels have been excavated containing ochre fragments, ochre pencils and stained 'palettes' from about 29,000 years ago onwards (Leakey 1983: 21–22). Moreover, as mentioned earlier (Chapter 2), pieces of pigment have been recovered from Zimbabwean shelter deposits of more than 125,000 years ago, while a Stone Age site at Nooitgedacht near Kimberley has yielded a ground ochre fragment with an estimated date of over 200,000 years ago, and pieces of haematite or ochre even appear to have been carried into sites in South Africa up to 800,000 or 900,000 years ago.

Fabrizio Mori (e.g. 1974), like Leo Frobenius before him, proposed that the earliest rock-engravings of the Sahara may date back to the late Pleistocene. However, other scholars such as Alfred Muzzolini (1986: 312–14) pointed out that this reasoning is based on a few isolated, and possibly anomalous, radiocarbon dates from occupations at the foot of decorated rocks, which may have no association at all with the engravings. The question therefore remains open for the moment.

Portable Palaeolithic art has been well authenticated in Namibia, where seven fragments of stone found between 1969 and 1972 by Eric Wendt in the Apollo 11 cave have paint on them, including four or five recognizable animal figures such as a black rhino and two possible zebras (FIG. 88); they display a use of two colours, and were associated with charcoal that provided a radiocarbon date of at least 19,000 and perhaps even 26,000 years ago; recent excavations have produced a more precise date for this

88. One of seven painted plaques discovered in
stratigraphy in Apollo 11 cave (Namibia) and recently
dated by radiocarbon to *c.* 30,000 BP.

layer of around 30,000 years ago (Wendt 1974, 1976; Vogelsang et al. 2010).
The site also yielded some notched bones of similar or greater age.

Engraved pieces of wood and bone, including a baboon fibula with
twenty-nine parallel incised notches, have been recovered from Border
Cave (KwaZulu-Natal), and dated to more than 40,000 years ago – the
baboon fibula has been compared with similar calendar sticks of wood
which are still in use by some Bushman clans in southwest Africa (Butzer
et al. 1979: 1212; Bahn 1991; d'Errico et al. 2012). More recently, this site
has also yielded several bone fragments 'decorated' with multiple incised
parallel lines in levels dating to more than 100,000 years ago, as well as
some perforated shells directly dated to 42,000 years ago (Beaumont 1973:
44, note 44; d'Errico et al. 2012); an infant burial at the same site was
accompanied by a perforated *Conus* shell, and dates to about 74,000 years
ago (d'Errico & Backwell 2016).

Similarly, a Middle Stone Age layer at the Klasies River Mouth caves
(South Africa) has yielded some notched and grooved bones dating to
more than 100,000 years ago (Singer & Wymer 1982: 116, 149), while
Sibudu cave produced a notched bone dating to 28,880 BP (Cain 2006).
A bored stone decorated with incisions has been found in a layer of

Matupi cave (Democratic Republic of Congo), dating to about 20,000 years ago (Van Noten 1977: 38).

We saw in earlier chapters some of the extraordinary wealth of very early artistic activity of various kinds that has emerged in different parts of Africa in recent years, most notably at Blombos cave – such as shell beads, engraved pieces of ochre and decorated fragments of ostrich eggshell. Surprisingly, however, the most important evidence for artistic activity in the late Pleistocene has come not from the south but from the north of the continent. A ceramic fragment with incised decoration, dating to about 20,000 years ago, from Tamar Hat cave (Algeria), was found some years ago (Saxon 1976). That this was not an isolated phenomenon was proved by the subsequent discovery in eastern Algeria of about fifty fragments of terracotta figurines at the site of Afalou-Bou Rhummel, in layers spanning the millennia between 18,000 and 11,000 years ago (FIG. 89). Made of a red clayey paste, they are mostly of horned animal heads, although it has not been possible to fit any fragments together, and tests have shown that most were fired at temperatures in the range 800–850°C (1475–1560°F) (Hachi 2003).

The most important new development, however, has been the discovery in Egypt of Pleistocene petroglyphs along the Nile – at el-Hosh and more

89. Fragment of a terracotta figurine from Afalou-Bou Rhummel (Algeria), one of about fifty similar objects found at the site.

A global phenomenon

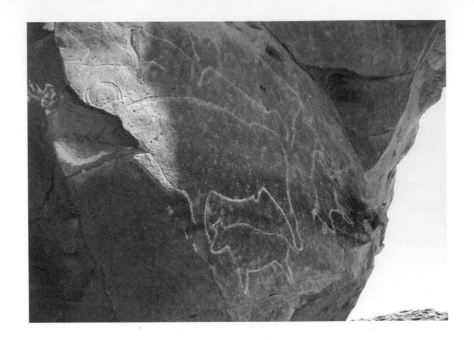

90. Naturalistic petroglyphs of animals on a rock outcrop at Qurta (Egypt), dated by OSL to at least 15,000 years ago and thus confirming the existence of parietal Palaeolithic art in Africa.

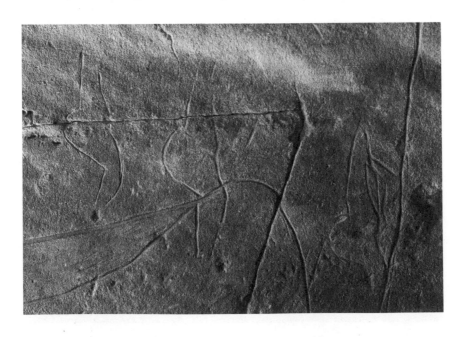

91. Petroglyphs of three stylized women at Qurta; their exaggerated features are reminiscent of Upper Palaeolithic 'Venuses' from Europe.

particularly at Qurta, in the Edfu region – where pecked images of aurochs, hippos, fish and birds have been found, as well as some Gönnersdorf-style females (FIGS 90, 91). OSL dating of sediments covering some of the petroglyphs at Qurta has proved that they have a minimum age of 15,000 years (Huyge 2009; Huyge & Claes 2008; Huyge et al. 2011). These discoveries triggered searches elsewhere, and rapidly led to new similar finds – about thirty figures so far – at Wadi Abu Subeira, near Aswan (Storemyr et al. 2008; Kelany 2012, 2014).

Moreover, now that the existence of parietal Palaeolithic art in Africa has been established at last, eyes are turning again to some red marks that have been exposed on a wall covered by final Palaeolithic sediments at the Moroccan shelter of Ifri n'Ammar; they date to at least 13,000 years ago, and a burial was found directly beneath them (Moser 2003: 105–7; Eiwanger 2003, 2012; Eiwanger & Hutterer 2004).

Asia

Turkey has yielded a few pieces of Pleistocene portable art (Otte et al. 1995), but the most impressive and important phenomenon in the country has been the discovery of the 'temple' of Göbekli Tepe in southeastern Anatolia, with its extraordinary monumental stone pillars decorated with animal sculptures, dating to about 12,000 years ago, and hence created by hunter-gatherers (Schmidt 2006).

Israel too has produced several pieces of art from the Pleistocene. Among the youngest are the limestone pebble from the Epi-Palaeolithic (c. 19,000–14,500 years ago) site of Urkan e-Rub that has engravings of 'ladder' motifs and parallel lines on it (Hovers 1990), and a number of figurines from the Natufian of el-Wad cave, dating to 12,800–10,300 years ago (Weinstein-Evron & Belfer-Cohen 1993). There is also a crude engraving of a possible animal on a limestone slab from the Aurignacian of Hayonim cave (Belfer-Cohen & Bar-Yosef 1981: 35). However, the two most important finds from Israel are the Quneitra flint plaque and the Berekhat Ram figurine, mentioned earlier (pp. 152–53, 161–65).

In India, the hundreds of caves and rockshelters around Bhimbetka, near Bhopal, contain parietal paintings spanning a long period, and claims have been put forward that the earliest are Upper Palaeolithic in age (Wakankar 1984, 1985), especially since engraved ostrich eggshells from excavated layers here are said to have been dated to between 25,000 and 40,000 years ago (Kumar et al. 1988). One particularly fine fragment

9 2 . Drawing of a fragment of ostrich eggshell
from Patne (India), with a criss-cross pattern.

from Patne has a criss-cross pattern engraved between two parallel lines
(FIG. 92). From elsewhere in India, we have already mentioned (Chapter 2)
the small ochre pebble from Hunsgi, which seems to have been used as
a crayon on rock around 300,000 years ago, and examined (Chapter 7)
the unfounded claims for extremely ancient petroglyphs at Auditorium
shelter and Daraki Chattan.

China's Palaeolithic art was limited for many years to the 120 beads
and other decorative objects from the upper cave at Zhoukoudian.
However, one other definite piece of Palaeolithic art has emerged – an
engraved 14-cm (5.5-in.) piece of antler from Longgu cave (Hebei province),
radiocarbon dated to c. 13,000 years ago (Bednarik & You 1991; Bednarik
1994b). Elsewhere, the site of Shiyu (Shanxi province) has yielded half of a
perforated stone disc, 8 cm (3 in.) in diameter, which is about 28,000 years
old, and thus one of the world's oldest known perforated stone objects (see
Yi Wei et al. 2016 for further examples of early ornaments in China and
elsewhere in Asia). In Japan there are some extremely interesting engraved
pebbles from the cave of Kamikuroiwa. Layer IX (Initial Jomon) has been
dated to 14,500 BP, and contained thirteen little pebbles with engravings
on them, some of which seem to represent breasts and 'skirts' (Aikens
& Higuchi 1982: 107; Harunari 2009) (FIG. 93). Mongolia has some small
open-air petroglyphs of what appear to be mammoths, which have been
found at Baga-Oygur and Tsagaan-Salaa (Jacobson et al. 2001; Jacobson-
Tepfer 2013). On the basis of present knowledge, mammoths were extinct
on the mainland of Eurasia by the end of the Ice Age, so these figures must
therefore be of the late Pleistocene, unless the species survived into the
Holocene, as is possible in this vast region (Lister & Bahn 2007: 55).

In Borneo, cave paintings, including hundreds of hand stencils, often
arranged in panels, have been discovered since 1994; calcite overlying

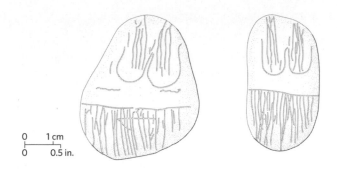

93. Decorated pebbles from Kamikuroiwa (Japan),
possibly depicting breasts and 'skirts'.

some of them has been dated to more than 10,000–14,000 years ago.
Calcite covering two hands at Ilas Kenceng, for example, has produced
an age between 13,000 and 10,000 BP (Chazine 2000; Fage & Chazine
2009: 24). More recently, calcite in caves at Maros (Sulawesi), covering
a dozen hand stencils and two animal figures, has yielded far older dates
spanning a period from around 40,000 to 25,000 years ago; among the
oldest are a hand stencil in Leang Timpuseng, which has a minimum age
of 39,900, and a nearby figure thought to be a babirusa (pig-deer), which
was made at least 35,400 years ago (Aubert et al. 2014) (PL. XXIV).

Finally, in East Timor, uranium-series dating of some carbonate
coatings that bracket red pigment in Lene Hara cave suggests that
this possible painting episode took place between 29,300 and 24,000
years ago (Aubert et al. 2007); the same cave also contains a petroglyph
of a human face that is ascribed to between 12,500 and 10,200 BP
(O'Connor et al. 2010). It will also be recalled (Chapter 6) that Trinil
in Java has yielded what is currently Asia's oldest piece of art, an
engraved freshwater mussel shell from at least 430,000 years ago
(Joordens et al. 2015).

Australia

It is in Australia, with its incredible wealth of rock art, that one finds
most of the non-European examples of Pleistocene parietal art (Rosenfeld
1993; Brumm & Moore 2005; Habgood & Franklin 2008; Mulvaney 2013).
The first site where its existence was authenticated was Koonalda cave
(South Australia), which was found to contain abundant 'digital flutings'
(lines made with fingers) on the ceiling and walls, some distance inside

A global phenomenon

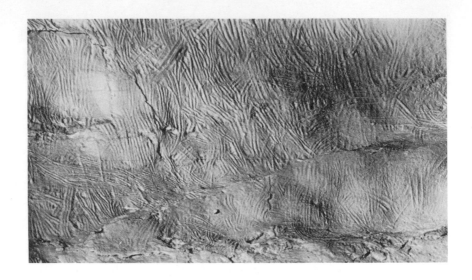

94. 'Digital flutings' at Koonalda cave (South Australia),
dating to around 20,000–30,000 BP; these are strikingly
similar to finger-flutings found on some cave walls in Europe.

the cave and in total darkness; they seemed to be associated with the
extraction of flint (Wright 1971) (FIG. 94). The site's archaeology showed
that the mining activity took place at least 15,000 to 30,000 years ago,
and so the marks are probably of similar age. These finger-flutings are
identical to those known in several of the European Palaeolithic caves
(FIGS 1, 3, 84). Further proof of the antiquity of Australian art came
from the Early Man shelter in Queensland, where very weathered and
patinated engravings (circles, grids and intertwined lines) covered the
back wall and disappeared into the archaeological layer. As the layer
yielded a radiocarbon date of 13,200 years ago (Rosenfeld et al. 1981), it
is clear that the engravings must be at least this old (FIG. 95). Early Man
shelter also has ochre dating back to 18,200 years ago.

In the 1980s, twenty-three red hand stencils were found 20 m
(65 ft) from daylight inside Ballawinne cave in the Maxwell valley,
southwest Tasmania. They are undated, but, from a comparison of the
cave's archaeological material with that of similar sites in the region,
it has been estimated that they may be at least 14,000 years old (Brown
1987: 59; Brewster 1986; McGowan et al. 1993). A further twenty-
three hand stencils, a roughly drawn circle and extensive areas of wall
smeared with deep red pigment were found in another large limestone
cave in southwest Tasmania, Wargata Mina (Judds Cavern), mostly in
a high alcove about 35 m (115 ft) from the entrance, at the limit of light

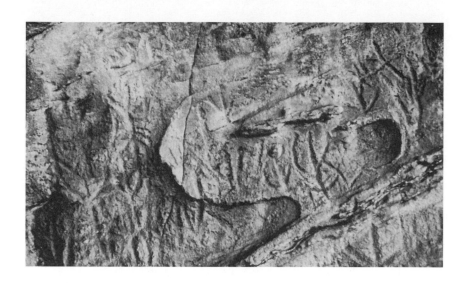

95. Engraved grids and lines on the cave wall
at Early Man shelter (Queensland, Australia),
dating to at least 13,200 years ago.

penetration (Cosgrove & Jones 1989; McGowan et al. 1993). The red
pigment was found to contain human blood, and radiocarbon dating of
samples of it from the cave produced results of 9,240 and 10,730 years ago
(Loy et al. 1990). In 1988, a third cave in southwest Tasmania, TASI 3614,
was also found to contain three red hand stencils, situated 10 m and 50 m
(30 and 165 ft) from the entrance.

There is evidence of even older rock paintings in other parts of the
country. What may be a painting on the wall of the Sandy Creek 2
rockshelter in Queensland has produced a date of 24,600 years ago
(Watchman 1993); while excavations in Sandy Creek 1 produced two
striated fragments of red pigment dating to around 32,000 years ago,
and two yellow fragments date to 28,000 and 25,900 years ago. Sandy
Creek also yielded a fragment of sandstone with part of a deeply pecked
motif in a layer dating to 14,400 years ago (Cole, Watchman & Morwood
1995). On a boulder at Walkunder Arch cave in the Chillagoe region
of north Queensland, a crust sample containing layers of paint from
three different painting episodes has produced radiocarbon estimates
of 16,100, 25,800 and 28,100 years ago (Watchman & Hatte 1996). And
at Puritjarra rockshelter in central Australia, production of pigment and
engravings seems to have started by around 13,000 years ago, and some
red ochre came from a quarry 150 km (90 miles) away (Rosenfeld &
Smith 2002; Habgood & Franklin 2008: 189).

A global phenomenon

At Carpenter's Gap rockshelter in the Kimberley, a pellet of red ochre was found in a level dated to between *c.* 42,800 and 33,600 BP, and what seems to be a fallen fragment of painted wall was found in a layer containing charcoal dated to about 40,000 years ago, suggesting a minimum age for the painting (O'Connor 1995; O'Connor & Fankhauser 2001). A wasp's nest overlying some of the Kimberley's famous and sophisticated painted 'Bradshaw figures' (also known as Gwion Gwion) yielded an OSL date of 17,000 years ago, thus suggesting a Pleistocene age for this art corpus; however, radiocarbon dating only suggests that the Bradshaws are at least 4,000 years old, so the debate remains open (Roberts et al. 1997; Watchman et al. 1997).

In Arnhem Land, northern Australia, used blocks of high-quality red and yellow ochre and ground haematite have been found in occupation layers at the shelters of Malakunanja II and Nauwalabila I, dating to at least 18,000–30,000 and perhaps 60,000 years ago (see Chapter 2). Most notable from the former site is a piece of high-quality haematite weighing around 1 kg (2.2 lbs), which was brought in from some distance and the facets and striations of which are clear signs of use (Chaloupka 1993). Recently, a piece of rock with a charcoal design on it has been reported from Nawarla Gabarnmang, dating to around 28,000 years ago (David et al. 2013). Many ochre 'pencils' with traces of wear have also been found in this region's shelters throughout the Pleistocene layers. Although much of this colouring material may have been used for body-painting or some other purpose, it is likely that at least some of it was used to produce wall art.

Some of the oldest paintings in Arnhem Land are covered by a thin siliceous film, which is deposited only in very arid conditions, and the last such period here occurred 18,000 years ago. Moreover, among these apparently ancient figures are animals, such as the marsupial tapir *Palorchestes*, which some researchers interpret as species extinct in Australia for at least that length of time (Chaloupka 1984; Murray & Chaloupka 1983/4; for arguments against, and a reply by Chaloupka & Murray, see *Archaeology in Oceania* 21, 1986: 140–47). A painting has recently been found in Arnhem Land of what may be *Genyornis newtoni*, a bird thought to have been extinct for at least 25,000 and perhaps even 45,000 years (Gunn et al. 2011). Other scholars disagree with these interpretations and the proposed chronology (Lewis 1988; Welch & Welch 2015), but everyone agrees that at least some of the art (the Boomerang/Dynamic/early Mimi-period style) is 'pre-estuarine' (i.e. corresponding roughly to the height of the last glaciation) and thus dates to perhaps thousands of years earlier than 9,000 years ago.

In northwest Australia, in the Pilbara, there are thousands of petroglyphs in the open air, and many researchers believe that the patina on some proves that they are extremely ancient, probably some 10,000 to 15,000 years old. At Gum Tree valley, on the Burrup Peninsula (Western Australia), some visibly very old engravings are closely associated with seashells that have been dated to 18,510 years ago (Lorblanchet 1988: 286) (FIG. 96). Ken Mulvaney (2011) has presented convincing evidence that some Burrup petroglyphs date back 25,000 years. At Sturts Meadows, in New South Wales, a compact carbonate overlying a desert varnish on petroglyphs has given radiocarbon results of 10,250 and 10,410 years ago, suggesting that most of this huge site's figures are probably of at least that age (Dragovich 1986).

As in North America (see pp. 242–43), the dating of desert varnish covering petroglyphs remains highly controversial and of uncertain validity, but it has produced some of the earliest direct dates for rock

9 6. Crude pecked, patinated human figures in the Gum Tree valley (Western Australia); here Pleistocene carvings are associated with artifacts of the old core-tool tradition, and radiocarbon dates of 22,000–20,000 BP.

A global phenomenon

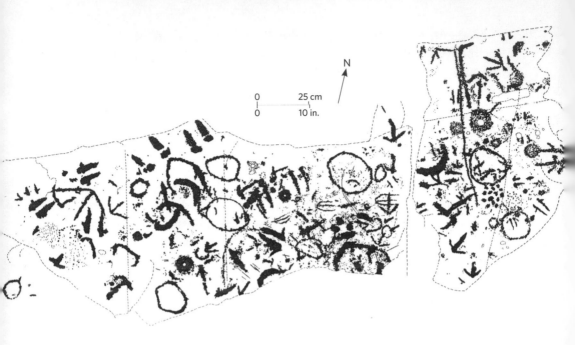

97. Art from the site of Panaramitee (southern Australia), showing circles, arcs, kangaroo and bird (often emu) tracks, and dots (cupules).

art in the world so far: in the Olary region of South Australia the cation ratio technique first produced a date of over 30,000 years ago (Nobbs & Dorn 1988; Dorn et al. 1988), while subsequent dating of varnish by both radiocarbon and cation ratio produced results of more than 42,000 years ago for an oval motif at Wharton Hill and 43,140 years ago for a curvilinear motif at Panaramitee North (Nobbs & Dorn 1993). However, direct dating of organics in varnish remains highly dubious – we have no way of knowing whether the results produced are reliable or not. Nevertheless, the Panaramitee style, which is 'pan-Australian' and found over a vast geographical area, is generally considered to be extremely old. This is because its petroglyphs often have a dark patina, and they never include dingo prints (an animal that was only introduced 7,000 years ago), whereas they may include prints of species that became extinct long ago. The style also features a wide variety of geometric motifs, as well as kangaroo and bird tracks, depictions of lizards or stylized humans, and occasionally human faces (FIG. 97).

Australia has produced little portable art from the Pleistocene so far. In the cave of Devil's Lair, Western Australia, three perforated bone beads have been found in a layer that is 12,000 to 15,000 years old, together with a possible stone pendant, a few pieces of red ochre

(dating to *c.* 30,000 BP) and some slabs of stone with possible engraved lines on them, though it is by no means certain that the lines are artificial (Dortch 1979, 1984). The upper incisor of a *Diprotodon* from a megafaunal assemblage at Spring Creek, Victoria, dating to the twentieth millennium BP, has been found to bear a series of twenty-eight incisions or grooves that observation and experimentation strongly suggest were made by humans (Vanderwal & Fullagar 1989). At Carpenter's Gap rockshelter, fragments of *Dentalium* shell beads have been recovered from levels dating to 42,000–29,000 years BP (O'Connor 2005; Habgood & Franklin 2008: 192). And a necklace of twenty-two small *Conus* shells deliberately modified as beads, dating to about 32,000 years ago, was discovered at Mandu Mandu Creek rockshelter, Western Australia (Morse 1993; see also Balme & Morse 2006), a site which also has red ochre throughout its deposits, peaking between 25,000 and 20,000 years ago, even though the nearest known source is 300 km (185 miles) away (Habgood & Franklin 2008: 189)! A pendant made from a tiger-shark tooth has been reported from New Ireland (Papua New Guinea), dating to somewhere between 39,500 and 28,000 years ago (Leavesley 2007).

The distribution of early rock art

On the one hand, given the examples described above, we can conclude that the map of Pleistocene artistic activity is rapidly filling up, with every continent – and especially Australia, Southeast Asia and South America – providing well-dated examples, not only of rock art but also of portable art objects and other finds related to this phenomenon. It is probable that there are innumerable similar surprises in store for us, although Europe remains supreme, for the moment, in the quantity and quality of its surviving Palaeolithic art. But on the other hand our knowledge of early rock art remains extremely patchy around the world: for example, New Guinea, both ancient and modern, has magnificent body-painting and other art forms, but relatively little rock art; and vast territories such as China and India have almost no Pleistocene art, while for the whole of Africa we have only the Apollo 11 stones, a few terracottas and eggshells, and the petroglyphs along the Nile. Yet the Holocene sees a tremendous wealth of rock art in all these areas.

One factor may be the highly uneven history of prehistoric research, especially in southern Asia, and of course the vast majority of rock art is undated or poorly dated. In the Third World we have a marked lack

of accurate recordings, of direct dates and analyses of pigments (for example in India, see p. 267). This unsatisfactory and unequal situation casts doubt on many of our generalizations about rock art at a global or continental scale. Even in smaller areas such as the Palaeolithic art of Western Europe, some caves have been studied very thoroughly and others only superficially, which often makes valid comparisons difficult. A further source of bias is the problem of 'taphonomy', the differential conservation of vestiges; as we have seen, this problem is especially acute for the earliest phases, but exists in all periods of prehistory, including the Upper Palaeolithic (both in cave and open-air art).

Our present knowledge of 'prehistoric art' is therefore partial, unequal, preliminary and constantly evolving. It is heavily biased, both chronologically and geographically, and new finds will doubtless modify our view profoundly in the next few years as more ancient finds, and finds in little-investigated regions, come to the fore.

Conclusion

Aesthetic expression arose very early in the history of humankind, both in the acquisition of natural productions and in the creation of new forms, processes that freed the first creators from the surrounding material world and elevated them into the world of ideas, symbols and art. The collection of curious stones, minerals and fossils – which drew attention because of their strange shapes, bright colours and sometimes their astonishing weight – reveals the permanence of behaviour that goes beyond the immediate satisfaction of subsistence needs. While hominins used local stones, they also diversified their materials by seeking exogenous rocks, chosen not only for their suitability for working, but also sometimes for the difficulty in obtaining them, which made them rare and precious. This search for materials combined with a desire for technical perfection shows that the manufacture of tools formed part of the spiritual world, where magic and aesthetics come together.

From 3 million years ago, since the time of the Australopithecines, the first humans collected unusual stones, not always to make implements but sometimes for their chromatic characteristics and their capacity for use as colouring materials. The use of red ochre extends over hundreds of millennia. Collected initially as a curiosity, it was

used from the Acheulian, at least 300,000 to 400,000 years ago, as a colouring material for painting on various supports, which have unfortunately not survived. It is also in this period that one starts to find abundant evidence of pigments being prepared – traces of scraping, crushing on grindstones, and heating to modify colours. Then, between 70,000 and 40,000 years ago, in Mousterian contexts and especially in the Périgord, the use of pigments, particularly black manganese dioxide, intensified and reached a level comparable to that of the Upper Palaeolithic. This rapid expansion indicates the probable development of artistic activities such as body-painting.

The creation of new forms began with the manufacture of the first human tools 2.7 million years ago, and that of stone polyhedrons and bolas (Chapter 3) and cupules (Chapter 7), the first spherical, artificial geometric forms. Stone balls and cupules were native forms of sculpture and marking, and constitute the longest traditions of human symbolic productions that were not directly utilitarian; their manufacture extends over 2 million years among *Homo erectus* and the Neanderthals. Cupules diversified their functions, and even continued their career in the world of modern humans, where they gave birth to the first engraved and pecked figures of the Upper Palaeolithic and then developed further in protohistory. The quest for beauty also began with the functional aesthetics of tools. From about 500,000 BP, in some regions of Africa, the Near East and Europe, one even sees a refinement in the making of handaxes, which became veritable 'objets d'art' achieving the 'perfection of the planned shape that provides service and brings pleasure' (Roy 1992). Doubtless in that period, each tool had a spiritual and magical dimension. It is probable too that the unusual natural shapes of animal, plant or mineral materials attracted the attention of hominins who sometimes integrated them into their creations by completing them; in the interests of objectivity, archaeology can only accept a few rare examples of these questionable protosculptures – those of Berekhat Ram (Israel), La Roche-Cotard (France), Tolbaga (Siberia) and Srbsko (Czech Republic) (Chapter 5).

The various daily activities of Palaeolithic people left marks on the bones of the animals they hunted. Numerous incisions have been found on bone fragments, and some of them form apparently organized patterns, which have often been considered symbolic. Several authors have seen in this the origin of the portable art tradition that developed in the Upper Palaeolithic. Four pieces dating between 50,000 and 38,000 BP stand out for the clearly intentional and decorative character of their incisions –

those from La Ferrassie (France), Bacho Kiro (Bulgaria), Turské Mastale (Czech Republic) and Border Cave (South Africa) (Chapter 4). Alongside the cupules tradition, marks on stones have also been described – the clearest, dated to 40,000 to 50,000 BP, are those of Temnata (Bulgaria), Brno-Bohunice (Slovakia) and Quneitra (Israel) (Chapter 4). So far, the shell from Trinil (Java), engraved with fine incisions, and dating to 430,000 years ago, is an isolated find (Chapter 6).

The first jewelry made a timid appearance in the Middle Palaeolithic in Africa and the Near East in the form of shell beads and fragments of decorated ostrich eggshells (Chapter 6), while in Europe the Mousterian of the caves of Los Aviones and Antón (Spain) contained painted and perforated shells (Chapter 2). Perforated bones and stones were also made; ornaments became a little more abundant in the Mousterian, their number increased in the Châtelperronian at the dawn of the Upper Palaeolithic, and then they spread abruptly in the Aurignacian (Chapter 6). Some very early perforated bones interpreted as flutes or whistles are extremely doubtful (Chapter 6), while the existence of a bone 'rasp' at Schulen (Belgium) is likewise uncertain, and insufficient to confirm an origin of music before the first flutes or the first unquestionable whistles, which do not date back beyond the Gravettian, at most thirty millennia ago.

All these beginnings are spread across human history in its entirety, although they seem to multiply towards the end of the Middle Palaeolithic, perhaps linked to an increase in population density. The emergence of properly figurative art, around 35,000 or 40,000 BP, in parietal and portable forms in which figurative and abstract coexist from the start, cannot be seen as a total 'revolution' nor, a fortiori, as an 'explosion'. In the artistic domain, as in that of tools and ways of life, the break in the Upper Palaeolithic with what went before was far from total. It appears rather to have been a gradual change. In our present state of knowledge, there is also no 'cradle of art': the emergence of art is a splintered phenomenon, disseminated across the planet and over hundreds of millennia. In some parts of the world one can even envisage appearances, disappearances and renaissances of the artistic phenomenon, adopting a succession of different forms and styles, with no link between them.

What the start of the Upper Palaeolithic brings is, above all, a quantitative change marked by an increased abundance of evidence of symbolic behaviour, such as the proliferation of geometric marks and lines on bone and stone, and the multiplication of jewelry and burials,

indicating a general rise in ritual activities and beliefs related to human destiny. In contrast, an unquestionable qualitative change takes place with the appearance of figurative rock art, that is, with the development on rock walls, in the open air and in caves, of identifiable images that refer to the surrounding physical world, often accompanied by geometric motifs. So the support changes, and the themes diversify considerably. In this book we have tried to gather together the slightest evidence for aesthetic behaviour from its origins, and to understand the appearance of rock art in the world, since it marks a major stage in human evolution. It seems to have been cupules which first – on portable blocks – spread through the landscape in Africa and India, perhaps in the Middle Palaeolithic, though we still lack proof of this (Chapter 7). In Europe there is a clear link between the Mousterian cupules on blocks and the tradition of figurative pecked parietal engravings that arises at the start of the Upper Palaeolithic. Current research may soon confirm that, before modern humans, Neanderthals were the first artist-painters on walls, through a few modest productions: dots, hand stencils and peckings (Chapter 8).

Artistic milestones and the first cosmogenies
The history of prehistoric art is linked to that of the human brain, and does not follow a regular curve; like biological evolution, it occurs through successive leaps that made cumulative acquisitions possible. After slow and timid beginnings, around 500,000 to 400,000 years ago, a first milestone was attained with the development of new techniques of toolworking (the Levallois technique), the refinement of handaxe production, which became increasingly elegant, and the discovery of the colouring capacities of ochre (heating could modify its colour, and fire had by now been mastered). The second leap corresponds to the later phases of the Middle Palaeolithic, around 70,000 to 40,000 years ago, and is marked by an intensification of pigment use, the appearance of organized marks on bones and stones, the first jewelry and a general development of ritual activities. The final stage saw the emergence of figurative rock art and the rise of portable art from 40,000 years ago onwards, at the dawn of the Upper Palaeolithic. The first parietal productions of the Neanderthals seem to arise during the last stage, but research does not yet enable us to know if the transition of cupules from portable art to rock art occurred in the first or second stage.

For 2.5 million years humans, therefore, were simply an element of nature: like certain birds or crabs, they collected bric-a-brac such as

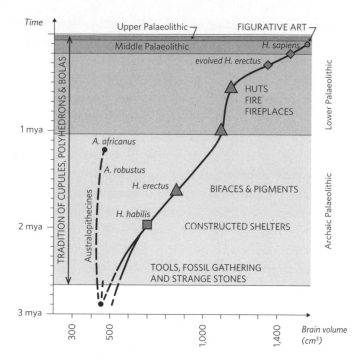

98. Schematic diagram (after J-M. Le Tensorer) showing human evolution. The increase in brain capacity (from 400 to 1,500 cc) is accompanied by successive cultural acquisitions; evolution is a bio-cultural phenomenon.

the natural forms with bizarre shapes or colours that still today fill our museums and our cabinets of curiosities. Through the choice of these objects they captured beauty; they proclaimed them to be 'objets d'art' and dreamed of being their maker. By becoming conscious of what nature offered, they soon grew aware of their own creative powers: 'Everything that seems harmonious to Man can only be what shows the laws that govern both the world and himself, what he sees and what he is, and hence what through Nature... suits him and fulfils him. He is the captive of the framework into which he is woven' (Caillois 1987). Modern painters have reached an identical position: as Paul Klee declared, 'the artist is man; he is himself Nature, a piece of Nature in the area of Nature' (1985: 43).

Since they were not outside nature, it follows that prehistoric people did not slavishly copy the creations that fascinated them. They constituted a cog in the universal mechanism. As an active force of nature, they created by obeying it but not dominating it – the desire for domination was to come much later with agriculture and writing. But creating in accordance with nature can lead to resemblance, to the spontaneous figurative or to abstraction which is, in itself, a metaphysical

Conclusion

game that expresses the deep agreement with the laws ruling the world's harmonious structure. No art form is gratuitous, since it translates humankind's place in the universe.

The examples our book has collected together – all these artistic attempts and beginnings that often led nowhere, over hundreds of millennia – are characterized by their isolation, their extreme dispersal in space and time, and often doubtless their semantic vacuum. These successive stirrings belong to the deep heartbeat of humankind. Within the millions of years of human history, the birth of art was not the exclusive signature of a particular type of human; it was the work of humankind in general, which underwent different forms over the course of time.

The images that can be seen in rock art are linked to the emergence of the first cosmogonies, the first religious or mythological systems explaining the creation of the world – these arouse figuration because they have a content to be told and taught with images, and this teaching must have occurred in the first sanctuaries. Figurative rock art was probably born *with* religion and *from* religion. Early *Homo aestheticus* gradually became coupled with *Homo religiosus*. In Western Europe this was primarily a religion of caves and, in places, of mountains and valleys. Neanderthals and their predecessors were certainly mentally and physically capable of painting walls, but did they do so? Did they already feel the mystical need to do it?

Through the figures they created on rock, for the first time humans escaped their individual microcosm; they spread out into the landscape, and left their durable imprint there. They did not yet dominate the world, but impregnated it with their spirit; they humanized it. The sanctuarization of space – a symbolic taking of possession – foreshadowed the real, biological and physical taking of possession that was to accompany the arrival of agriculture. Humans could then mould the earth into their image. Hence the origin and expansion of art are essential aspects of humanity's progress, and its slow appropriation of the universe.

Gaps and uncertainties

It was with a constant concern for objectivity that we undertook this enquiry. We have not sought to hide the uncertainties in our present knowledge of art's prehistoric origins.

First and foremost, the subject of our study is irremediably fragmentary. We do not have a global view and instead try to grasp our

interpretations through the analysis of poor vestiges forgotten on the edges of time, which punishes the study of art far more than that of lithic industries (the latter, by definition, resist the ravages of time!). Simple ethnographic comparisons show us the extent of our losses: all perishable materials have disappeared. Not only voices, songs and poems have gone, but also the embroideries, the garments, the feathers, the painted and carved wood, paintings on human or animal skins, ephemeral images made on the ground, the rites, and so on. This natural selection of vestiges through time introduces a major source of bias in our knowledge of prehistoric people, who we approach primarily through the material, durable aspects of their creations. Hence we risk underestimating the past symbolic and spiritual activities of humankind, in the broadest sense, since their traces are far harder to detect.

There are also uncertainties linked to the very limits of our discipline: the superficiality of some approaches to art, which are satisfied with a direct, rapid and immediate understanding of prehistoric art sites, and which consider recordings and tracings of decorated walls superfluous, whereas they are the equivalent of excavations. This disparity in the levels of study deprives specialists of some of the data that would be accessible to authentic research. In addition, certain excavators have sometimes ignored pieces that could have had a symbolic function (for example, some have rejected natural 'pierres-figures', even when brought into habitation sites), while others have confused natural traces with engraved incisions. Hence many important pieces that could shed light on the earliest humans have been insufficiently studied; they deserve to be subjected to collective, international expertise.

This disparity in data also exists at a global level, because numerous countries have not yet sufficiently developed the study of their early art. For example, we still do not have a single direct date or pigment analysis for any rock art in India. Although it is one of the foremost countries of the world in terms of the wealth, beauty and antiquity of its rock art sites, India has been very late in developing scientific recording of parietal paintings in association with excavations and the physico-chemical analyses of pigments; this is particularly ironic when one recalls that the Raman spectrometer, now so widely used elsewhere in the world for modern and sophisticated non-destructive analysis of pigments, was invented by the renowned Indian physicist Sir Chandrasekhara Venkata Raman, winner of the Nobel Prize for Physics in 1930! We still need to acquire a great deal of scientific data about the rock art and the oldest artistic expressions in numerous countries in Europe, Asia and Africa.

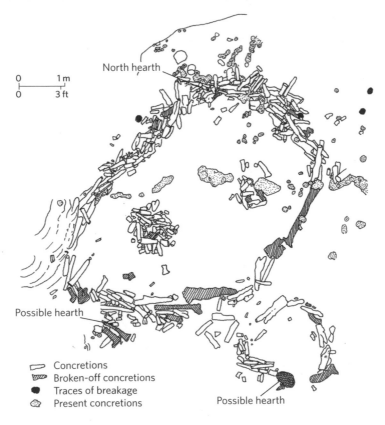

North hearth

Possible hearth

Possible hearth

0 1 m
0 3 ft

▱ Concretions
▨ Broken-off concretions
● Traces of breakage
◉ Present concretions

99. The stalagmitic structures at Bruniquel
(Tarn-et-Garonne, France), dating to *c*. 176,000 BP:
evidence of early Neanderthal activity within caves.

The limits of our knowledge are also the result of the prejudices that predominate in some schools. Fortunately our discipline has seen several victories by prehistorians against other prehistorians, which have made possible a constant elevation of the mind above the derogatory and simplistic views of prehistoric people that often dominate our discipline. In the 'battle of Altamira' it took twenty-three years for the idea to be generally accepted that such a sumptuous parietal art (discovered in 1879) could be the work of Ice Age people (see Bahn 2016, and Chapter 1); and in the 'battle of La Chapelle-aux-Saints' the discovery of the Neanderthal burial (1908) established – against the dominant ideas of the time – the existence of spirituality in prehistoric people, and particularly Neanderthals. A future battle could be that of the antiquity of parietal art leading to the final scientific confirmation of the spiritual dimension of Neanderthals, expressed not only in burial rites but also in the fact that they seem to have started making a few crude motifs on the walls of certain caves. Certainly they ventured deep inside some caverns, even in very remote periods, as has recently been confirmed by the dating of their stalagmitic structures in Bruniquel (Tarn-et-Garonne) to c. 176,000 years ago (FIG. 99).

The politics of research
Finally, in the very countries where the study of prehistoric art has been able to develop for a long time, our knowledge is sometimes likewise limited by politics. In France, for example, the study of decorated caves is to be constrained by new rules that impose a systematic ban on interventions on painted walls – the abandonment of sampling methods and physico-chemical analyses of pigments – under the pretext of preservation of the paintings (these samplings are of the order of a few dozen milligrams, and cause no damage to the figures). It would seem that the authorities wish to make the study methods employed at Chauvet – where only 2 per cent of the parietal figures have been radiocarbon dated and where analysis of pigments has not been carried out – the new norm.

We fully acknowledge that the study of cave floors and their contents certainly bring complementary data to the study of the decorated walls, but they cannot replace it. These bans and rules are imposed to the detriment of the acquisition of data and the scientific development of methods of dating parietal works, such as the U-Th dating of calcite covering some figures, which now makes it possible to date any parietal image including those made with mineral pigments, or by engraving or

sculpture. Pigment analyses (carried out systematically, for example, in the painted caves of the Quercy – see Lorblanchet 2010) can contribute precious information concerning the precise composition and the geographic origin of the pigments, as well as about their preparations, episodes of repainting, and so on. Such studies in Cougnac cave have revealed that Magdalenians performed rites in a Gravettian sanctuary without producing new figures.

Simply studying the floor of a cave cannot replace the detailed study of its decorated walls, even when this is carried out using sophisticated photographic and computerized methods. Direct multidisciplinary study of rock art, using all available methods of physico-chemical analysis – which today are essentially non-destructive – should be encouraged all over the world.

It is true that the countries that open their sites to intensive tourism are often justifiably preoccupied by the conservation of the parietal artworks, since some examples of humanity's heritage, and especially Lascaux, have suffered greatly from these visits. And together with tourism, other aspects of economic development may affect rock art sites, and even prevent progress in studies and scientific publications: the interruption by the government of Portugal of the construction of a dam, in order to preserve the Palaeolithic rock-engravings of the Côa valley, remains a unique example in the world! The rock-engravings of the Dampier Peninsula (Western Australia) are likewise threatened by economic development, but here the governmental politics do not seem to favour the protection of the hundreds of thousands of engravings, some of which date back to the Pleistocene, and which should be included on UNESCO's World Heritage list.

Despite all the disparities in the level of our knowledge of – and research into – world rock art, disparities that we have not sought to conceal, we have sketched out a narrative thread that takes the researcher from the first collections of natural curiosities by Australopithecines to the splendour of Chauvet. The latter may certainly appear to be like a thunderclap in a peaceful sky... but nevertheless it is the successor to more than 2 million years of expressions of the artistic feelings of the first humans. The overall message of this book is that art is a universal found throughout the world and from the earliest times – it began at the same time as humankind and it is an essential factor in hominization. But art is also a diversified and discontinuous phenomenon; it has seen many spectacular flowerings, but not always at the same times or in the same

places. Why is great art Palaeolithic in Europe but Neolithic in Africa, when the latter continent seems to have one of the cradles of humankind? How can we explain the successive appearances and disappearances of art, and especially rock art, in different parts of the world and at different times? It is to be hoped that future research and discoveries of extremely early portable and parietal art will help us to tackle such questions. Our long retrospective demands a search for all available evidence, in order to achieve as complete a view as possible of the earliest behaviours.

Hitherto, most specialists have seen early prehistory as a somewhat 'monochrome' scenario, with the 'clack, clack, clack' of tool-knapping as its only soundtrack. But this book's quest for early artistic evidence has highlighted the fact that so much more was going on, that this was a 'coloured' world, and that our early ancestors were concerned not only with making tools, and killing and eating animals, but also with matters of the mind, with spiritual concerns that went far beyond the need for survival. That is the principal message of this book, and it therefore teaches us something about ourselves – that our present-day materialism is a very recent cultural phenomenon. By studying the remote past, we have the ability to gain the broadest possible perspective on our evolution, and this view of the long trajectory of our artistic activity thus provides us with a clearer understanding of our modern selves.

Bibliography

ABRAMOVA, Z. 1990. L'art mobilier paléolithique en Sibérie. *Bolletino del Centro Camuno di Studi Preistorici* 25/26: 80–98.

ABRAMOVA, Z. 1995. *L'Art Paléolithique d'Europe Orientale et de Sibérie.* Editions Jérôme Millon: Grenoble.

ABSOLON, C. 1937. Les flûtes paléolithiques de l'Aurignacien et du Magdalénien de Moravie (analyse musicale et ethnologique comparative, avec démonstrations). *12e Congrès Préhist. de France*, Toulouse/Foix 1936: 770–84.

AIKENS, C.M. & HIGUCHI, T. 1982. *Prehistory of Japan.* Academic Press: London/New York.

ALCALDE DEL RIO, H., BREUIL, H. & SIERRA, L. 1912. *Les Cavernes de la Région Cantabrique.* Monaco.

ALLAIN, J. 1950. Un appeau magdalénien. *Bull. Soc. Préhist. Française* 47: 181–92.

AMBERT, P. 1972. Le mammouth de l'Aldène. *Bull. Soc. Préhist. de l'Ariège* XXVIII: 59–72.

AMBROSE, S.H. 1998. Chronology of the Later Stone Age and food production in East Africa. *Journal of Archaeological Science* 25: 377–92.

ANATI, E. 1989. *Les Origines de l'Art et la Formation de l'Esprit Humain.* Albin Michel: Paris.

ANATI, E. 1997. *L'Art Rupestre dans le Monde.* Larousse: Paris.

ANDERSON-GERFAUD, P., MOSS, E. & PLISSON, H. 1987. A quoi ont-ils servi? *Bull. Soc. Préhist. Française* 84(8): 226–36.

ARAMBOURG, C. 1950. Traces possibles d'une industrie primitive dans un niveau villafranchien de l'Afrique du Nord. *Bull. Soc. Préhist. Française* 47: 348–50.

ARIAS, P. et al. 2012. Grabados del Holoceno temprano en la Cueva Epullán Grande, Provincia del Neuquén, Argentina. Nuevas investigaciones, pp. 793–806 in (J. Clottes, ed.) *L'art pléistocène dans le monde / Pleistocene art of the world / Arte pleistoceno en el mundo*, Actes du Congrès IFRAO, Tarascon-sur-Ariège, September 2010. Special issue, *Préhistoire, Art et Sociétés, Bull. Soc. Préhist. Ariège-Pyrénées*, LXV–LXVI, 2010–11, CD.

ASCHERO, C.A. & PODESTÁ, M.M. 1986. El arte rupestre en asentamientos precerámicos de la Puna argentina. *Runa* (Buenos Aires) 16: 29–57.

ATLAS OF PRIMITIVE MAN IN CHINA. 1980. Science Press: Beijing.

AUBERT, M. 2012. A review of rock art dating in the Kimberley (Western Australia). *Journal of Archaeological Science* 39(3): 573–77.

AUBERT, M. et al. 2007. Uranium-series dating rock art in East Timor. *Journal of Archaeological Science* 34: 991–96.

AUBERT, M. et al. 2014. Pleistocene cave art from Sulawesi, Indonesia. *Nature* 514: 223–27.

AUDOUIN, F. & PLISSON, H. 1982. Les ocres et leurs témoins au Paléolithique en France: enquête et expériences sur leur validité archéologique. *Cahiers du Centre de Recherches Préhistoriques* 8: 33–80.

AVELEYRA ARROYO DE ANDA, L. 1965. The Pleistocene carved bone from Tequixquiac, Mexico: A reappraisal. *American Antiquity* 30: 261–77.

AYTA, W. 2004. Datação termoluminescente e de ressonância paramagnética eletrônica da calcita coletada sobre pinturas rupestres de dois sitios no Parque Nacional da Serra da Capivara, Piauí, Brasil. *Fumdhamentos* 4: 8–26.

AZEMA, M. et al. 2012. L'art paléolithique de la Baume Latrone (France, Gard): nouveaux éléments de datation. *INORA* 64: 6–12.

BADER, N.O. & LAVRISHIN, Y.A. (eds) 1998. *The Upper Palaeolithic Settlement of Sungir (Burials and Environment).* Scientific World: Moscow (in Russian).

BAFFIER, D. 1999. *Les Derniers Néandertaliens. Le Châtelperronien.* La Maison des Roches: Paris.

BAFFIER, D. & GIRARD, M. 1998. *Les Cavernes d'Arcy-sur-Cure.* La Maison des Roches: Paris.

BAHN, P.G. 1977. Seasonal migration in S.W. France during the late glacial period. *Journal of Archaeological Science* 4: 245–57.

BAHN, P.G. 1982. Inter-site and inter-regional links during the Upper Palaeolithic: the Pyrenean evidence. *The Oxford Journal of Archaeology* 1: 247–68.

BAHN, P.G. 1987. A la recherche de l'iconographie paléolithique hors de l'Europe.

Travaux de l'Institut d'Art Préhist. de Toulouse 29: 7–18.

BAHN, P.G. 1991. Pleistocene images outside Europe. *Proceedings of the Prehistoric Society* 57: 91–102.

BAHN, P.G. (ed.) 1996a. *The Cambridge Illustrated History of Archaeology*. Cambridge University Press: Cambridge.

BAHN, P.G. 1996b. Further back down under! *Nature* 388: 557–58.

BAHN, P.G. 1997. Membrane and numb brain: a close look at a recent claim for shamanism in Palaeolithic art. *Rock Art Research* 14(1): 62–68.

BAHN, P.G. 1999. Face to face with the earliest 'art object', pp. 75–77 in (M. Strecker & P. Bahn, eds) *Dating and the Earliest Known Rock Art*. Oxbow Books: Oxford.

BAHN, P.G. 2007a. Pleistocene imagery outside Europe, pp. 3–16 in (C. Renfrew & I. Morley, eds) *Image and Imagination: A Global Prehistory of Figurative Representation*. McDonald Institute Monographs: Cambridge.

BAHN, P.G. 2010. *Prehistoric Rock Art: Polemics and Progress*. Cambridge University Press: Cambridge.

BAHN, P.G. 2015. Bow and errors, pp. 59–65 in (H. Stebergløkken et al., eds) *Ritual Landscapes and Borders within Rock Art Research. Papers in Honour of Professor Kalle Sognnes*. Archaeopress: Oxford.

BAHN, P.G. 2016. *Images of the Ice Age*. Oxford University Press: Oxford.

BAHN, P.G. & VERTUT, J. 1988. *Images of the Ice Age*. Windward: London.

BAHN, P.G. & VERTUT, J. 1997. *Journey Through the Ice Age*. Weidenfeld & Nicolson: London.

de BALBÍN, R., ALCOLEA GONZALEZ, J. & GONZALEZ PEREDA, M.A. 2003. El macizo de Ardines: un lugar mayor del arte paleolítico europeo, pp. 91–151 in (R. de Balbín Behrmann & P. Bueno Ramírez, eds) *El Arte Prehistórico desde los Inicios del Siglo XXI. Primer Symposium Int. de Arte Prehistórico de Ribadesella*. Asosiación Cultural Amigos de Ribadesella.

BALME, J. & MORSE, K. 2006. Shell beads and social behaviour in Pleistocene Australia. *Antiquity* 80: 799–811.

BALOUT, L. 1955. *Préhistoire de l'Afrique du Nord*. Arts et Métiers Graphiques: Paris.

BARANDIARÁN, I. 2006. *Imágenes y adornos en el arte portátil paleolítico*. Ariel Prehistoria: Barcelona.

de BARANDIARÁN, J.M. 1980. Excavaciones en Axlor (campaña de 1969), pp. 129–384 in *Obras Completas*. Vol. 17.

BARHAM, L.S. 1998. Possible early pigment use in South-Central Africa. *Current Anthropology* 39(5): 703–10.

BARHAM, L.S. 2002. Systematic pigment use in the Middle Pleistocene of South-Central Africa. *Current Anthropology* 43(1): 181–90.

BARKAI, R. & GOPHER, A. 2016. On anachronism: the curious presence of spheroids and polyhedrons at Acheulo-Yabrudian Qesem Cave, Israel. *Quaternary International* 398: 118–28.

BARTOLOMEI, G. et al. 1992. La grotte de Fumane, un site aurignacien au pied des Alpes. *Preistoria Alpina* 28: 131–79.

BAR-YOSEF, O. 1992. Middle Palaeolithic human adaptations in the Mediterranean Levant, pp. 189–216 in (T. Akazawa, K. Aoki & T. Kimura, eds) *The Evolution and Dispersal of Modern Humans in Asia*. Hokusen-Sha: Tokyo.

BAR-YOSEF, O. 1995. The Lower and Middle Palaeolithic in the Mediterranean Levant: chronology and cultural entities, pp. 247–63 in (H. Ullrich, ed.) *Man and Environment in the Palaeolithic*. ERAUL 62: Liège.

BAR-YOSEF, O. & GOREN-INBAR, N. 1993. *The lithic assemblages of Ubeidiya, a Lower Palaeolithic site in the Jordan Valley*. Monograph of the Institute of Archaeology 34: Jerusalem.

BAR-YOSEF MAYER, D.E., VANDERMEERSCH, B. & BAR-YOSEF, O. 2009. Shells and ochre in Middle Paleolithic Qafzeh Cave, Israel: indications for modern behavior. *Journal of Human Evolution* 56: 307–14.

BEAUMONT, P.B. 1973. Border Cave: a progress report. *South African Journal of Science* 69: 41–46.

BEAUMONT, P.B. & BEDNARIK, R.G. 2012a. On a search for ancestral rock art in the South-Eastern Kalahari-South Africa, pp. 94 & 549–60 in (J. Clottes, ed.) *L'art pléistocène dans le monde / Pleistocene art of the world / Arte pleistoceno en el mundo*, Actes du Congrès IFRAO, Tarascon-sur-Ariège, September 2010. Special issue, *Préhistoire, Art et Sociétés, Bull. Soc. Préhist. Ariège-Pyrénées*, LXV–LXVI, 2010–11, CD.

BEAUMONT, P.B. & BEDNARIK, R.G. 2012b. A brief overview of major Pleistocene palaeoart sites in Sub-Saharan Africa, pp. 92 & 541–48 in (J. Clottes, ed.) *L'art pléistocène dans le monde / Pleistocene art of the world / Arte pleistoceno en el mundo*, Actes du Congrès IFRAO, Tarascon-sur-Ariège, September 2010. Special issue, *Préhistoire, Art et Sociétés, Bull. Soc. Préhist. Ariège-Pyrénées*, LXV–LXVI, 2010–11, CD.

BEDNARIK, R.G. 1992. The palaeolithic art of Asia, pp. 383–90 in (S. Goldsmith et al., eds) *Ancient Images, Ancient Thought: the Archaeology of Ideology*. Archaeological Association, University of Calgary: Calgary.

Bibliography

BEDNARIK, R.G. 1993. Palaeolithic art in India. *Man and Environment* 18(2): 33–40.

BEDNARIK, R.G. 1994a. Art origins. *Anthropos* 89: 169–80.

BEDNARIK, R.G. 1994b. The Pleistocene art of Asia. *Journal of World Prehistory* 8(4): 351–75.

BEDNARIK, R.G. 1995a. Concept-mediated marking in the Lower Palaeolithic. *Current Anthropology* 36(4): 605–33.

BEDNARIK, R.G. 1995b. The age of the Côa Valley petroglyphs in Portugal. *Rock Art Research* 12: 86–103.

BEDNARIK, R.G. 1996. The cupules on Chief's Rock, Auditorium Cave, Bhimbetka. *The Artefact* 19: 63–72.

BEDNARIK, R.G. 2001. Cupules: the oldest surviving rock art. *INORA* 30: 18–22.

BEDNARIK, R.G. 2003. A figurine from the African Acheulian. *Current Anthropology* 44(3): 405–13.

BEDNARIK, R.G. 2012. Indian Pleistocene rock art in a global context, pp. 150–51 & 869–78 in (J. Clottes, ed.) *L'art pléistocène dans le monde / Pleistocene art of the world / Arte pleistoceno en el mundo*, Actes du Congrès IFRAO, Tarascon-sur-Ariège, September 2010. Special issue, *Préhistoire, Art et Sociétés, Bull. Soc. Préhist. Ariège-Pyrénées*, LXV–LXVI, 2010–11, CD.

BEDNARIK, R.G. & BEAUMONT, P.B. 2012. Pleistocene engravings from Wonderwerk Cave, South Africa, pp. 96–97 & 561–70 in (J. Clottes, ed.) *L'art pléistocène dans le monde / Pleistocene art of the world / Arte pleistoceno en el mundo*, Actes du Congrès IFRAO, Tarascon-sur-Ariège, September 2010. Special issue, *Préhistoire, Art et Sociétés, Bull. Soc. Préhist. Ariège-Pyrénées*, LXV–LXVI, 2010–11, CD.

BEDNARIK, R.G. & YOU, Y. 1991. Palaeolithic art from China. *Rock Art Research* 8: 119–23.

BEGOUEN, R. & CLOTTES, J. 1981. Nouvelles fouilles dans la Salle des Morts de la Caverne d'Enlène à Montesquieu-Avantès (Ariège), pp. 33–56 in *21e Congrès Préhist. de France*, Montauban/Cahors 1979, vol. 1.

BEGOUEN, R. & CLOTTES, J. 1983. El arte mobiliar de las cavernas del Volp (en Montesquieu-Avantès/Ariège). *Revista de Arqueologia* Año IV(27): 6–17.

BEGOUEN, R. & CLOTTES, J. 1985. L'art mobilier des Magdaléniens. *Archéologia* 207, November: 40–49.

BEHM-BLANCKE, G. 1987. Zur geistigen Welt des *Homo erectus* von Bilzingsleben. *Jahresschrift für mitteldeutsche Vorgeschichte* 70: 41–82.

BELFER-COHEN, A. & BAR-YOSEF, O. 1981. The Aurignacian at Hayonim Cave. *Paléorient* 7(2): 19–42.

BELLAIR, P. & POMEROL, C. 1965. *Eléments de Géologie*. A. Colin: Paris.

BELTING, H. 1989. *L'Histoire de l'Art est-elle finie?* J. Chambon: Nîmes.

BENSON, L.V. et al. 2013. Dating North America's oldest petroglyphs, Winnemucca Lake subbasin, Nevada. *Journal of Archaeological Science* 40(12): 4466–76.

BEYRIES, S. & INIZAN, M. 1982. Typologie, ocre, fonction. *Studia Praehistorica Belgica* 2: 313–22.

BIBIKOV, S.N. 1981. *The Oldest Musical Complex made of mammoth bones*. Naukova Dumka: Kiev. (In Russian). (See also 1975, A Stone Age orchestra. *UNESCO Courier*, June, 8–15.)

BINFORD, L.R. 1981. *Bones: Ancient Men and Modern Myths*. Academic Press: London.

BIRDSELL, J.B. 1953. Some environmental and cultural factors influencing the structuring of Australian Aboriginal populations. *American Naturalist* 87: 171–207.

BONJEAN, D. et al. 2015. A new Cambrian black pigment used during the late Middle Palaeolithic discovered at Scladina Cave (Andenne, Belgium). *Journal of Archaeological Science* 55: 253–65.

BORDES, F. 1954–55. Le Moustérien de Tradition Acheuléenne de Pech de l'Azé. *L'Anthropologie* 58: 420–50 & 59: 1–32.

BORDES, F. 1961. *Typologie du Paléolithique Ancien et Moyen*. 2 vols. Delmas: Bordeaux.

BORDES, F. 1969. Os percé moustérien et os gravé acheuléen du Pech de l'Azé II. *Quaternaria* 11: 281–82.

BORDES, F. 1992. *Leçons sur le Paléolithique*. 2 vols. CNRS: Paris.

BOREL, A. et al. 2016. Do orangutans share early human interest in odd objects? *Current Anthropology* 57(6): 828–37.

BOSHIER, A. & BEAUMONT, P.B. 1972. Mining in Southern Africa and the emergence of modern man. *Optima* 22(1): 2–12.

BOSINSKI, G. 1973. Le site magdalénien de Gönnersdorf (Commune de Neuwied, Vallée du Rhin Moyen, RFA). *Bull. Soc. Préhist. Ariège* 28: 25–48.

BOSINSKI, G. 1996. *Les Origines de l'Homme en Europe et en Asie. Atlas des sites du Paléolithique Inférieur*. Errance: Paris.

BOSINSKI, G. & FISCHER, G. 1974. *Die Menschendarstellungen von Gönnersdorf der Ausgrabungen von 1968*. Steiner: Wiesbaden.

BOTTET, B. & BOTTET, B. 1947. La Baume Bonne, à Quinson (B.A.). (Industries paleolithiques avec oeuvres d'Art). *Bull. Soc. Préhist. Française* 44(5): 152–70.

BOUCHER-DE-PERTHES, J. 1847. *Antiquités celtiques et antédiluviennes. De l'industrie primitive ou des arts à leur origine*. (Chapter 1 of vol. II.) Treuttel et Würtz: Paris. 3 vols, 1847–64.

BOULE, M. & de VILLENEUVE, L. 1927. La grotte de l'Observatoire à Monaco. *Archives de l'Institut de Paléontologie Humaine*, Mémoire 1. Masson: Paris.

BOURDIER, F. 1967. *Préhistoire de France*. Flammarion: Paris.

BOURRILLON, R. et al. 2017. A new Aurignacian engraving from Abri Blanchard, France: Implications for understanding Aurignacian graphic expression in Western and Central Europe. *Quaternary International* (in press).

BOUZOUGGAR, A. et al. 2007. 82,000-year old shell beads from North Africa and implications for the origins of modern human behavior. *Proceedings of the National Academy of Sciences of the USA* 104(24): 9964–69.

BREUIL, H. 1906. L'art à ses débuts. L'enfant. Les primitifs. *Revue philosophique* 7: 161–78.

BREUIL, H. 1926. Les origines de l'art décoratif. *Journal de Psychologie Normale et Pathologique* 23: 364–75.

BREUIL, H. 1952. *Four Hundred Centuries of Cave Art*. Centre d'Études et de Documentation Préhistoriques: Montignac.

BREWSTER, R. 1986. Aboriginal cave paintings among oldest in world. *Popular Archaeology* 7(6): 44.

BREZILLON, M.N. 1968. *La Dénomination des Objets de Pierre Taillée*. CNRS: Paris.

BROGLIO, A. et al. 2009. L'art aurignacien dans la décoration de la Grotte de Fumane. *L'Anthropologie* 113: 753–61.

BROWN, S. 1987. The 1986 AURA Franco-Cantabrian field trip: summary report. *Rock Art Research* 4(1): 56–60.

BRUMM, A. & MOORE, M.W. 2005. Symbolic revolutions and the Australian archaeological record. *Cambridge Archaeological Journal* 15(2): 157–75.

BUISSON, D. 1990. Les flûtes paléolithiques d'Isturitz. *Bull. Soc. Préhist. Française* 87: 420–33.

BUTZER, K.W. et al. 1979. Dating and context of rock engravings in southern Africa. *Science* 203: 1201–14.

CAILLOIS, R. 1987. *L'Écriture des Pierres*. Flammarion: Paris.

CAIN, C.R. 2006. Implications of the marked artifacts of the Middle Stone Age of Africa. *Current Anthropology* 47(4): 675–81.

CAMPS, M. & CHAUHAN, P.R. (eds) 2009. *Sourcebook of Paleolithic transitions – Methods, theories, and interpretations*. Springer: New York & London.

CANBY, T.Y. 1979. The search for the first Americans. *National Geographic* 156(3), Sept.: 330–63.

CAPITAN, L. & BOUYSSONIE, J. 1924. *Un atelier d'art préhistorique. Limeuil. Son gisement à gravures sur pierres de l'âge du Renne*. Nourry: Paris.

CAPITAN, L. & PEYRONY, D. 1921. Les origines de l'art à l'Aurignacien moyen. Nouvelles découvertes à La Ferrassie. *Revue Anthropologique*, 92–112.

CAPITAN, L. & PEYRONY, D. 1928. *La Madeleine. Son gisement, son industrie, ses oeuvres d'art*. Nourry: Paris.

CÂRCIUMARU, M. & TUTUIANU-CÂRCIUMARU, M. 2009. L'ocre et les récipients pour ocre de la grotte Cioarei, village Borosteni, commune Pestisani, dép. de Gorj, Roumania. *Annales d'Université Valahia Targoviste, Section d'Archéologie et d'Histoire* 11(1): 7–19.

CÂRCIUMARU, M. & TUTUIANU-CÂRCIUMARU, M. 2011. Le sifflet gravettien de Poiana Ciresului-Piatra Neamt (Roumanie). *Annales d'Université Valahia Targoviste, Section d'Archéologie et d'Histoire* 13(2): 41–58.

CÂRCIUMARU, M. et al. 2015. A geode painted with ochre by the Neanderthal man. *Comptes rendus Palevol* 14(1): 31–41.

CARDICH, A. 1987. Arqueología de Los Toldos y El Ceibo (Provincia de Santa Cruz, Argentina). *Estudios Atacameños* (San Pedro de Atacama, Chile) 8: 98–117.

CHAFFEE, S.D., HYMAN, M. & ROWE, M. 1993. AMS 14C dating of rock paintings, pp. 67–73 in (J. Steinbring et al., eds) *Time and Space. Dating and Spatial Considerations in Rock Art Research*. AURA Publication 8: Melbourne.

CHALOUPKA, G. 1984. *From Palaeoart to Casual Paintings*. Monograph 1, Northern Territory Museum of Arts and Sciences: Darwin.

CHALOUPKA, G. 1993. *Journey in Time. The World's Longest Continuing Art Tradition. The 50,000-Year Story of the Australian Aboriginal Rock Art of Arnhem Land*. Reed: Chatswood, NSW.

CHASE, P. G. 1990. Sifflets du paleolithique moyen? Les implications d'un coprolithe de coyote actuel. *Bull. Soc. Préhist. Française* 87: 165–67.

CHASE, P.G. & DIBBLE, H.L. 1987. Middle Palaeolithic symbolism: a review of current evidence and interpretations. *Journal of Anthropological Archaeology* 6: 263–96.

CHAVAILLON, J. 1992. L'Afrique, in (J. Garanger, ed.) *La Préhistoire dans le Monde*. PUF/Nouvelle Clio: Paris.

CHAVAILLON, J., CHAVAILLON, N., HOURS, F. & PIPERNO, M. 1979. From the Oldowan to the Middle Stone Age at Melka-Kunture (Ethiopia). Understanding cultural changes. *Quaternaria* 21: 87–114.

CHAZINE, J-M. 2000. Découverte de peintures rupestres à Bornéo. *L'Anthropologie* 104(3): 459–71.

CHOLLOT-VARAGNAC, M. 1980. *Les Origines du Graphisme Symbolique.* Editions de la Fondation Singer-Polignac: Paris.

CLARK, J.D. & KURASHINA, H. 1979. Hominid occupation of the east-central highlands of Ethiopia in the Pleistocene. *Nature* 282: 33–39.

CLOTTES, J. & CEROU, E. 1970. La statuette féminine de Montpazier (Dordogne). *Bull. Soc. Préhist. Française* 67: 335–44.

CLOTTES, J. & LEWIS-WILLIAMS, J.D. 1996. *Les Chamanes de la Préhistoire. Transe et Magie dans les Grottes Ornées.* Le Seuil: Paris.

COLE, N.A., WATCHMAN, A. & MORWOOD, M.J. 1995. Chronology of Laura rock art, pp. 147–60 in (M.J. Morwood & D.R. Hobbs, eds) *Quinkan Prehistory. The Archaeology of Aboriginal Art in S.E. Cape York Peninsula, Australia.* Tempus vol. 3. Univ. of Queensland.

COMBIER, J. & JOUVE, G. 2012. Chauvet cave's art is not Aurignacian: a new examination of the archaeological evidence and dating procedures. *Quartär* 59: 131–52.

COMBIER, J. & JOUVE, G. 2014. Nouvelles recherches sur l'identité cuturelle et stylistique de la grotte Chauvet et sur sa datation par la méthode du 14C. *L'Anthropologie* 118(2): 115–51.

COMMONT, V. 1916. Sur la station d'Hermiès-Somme. *L'Anthropologie* 27: fig. 36, p. 537.

CONARD, N. 2005. Aurignacian art in Swabia and the beginnings of figurative representation in Europe, pp. 82–88 in (A. Broglio & G. Dalmeri, eds) *Pitture Paleolitiche nelle Prealpi Venete. Grotta di Fumane e Riparo Dalmeri.* Memorie del Museo Civico di Storia Naturale di Verona. Preistoria Alpina, Nr. speciale. Verona.

CONARD, N.J. 2007. Les flûtes aurignaciennes des grottes du Geissenklösterle et du Vogelherd (Jura souabe), pp. 353–62 in (H. Floss & N. Rouquerol, eds) *Les Chemins de l'Art Aurignacien en Europe. Das Aurignacien und die Anfänge der Kunst in Europa.* Colloque international – Internationale Fachtagung Aurignac 2005. Editions Musée – forum Aurignac Cahier 4.

CONARD, N. et al. 2004. Unexpectedly recent dates for human remains from Vogelherd. *Nature* 430: 198–201.

CONARD, N.J. et al. 2009. New flutes document the earliest musical tradition in southwestern Germany. *Nature* 460: 737–40.

CONKEY, M. 1983. On the origins of Palaeolithic art: a review and some critical thoughts, pp. 201–27 in (E. Trinkaus, ed.) *The Mousterian Legacy.* British Arch. Reports: Oxford.

CORCHON, S. et al. 2014. Back to the point: new datings for La Peña de Candamo cave art (Asturias). *Zephyrus* 73: 67–81.

COSGROVE, R. & JONES, R. 1989. Judds Cavern: a subterranean aboriginal dating site, Southern Tasmania. *Rock Art Research* 6: 96–104.

COURAUD, C. & LAMING-EMPERAIRE, A. 1979. Les colorants, pp. 153–70 in (A. Leroi-Gourhan & J. Allain, eds) *Lascaux Inconnu.* XIIe suppl. À Gallia Préhistoire. CNRS: Paris.

COUTIER, L. & EMETAZ, M. 1926. Station des Rochettes (Dordogne). *Bulletin et Mémoires de la Société d'Anthropologie de Paris*, pp. 145–48.

COX, M.V. 1992. *Children's Drawings.* Penguin Books: London.

CREMADES, M. 1989. *Contribution à l'étude de l'art mobilier du Paléolithique Supérieur du Bassin Aquitain: Techniques de gravure sur os et matériaux organiques.* 2 vols. Thèse de Doctorat de l'Univ. de Bordeaux I.

CREMADES, M. et al. 1995. Une pierre gravée de 50 000 ans B.P. dans les Balkans. *Paleo* 7: 201–19.

CRIVELLI MONTERO, E.A. & FERNANDEZ, M.M. 1996. Palaeoindian bedrock petroglyphs at Epullán Grande Cave, northern Patagonia, Argentina. *Rock Art Research* 13(2): 124–28.

DAMS, L. 1984a. Preliminary findings at the 'organ' sanctuary in the cave of Nerja, Málaga, Spain. *Oxford Journal of Archaeology* 3: 1–14.

DAMS, L. 1984b. *L'art rupestre du Levant espagnol.* Picard: Paris.

DAMS, L. 1985. Palaeolithic lithophones: descriptions and comparisons. *Oxford Journal of Archaeology* 4: 31–46.

DAMS, L. 1987. *L'Art Paléolithique de la Grotte de Nerja (Málaga, Espagne).* British Arch. Reports, Int. Series 385, Oxford.

DART, R.A. 1968. The birth of symbology. *African Studies* 27: 15–27.

DART, R.A. 1974. The water-worn australopithecine pebble of many faces from Makapansgat. *South African Journal of Science* 70: 167–69.

DAUVOIS, M. 1989. Son et musique paléolithiques. *La Musique dans l'Antiquité, Les Dossiers d'Arch*, 142, Nov.: 2–11.

DAUVOIS, M. 1994. Les témoins sonores paléolithiques extérieur et souterrain, pp. 11–31 in (M. Otte, ed.) *'Sons Originels', Préhistoire de la Musique.* Actes du Colloque de Musicologie, Dec. 1992. ERAUL 61: Liège.

DAUVOIS, M. & BOUTILLON, X. 1990. Études acoustiques au Réseau Clastres: Salle des Peintures et lithophones naturels. *Bull. Soc. Préhist. Ariège-Pyrénées* 45: 175–86.

DAVID, B. et al. 2013. A 28,000 year old excavated painted rock from Nawarla

Bibliography

Gabarnmang, northern Australia. *Journal of Archaeological Science* 40: 2493–501.

DAVIDSON, I. 1988. Comment on 'Deliberate engravings on bone artefacts of *Homo erectus*' by D. and U. Mania. *Rock Art Research* 5: 100–01.

DAVIDSON, I. 1990. Bilzingsleben and early marking. *Rock Art Research* 7: 52–56.

DAVIDSON, I. & NOBLE, W. 1989. The archaeology of perception: traces of depiction and language. *Current Anthropology* 30(2): 125–54.

DAVIS, S. 1974. Incised bones from the Mousterian of Kebara Cave (Mount Carmel) and the Aurignacian of Ha-Yonim Cave (western Galilee), Israel. *Paléorient* 2: 181–82.

DAVIS, W. 1986. The origins of image making. *Current Anthropology* 27: 193–215.

DAYET-BOUILLOT, L. & d'ERRICO, F. 2016. Colorer et graver: à la recherche d'expressions symboliques chez les néandertaliens, pp. 112–19 in (A. Turq et al., eds) *Néandertal à la Loupe*. Musée National de Préhistoire: Les Eyzies.

DEBENATH, A. & DUPORT, L. 1971. Os travaillés du Paléolithique ancien et moyen du Charente. *Bull. Soc. Archéologique et Historique de la Charente* pp. 189–202.

DEBRAY, R. 1992. *Vie et Mort de l'Image. Une histoire du regard en Occident.* Gallimard: Paris.

DELLUC, B. & DELLUC, G. 1983. La Croze à Gontran, grotte ornée aux Eyzies-de-Tayac (Dordogne). *Ars Praehistorica* 2: 13–48.

DELLUC, B. & DELLUC, G. 1984a. La Ferrassie, pp. 214–15 in *L'Art des Cavernes*. Ministère de la Culture: Paris.

DELLUC, B. & DELLUC, G. 1984b. L'abri Blanchard, pp. 216–17 in *L'Art des Cavernes*. Ministère de la Culture: Paris.

DELLUC, B. & DELLUC, G. 1985. De l'empreinte au signe. *Traces et Messages de la Préhistoire. Dossiers, Histoire et Archéologie* 90: 56–62.

DELLUC, B. & DELLUC, G. 1991. *L'Art Pariétal Archaïque en Aquitaine*. XXVIIIème supplément à Gallia Préhistoire. CNRS: Paris.

DELPORTE, H. 1979. *L'Image de la Femme dans l'Art Préhistorique*. Picard: Paris.

DELPORTE, H. & MONS, L. 1980. Gravure sur os et argile, in *Revivre la Préhistoire*, Dossier de l'Archéologie 46: 40–45.

DEMARS, Y. 1992. Les colorants dans le Moustérien du Périgord: l'apport des fouilles de F. Bordes. *Bull. Soc. Préhist. de l'Ariège* 47: 185–94.

DESBROSSE, R., FERRIER, J. & TABORIN, Y. 1976. La parure, pp. 710–13 in (H. de Lumley, ed.) *La Préhistoire française*, I:1. CNRS: Paris.

DORN, R.I., NOBBS, M. & CAHILL, T.A. 1988. Cation-ratio dating of rock engravings from the Olary Province of arid South Australia. *Antiquity* 62: 681–89.

DORTCH, C. 1979. Australia's oldest known ornaments. *Antiquity* 53: 39–43.

DORTCH, C. 1984. *Devil's Lair: A study in prehistory*. Western Australia Museum: Perth.

DRAGOVICH, D. 1986. Minimum age of some desert varnish near Broken Hill, New South Wales. *Search* 17: 149–51.

DUBOIS, A. & STEHLIN, H.G. 1933. La grotte de Cotencher, station moustérienne. *Mémoire de la Société Paléontologique Suisse* LII–LIII.

DUPREE, L. 1972. Prehistoric research in Afghanistan (1959–1966). *Transactions of the American Philosophical Society* 62: 74–82.

EIWANGER, J. 2003. An der Nahtstelle zweier Kontinente. *Archäologie in Deutschland* 2: 14–18.

EIWANGER, J. 2012. Am Ursprung der Gegenwart – Urgeschichte im marokkanischen Rif. *Archäologie in Deutschland* 2: 14–19.

EIWANGER, J. & HUTTERER, R. 2004. Schildkrötenpanzer als Behälter für Farbpigmente aus dem Ibéromaurusien der Ifri n'Ammar (Marokko). *Beiträge zur Allgemeinen und Vergleichenden Archäologie* 24: 139–48.

ELKIN, A.P. 1964. *The Australian Aborigines*. Doubleday: New York.

ELKINS, J. 1996. On the impossibility of close reading. *Current Anthropology* 37(2): 185–201.

d'ERRICO, F. 1991. Carnivore traces or Mousterian skiffle? Comment. *Rock Art Research* 8(1): 61–63.

d'ERRICO, F. 1994. *L'Art Gravé Azilien, de la technique à la signification*. XXXIe suppl. à Gallia Préhistoire. CNRS: Paris.

d'ERRICO, F. 2003. The invisible frontier. A multiple species model for the origin of behavioral modernity. *Evolutionary Anthropology* 12: 188–202.

d'ERRICO, F. 2007. The origin of humanity and modern cultures. archaeology's view. *Diogenes* 214: 122–33.

d'ERRICO, F. & BACKWELL, L. 2016. Earliest evidence of personal ornaments associated with burial: the *Conus* shells from Border Cave. *Journal of Human Evolution* 93: 91–108.

d'ERRICO, F., BAFFIER, D. & JULIEN, M. 2007. Les inventions des derniers Néandertaliens. *Dossier Pour la Science, 'Sur la Trace de nos Ancêtres'* Oct./Dec., pp. 16–19 (& in *Pour La Science*, Dec. 1998, 80–83).

d'ERRICO, F., GAILLARD, C. & MISRA, V.N. 1989. Collection of non-utilitarian objects by *Homo erectus* in India, pp. 237–39 in *Hominidae. Proceedings of the 2nd International Congress of Human Palaeontology*. Jaca Books: Milan.

d'ERRICO, F., GARCÍA MORENO, R. & RIFKIN, R.F. 2012. Technological, elemental and colorimetric analysis of an engraved

ochre fragment from the Middle Stone Age levels of Klasies River Cave 1, South Africa. *Journal of Archaeological Science* 39(4): 942–52.

d'ERRICO, F., GIACOBINI, G. & PUECH, P. F. 1984. Les répliques en vernis des surfaces osseuses façonnées: études expérimentales. *Bull. Soc. Préhist. Française* 81(6): 169–70.

d'ERRICO, F. & HENSHILWOOD, C.S. 2011. The origin of symbolically mediated behaviour, pp. 49–74 in (C.S. Henshilwood & F. d'Errico, eds) *Homo symbolicus. The dawn of language, imagination and spirituality*. John Benjamins Publishing Company: Amsterdam & Philadelphia.

d'ERRICO, F. & LAWSON, G. 2006. The sound paradox. How to assess the acoustic significance of archaeological evidence?, pp. 41–57 in (C. Scarre & G. Lawson, eds) *Archaeoacoustics*. McDonald Institute Monographs: Cambridge.

d'ERRICO, F. & NOWELL, A. 2000. A new look at the Berekhat Ram figurine: implications for the origins of symbolism. *Cambridge Archaeological Journal* 10(1): 123–67.

d'ERRICO, F. & SORESSI, M. 2006. Une vie en couleurs, in Neandertal – Enquête sur une disparition. *Les Dossiers de La Recherche* 24: 84–87.

d'ERRICO, F. & VANHAEREN, M. 2008. Microscopic and technological analysis of decorated ochre crayons from Piekary IIa, layer 6. Implications for the emergence of symbolism in Europe, pp. 149–60 in (V. Sitlivy, A. Zieba & K. Sobczyk, eds) *Middle and Early Upper Palaeolithic of the Krakow region. Piekary IIa*. Musées royaux d'Art et d'Histoire, Monographie de Préhistoire générale 6: Brussels.

d'ERRICO, F., VANHAEREN, M. & WADLEY, L. 2008. Possible shell beads from the Middle Stone Age layers of Sibudu Cave, South Africa. *Journal of Archaeological Science* 35: 2675–85.

d'ERRICO, F. & VILLA, P. 1997. Holes and grooves: the contribution of microscopy and taphonomy to the problem of art origins. *Journal of Human Evolution* 33: 1–31.

d'ERRICO, F., VILLA, P., PINTO, A.C. & RUIZ IDARRAGA, R. 1998. A Middle Palaeolithic origin of music? Using cave bear bone accumulations to assess the Divje Babe I bone 'flute'. *Antiquity* 72: 65–79.

d'ERRICO, F. et al. 2003. Archaeological evidence for the emergence of language, symbolism, and music – an alternative multidisciplinary perspective. *Journal of World Prehistory* 17(1): 1–70.

d'ERRICO, F. et al. 2005. *Nassarius kraussianus* shell beads from Blombos Cave: evidence for symbolic behaviour in the Middle Stone Age. *Journal of Human Evolution* 48: 3–24.

d'ERRICO, F. et al. 2009. Additional evidence on the use of personal ornaments in the Middle Paleolithic of North Africa. *Proceedings of the National Academy of Sciences of the USA* 106(38): 16051–56.

d'ERRICO, F. et al. 2012. Early evidence of San material culture represented by organic artifacts from Border Cave, South Africa. *Proceedings of the National Academy of Sciences of the USA* 109(33): 13214–19.

FAGE, L-H. & CHAZINE, J-M. 2009. *Bornéo, la Mémoire des Grottes*. Editions Fage: Lyon.

FAGES, G. & MOURER-CHAUVIRÉ, C. 1983. La flûte en os d'oiseau de la grotte sépulcrale de Veyreau (Aveyron) et inventaire des flûtes préhistoriques d'Europe, pp. 95–103 in *La Faune et l'Homme Préhistoriques*, Mém. 16 de la Soc. Préhist. française.

FARIZY, C. (ed.) 1990. *Paléolithique Moyen Récent et Paléolithique Supérieur Ancien en Europe. Ruptures et transitions: examen critique des données archéologiques*. Actes du colloque de Nemours 1988.

FAVRAUD, A. 1908. La station moustérienne du Petit-Puymoyen (Charente). *Revue de l'Ecole d'Anthropologie*: 46–72.

FIELD, J. & McINTOSH, P.D. 2009. A re-evaluation of 'petroglyphs' on Blue Tier, Northeast Tasmania. *Australian Archaeology* 69: 11–20.

FIELD, J. & McINTOSH, P.D. 2010. Reply. *Australian Archaeology* 70: 87–88.

FINLAYSON, C. et al. 2012. Birds of a feather: Neanderthal exploitation of raptors and corvids. *PLOS ONE*. 2012;7: e45927doi:10.1371/journal.pone.0045927. pmid:23029321

FLOOD, J. 1983. *Archaeology of the Dreamtime*, Collins: Sydney.

FLOOD, J. 1997. *Rock Art of the Dreamtime*. Angus & Robertson: Sydney.

FONTUGNE, M. et al. 2013. Cross-dating (Th/U-14C) of calcite covering prehistoric paintings at Serra da Capivara National Park, Piauí, Brazil. *Radiocarbon* 55(2–3): 1191–98.

FORTEA, J. 1981. Investigaciones en la cuenca media del Nalón, Asturias (España). Noticia y primeros resultados. *Zephyrus* 32/33: 5–16.

FORTEA, J. 1994. Abrigo de la Viña. Informe y primera valoración de las campañas 1991 a 1994, pp. 19–32 in *Excavaciones Arqueológicas en Asturias*. Principado de Asturias: Oviedo.

FORTEA PEREZ, J. 2002. Trente-neuf dates C14-SMA pour l'art paléolithique des Asturies. *Préhistoire, Arts et Sociétés, Bull. Soc. Préhist. Ariège-Pyrénées* LVII: 7–28).

FRANCFORT, H-P. & HAMAYON, R.N. (eds) 2001. *The Concept of Shamanism: Uses and Abuses*. (*Bibliotheca Shamanistica*, vol. 10). Akadémiai Kiadó: Budapest.

FRANKLIN, N. 1991. Explorations of the Panaramittee Style, pp. 120–35 in (P. Bahn & A. Rosenfeld, eds) *Rock Art and Prehistory*. Oxbow Books; Oxford.

FRIDRICH, J. 1976. Prispevek K problematice pocatku umeleckého citeni u paleanthropu. *Pamatky archeologické* 67: 5–27.

FRITZ, C. 1999. *La Gravure dans l'Art Mobilier Magdalénien. Du geste à la représentation.* Documents d'Archéologie française 75. Editions de la Maison des Sciences de l'Homme: Paris.

FROLOV, B.A. 1977/9. Numbers in Paleolithic graphic art and the initial stages in the development of mathematics. *Soviet Anth. and Arch.* 16, 1977/8: 142–66; and 17, 1978/9: 73–93, 41–74 & 61–113.

FROLOV, B.A. 1981. L'art paléolithique: Préhistoire de la science?, pp. 60–81 in *Arte Paleolítico*, Comisión XI, Xth Congress UISPP, Mexico City.

FULLAGAR, R., PRICE, D. & HEAD, L. 1996. Early human occupation of northern Australia; archaeology and thermoluminescence dating of Jinmium rock-shelter, Northern Territory. *Antiquity* 70: 751–73.

GÁBORI-CSÁNK, V. 1968. *La station du paléolithique moyen d'Érd – Hongrie.* Akadémia Kiadó: Budapest.

GAILLARD, C. 1993. *Contribution à la connaissance du Paléolithique inférieur et moyen en Inde.* Biological Anthropology, Muséum National d'Histoire Naturelle: Paris.

GAMBLE, C. 1982. Interaction and alliance in Palaeolithic society. *Man* 17: 92–107.

GAMBLE, C. 1986. *The Palaeolithic Settlement of Europe.* Cambridge University Press: Cambridge.

GARCIA-DÍEZ, M., OCHOA FRAILE, B. & BARANDIARÁN MAESTU, I. 2013. Neanderthal graphic behavior. The pecked pebble from Axlor rockshelter (northern Spain). *The Journal of Anthropological Research* 69(3): 397–410.

GAUTIER, A. 1986. Une histoire de dents: les soi-disant incisives travaillées du Paléolithique Moyen de Sclayn. *Helinium* 26: 177–81.

GENESTE, J.M. 1988. Système d'approvisionnement en matières premières au Paléolithique moyen et Paléolithique supérieur en Aquitaine, pp. 61–70 in (J. K. Kozlowski, ed.) *L'Homme de Néandertal, vol. 8. La Mutation.* ERAUL: Liège.

GILLAM, M.L. & WAKELEY, L.D. 2013. Are Utah's Sand Island 'mammoths' late Pleistocene? A geologic view, pp. 147–72 in (P. Whitehead, ed.) *IFRAO 2013 Proceedings, American Indian Rock Art*, vol. 40. American Rock Art Research Association.

de GIVENCHY, P. 1923. Pointes paléolithiques en crystal de roche limpide (quartz hyalin). *Bull. Soc. Préhist. Française* 20: 166–70.

GLORY, A. 1968. L'énigme de l'art quaternaire peut-elle être résolue par la théorie du culte des ongones?, pp. 25–60 in *Simposio de Arte Rupestre*, Barcelona 1966.

GOMBRICH, E. 1950. (revised ed. 1995). *The Story of Art.* Phaidon Press: Oxford.

GOMBRICH, E.H. 1969. *Art and Illusion.* Princeton University Press: Princeton.

GONZALEZ ECHEGARAY, J. 1988. Decorative patterns in the Mousterian of Cueva Morín, pp. 37–42 in (O. Bar-Yosef, ed.) *L'Homme de Néandertal, vol. 5. La Pensée.* ERAUL: Liège.

GOREN-INBAR, N. 1986. A figurine from the Acheulian site of Berekhat Ram. *Mi'tekufat Ha'even* 19: 7–12.

GOREN-INBAR, N., LEWY, Z. & KISLEV, M.E. 1991. Bead-like fossils from an acheulian occupation site, Israel. *Rock Art Research* 8(2): 133–36.

GOREN-INBAR, N. & PELTZ, S. 1995. Additional remarks on the Berekhat Ram figurine. *Rock Art Research* 12: 131–32.

GRANGER, J-M. & LEVEQUE, F. 1997. Parure castelperronienne et aurignacienne: étude de trois séries inédites de dents percées et comparaisons. *C. R. Acad. Sci. Paris* 325: 537–43.

GUFFROY, J. 1999. *El Arte Rupestre del Antiguo Perú.* Institut français d'Études Andines: Lima.

GUIDON, N. & DELIBRIAS, G. 1986. Carbon-14 dates point to man in the Americas 32,000 years ago. *Nature* 321: 769–71.

GUIDON, N., MARTIN, G. & PESSIS, A-M. 2012. Chronologie des peintures rupestres du Parc national Serra da Capivara, Brésil, pp. 711–17 in (J. Clottes, ed.) *L'art pléistocène dans le monde / Pleistocene art of the world / Arte pleistoceno en el mundo*, Actes du Congrès IFRAO, Tarascon-sur-Ariège, September 2010. Special issue, *Préhistoire, Art et Sociétés, Bull. Soc. Préhist. Ariège-Pyrénées*, LXV–LXVI, 2010–11, CD.

GUILLAUME, P. 1979. *La Psychologie de la Forme.* Flammarion: Paris.

GUNN, R.G., DOUGLAS, L.C. & WHEAR, R.L. 2011. What bird is that? Identifying a probable painting of *Genyornis newtoni* in Western Arnhem Land. *Australian Archaeology* 73, December: 1–12.

HABGOOD, P.J. & FRANKLIN, N.R. 2008. The revolution that didn't arrive: a review of Pleistocene Sahul. *Journal of Human Evolution* 55: 187–222.

HACHI, S. 2003. *Aux Origines des Arts Premiers en Afrique du Nord.* Mémoires du Centre National de Recherches Préhistoriques,

Anthropologiques et Historiques, Alger, Nlle série 6.

HAHN, J. et al. (eds) 1995. *Le Travail et l'Usage de l'Ivoire au Paléolithique Supérieur*. Istituto Poligrafico e Zecca della Stato, Libreria dello Stato: Rome.

HAMAYON, R.N. 1995. Pour en finir avec la 'transe' et 'l'extase' dans l'étude du chamanisme. *Études mongoles et sibériennes* 26: 155–90.

HAMAYON, R.N. 1997. La transe d'un préhistorien: à propos du livre de J. Clottes et D. Lewis-Williams. *Les Nouvelles de l'Archéologie* 67: 65–67.

HARRISON, R.A. 1978. A pierced reindeer phalanx from Banwell Bone Cave and some experimental work on phalangeal whistles. *Proc. Univ. Bristol Spel. Soc.* 15, 7–22, 1 pl.

HARUNARI, H. 2009. Studies of the Kamikuroiwa site in Ehime Prefecture, Japan. *Bull. National Museum of Japanese History* 154, September (English summary 551–57).

HAYDEN, B. 1993. The cultural capacities of Neandertals: a review and re-evaluation. *Journal of Human Evolution* 24: 113–46.

HELVENSTON, P. & BAHN, P G. 2005. *Waking the Trance Fixed*. Wasteland Press: Kentucky.

HENRI-MARTIN, G. 1957. *La Grotte de Fontéchevade*. Mémoire de l'Institut de Paléontologie Humaine 28. Paris.

HENSHILWOOD, C.S. & d'ERRICO, F. 2011. Middle Stone Age engravings and their significance to the debate on the emergence of symbolic material culture, pp. 75–96 in (C.S. Henshilwood & F. d'Errico, eds) *Homo symbolicus. The dawn of language, imagination and spirituality*. John Benjamins Publishing Company: Amsterdam & Philadelphia.

HENSHILWOOD, C.S., d'ERRICO, F. & WATTS, I. 2009. Engraved ochres from the Middle Stone Age levels at Blombos Cave, South Africa. *Journal of Human Evolution* 57(1): 27–47.

HENSHILWOOD, C.S. et al. 2002. Emergence of modern human behavior: Middle Stone Age engravings from South Africa. *Science* 295: 1278–80.

HENSHILWOOD, C.S. et al. 2004. Middle Stone Age shell beads from South Africa. *Science* 304: 404.

HENSHILWOOD, C.S. et al. 2011. A 100,000-year-old ochre-processing workshop at Blombos Cave, South Africa. *Science* 334: 219–22.

HODGSKISS, T. 2014. Cognitive requirements for ochre use in the Middle Stone Age at Sibudu, South Africa. *Cambridge Archaeological Journal* 24(3): 405–28.

HOVERS, E. 1990. Art in the Levantine Epi-Palaeolithic: an engraved pebble from a Kebaran site in the lower Jordan Valley. *Current Anthropology* 31: 317–22.

HOVERS, E. et al. 2003. An early case of color symbolism. Ochre use by modern humans in Qafzeh Cave. *Current Anthropology* 44(4): 491–522.

HOWELL, F.C. 1966. Observations on the earlier phases of the European Lower Palaeolithic. *American Anthropologist* 68(2): 88–201.

HUBLIN, J-J. et al. 1996. A late Neanderthal associated with Upper Palaeolithic artefacts. *Nature* 382: 224–26.

HUGUES, C., GAGNIÈRE, S. & RAPPAZ, O. 1960. *Le Moustérien de Sainte-Anastasie, Gard*. Festschr. Lothar Zotz: Bonn.

HUXLEY, J.S. 1942. Origins of human graphic art. *Nature* 3788, June: 637.

HUYGE, D. 1990. Mousterian skiffle? Note on a Middle Palaeolithic engraved bone from Schulen, Belgium. *Rock Art Research* 7: 125–32 (and 8: 63–64).

HUYGE, D. 2009. Late Palaeolithic and Epipalaeolithic rock art in Egypt: Qurta and El-Hosh. *Archéo-Nil* 19, janvier: 106–18.

HUYGE, D. & CLAES, W. 2008. 'Ice Age' art along the Nile. *Egyptian Archaeology* 33: 25–28.

HUYGE, D. et al. 2011. First evidence of Pleistocene rock art in North Africa: securing the age of the Qurta petroglyphs (Egypt) through OSL dating. *Antiquity* 85: 1184–93.

IBÁÑEZ, J.J. et al. 2015. Use and sonority of a 23,000-year-old bone aerophone from Davant Pau Cave (NE of the Iberian Peninsula). *Current Anthropology* 56(2): 282–89.

IMAZ, M. 1990. Estratigrafía de los moluscos marinos en los yacimientos prehistóricos vascos. *Munibe* 42: 269–74.

ISAAC, G. 1977. *Olorgesailie*. University of Chicago Press: Chicago.

ISNARDIS, A. & PROUS, A. 2012. Rock art studies in Brazil (2005–2009), pp. 338–48 in (P. Bahn, N. Franklin & M. Strecker, eds) *Rock Art Studies; News of the World IV*. Oxbow Books: Oxford.

ITURBE, G. et al. 1993. Cova Beneito (Muro, Alicante): una perspectiva interdisciplinare. *Recerques del Museo d'Alcoi* 2: 23–88.

JACOBSON, E., KUBAREV, V. & TSEEVENDORJ, D. 2001. *Répertoire des Pétroglyphes d'Asie Centrale. Fasc. 6, Mongolie du Nord-Ouest*. De Boccard: Paris.

JACOBSON-TEPFER, E. 2013. Late Pleistocene and early Holocene rock art from the Mongolian Altai: the material and its cultural implications. *Arts* 2: 151–81.

JACOBSON-WIDDING, A. 1979. *Red-White-Black as a mode of thought: a study of triadic*

classification by colours in the ritual symbolism and cognitive thought of the people of the Lower Congo. Uppsala Studies in Cultural Anthropology 1: Uppsala.

JELINEK, J. 1978. Encyclopédie Illustrée de l'Homme Préhistorique. Gründ: Paris.

JIA, L. 1978. La Caverne de l'Homme de Pékin. Editions en langues étrangères: Beijing.

JIA, L. 1980. Early Man in China. Foreign Languages Press: Beijing.

JOCHIM, M. 1983. Palaeolithic cave art in ecological perspective, pp. 212–19 in (G.N. Bailey, ed.) Hunter-Gatherer Economy in Prehistory. Cambridge University Press: Cambridge.

JOORDENS, J.C.A. et al. 2015. Homo erectus at Trinil on Java used shells for tool production and engraving. Nature 518: 228–31.

JOUILLE, H. 1963. Les sphéroïdes de la vallée de l'Aisne. Bull. Soc. Préhist. Française 60: 547–51.

JULIEN, M. & LAVALLÉE, D. 1987. Les chasseurs de la préhistoire, pp. 45–60 in Ancien Pérou: Vie, Pouvoir et Mort. Exhibition catalogue, Musée de l'Homme. Nathan: Paris.

KAMMINGA, J. & ALLEN, H. 1973. Alligator River environmental fact-finding study; Report of the archaeological survey. Government Printer: Darwin.

KEELEY, L.H. 1980. Experimental Determination of Stone Tool Uses: a Microwear Analysis. University of Chicago Press: Chicago.

KELANY, A. 2012. More Late Palaeolithic rock art at Wadi Abu Subeira, Upper Egypt. Bull. des Musées royaux d'art et d'histoire (Brussels) 83: 5–21.

KELANY, A. 2014. Late Palaeolithic rock art sites at Wadi Abu Subeira and el-'Aqaba el-Saghira, Upper Egypt. Cahiers de l'AARS 17: 105–15.

KELLOGG, R. 1955. What Children Scribble and Why. Author's Edition: San Francisco.

KELLOGG, R. 1967. The Psychology of Children's Art. Random House: New York.

KELLOGG, R. 1969. Analyzing Children's Art. National Press Books: Palo Alto, Ca.

KERVAZO, B., TURQ, A. & DIOT, M.F. 1989. Le site moustérien de plein air de la Plane, commune de Mazeyrolles, Dordogne. Note préliminaire. Bull. Soc. Préhist. Française 86: 268–74.

KLEE, P. 1985. Théorie de l'Art Moderne. Denoël: Paris.

KLEIN, K. 1978. Preliminary analysis of the mammalian fauna from the Redcliff Stone Age cave site, Rhodesia. Occasional Papers, National Museum of Southern Rhodesia A4(2): 74–80.

KLIMA, B. 1954. Palaeolithic huts at Dolní Vestonice, Czechoslovakia. Antiquity 28: 4–14.

KOZLOWSKI, J.K. 1992. L'Art de la Préhistoire en Europe Orientale. CNRS: Paris.

KRISHNA, R. & KUMAR, G. 2011. Physico-psychological approach for understanding the significance of Lower Palaeolithic cupules, pp. 156–57 & 907–18 in (J. Clottes, ed.) L'art pléistocène dans le monde / Pleistocene art of the world / Arte pleistoceno en el mundo, Actes du Congrès IFRAO, Tarascon-sur-Ariège, September 2010. Special issue, Préhistoire, Art et Sociétés, Bull. Soc. Préhist. Ariège-Pyrénées, LXV–LXVI, 2010–11, CD.

KUHN, S.L. et al. 2001. Ornaments of the earliest Upper Paleolithic: new insights from the Levant. Proceedings of the National Academy of Sciences of the USA, June, 98(13): 7641–46.

KUMAR, G. 1995. Daraki-Chattan: a palaeolithic cupule site in India. Purakala 6(1–2): 17–28.

KUMAR, G. 1996. Daraki-Chattan: a palaeolithic cupule site in India. Rock Art Research 13(1): 38–46.

KUMAR, G. 1998. Morajhari: a unique cupule site in Ajmer district, Rajasthan. Purakala 9(1–2): 61–64.

KUMAR, G. 2001. Early Indian petroglyphs: scientific investigations and dating by international commission, April 2001 to March 2004, Project: Making and progress. Purakala 11–12: 49–68.

KUMAR, G. 2002. Archaeological excavation and explorations at Daraki-Chattan – a preliminary report. Purakala 13(1–2): 5–20.

KUMAR, G. 2015. Rock Art of India. Sharad Publishing House: New Delhi.

KUMAR, G. & BEDNARIK, R.G. 2002. The quartz cupules of Ajmer, Rajasthan. Purakala 13(1–2): 45–50.

KUMAR, G. & BEDNARIK, R. 2012. The difficulties of determining the approximate antiquity of the Lower Palaeolithic petroglyphs in India, pp. 202–3 & 1157–66 in (J. Clottes, ed.) L'art pléistocène dans le monde / Pleistocene art of the world / Arte pleistoceno en el mundo, Actes du Congrès IFRAO, Tarascon-sur-Ariège, September 2010. Special issue, Préhistoire, Art et Sociétés, Bull. Soc. Préhist. Ariège-Pyrénées, LXV–LXVI, 2010–11, CD.

KUMAR, G., NARVARE, G. & PANCHOLI, R. 1988. Engraved ostrich eggshell objects: new evidence of Upper Palaeolithic art in India. Rock Art Research 5(1): 43–53.

LADIER, E., WELTÉ, A-C. & SABATIER, J. 2003. Griffades ou gravures? La grotte des Battuts (Penne, Tarn), pp. 145–52 in (M. Lorblanchet & J-M. Le Tensorer, eds) Colloque, "Griffades et Gravures". Préhistoire du Sud-Ouest 2003–2, no. 10.

LALANDE, P. 1869. Cristal de roche Chez Pourré-Chez Comte. Matériaux pour l'Histoire Primitive et Naturelle de l'Homme 5: 458.

LAMING, A. 1964. *Les Origines de l'Archéologie Préhistorique en France*. Picard: Paris.

LANGLEY, M.C. & O'CONNOR, S. 2016. An enduring shell artefact tradition from Timor-Leste: *Oliva* bead production from the Pleistocene to Late Holocene at Jerimalai, Lene Hara, and Matja Kuru 1 and 2. *PLOS ONE* 11(8): e0161071 http://dx.doi.org/10.1371/journal.pone.0161071

LANGLEY, M.C., O'CONNOR, S. & PIOTTO, E. 2016. 42,000-year old worked and pigment-stained *Nautilus* shell from Jerimalai (Timor-Leste): evidence for an early coastal adaptation in ISEA. *Journal of Human Evolution* 97.

LEAKEY, L.S.B. 1958. Recent discoveries at Oldowai Gorge, Tanganyika. *Nature* pp. 1099–103.

LEAKEY, M.D. 1971. *Olduvai Gorge, vol. 3. Excavations in Beds I and II, 1960–63*. Cambridge University Press: Cambridge.

LEAKEY, M. 1983. *Africa's Vanishing Art*. Doubleday: New York.

LEAVESLEY, M.G. 2007. A shark-tooth ornament from Pleistocene Sahul. *Antiquity* 81: 308–15.

LEMKE, A.K. et al. 2015. Early art in North America: Clovis and later Paleoindian incised artifacts from the Gault site, Texas (41BL323). *American Antiquity* 80(1): 113–33.

LEMOZI, A. 1961. Le Combel, continuation de la Grotte-Temple du Pech-Merle. *Bull. Soc. des Études du Lot*, pp. 90–99.

LENAIN, T. 1997. *Monkey Painting*. Reaktion Books: London.

LEONARDI, P. 1976. Les incisions pré-leptolithiques du Riparo Tagliente (Vérone) et de Terra Amata (Nice) en relation avec le problème de la naissance de l'art. *Atti della Accademia Nazionale dei Lincei*, Rome.

LEROI-GOURHAN, A. 1955. *Les Hommes de la Préhistoire*. Bourrelier: Paris.

LEROI-GOURHAN, A. 1961. Les fouilles d'Arcy-sur-Cure. *Gallia Préhistoire* 4: 3–16.

LEROI-GOURHAN, A. 1964. *Les Religions de la Préhistoire*. Presses Universitaires de France: Paris.

LEROI-GOURHAN, A. 1964–65. *Le Geste et la Parole*. 2 vols. Albin Michel: Paris.

LEROI-GOURHAN, A. 1965. *Préhistoire de l'Art Occidental*. Mazenod: Paris.

LEROY-PROST, C. 1984. L'art mobilier, in *Les Premiers Artistes, Dossier de l'Archéologie* 87: 45–51.

LE TENSORER, JM. 1997. *Les Premiers Hommes du Désert Syrien*. Exhibition Catalogue, Musée de l'Homme: Paris.

LE TENSORER, J.M. 1998. Les prémices de la créativité artistique chez *Homo erectus*, pp. 327–35 in *Mille Fiori, Festschrift für Ludwig Berger zu seinem 65*. Romermuseum: Augst.

LE TENSORER, J.M. et al. 2011. Étude préliminaire des industries archaïques de faciès Oldowayen du site de Hummal (El Kowm, Syrie centrale). *L'Anthropologie* 115(2): 247–66.

LE TENSORER, J-M. et al. 2015. The Oldowan site Aïn al Fil (El Kowm, Syria) and the first humans of the Syrian desert. *L'Anthroplogie* 119: 581–94.

LEWIS, D. 1988. *The Rock Paintings of Arnhem Land, Australia. Social, Ecological and Material Culture Change in the Post-glacial Period*. British Arch. Reports, Int. Series 415: Oxford.

LEWIS-WILLIAMS, J.D. 2002. *The Mind in the Cave*. Thames & Hudson: London and New York.

LEWIS-WILLIAMS, J.D. & DOWSON, T.A. 1988. The signs of all times: entoptic phenomena in Upper Palaeolithic art. *Current Anthropology* 29: 201–45.

LINARES MÁLAGA, E. 1988. Arte mobiliar con tradición rupestre en el Sur del Perú. *Rock Art Research* 5(1): 54–66.

LISTER, A. & BAHN, P.G. 2007. *Mammoths*. (3rd edition). University of California Press: Berkeley / Marshall Editions: London.

LJUBIN, L.V. 1988. La grotte d'Erevan, p. 361 in (A. Leroi-Gourhan, ed.) *Dictionnaire de la Préhistoire*. P.U.F.: Paris.

LORBLANCHET, M. 1967. *Géographie Préhistorique, Protohistorique et Gallo-romaine des Cévennes Méridionales et de leurs Abords*. Université de Montpellier; Unpublished Diplôme d'Études Supérieures.

LORBLANCHET, M. 1988. De l'art pariétal des chasseurs de rennes à l'art rupestre des chasseurs de kangourous. *L'Anthropologie* 92: 271–316.

LORBLANCHET, M. 1989. From man to animal and sign in Palaeolithic art, pp. 109–41 in (H. Morphy, ed.) *Animals into Art*. Unwin Hyman: London.

LORBLANCHET, M. 1992. Le triomphe du naturalisme dans l'art paléolithique, pp. 115–39 in (J. Clottes & T. Shay, eds) *The Limitations of Archaeological Knowledge*. ERAUL 49, Liège.

LORBLANCHET, M. 1995. *Les Grottes Ornées de la Préhistoire*. Errance: Paris.

LORBLANCHET, M. 1999. *La Naissance de l'Art; genèse de l'art préhistorique*. Éditions Errance: Paris.

LORBLANCHET, M. 2003. Des griffades aux tracés pariétaux, pp. 157–76 in (M. Lorblanchet & J-M. Le Tensorer, eds) Colloque, "Griffades et Gravures". *Préhistoire du Sud-Ouest* 2003–2, no. 10.

LORBLANCHET, M. 2007. A la recherche de l'art parietal aurignacien du Quercy, pp. 187–208 in (H. Floss & N. Rouquerol, eds) *Les Chemins de l'Art Aurignacien en*

Europe. Das Aurignacien und die Anfänge der Kunst in Europa. Colloque international – Internationale Fachtagung Aurignac 2005. Editions Musée – forum Aurignac Cahier 4.

LORBLANCHET, M. 2009. Les hommes blessés de l'art paléolithique, pp. 415–26 in *De La Méditerranée et d'ailleurs...Mélanges offerts à Jean Guilaine.* Archives d'Ecole Préhistorique: Toulouse.

LORBLANCHET, M. 2010. *Art Pariétal. Grottes Ornées du Quercy.* Rouergue: Rodez.

LORBLANCHET, M. 2014. Au sujet de l'article de J. Combier et G. Jouve et de la datation de la grotte Chauvet. *L'Anthropologie* 118(2): 152–58.

LORBLANCHET, M. 2015. Les commencements de l'art rupestre dans le monde, pp. 345–81 in (H. de Lumley, ed.) *Sur le Chemin de l'Humanité. Colloque International de l'Académie Pontificale des Sciences, 19–21 avril 2013.* CNRS: Paris.

LORBLANCHET, M. (in press) *Archaeology and Petroglyphs of Dampier.* Terra Australis: ANU (Canberra).

LORBLANCHET, M. & LE TENSORER, J-M. 2003. Le colloque 'Griffades et Gravures', pp. 121–24 in (M. Lorblanchet & J-M. Le Tensorer, eds) *Colloque, Griffades et Gravures. Préhistoire du Sud-Ouest* 2003-2, no. 10.

LORBLANCHET, M. et al. (eds) 2006. *Chamanismes et Arts Préhistoriques. Vision Critique.* Errance: Paris.

LORENZO, J.L. 1968. Sur les pièces d'art mobilier de la préhistoire mexicaine, pp. 283–89, 5 pl, in *La Préhistoire: Problèmes et Tendances.* CNRS: Paris.

LOY, T.H. et al. 1990. Accelerator radiocarbon dating of human blood protein pigments from Late Pleistocene art sites in Australia. *Antiquity* 64: 110–16.

de LUMLEY, H. 1966. Les Fouilles de Terra Amata à Nice. *Bull. Musée Anthropologique de Monaco* 13.

de LUMLEY, H. et al. (eds) 1969. *Une cabane acheuléenne dans la grotte du Lazaret (Nice).* Mémoire de la Société Préhistorique française 7.

LUQUET, G.H. 1926. *L'Art et la Religion des Hommes Fossiles.* Masson: Paris.

LUQUET, G-H. 1927 (2001). *Children's Drawings.* Free Association Books: London.

MACHÓN, A. 2013. *Children's Drawings. The Genesis and Nature of Graphic Representation. A Developmental Study.* Fibulas: Madrid.

MACKAY, A. & WELZ, A. 2008. Engraved ochre from a Middle Stone Age context at Klein Kliphuis in the Western Cape of South Africa. *Journal of Archaeological Science* 35: 1521–32.

MALOTKI, E. & WALLACE, H.D. 2011. Columbian mammoth petroglyphs from the San Juan River near Bluff, Utah, United States. *Rock Art Research* 28(2): 143–52 [& see also 29(2): 234–38)].

MANIA, D. 1990. *Auf den Spuren des Ur-Menschen. Die Funde von Bilzingsleben.* Deutscher Verlag der Wissenschaften: Berlin.

MANIA, D. 1991. Zur Vorstellungswelt des *Homo erectus* von Bilzingsleben, pp. 287–96 in (J. Hermann & H. Ullrich, eds) *Menschwerdung: Millionen Jahre Menschheitsentwicklung.* Berlin.

MANIA, D. & MANIA, U. 1988. Deliberate engravings on bone artefacts of *Homo erectus. Rock Art Research* 5: 91–107.

MAREAN, C. et al. 2007. Early human use of marine resources and pigment in South Africa during the Middle Pleistocene. *Nature* 449: 905–8.

MARQUET, J-C. 1976. Un niveau moustérien en place dans une formation alluviale de la Loire à Langeais (Indre-et-Loire). *Bull. Soc. Préhist. Française* 73, 1976: 270–72.

MARQUET, J-C. 1997. *Le Site Préhistorique de la Roche-Cotard (Indre-et-Loire).* Éditions CLD.

MARQUET, J-C. & LORBLANCHET, M. 2000. Le 'masque' moustérien de la Roche-Cotard, Langeais (Indre-et-Loire). *Paleo* 12: 325–38.

MARQUET, J-C. & LORBLANCHET, M. 2003. A Neanderthal face? The proto-figurine from La Roche-Cotard, Langeais (Indre-et-Loire, France). *Antiquity* 77: 661–70.

MARQUET, J-C. & LORBLANCHET, M. 2014. Les productions à caractère symbolique du site moustérien de La Roche-Cotard à Langeais (Indre-et-Loire) dans leur contexte géologique. *Paleo* 25: 169–94.

MARQUET, J-C. & LORBLANCHET, M. (in press). Nouvelle datation du 'masque' de La Roche-Cotard (Langeais, Indre-et-Loire). *Paleo.*

MARSHACK, A. 1977. The meander as a system: the analysis and recognition of iconographic units in Upper Paleolithic compositions, pp. 286–317 in (P. J. Ucko, ed.) *Form in Indigenous Art.* Duckworth: London.

MARSHACK, A. 1981. On paleolithic ochre and the early uses of color and symbol. *Current Anthropology* 22(2): 188–91.

MARSHACK, A. 1988a. The Neanderthals and the human capacity for symbolic thought: cognitive and problem-solving aspects of Mousterian symbol, pp. 57–91 in (O. Bar-Yosef, ed.) *L'Homme de Néandertal, vol. 5, La Pensée.* ERAUL: Liège.

MARSHACK, A. 1988b. La pensée symbolique et l'art, in *L'Homme de Néandertal, Dossiers de l'Archéologie* 124: 80–90.

MARSHACK, A. 1990. Early hominid symbol and evolution of the human capacity, pp. 457–98 in (P. Mellars, ed.) *The Emergence of Modern Humans.* Edinburgh Univ. Press.

MARSHACK, A. 1991. A reply to Davidson on Mania and Mania. *Rock Art Research* 8: 47–58.

MARSHACK, A. 1996. A Middle Palaeolithic symbolic composition from the Golan Heights: the earliest known depictive image. *Current Anthropology* 37(2): 357–65.

MARSHACK, A. 1997. The Berekhat Ram figurine: a late Acheulian carving from the Middle East. *Antiquity* 71: 327–37.

MARTIN, H. 1910. Fragment d'omoplate de bovidé avec traits gravés intentionnels, trouvés dans le Moustérien supérieur de la Quina (Charente). *Bull. Soc. Préhist. Française* 7: 40–42.

MARTIN, H. 1926. Commentaire sur la communication de Coutier et Emmetaz sur les Rochettes. *Bull. et Mémoires de la Société d'Anthropologie de Paris*, pp. 147–48.

MASSON, A. 1986. Les ocres et la pétroarchéologie: l'aspect taphonomique. *Revue d'Archéométrie* 10: 87–93.

McGOWAN, A., SHREEVE, B., BROLSMA, H. & HUGHES, C. 1993. Photogrammetric recording of Pleistocene cave paintings in Southwest Tasmania, pp. 225–32 in (M.A. Smith, M. Spriggs & B. Fankhauser, eds) *Sahul in Review*. Occasional papers in prehistory 24, ANU: Canberra.

MELARD, N. 2008. Pierres gravées de La Marche à Lussac-les-Châteaux (Vienne). Techniques, technologie et interprétations. *Gallia Préhistoire* 50: 143–268.

MENESES LAGE, M.C.S. 1999. Dating of the prehistoric paintings of the archaeological area of the Serra da Capivara National Park, pp. 49–52 in (M. Strecker & P. Bahn, eds) *Dating and the Earliest Known Rock Art*. Oxbow Books: Oxford.

MESSMACHER, M. 1981. El arte paleolítico en México, pp. 82–110 in *Arte Paleolítico*, Comisión XI, Xth Congress, UISPP, Mexico City.

MESZAROS, G. & VERTES, L. 1955. A paint mine from the early Upper Palaeolithic age near Lovas (Hungary, County Veszprém). *Acta Arch. Hungarica* 5: 1–34.

MISRA, V.N. 1985. The Acheulian succession at Bhimbetka, Central India, pp. 35–47 in *Recent Advances in Indo-Pacific Prehistory*, International symposium Poona 1978, New Delhi.

MISRA, V.N., MATHPAL, Y. & NAGAR, M. 1977. *Bhimbetka Prehistoric man and his Art in Central India*. Pune Deccan College.

de MORGAN, J. 1927. *La Préhistoire Orientale. Tome III, L'Asie Antérieure*. P. Geuthner: Paris.

MORI, F. 1974. The earliest Saharan rock-engravings. *Antiquity* 48: 87–92.

MORLEY, I. 2006. Mousterian musicianship? The case of the Divje Babe I bone. *Oxford Journal of Archaeology* 25(4): 317–33.

MORLEY, I. 2013. *The Prehistory of Music. Human Evolution, Archaeology, and the Origins of Musicality*. Oxford University Press: Oxford.

MORRIS, D. 1962. *The Biology of Art. A Study of the Picture-making Behaviour of the Great Apes and its Relationship to Human Art*. Methuen: London.

MORRIS, D. 2013. *The Artistic Ape. Three Million Years of Art*. Red Lemon Press: London.

de MORTILLET, G. 1885. *Le Préhistorique*. Reinwald: Paris.

MOSER, J. 2003. *La Grotte d'Ifri n'Ammar. Tome 1: L'Ibéromaurusien*. Forschungen zur Allgemeinen und Vergleichenden Archäologie 8. Linden Soft: Cologne.

MOURE ROMANILLO, J.A. 1985. Nouveautés dans l'art mobilier figuratif du Paléolithique cantabrique. *Bull. Soc. Préhist. Ariège* 40: 99–129.

MULVANEY, K. 2011. About time: toward a sequencing of the Dampier Archipelago petroglyphs of the Pilbara region, Western Australia, pp. 30–49 in (C. Bird & R.E. Webb, eds) '*Fire and Hearth*' forty years on. Essays in Honour of Sylvia J. Hallam. Records of the Western Australian Museum, Suppl. 79. Perth.

MULVANEY, K. 2013. Iconic imagery: Pleistocene rock art development across northern Australia. *Quaternary International* 285: 99–110.

MURRAY, P. & CHALOUPKA, G. 1983/4. The Dreamtime animals: extinct megafauna in Arnhem Land rock art. *Archaeology in Oceania* 18/19: 105–16.

MUZZOLINI, A. 1986. *L'Art Rupestre Préhistorique des Massifs Centraux Sahariens*. British Arch. Reports, Int. Series 318, Oxford.

NEUSTUPNY, J. 1948. Le Paléolithique et son art en Bohême. *Artibus Asiae Ascona*: 214–30.

NEVES, W.A. et al. 2012. Rock art at the Pleistocene/Holocene boundary in Eastern South America. *PLOS ONE* 7(2): e32228. doi:10.1371/journal.pone.0032228

NOBBS, M. & DORN, R. I. 1988. Age determination for rock varnish formation within petroglyphs. *Rock Art Research* 5(2): 108–46.

NOBBS, M. & DORN, R. 1993. New surface exposure ages for petroglyphs from the Olary province, South Australia. *Archaeology in Oceania* 28: 18–39.

NOMADE, S. et al. 2016. A 36,000-year-old volcanic eruption depicted in the Chauvet-Pont d'Arc Cave (Ardèche, France)? *PLOS ONE* | DOI:10.1371/journal.pone.0146621

NORTON, C.J., GAO, X. & FENG, X. 2009. The East Asian Middle Paleolithic reexamined, pp. 245–54 in (M. Camps & P.R. Chauhan,

eds) *Sourcebook of Paleolithic Transitions – Methods, theories, and interpretations.* Springer: New York & London.

NOWELL, A. & d'ERRICO, F. 2007. The art of taphonomy and the taphonomy of art: layer IV, Molodova I, Ukraine. *Journal of Archaeological Method and Theory* 14(1): 1–26.

OAKLEY, K.P. 1971. Fossils collected by the earlier Palaeolithic men, pp. 581–84 in *Mélanges de Préhistoire d'archéocivilisation et d'ethnologie offerts à André Varagnac.* Seupen: Paris.

OAKLEY, K.P. 1981. Emergence of higher thought, 3.0 – 0.2 Ma. B.P. *Philosophical Transactions of the Royal Society of London* B292: 205–11.

O'CONNOR, S. 1995. Carpenter's Gap Rockshelter 1: 40,000 years of Aboriginal occupation in the Napier Ranges, Kimberley, WA. *Australian Archaeology* 40: 58–59.

O'CONNOR, S. & FANKHAUSER, B. 2001. Art at 40,000 BP? One step closer: an ochre covered rock from Carpenter's Gap Shelter I, Kimberley region, Western Australia, pp. 287–300 in (A. Anderson et al. eds) *Histories of Old Ages. Essays in Honour of Rhys Jones.* Pandanus Books, ANU: Canberra.

O'CONNOR, S. et al. 2010. Faces of the ancestors revealed: discovery and dating of a Pleistocene-age petroglyph in Lene Hara Cave, East Timor. *Antiquity* 84: 649–65.

ONORATINI, G. 1985. Diversité minérale et origine des matériaux colorants utilizes dès le Paléolithique supérieur en Provence. *Bull. Musée d'Histoire Naturelle de Marseille* 45.

OTTE, M. 1974. Observations sur le débitage et le façonnage de l'ivoire dans l'Aurignacien en Belgique, pp. 93–96 in (H. Camps-Fabrer, ed.) *Premier Colloque Int. sur l'Industrie de l'Os dans la Préhistoire.* Univ. de Provence.

OTTE, M. 1995. Traditions bifaces, pp. 195–200 in *Paleo Supplément 1, Actes du Colloque de Miskolc.*

OTTE, M. 1996. Aspects spirituels, pp. 269–75 in (D. Bonjean, ed.) *Néandertal.* ASBL Archéologie Andennaise: Andenne.

OTTE, M., CORDY, J-M. & MAGNON, D. 1985. Dents incises du paléolithique moyen. *Cahiers de Préhistoire Liégeoise* I: 80–84.

OTTE, M. et al. 1995. The Epi-Palaeolithic of Öküzini Cave (SW Anatolia) and its mobiliary art. *Antiquity* 69: 931–44.

PALES, L. 1969. *Les Gravures de La Marche: I, Félins et Ours.* Mémoire 7, Publications de l'Inst. de Préhistoire de Bordeaux. Delmas: Bordeaux.

PARKINGTON, J. et al. 2005. From tool to symbol: the behavioural context of intentionally marked ostrich eggshell from Diepkloof, Western Cape, pp. 475–92 in (F. d'Errico & L. Backwell, eds) *From Tools to Symbol. From Early Hominids to Modern Humans.* Witwatersrand University Press: Johannesburg.

PAUNESCU, A. 1989. Structures d'habitat moustériennes mises au jour dans l'établissement de Ripiceni-Izvor (Roumanie) et quelques considerations concernant le type d'habitat paléolithique moyen de l'Est des Carpates, pp. 127–43 in (L. Freeman & M. Patou, eds) *L'Homme de Néandertal, vol. 6, La subsistence.* ERAUL: Liège.

PEI, W.C. 1931. Notice of discovery of quartz and other stone artifacts in the lower Pleistocene hominid-bearing sediment of Choukoutien cave deposit. *Bull. Geol. Society of China*: 109–46.

PEI, W.C. 1933. *Le Rôle des Animaux et des Causes Naturelles dans la Cassure des Os.* Palaeontologica Sinica, Geological Survey of China: Beijing.

PELCIN, A. 1994. A geological explanation for the Berekhat Ram figurine. *Current Anthropology* 35: 674–75.

PERESANI, M. et al. 2013. An ochered fossil marine shell from the Mousterian of Fumane Cave, Italy. *PLOS ONE* 10.1371/journal. pone.0068572

PETTITT, P. & BAHN, P.G. 2003. Current problems in dating Palaeolithic cave art: Candamo and Chauvet. *Antiquity* 77: 134–41.

PETTITT, P. & BAHN, P. 2014. Against Chauvet-nism. A critique of recent attempts to validate an early chronology for the art of Chauvet Cave. *L'Anthropologie* 118(2): 163–82.

PETTITT, P. & BAHN, P. 2015. An alternative chronology for the art of Chauvet cave. *Antiquity* 89: 542–53.

PETTITT, P., BAHN, P. & ZUCHNER, C. 2009. The Chauvet conundrum: are claims for the 'birthplace of art' premature?, pp. 239–62 in (P.G. Bahn, ed.) *An Enquiring Mind. Studies in Honour of Alexander Marshack.* American School of Prehistoric Research Monograph series. Oxbow Books: Oxford.

PETTITT, P. et al. 2015. Are hand stencils in European cave art older than we think? An evaluation of the existing data and their potential implications, pp. 31–43 in (P. Bueno-Ramírez & P.G. Bahn, eds) *Prehistoric Art as Prehistoric Culture. Studies in Honour of Professor Rodrigo de Balbín-Behrmann.* Archaeopress: Oxford.

PEYRONY, D. 1921. Une pierre colorée d'époque moustérienne. *Association Française pour l'Avancement des Sciences 44e session, Strasbourg*, pp. 494–95.

PEYRONY, D. 1930. *Le Moustier, ses gisements, ses industries, ses couches géologiques.* Nourry: Paris.

PEYRONY, D. 1934. La Ferrassie. *Préhistoire* 3: 1–92.

PEYRONY, D. 1948. *Eléments de Préhistoire.* Costes: Paris.

PFEIFFER, J. 1982. *The Creative Explosion. An Inquiry into the Origins of Art and Religion.* Harper & Row: New York.

PIKE, A.W.G. et al. 2012. U-Series dating of paleolithic art in 11 caves in Spain. *Science* 336: 1409–13.

PIKE, A.W.G. et al. 2016. Dating Paleolithic cave art: Why U-Th is the way to go. *Quaternary International,* 9pp.

PODESTÁ, M.M. & ASCHERO, C.A. 2012. Evidencias tempranas del arte rupestre de los cazadores-recolectores de la Puna (NO de la Argentina), pp. 773–91 in (J. Clottes, ed.) *L'art pléistocène dans le monde / Pleistocene art of the world / Arte pleistoceno en el mundo,* Actes du Congrès IFRAO, Tarascon-sur-Ariège, September 2010. Special issue, *Préhistoire, Art et Sociétés, Bull. Soc. Préhist. Ariège-Pyrénées,* LXV–LXVI, 2010–11, CD.

POND, A.W. 1925. The oldest jewelry in the world. *Art and Archaeology* 19: 131–34, 1 pl.

POPLIN, F. 1983. Incisives de renne sciées du Magdalénien d'Europe occidentale, pp. 55–67 in *La Faune et l'Homme Préhistoriques,* Mém. 16, Soc. Préhist. française.

POPLIN, F. 1988. Aux origines néandertaliennes de l'art. Matière, forme, symmetries. Contribution d'une galène et d'un oursin fossile taillé de Merry-sur-Yonne (France), pp. 109–16 in (O. Bar-Yosef, ed.) *L'Homme de Néandertal, vol. 5, La Pensée.* ERAUL: Liège.

PRADEL, L. 1950. Les gisements moustériens de Fontmaure, commune de Vallèches (Vienne). *Congrès Préhistorique de France,* Paris, pp. 349–62.

PROUS, A. 1994. L'art rupestre du Brésil. *Bull. Soc. Préhist. Ariège-Pyrénées* 49: 77–144.

PUECH, P.F. 1976. Recherche sur le mode d'alimentation des hommes du Paléolithique par l'étude microscopique des couronnes dentaires, pp. 708–09 in *La Préhistoire Française,* vol. 1. CNRS: Paris.

PURDY, B.A. 1996a. *Indian Art of Ancient Florida.* University Press of Florida: Gainesville.

PURDY, B.A. 1996b. *How to do Archaeology the right way.* University Press of Florida: Gainesville.

PURDY, B.A. 2012. The mammoth engraving from Vero Beach, Florida: ancient or recent? *The Florida Anthropologist* 65(4): 205–17.

PURDY, B.A. et al. 2011. Earliest art in the Americas: incised image of a proboscidean on a mineralized extinct animal bone from Vero Beach, Florida. *Journal of Archaeological Science* 38: 2908–13.

QUILES, A. et al. 2016. A high-precision chronological model for the decorated Upper Paleolithic cave of Chauvet-Pont d'Arc, Ardèche. France. *Proc. Nat. Acad. Sc.* 113(17): 4670–75.

RABINOVICH, R. 1990. Taphonomic research on the faunal assemblage from the Quneitra site, pp. 189–219 in *Quneitra: a Mousterian site on the Golan Heights.* Qedem, Monograph of the Institute of Archaeology: Jerusalem.

RADMILLI, A.M. 1984. Malagrotta, Lazio, pp. 173–76 in *I Primi Abitanti d'Europa.* Catalogo della mostra. Ed. De Luca: Rome.

RADOVCIC, D. et al. 2015. Evidence for Neandertal jewelry: modified white-tailed eagle claws at Krapina. *PLOS ONE* 10(3): e0119802. doi:10.1371/journal.pone.0119802

RAYMOND, P. 1904. Commentaires à la communication de M. Ballet sur la découverte de silex taillés pliocènes à Saint-Hilaire-en Lignères (Cher). *Bull. Soc. Préhist. Française* 1: 23–24.

RAYNAL, J.P. & SEGUI, R. 1986. Os incisé acheuléen de Sainte Anne 1 (Polignac, Haute-Loire). *Revue Archéologique du Centre de la France* 25(1). Notes et documents: 79–80.

RENSCH, B. 1984. *Psychologische Grundlagen der Wertung bildender Kunst.* Die Blaue Eule: Essen.

RIBEIRO, L. & PROUS, A. 2008. Rock art research in Brazil, 2000–2004: a critical evaluation, pp. 294–308 in (P. Bahn, N. Franklin & M. Strecker, eds) *Rock Art Studies; News of the World III.* Oxbow Books: Oxford.

RIGAUD, S. et al. 2008. Critical reassessment of putative Acheulean *Porosphaera globularis* beads. *Journal of Archaeological Science* 36(1): 25–34.

ROBERTS, R.G., JONES, R. & SMITH, M.A. 1994. Beyond the radiocarbon barrier in Australian prehistory. *Antiquity* 68: 611–16.

ROBERTS, R. et al. 1997. Luminescence dating of rock art and past environments using mud wasp nests in northern Australia. *Nature* 387: 696–99.

ROBERTS, R. et al. 1998. Optical and radiocarbon dating at Jinmium rock-shelter in Northern Australia. *Nature* 393: 358–62.

ROCHE, H. & TEXIER, P.J. 1991. La notion de complexité dans un ensemble acheuléen, Isernia-Kenya, pp. 99–108 in *25 Ans d'Études Technologiques en Préhistoire. XIe rencontres internationals d'Archéologie et d'Histoire d'Antibes.* APDCA: Juans les Pins.

RODRÍGUEZ-VIDAL, J. et al. 2014. A rock engraving made by Neanderthals in Gibraltar. *Proc. Nat. Acad. Sciences* 111: 13301–306.

ROE, D. 1981. *The Lower and Middle Palaeolithic Periods in Britain.* Routledge & Kegan Paul: London.

ROEBROEKS, W. et al. 2012. Use of red ochre by early Neandertals. *Proceedings of the*

National Academy of Sciences of the USA 109(6): 1889–94.

ROOSEVELT, A.C. 1999. Dating the rock art at Monte Alegre, Brazil, pp. 35–40 in (M. Strecker & P. Bahn, eds) *Dating and the Earliest Known Rock Art.* Oxbow Books: Oxford.

ROOSEVELT, A.C. et al. 1996. Paleoindian cave dwellers in the Amazon: the peopling of the Americas. *Science* 272: 373–84.

ROSENFELD, A. 1993. A review of the evidence for the emergence of rock art in Australia, pp. 71–80 in (M.A. Smith, M. Spriggs & B. Fankhauser, eds) *Sahul in Review. Occasional Papers in Prehistory* 24, ANU: Canberra.

ROSENFELD, A., HORTON, D. & WINTER, J. 1981. Early Man in North Queensland. *Terra Australis* 6, ANU: Canberra.

ROSENFELD, A. & SMITH, M.A. 2002. Rock-art and the history of Puritjarra rock shelter, Cleland Hills, Central Australia. *Proceedings of the Prehistoric Society* 68: 103–24.

ROSSO, D.E. et al. 2016. Middle Stone Age ochre processing and behavioural complexity in the Horn of Africa: evidence from, Porc-Epic Cave, Dire Dawa, Ethiopia. *PLOS ONE* 11(11): e0164793. doi:10.1371/journal.pone.0164793

ROUSSOT, A. 1970. Flûtes et sifflets paléolithiques en Gironde. *Rev. Historique de Bordeaux et du Dept. de la Gironde,* 5–12.

ROWE, M.W. 2012. Dating of rock paintings in the Americas: a word of caution, pp. 573–84 in (J. Clottes, ed.) *L'art pléistocène dans le monde / Pleistocene art of the world / Arte pleistoceno en el mundo,* Actes du Congrès IFRAO, Tarascon-sur-Ariège, September 2010. Special issue, *Préhistoire, Art et Sociétés, Bull. Soc. Préhist. Ariège-Pyrénées,* LXV–LXVI, 2010–11, CD.

ROWE, M.W. & STEELMAN, K.L. 2003. Comment on 'some evidence of a date of first humans to arrive in Brazil'. *Journal of Archaeological Science* 30: 1349–51.

ROZOY, J.G. 1985. Peut-on identifier les animaux de Roc-la-Tour I? *Anthropozoologica* 2: 5–7.

ROZOY, J.G. 1988. Le Magdalénien Supérieur du Roc-La-Tour I. *Helinium* 28: 157–91.

ROZOY, J.G. 1990. Les plaquettes gravées magdaléniennes de Roc-La-Tour I, pp. 261–77 in (J. Clottes, ed.) *L'Art des Objets au Paléolithique,* vol. 1.

RUHLEN, M. 1994. *The Origin of Language. Tracing the Evolution of the Mother Tongue.* Wiley: New York.

RUSSELL, P.M. 1989a. Plaques as palaeolithic slates: an experiment to reproduce them. *Rock Art Research* 6: 68–69 & 40–41.

RUSSELL, P.M. 1989b. Who and why in

Palaeolithic art. *Oxford Journal of Archaeology* 8: 237–49.

SACCHI, D. 2003. Bref aperçu historique sur l'identification des griffades animales et l'interprétation de leur présence au sein des décors pariétaux, pp. 177–80 in (M. Lorblanchet & J-M. Le Tensorer, eds) Colloque, "Griffades et Gravures". *Préhistoire du Sud-Ouest* 2003-2, no. 10.

SAHNOUNI, M., SCHICK, K. & TOTH, N. 1997. An experimental investigation into the nature of faceted limestone 'spheroids' in the Early Palaeolithic. *Journal of Archaeological Science* 24: 701–13.

de SAINT-PÉRIER, R. 1930. *La Grotte d'Isturitz. Le Magdalénien de la Salle de Saint-Martin.* Archives de l'Institut de Paléontologie Humaine 7. Masson: Paris.

de SAINT-PÉRIER, R. & de SAINT-PÉRIER, S. 1952. La Grotte d'Isturitz III: Les Solutréens, les Aurignaciens et les Moustériens. *Archives de l'Institut de Paléontologie Humaine* 25. Masson: Paris.

SAN-JUAN, C. 1985. *Colorants del Paleolítico en Cantabria.* Memoria de Licenciatura, Universidad de Santander: Santander.

SAN-JUAN, C. 1990a. Colorants et art mobilier, pp. 223–26 in *L'Art des Objets au Paléolithique; Actes du Colloque de Foix-le Mas d'Azil, Nov. 1987.* Ministère de la Culture: Paris.

SAN-JUAN, C. 1990b. Les matières colorants dans les collections du Musée National de Préhistoire des Eyzies. *Paléo* 2: 229–42.

SANKALIA, H.D. 1978. *Prehistoric Art in India.* Vikas: New Delhi.

SAUVET, G. 2004. L'art mobilier non classique de la grotte magdalénienne de Bédeilhac (Ariège), pp. 167–76 in (M. Lejeune & A-C. Welté, eds) *L'Art Pariétal dans son contexte naturel.* Actes du colloque UISPP, Liège 2001. ERAUL 107: Liège.

SAXON, E.C. 1976. Pre-Neolithic pottery: new evidence from North Africa. *Proceedings of the Prehistoric Society* 42: 327–29.

SCHAAFSMA, P. 2013. Lines of confusion: the Bluff "mammoths", pp. 173–88 in (P. Whitehead, ed.) *IFRAO 2013 Proceedings, American Indian Rock Art,* vol. 40. American Rock Art Research Association.

SCHÄFER, J. 1996. Un gisement préhistorique de la fin du Pléistocène moyen: Schweinskopf-Karmelenberg en Rhénanie moyenne, pp. 42–47 in *La Vie Préhistorique.* Société Préhistorique française. Faton: Dijon.

SCHILLER, P.H. 1951. Figural preferences in the drawings of a chimpanzee. *Journal of Comparative Psychology* 44: 101–11.

SCHMIDT, K. 2006. *Sie Bauten die Ersten Tempel. Das rätselhafte Heiligtum der Steinzeitjäger.* Verlag C.H. Beck: Munich.

SCHMIDT, R.R. 1936. *The Dawn of the Human Mind: A Study of Palaeolithic Man*. Sidgwick & Jackson: London.

SCHOBINGER, J. 1997. *Arte Prehistórico de América*. Jaca Book: Milan.

SÉMAH, F. 2001. La position stratigraphique du site de Ngebung 2 (Dôme de Sangiran, Java Central, Indonésie), pp. 299–330 in (F. Sémah, C. Falguères, D. Grimaud-Hervé & A-M. Sémah, eds) *Origine des Peuplements et Chronologie des Cultures Paléolithiques dans le Sud-Est Asiatique*. Semenanjung-Artcom: Paris.

SEMENOV, S.A. 1964. *Prehistoric Technology*. Adams & Dart: Bath.

SHANKAR, T. 1984. Excavation at Bhimbetka; a re-assessment, pp. 149–53 in (K.K. Chakravarti, ed.) *Rock Art of India*. New Delhi.

SHIPMAN, P. & ROSE, J.J. 1983. Evidence of butchery and hominid activities at Torralba and Ambrona; an evaluation using microscopic techniques. *Journal of Archaeological Science* 10(5): 465–74.

SIMANJUNTAK, T., SÉMAH, F. & GAILLARD, C. 2010. The Palaeolithic in Indonesia: nature and chronology. *Quaternary International* 223–24: 418–40.

SINGER, R. & WYMER, J. 1982. *The Middle Stone Age at Klasies River Mouth in South Africa*. Chicago University Press: Chicago.

SOFFER, O. 1985. Patterns of intensification as seen from the Upper Paleolithic of the Central Russian Plain, pp. 235–70 in (T.D. Price & J.A. Brown, eds) *Prehistoric Hunter-Gatherers: The Emergence of Cultural Complexity*. Academic Press: New York/London.

SOLECKI, R. 1975. The Middle Palaeolithic site of Nahr Ibrahim (Asfurieh cave) in Lebanon, pp. 283–95 in (F. Wendorf & A.E. Marks, eds) *Problems in Prehistory: North Africa and the Levant*. Southern Methodist University Press: Dallas.

SORESSI, M. & d'ERRICO, F. 2007. Pigments, gravures, parures: les comportements symboliques controversés des Néandertaliens, pp. 297–309 in (B. Vandermeersch & B. Maureille, eds) *Les Néandertaliens. Biologie et Cultures*. Documents préhistoriques 23. Editions du Comité des Travaux Historiques et Scientifiques: Paris.

SOUTOU, A. 1963. Le sanctuaire de roches à bassins de Las Cogotas (Cardeñosa, Avila) et les sites analogues du Haut Languedoc. *OGAM* (avril-juin) pp.191–206.

SPOONER, N.A. 1998. Human occupation at Jinmium, northern Australia: 116,000 years ago or much less? *Antiquity* 72 (275): 173–78.

STEELMAN, K. et al. 2001. Accelerator Mass Spectrometry radiocarbon ages of an oxalate accretion and rock paintings at Toca do Serrote da Bastiana, Brazil, pp. 22–25 in (K. Jakes, ed.) *Archaeological Chemistry VI*. American Chemical Society: Washington.

STEPANCHUK, V.N. 1993. Prolom II, a Middle Palaeolithic cave site in the eastern Crimea with non-utilitarian bone artefacts. *Proceedings of the Prehistoric Society* 59: 17–37.

STOREMYR, P. et al. 2008. More 'Lascaux along the Nile'? Possible late Palaeolithic rock art in Wadi Abu Subeira, Upper Egypt. *Sahara* 19: 155–58.

STRAUS, L.G. 1992. *Iberia Before the Iberians*. University of New Mexico Press: Albuquerque.

TABORIN, Y. 1982. La parure des morts, in *La Mort dans la Préhistoire, Dossier de l'Arch.* 66: 42–51.

TABORIN, Y. 1985. Les origines des coquillages paléolithiques en France, pp. 278–301 in (M. Otte, ed.) *La Signification culturelle des Industries Lithiques*. British Arch. Reports, Int. Series 239, Oxford.

TABORIN, Y. 1990. Les prémices de la parure, pp. 224–335 in (C. Farizy, ed.) *Paléolithique Moyen Récent et Paléolithique Supérieur Ancien en Europe*. Musée de Préhistoire d'Ile-de-France: Nemours.

TABORIN, Y. 1993. *La Parure en Coquillage au Paléolithique*. 29e Suppl. à Gallia Préhistoire. CNRS: Paris.

TABORIN, Y. 2004. *Langage sans Parole: La parure aux temps préhistoriques*. La Maison des Roches: Paris.

TCHERNYCH, A.P. 1965. Ranny I sredniy paleolit Pridniestroya, in *Trudy Kom. Izutch. Tchetvert perioda* 25, 137pp.

TEXIER, P.J. 1996. L'Acheuléen d'Isenya (Kenya), pp. 58–63 in *La Vie Préhistorique*. Société Préhistorique française. Faton: Dijon.

TEXIER, P.J. & ROCHE, H. 1995. Polyèdre, sub-sphéroïde, sphéroïde, et bola: des segments plus ou moins longs d'une même chaîne opératoire. *Cahier Noir* 7: 31–40.

TEXIER, P.J. et al. 2010. A Howiesons Poort tradition of engraving ostrich eggshell containers dated to 60,000 years ago at Diepkloof rock shelter, South Africa. *Proceedings of the National Academy of Sciences of the USA* 107(14): 6180–85.

THOMAS, G.V. & SILK, A.M.J. 1990. *An Introduction to the Psychology of Children's Drawings*. Harvester Wheatsheaf: Hemel Hempstead.

TINDALE, N. 1974. *Aboriginal Tribes of Australia*. ANU Press: Canberra.

TIXIER, J. 1958–59. Les industries lithiques d'Aïn Fritissa (Maroc oriental). *Bull. d'Archéologie Marocaine* 3: 107–244.

Bibliography

TIXIER, J., INIZAN, M.L. & ROCHE, H. 1980. *Préhistoire de la Pierre Taillée.* Cercle de Recherches et d'Études Préhistoriques: Valbonne.

TIXIER, J. & de SAINT-BLANQUAT, H. 1992. *Le Biface silex-taillé.* Casterman: Paris.

TOSELLO, G. 2003a. *Pierres Gravées du Périgord Magdalénien. Art, symboles, territoires.* XXXVIe Supplément à Gallia Préhistoire. CNRS: Paris.

TOSELLO, G. 2003b. Les schistes gravés du site magdalénien du Rocher de la Caille, pp. 183–222 in (H. Deloge & L. Deloge, eds) *Le Rocher de la Caille. Un site magdalénien de plein air au Saut-du-Perron.* Mémoires de la Société Préhistorique française 31.

TRATEBAS, A. 1999. The earliest petroglyph traditions on the North American plains, pp. 15–27 in (M. Strecker & P. Bahn, eds) *Dating and the Earliest Known Rock Art.* Oxbow Books: Oxford.

TURK, I. (ed.) 1997. *Mousterian 'Bone Flute' and other finds from Divje Babe I Cave site in Slovenia.* Opera Instituti archeologici Sloveniae 2. Znanstvenoraziskovalni center SAZU: Ljubljana.

UCKO, P.J. 1987. Débuts illusoires dans l'étude de la tradition artistique. *Bull. Soc. Préhist. Ariège-Pyrénées* 42: 15–81.

VALOCH, K. 1976. *Die altsteinzeitliche Fundstelle in Brno-Bohunice.* Studie archeologic Kého ustav CSAV Brno, 4–1.

VALOCH, K. 1996. *Le Paléolithique en Tchéquie et en Slovaquie.* Éditions Millon: Grenoble.

VANDERMEERSCH, B. 1969. Découverte d'un objet en ocre avec traces d'utilisation dans le Moustérien de Qafzeh (Israel). *Bull. Soc. Préhist. Française* 66(5): 157–58.

VANDERMEERSCH, B. 1981. *Les Hommes Fossiles de Qafzeh (Israel).* CNRS: Paris.

VANDERWAL, R. & FULLAGAR, R. 1989. Engraved *Diprotodon* tooth from the Spring Creek locality, Victoria. *Archaeology in Oceania* 24: 13–16.

VANHAEREN, M. 2010. *Les Fonctions de la Parure au Paléolithique Supérieur: de l'individu à l'unité culturelle.* Éditions Universitaires Européennes: Saarbrücken.

VANHAEREN, M. & d'ERRICO, F. 2001. La parure de l'enfant de La Madeleine (Fouilles Peyrony). Un nouveau regard sur l'enfance au Paléolithique Supérieur. *Paleo* 13: 201–40.

VANHAEREN, M. & d'ERRICO, F. 2006. Aurignacian ethno-linguistic geography of Europe revealed by personal ornaments. *Journal of Archaeological Science* 33: 1105–28.

VANHAEREN, M. et al. 2006. Middle Paleolithic shell beads in Israel and Algeria. *Science* 312: 1785–88.

VAN NOTEN, F. 1977. Excavations at Matupi Cave. *Antiquity* 51: 35–40.

VAN PEER, P. et al. 2003. The Early to Middle Stone Age transition and the emergence of modern human behavior at Site 8-B-11, Sai Island – Sudan. *Journal of Human Evolution* 45: 187–93.

VAUGHAN, P. 1983. La fonction des outils préhistoriques. *La Recherche* 14/148: 1226–29.

VIALET, A. 2015. Les premières sepultures, pp. 291–304 in (H. de Lumley, ed.) *Sur le Chemin de l'Humanité. Colloque International de l'Académie Pontificale des Sciences, 19–21 avril 2013.* CNRS: Paris.

VIALOU, D. 1979. Grotte de l'Aldène à Cesseras (Hérault). *Gallia Préhistoire* 22(1): 1–85.

VIALOU, D. 1995. L'art, cette étincelle qui fait basculer le monde. *Phréatique, langage et creation* 74–75: 4–12.

VILLA, P. et al. 2015. A milk and ochre paint mixture used 49,000 years ago at Sibudu, South Africa. *PLOS ONE* 10(6): e0131273. doi:10.1371/journal.pone.0131273.

VOGELSANG, R. et al. 2010. New excavations of Middle Stone Age deposits at Apollo 11 rockshelter, Namibia: stratigraphy, archaeology, chronology and past environments. *Journal of African Archaeology* 8(2): 185–218.

WAKANKAR, V.S. 1973. Bhimbetka excavation (III F-24). *Journal of Indian History,* Trivandrum, pp. 23–32.

WAKANKAR, V.S. 1975. Bhimbetka the prehistoric paradise. *Prachya Prathiba* 3(2): 7–29.

WAKANKAR, V.S. 1984. Bhimbetka and dating of Indian rock paintings, pp. 44–45 in (K.K. Chakravarti, ed.) *Rock Art of India.* Arnold-Heinemann: New Delhi.

WAKANKAR, V.S. 1985. Bhimbetka: the stone tool industries and rock paintings, pp. 175–76 in (V.N. Misra & P. Bellwood, eds) *Recent Advances in Indo-Pacific Prehistory.* Oxford & IBH Publishing Co.: New Delhi.

WALKER, N.J. 1987. The dating of Zimbabwean rock art. *Rock Art Research* 4: 137–49.

WALKER, N.J. 1996. *The Painted Hills. Rock Art of the Matopos.* Mambo Press: Gweru, Zimbabwe.

WALSH, G.L. 1983. Composite stencil art: elemental and specialised. *Australian Aboriginal Studies* 2: 34–44.

WALSH, G. 1994. *Bradshaws: Ancient Rock Paintings of Australia.* Édition Limitée: Geneva.

WATANABE, S. 2004. Comunicação do Prof. Dr. Shigueo Watanabe – Instituto de Fisica da USP – São Paulo. *Fumdhamentos* 4: 94–104.

WATANABE, S. et al. 2003. Some evidence of a date of first humans to arrive in Brazil. *Journal of Archaeological Science* 30: 351–54.

WATCHMAN, A. 1993. Evidence of a 25,000-year-old pictograph in northern Australia. *Geoarchaeology* 8: 465–73.

WATCHMAN, A. & HATTE, E. 1996. A nano approach to the study of rock art: "The Walkunders", Chillagoe, north Queensland, Australia. *Rock Art Research* 13(2): 85–92.

WATCHMAN, A., WALSH, G.L. & MORWOOD, M.J. 1997. AMS Radiocarbon age estimates for early rock paintings in the Kimberley, N. W. Australia: preliminary results. *Rock Art Research* 14: 18–26.

WATCHMAN, A. et al. 2000. Minimum ages for pecked rock markings from Jinmium, northwestern Australia. *Archaeology in Oceania* 35: 1–10.

WATTS, I. 2010. The pigments from Pinnacle Point cave 13B, Western Cape, South Africa. *Journal of Human Evolution* 59: 392–411.

WATTS, I., CHAZAN, M. & WILKINS, J. 2016. Early evidence for brilliant ritualized display: specularite use in the Northern Cape (South Africa) between ~500 and ~300 Ka. *Current Anthropology* 57(3): 287–310.

WEINSTEIN-EVRON, M. & BELFER-COHEN, A. 1993. Natufian figurines from the new excavations of the El-Wad Cave, Mt Carmel, Israel. *Rock Art Research* 10: 102–6.

WELCH, D.M. & WELCH, A. 2015. Palorchestes or bunyip? *INORA* 72: 18–24.

WELKER, F. et al. 2016. Palaeoproteomic evidence identifies archaic hominins associated with the Châtelperronian at the Grotte du Renne. *Proc. Nat. Acad. Sciences* 113(40): 11162–67.

WENDT, W.E. 1974. 'Art mobilier' aus der Apollo 11-Grotte in Südwest-Afrika. *Acta Praehistorica et Archaeologica* 5: 1–42.

WENDT, W.E. 1976. 'Art mobilier' from the Apollo 11 cave, South West Africa; Africa's oldest dated works of art. *South African Archaeological Bulletin* 31: 5–11.

WESTERGAARD, G.C. & SUOMI, S.J. 1997. Modification of clay forms by tufted Capuchins (*Cebus apella*), *International Journal of Primatology* 18(3): 455–67.

WHITLEY, D.S. & DORN, R.I. 1987. Rock art chronology in eastern California. *World Archaeology* 19(2): 150–64.

WHITLEY, D.S. & DORN, R.I. 1993. New perspectives on the Clovis vs Pre-Clovis controversy. *American Antiquity* 58: 626–47.

WHITLEY, D.S. & DORN, R.I. 2012. The earliest rock art in Far Western North America, pp. 585–90 in (J. Clottes, ed.) *L'art pléistocène dans le monde / Pleistocene art of the world / Arte pleistoceno en el mundo*, Actes du Congrès IFRAO, Tarascon-sur-Ariège, September 2010. Special issue, *Préhistoire, Art et Sociétés, Bull. Soc. Préhist. Ariège-Pyrénées*, LXV–LXVI, 2010–11, CD.

WHITLEY, D.S. et al. 1996. Recent advances in petroglyph dating and their implications for the pre-Clovis occupation of North America. *Proceedings of the Society for California Archaeology* 9: 92–103.

WILSON, A.D. et al. 2016. A dynamical analysis of the suitability of prehistoric spheroids from the Cave of Hearths as thrown projectiles. *Scientific Reports* 6, Article 30614, doi:10.1038/srep30614

WRESCHNER, E. 1980. Red ochre and human evolution: a case for discussion. *Current Anthropology* 21: 631–34.

WRIGHT, D. et al. 2014. A scientific study of a new cupule site in Jabiluka (Western Australia). *Rock Art Research* 31(1): 92–100.

WRIGHT, R.S.V. (ed.) 1971. *Archaeology of the Gallus Site, Koonalda Cave*. Australian Institute of Aboriginal Studies: Canberra.

WYNN, T. 1985. Piaget, stone tools and the evolution of human intelligence. *World Archaeology* 17: 32–43.

YERKES, R.M. 1943. *Chimpanzees. A Laboratory Colony*. Yale University Press: New Haven.

YI WEI et al. 2016. An early instance of Upper Palaeolithic personal ornamentation from China: the freshwater shell bead from Shuidonggou 2. *PLOS ONE* http://dx.doi.org/10.1371/journal.pone.0155847

ZILHÃO, J. 1995. The age of the Coâ valley (Portugal) rock art: validation of archaeological dating to the Palaeolithic and refutation of the 'scientific' dating to historic or proto-historic times. *Antiquity* 69(266): 883–901.

ZILHÃO, J. 2007. The emergence of ornaments and art: an archaeological perspective on the origins of 'behavioral modernity'. *Journal of Archaeological Research* 15: 1–54.

ZILHÃO, J. et al. 2010. Symbolic use of marine shells and mineral pigments by Iberian Neandertals. *Proceedings of the National Academy of Sciences of the USA* 107(3): 1023–28.

ZOTZ, L. 1951. *Altsteinzeitkunde Mitteleuropas*. Enke: Stuttgart.

Acknowledgments

The origins of this book lie with Professor Henry de Lumley, who invited us both to present talks on the earliest art at the conference entitled 'Sur le Chemin de l'Humanité' at the Vatican in April 2013. This was a wonderful experience in many ways, and we thank him profoundly for the invitation.

For the supply of images, we are also deeply grateful to the following friends and colleagues: Maxime Aubert, Larry Benson, Alberto Broglio, Augusto Cardich, Francesco d'Errico, Ben Gunn, Slimane Hachi, Don Johanson, Jean-Marie Le Tensorer, Jean-Claude Marquet, the late Alex Marshack, Desmond Morris, François Poplin; Anna Roosevelt, François Sémah, Pierre-Jean Texier and João Zilhão.

In addition, ML would like to thank Josseline Lorblanchet for her constant and varied help during his work, as well as the following colleagues and museums for providing access to objects in their collections: the Musée National de Préhistoire in Les Eyzies, Dordogne (especially its director, Jean-Jacques Cleyet-Merle, and André Morala); the Musée de Préhistoire des Gorges du Verdon at Quinson, Alpes de Haute Provence; the Musée du Colombier at Alès (Gard) and Madame J. Hochapfel-Altes; that of Le Grand-Pressigny, Indre-et-Loire; and that of Brive-la-Gaillarde, Corrèze.

For their help with his research into cupules, bolas and other topics, ML also wishes to acknowledge Sébastien Lacam, Michel Rochevalier, Jacques Tixier and Alain Turq.

We are grateful to Colin Ridler, Ben Plumridge and Jen Moore at Thames & Hudson for turning our texts and images into a book.

Finally, we offer our profound thanks to the painter Pierre Soulages for doing us the great honour of writing a preface for this volume.

Sources of illustrations

All photos and drawings from authors' collections, apart from: **1** Photo A. Weider; **2** B. Plumridge © Thames & Hudson Ltd; **5** (West Tofts) After photos by K. Oakley (1981); **6** (Saint-Just-des-Marais) After K. Oakley; (Schweinskopf-Karmelenberg) after J. Schäfer; (Grotte de l'Hyène) after A. Leroi-Gourhan; **7** (burin) after A. Morala; **9** (Chez Pourré-Chez Comte drawing) V. Herring © Thames & Hudson Ltd, after P. Lalande (1969); (Sangi Talav) V. Herring © Thames & Hudson Ltd, after F. d'Errico et al. (1989); **10** (Becov) After photo by A. Marshack; (Qafzeh) after B. Vandermeersch; **13** (Vailly-sur-Aisne) After photo by H. Jouillé (1963); (Aïn Hanech) after F. Bordes (1961); **14** Photo M. Bouis; **16** After G. Henri-Martin, F. Bordes & L. Pradel; **17** After A. Turq; **18** Drawing by G. de Mortillet (1885: 54, fig. 2); **19** After H. Martin; **20** After Pei Wen-Chung (1933); **21** Photo F. Bordes (1969); (middle drawing) P. Laurent (1969); (bottom drawing) d'Errico & Villa (1997); **23** After C. V. Chirica; **28** D. Mania (1988); **29** D. Mania (1990); **30** D. Mania (1991); **31** V. Herring © Thames & Hudson Ltd; **32** (1–3, 8–10) After Debénath & Duport; (4) after Raynal & Ségui; (5) after S. Davis; (6) after González Echegaray; (7) after D. Peyrony; (11) after Dubois & Stehlin; (12) after Hugues, Gagnières & Rappaz; (13) after H. Martin; (14) after L. Duport; **33** (La Ferrassie) After D. Peyrony (1934); (Border Cave) after P. B. Beaumont; (Turské Maštale) after J. Neustupny; (Prolom II) V. Herring © Thames & Hudson Ltd; **34** (1) After G. Iturbe et al.; (2) after D. Peyrony (1934); (3–5) after M. Chollot-Varagnac (1980); (6) after A. Leroi-Gourhan (1961); (7, 8) after H. Breuil (1906); **35** (1) after M. Crémades; (2) after V. Commont; (3) after M. Boule & L. de Villeneuve; (4) after de Saint-Périer; **36** After M. García-Diez et al. (2013); **37** After K. Valoch (1996), tab. VIII; **38** A. Marshack (1996), PB collection; **39** (Kostenki) After Abramova (1995) figs 71, 74, 82, 86; **40** (1–3) Photos courtesy J. J. Blanc; (3) drawing V. Herring © Thames & Hudson Ltd; (4) drawing V. Herring © Thames & Hudson Ltd, after Zotz (1951) and Delporte (1979), fig. 79; (5) after Abramova (1995), fig. 15; (6) after Abramova (1995), fig. 30; **41** National Treasures Department, Israel Antiquities Authority, Jerusalem; **42** A. Marshack, PB collection; **43** © J-C. Marquet; **44** Photo Museum National d'Histoire Naturelle, Paris (by permission of J-C. Marquet), drawing after Marquet & Lorblanchet (2000), fig. 15; **45** V. Herring © Thames & Hudson Ltd, after S. Avdeev; **46** (1) After photo by P. Chase (1990); (3) after C. McBurney; (6) after G. Henri-Martin; (7) after F. Bourdier; **47** (1) After H. Martin; (4) after G. Iturbe et al.; (5) after Wetzel & Bosinski (1969); (7) after D. Roe (1981); (8–11) after Y. Taborin & G. Tosello; **48** Photo F. d'Errico & M. Vanhaeren; **49** W. Lustenhouwer, VU University Amsterdam; **50** After N. Bader; **51** After D. Huyge; **52** V. Herring © Thames & Hudson Ltd; **53** Photo H. Jensen © University of Tübingen; **56, 57** Photos J-M. Le Tensorer; **60** Drawing V. Herring © Thames & Hudson Ltd; **61** After Van Peer et al.; **63** D. Peyrony (1934); **75** Photo and drawing F. d'Errico; **77** Photo A. Weider; (1) after Lemozi (1961); (2) after Dams (1984b); **78** After Ladier, Welte & Sabatier (2003); **79** After Sacchi (2003) and Ambert (1972); **80** (Chauvet) Regional Direction for Cultural Affairs, Rhône-Alpes, Regional Department for Archaeology; (Fumane) Courtesy A. Broglio, M. de Stefani & F. Gurioli, University of Ferrara, Italy; **81** After B. & G. Delluc; photo A. Cardich; **88** From Rifkin, R.F. (2015), Pleistocene figurative art mobilier from Apollo 11, southern Namibia. *Expression* 9: 97–101; **89** Photo S. Hachi; **92** V. Herring © Thames & Hudson Ltd, after G. Kumar et al.; **93** V. Herring © Thames & Hudson Ltd, after C.M. Aikens & T. Higuchi; **94** Photo D. Johanson; **98** V. Herring © Thames & Hudson Ltd, after J-M. Le Tensorer; **99** M. Soulier/SSAC; **I** Collection Desmond Morris, Oxford; **III** Photo J-M. Le Tensorer; **IV** Museum of Archaeology and Anthropology, Cambridge; **V** Photo F. Poplin; **VIII** (Isenya) Photo P. J. Texier; **IX** Photo J. Zilhão; **X** Courtesy C. Henshilwood; **XI** Photo F. d'Errico & M. Vanhaeren; **XII** The Natural History Museum, London/Alamy; **XIII** Courtesy C. Henshilwood; **XIV** Photo F. d'Errico & C. Henshilwood; **XV** Photo R. Gunn, courtesy of the Jawoyn Association; **XVIII** Photo Musée du Périgord, Périgueux; **XXIII** Photo M. García-Diez; illustration after H. Alcalde del Río, H. Breuil, L. Sierra, *Les cavernes de la Région Cantabrique*, 1911 (A. Chene, Mónaco); **XXIV** Photo M. Aubert; **XXV** Photo A. Roosevelt; **XXVIII** Photo L. Benson.

Index